LEONARDO

LEONARDO

ROBERT PAYNE

ROBERT HALE · LONDON

© *Robert Payne 1978*
First published in Great Britain 1979

ISBN 0 7091 7547 7

Robert Hale Limited
Clerkenwell House
Clerkenwell Green
London, EC1R 0HT

Printed in Great Britain by
Lowe & Brydone Printers Limited, Thetford, Norfolk.
Bound by Weatherby Woolnough Limited, Northants.

PATRICIA
amantissima mia diva

Contents

Illustrations

Between pages 268 and 269

Introduction

In the following pages I have attempted to draw a portrait of Leonardo da Vinci and to discover how it came about that a man born in an obscure hamlet in Italy, with no formal education, and with no natural advantages except a formidable intelligence, living at a time of incessant wars and at the mercy of many tyrants, opened up vast areas of human knowledge and painted so superbly that for many people he represents the single "universal genius," the prototype of Western man in his utmost accomplishment, Renaissance man in his utmost splendor.

I have tried to dispel some of the illusions that have been created around him—illusions that were partly of his own making. There is very little mystery about him: the only mystery is how he was able to accomplish so many works of genius in so short a time. We know where he was and what he was doing during the greater part of his life. No man of his age left a more voluminous account of himself, for he left about ten thousand pages of manuscript behind at his death and of these some five thousand survive, and in addition there exist official records in Florence, Milan, Rome, Mantua, and many other places to fill in the gaps. He was not a secretive person and did not hide his thoughts: those which he wrote down could be read very easily by holding them up to a mirror. He intended that his notes should be preserved and published, and he explained exactly how he wanted them printed. The remote, detached figure moving like a shadowless ghost through the Renaissance had no existence outside the imagination of Vasari, who was fanatically loyal to Michelangelo and was the first to insist that in a continuing quarrel Leonardo had shown himself to be monstrously haughty and Michelangelo had shown himself to be

humble and very human. In fact Michelangelo was as proud as Lucifer, and Leonardo could be more humble than Job.

Leonardo was a man like other men, and he accomplished what he set out to accomplish, not coldly, but with a human warmth, a gaiety, and an exquisite gentleness that delighted his contemporaries. He lived a full life, traveled extensively, achieved high positions and abandoned them when they had served his purpose, loved animals so much that he refused to eat them, loved horses especially and drew them better than they had ever been drawn before, and painted women so tenderly that it is inconceivable that he had never been in love with a woman.

He belonged to his age, and had the virtues and vices of his age. He enjoyed magnificence, the galas in the ducal courts, embroidered silks, handsome youths parading in splendid costumes, all the pageantry of court life, but he also enjoyed, and more profoundly, working in a hospital mortuary and cutting up dead bodies because he had set himself the task of discovering the machinery by which nature operates and he could not begin to solve the mystery without first mapping out the human body. He worked with the most primitive instruments, always hurrying against time, determined to complete his studies before decomposition set in, lacking microscopes, lacking formaldehyde, lacking the most elementary refrigeration, working alone at night amid the foul stench of the mortuary, drawing those precise three-dimensional anatomical designs which have never been surpassed for the sheer beauty of their forms and the power and dignity of the lines. An old man, a centenarian, died in the hospital where he was working. Leonardo talked to him during his last hours and discovered that he had never had a day's illness. Immediately after the man died, Leonardo began to cut him up in the hope of learning what changes in the physical body bring about death. At the top of the first page of his anatomical study of the old man, he drew, with grave courtesy, a portrait of the man as he was when alive. It was Leonardo's salute to the memory of the living man, while he was engaged in dismembering the corpse. His life was made up of such acts of courtesy.

If Leonardo modeled himself on anyone, it was the warm-hearted humanist Leon Battista Alberti, born at the beginning of the fifteenth century and dying in 1472, when Leonardo was twenty years old. It was said of him that he could leap over a man standing upright, drive an arrow into armor, and toss a coin till it could be heard ringing against the roof of a church. He painted, sculpted, designed churches, wrote songs, taught himself music and mathematics, devised machinery for raising sunken ships, wrote a comedy in Latin when he was twenty, and amid a host of other volumes went on to write an enter-

taining study of family life and the classic Renaissance work on architecture. His anonymous biographer says that "when he saw the cornfields and vineyards of autumn he wept," but no one therefore described him as melancholy by nature. It was said, too, that he would often sit at table lost in meditation for hours, but no one ever regarded him as remote and inaccessible. He was born illegitimate, like Boccaccio and Filippino Lippi, but this fact never weighed upon his conscience. When he had become one of the most famous architects of his time, he wrote, "Man is born not to mourn in idleness but to work at large and magnificent tasks, thereby pleasing and honoring God, and manifesting in himself perfect *virtù*, that is, the fruit of happiness."

Leonardo was Alberti *redivivus*, with an even more formidable intelligence, an even more acute and disciplined aesthetic sense. They were both "universal geniuses," which is to say that they applied their intelligences to the entire field of nature and felt that nothing human or divine was alien to them. What they were doing—what they spent most of their lives doing—was to discover the world, to force it to reveal its secrets and divest it of its mysteries; and like Columbus, who set out for the Indies in the belief that he was fulfilling the prophecies of Isaiah, they believed they were fulfilling a divine purpose. Vasari wrote in the first edition of his brief life of Leonardo that he scorned God; the passage was omitted in the second edition for good reason. It was not true. We lose some of our understanding of Leonardo if we think of him as a rebel against the Church or established conventions. He was deeply religious and rejoiced in the conventions of his time.

Much of the difficulty in drawing a credible portrait of Leonardo is caused by the red chalk drawing in Turin, supposed to be a self-portrait made by Leonardo when he was about sixty, although it is drawn in the style of a much earlier period. This portrait shows a man in extreme old age, powerful and forbidding, with furrowed brow, small cavernous eyes, a heavy fleshy nose, thin lips tightly compressed, hair and beard cascading like a waterfall; and there is about that face, so sharply drawn, a look of bitter pride and disdain for the world and all its fruits. It is a masterly and haunting drawing, and there is not the least doubt that Leonardo drew it. Wherever Leonardo's name appears, this drawing is reproduced. It has become his *imago*, the one picture that identifies him. Yet it is not a self-portrait of Leonardo. I hope to show persuasively that it is a portrait of Leonardo's father, the masterful Ser Piero da Vinci, who died in 1504 at the age of eighty.

A much more credible portrait exists in the Ambrosiana in Milan, where he appears in profile, delicately featured, without beetling brows or overhanging nose, gazing out at the world with quiet

confidence, while enveloped in his luxurious flowing hair. I believe
this to be a self-portrait perhaps worked over by one of his pupils, and
that it is a true likeness of the man as he wanted to be known. And
what is chiefly remarkable about this portrait is his calm and gen-
tleness, even a certain timidity and reserve, as of a man at peace with
the world, uninterested in his own fame, neither proud nor disdainful,
secure in the knowledge of his accomplishments. I see him as light of
foot, with a quick and penetrating mind and something of Shake-
speare's speed of thought, youthful and serene, a man who loved
dancing and music and telling stories, and wore his weight of learning
lightly. He lived in an age that showed some admiration for the *ter-
ribilità*, that audacious violence that attempts to take heaven and
mankind by storm; but he was one of those who take heaven and
mankind in their stride; he hated every form of violence, and was
more audacious than all the tyrants.

Today we know much more about Leonardo than anyone has
known since he was living. Four or five generations of scholars have
worked on his manuscripts; two forgotten codices have come to light
in rather mysterious circumstances in the National Library in Madrid;
the interrelationship between the surviving notebooks has been es-
tablished, and to each there has been given a suitable date, so that it
is now at last possible to watch the development of Leonardo's
thought. And slowly—very slowly—Leonardo's manuscripts are being
published in facsimile at prices which are still far beyond the purchas-
ing power of the general public but not altogether beyond the pur-
chasing power of libraries and institutions. Leonardo was above all
the master of the delicately shaded line drawing, and until these
drawings are all faithfully reproduced, the majesty of his achievement
will remain unknown to the public.

Many of the scholars who have worked on Leonardo's manuscripts
possessed something of the master's heroic spirit. The manuscripts
themselves present nearly insoluble problems not because the hand-
writing is difficult—on the contrary, the handwriting can be read easily
—but because Leonardo jumps about in the most extraordinary way
from one problem to another, so that on a single page he may discuss
a problem in mathematics, another in physics, discuss the nature of
the cardiac muscles, the flight of a bird, the movement of water, and
somewhere beneath all these observations there may be seen an archi-
tectural drawing of a palace without a single word to help us identify
the building, or whether it was one he intended to build or whether it
was simply a flight of imagination.

This extraordinary mass of manuscripts was not studied carefully or
critically until the later years of the nineteenth century, the first seri-

ous efforts being made by Gilberto Govi, Gustavo Uzielli, and Edmondo Solmi. Jean Paul Richter's massive translation of the notebooks into English was published in 1883. Then came Luca Beltrami, who wrote a large number of special studies and published *La Vita et le Opere di Leonardo da Vinci,* the one indispensable source for the biographer since it includes nearly every known document concerning the events of Leonardo's life. This was published in 1919 in an edition of six hundred copies and is now virtually unprocurable. By profession Luca Beltrami was an architect. A rich man, he spent a fortune saving the Castello at Milan from destruction and restoring it, so that today it appears very much as it appeared in Leonardo's time. I am deeply indebted to him and also to his friend Professor Carlo Pedretti, the author of six important books on Leonardo and some forty monographs, who gave me free access to his shelves and gently guided me through problems that sometimes seemed insoluble.

The world of Leonardo embodies its own sources, myths, and criticism. It is rounded and complete, open, rarely mysterious. Occasionally the shadows fall around him; as a painter he had studied shadows minutely and could create them at will. But for the most part he stands in the sunlight and we can walk around him and study his features and how he works. I have attempted to meet him in the flesh, to walk around his studio, to observe his sitters while they posed for him, and to watch him when he was standing alone and thinking those vast thoughts which were so much in advance of his time that we are only now catching up with him. I have deliberately quoted the documents at some length, because they bring us immediately into his time and into his presence. He stands at the beginning of our age, so huge and dominating a figure that he is more like a mountain range than a man, throwing us all in his shadow, blinding us with the beauty of his works. He was one of those rare men who throw shadows which are full of light and full of promise. There is another mountain range called Socrates; another is Dante; a third is Shakespeare. But Leonardo alone looked deeply into the future, shaping it with humility and unerring grace, taking all nature and all humanity in his glance, insisting always, even in those times that were most troubled, on the glory of the human creature, which he celebrated in his art, his inventions, and perhaps most of all in his anatomical studies. He strove for an impossible perfection of understanding, and he achieved it.

LEONARDO OF FLORENCE

The Young Leonardo

Leonardo was born in the spring of 1452, a year before the Byzantine Empire was shattered by the Ottoman army and forty years before Columbus discovered America.

There was nothing in the circumstances of his birth to suggest that he would be remembered over the centuries. He was born in Vinci, a sleepy village a day's journey by mule cart from Florence. The village, which consisted of about thirty houses, resembled a hundred other villages in Tuscany. There was a small castle and a church with a campanile, a forge, a smithy, a few shops, a huddle of red-roofed houses and farms, with silvery olive groves and terraced vineyards on the low hills, while higher up, on Monte Albano, the long mountain grasses were flecked with red and white poppies. The village was not on a main highway, nothing notable had ever taken place there, and a boy born in the village could expect to spend the rest of his life in it. What was remarkable about Vinci was that it was unremarkable.

Patient researchers have discovered that Vinci was a center for the cultivation of medicinal herbs, that mulberry trees were first planted there by Leonardo's uncle Francesco, and that the spinning of silk gave employment to some of the villagers, but mostly their wealth, such as it was, came from the olives and the vines. They have also discovered that in ancient Etruscan times Vinci was a substantial town on a main highway that ran around a great inland lake. Today nothing remains of the lake, which has been drained away except for a few scattered marshes. On the low-lying fields of Vinci oyster and clam shells are still being found.

Leonardo was born in this quiet village on the evening of April 15, 1452. This we know because the boy's grandfather, the notary Ser Antonio da Vinci, wrote an attestation concerning the event that has survived among the state documents of Florence. It is an extraordinary document written in a practiced legal hand, as remarkable for what it leaves out as for the information it contains. The boy's grandfather wrote down all he wanted known about the birth of his grandson:

> A grandson of mine was born, son of Ser Piero, my son, on April 15, Saturday, at three in the night [i.e., at 11 P.M.]. He was named Lionardo. He was baptized by the priest Piero di Bartolomeo, Papino di Nanni Banti, Meo di Tenino, Piero di Malvolto, Nanni di Venzo, Arrigo di Giovanni the German, Monna Lisa di Domenico di Brettone, Monna Antonia di Giuliano, Monna Nicolosa del Barna, Monna Maria, daughter of Nanni di Venzo, Monna Pippa di Previcone.

The ten people named after the priest Piero di Bartolomeo were friends of the family who attended the baptism, which in the normal course of events took place in the local Church of Santa Croce on the Sunday following Easter. There are five men and five women. The notary went to some pains to copy out their names carefully, for when he came to the last name, "Monna Pippa," he first wrote the name "Nanni di Venzo," repeating a name as people do when they are copying. He struck out "Nanni di Venzo" and wrote down the correct name.

Antonio da Vinci was descended from a long line of notaries and knew exactly what he was doing when he drew up this document. His purpose was to affirm that the baby, born out of wedlock, had been legitimately accepted into his family, by him and by his son, in the presence of ten worthy people in the community. The very fact of baptism in these circumstances conferred upon the baby a kind of legitimacy and respectability. Henceforth he was entitled to all the benefits conferred on the family and would be known as Leonardo di Ser Piero

da Vinci. "Ser," equivalent to "magister," was a special prefix attached to the names of notaries.

Although Antonio da Vinci painstakingly listed the name of the priest who officiated at the ceremony and the names of ten witnesses, he carefully and deliberately excluded the name of the baby's mother. The legend grew up in the nineteenth century that the mother was a poor peasant girl of the community who had been casually seduced by Ser Piero and whose name therefore was a matter of indifference to history. There is not the slightest foundation for the legend. We know very little about her because the information was deliberately suppressed. She may not have been poor, and was certainly not of peasant origins. The *Anonimo Gaddiano*, an anonymous compilation of short biographies of famous Florentines, intelligently and on the whole accurately written, describes Leonardo's mother as a woman *nata di buon sangue*, born of good blood, which meant and could only mean that she was of noble birth. "Good blood" meant "noble blood." The *Anonimo Gaddiano* was compiled at a time when there were many people still living who knew the name of the girl's family and could, if they had wanted to, have divulged the name to anyone inquiring into Leonardo's ancestry. For perfectly intelligible reasons they chose not to divulge it: in this way they protected the girl's honor and her family name, and they made it more possible for her to find a husband later, since Ser Piero refused to marry her.

We know from other documents that her name was Caterina, but this is all we know. The conspiracy of silence was so successful that today we have no idea where she came from, or how old she was, or what she looked like. Leonardo's mother remains a mystery, all the more mysterious because throughout a good part of his life we are obscurely aware of her presence.

But if we know nothing or very little about Caterina, we can document the life of Ser Piero in considerable detail. We know what he looked like because Leonardo, as though obsessed by his father's features, was continually drawing sketches of him in his notebooks. Ser Piero had a rugged and powerful face, with beetling brows, an aquiline nose, a heavy underlip, and a rounded but forceful jaw, and as he grew older, he grew fleshier and somewhat repulsive. It was a face to inspire respect and confidence in his abilities, but he was also a man who was mercenary to the highest degree. Everything we know about him predisposes us to believe that the reason he did not marry Caterina was because her family could not offer a sufficiently large dowry. It was an age when men demanded large dowries. Leon Battista Alberti, in his book *On the Family*, has one of his characters saying, "I counted a few days ago no less than twenty-two young

members of the Alberti house, living alone without a mate, not having
a wife, none less than sixteen and none older than thirty-six years of
age." The reason, he explains, is that they are all waiting for brides
with enormous dowries. The inevitable result was that many young
women went unmarried and entered nunneries, young widows prolif-
erated, old men married young girls, and the birth rate declined. Ex-
travagant dowries were a curse, but there was very little that could be
done about them.

In the same year that Leonardo was born Ser Piero married the six-
teen-year-old Albiera di Giovanni Amadori, a young heiress belong-
ing to a wealthy Florentine family. She brought him a suitable dowry,
but gave him no children, and the family continued to live at Vinci in
the large house owned by Ser Antonio, Leonardo's grandfather. Ser
Antonio's tax returns for 1457 have survived, and we learn that six
people were living in the house. They were Ser Antonio himself, who
was eighty-five years old, his wife, Lucia, who was sixty-four, Ser
Piero, who was thirty, his wife, Albiera, who was twenty-one, another
son Francesco, "who remains at home and does nothing," and finally
there was Leonardo, "the son of the afore-mentioned Ser Piero, ille-
gitimate, born of him and of Caterina, at present the wife of Achat-
tabriga di Piero del Vaccha da Vinci." Concerning Achattabriga we
know very little. He was a kiln maker, a *fornaciaio*, who is known to
have built pottery kilns in and around Vinci between 1449 and 1453,
and it is believed that he was also a farmer. His Christian name was
Antonio, and the name Achattabriga means "brawler." This was a per-
fectly respectable name and does not imply that he was himself a
brawler and a good-for-nothing. He lived in Vinci, and we may as-
sume that Leonardo remained on good terms with his mother and his
stepfather, while living in his grandfather's house. Like many chil-
dren, he may have discovered advantages in belonging to two fami-
lies.

In this quiet village in the backwaters Leonardo spent the early
years of his life. He worshiped in the village church, attended the vil-
lage school, took part in the local fiestas, and learned the local songs.
He possessed a villager's toughness and independence, qualities that
served him well when he came to live in the great cities. He grew up
into a bright-eyed and handsome boy, and his aged grandfather evi-
dently doted on him, and so did his uncle Francesco, while he appears
to have been somewhat intimidated by his reserved and masterful fa-
ther. It appears to have been one of those calm and happy childhoods
that leave few memories.

In all the surviving pages of his notebooks he records only one
childhood memory. He records it briefly and matter-of-factly, without

embroidery, and modern psychologists have sometimes read into it whatever they pleased. While writing a careful and elaborate study of the flight patterns of a kite, Leonardo paused abruptly to ask himself why on earth he was pouring so much intellectual energy into this work. Why was he so deeply concerned with this bird when there were others which could perhaps be studied just as usefully? He answered, "To write thus clearly about the kite would seem to be my fate, because in the earliest memory of my childhood it seemed to me that as I lay in my cradle a kite came down to me and opened my mouth with its tail and struck me with its tail many times between the lips."

Why this statement should have fascinated psychologists is something of a puzzle. Leonardo was not speaking about a dream, which might be fruitfully analyzed; he was referring to a vivid childhood memory, something that actually happened when he was very young. There was nothing in the least mysterious about it. Farmers took their babies into the fields and set them down in the shade. The babies usually lay in wicker baskets that were provided with hoops, and Leonardo remembered the moment when the kite alighted on the hoop above his face and the tail feathers forced his mouth open. Many years later he could still remember what appeared to be a brutal invasion of his mouth and the curious sensation of being struck repeatedly on the gums. Thereafter he sometimes felt that he lived in a very special relationship to birds, which he admired above all creatures. When he lived in the cities, it was his custom to buy caged birds in the market place, take them in his hand, and set them free.

But it was not only birds that he loved; from a very early age he appears to have been devoted to horses, admiring them not only for the sheer beauty of their forms but also for their intelligence. When he drew them, he also drew their intelligence. He drew dogs, cats, bears, and lions with the same courtesy. Indeed, he admired the whole animal kingdom, and was perfectly happy even among the most horrible animals. Vasari, writing nearly a century after the event, tells an entertaining story about the fearsome monster Leonardo contrived out of the lowliest and ugliest members of the animal kingdom.

> There is a story that a peasant on Ser Piero's country place brought a shield made from a fig tree he had cut down, and asked that Ser Piero have it painted for him in Florence. As the countryman was a very able huntsman and a great favorite with his master, the latter willingly promised to have it done. He took the wood, therefore, to Leonardo, not telling him for whom it was, and asked only that he paint something on it.
>
> Leonardo took the shield in hand, but since he found it

crooked, coarse, and badly made, he straightened it before the fire and sent it to a turner, who returned it smooth and delicately rounded. Leonardo covered it with gypsum and prepared it to his liking. He then considered what to put on it and thought of the head of Medusa and the terror it struck in the hearts of those who beheld it. He therefore assembled in a room that no one entered but himself a number of lizards, hedgehogs, newts, serpents, dragonflies, locusts, bats, glowworms, and every sort of strange animal he could lay his hands on.

Then he fashioned a fearsome monster, hideous and appalling, breathing poison and flames and surrounded by fire issuing from a cleft in a rock. He labored while the room filled with a mortal stench, of which he was quite unaware because he was so immersed in his work. He finished it, but had taken so long over the work that both his father and the countryman had long since stopped asking about it. Then he went to his father and told him he might send for the shield whenever he liked.

Ser Piero went to fetch it, and when he knocked on the door Leonardo asked him to wait a short while. He darkened the room and placed the shield in a dim light, and then invited his father to enter the room. Ser Piero drew back, startled, and turned away, not thinking of the round piece of wood, or that the face that he saw was painted, and then Leonardo stopped him, saying: "The shield will serve its purpose. Take it away, because it is producing the effect I intended." The work seemed almost a miracle to Ser Piero, and he warmly praised Leonardo's idea. He then quietly went out and bought another shield and had it painted with a heart transfixed by an arrow, and this he gave to the countryman, who cherished it all his life.

Ser Piero took Leonardo's work secretly to Florence and sold it to some merchants for one hundred ducats, and in a short time it came into the hands of the Duke of Milan, who bought it from them for three hundred ducats.

There is no way of knowing how much of the story is true, but it is well told, convincing, and full of those details beloved by good storytellers. It was just the kind of story that Leonardo might have enjoyed telling in middle age. Leonardo straightening the coarse wood in the fire and then getting a turner to complete the work is scarcely the kind of detail that anyone would invent, and the only suspicious part of the story concerns the long gestation of the painting, for this belongs to the legend of the slow, brooding, meditative Leonardo in contrast with the titanic Michelangelo, all action and intelligence. There is even a kind of corroboration of the story in Leonardo's notebooks where he writes that in order to paint a dragon the artist should "take

the head of a mastiff or setter, the eyes of a cat, the ears of a porcupine, the nose of a greyhound, the eyebrows of a lion, the temples of an old cock, and the neck of an old water-tortoise."

Vasari does not tell us when the incident occurred, but he implies that it took place when Leonardo was very young and while he was an apprentice in Verrocchio's studio, which he entered *nella sua fanciullezza,* in his childhood. This would mean that Leonardo entered the studio when he was nine or ten, or even younger. He might have first entered it when he was eight or nine years old, and then left it, and then returned, coming and going as he pleased. Ser Piero was a man of quality with important commissions at his disposal and Verrocchio would go out of his way to please him. What is certain is that Leonardo's skill in drawing and painting was revealed at a very early age and that he studied under Verrocchio. Vasari's statement that Leonardo entered the studio when he was a child should not be dismissed lightly.

On June 15, 1464, Albiera di Giovanni Amadori, the wife of Ser Piero, died in childbirth in Florence. Once more Ser Piero set out in search of an heiress, and in the following year he married Francesca

GENEALOGICAL TABLE

Ser Piero di Ser Guido (d. 1412)

|

Ser Antonio di Ser Piero di Ser Guido (1372–1464)

|

Ser Piero da Vinci (1426–1504)

|

LEONARDO DA VINCI (1452–1519)

Ser Piero da Vinci had four wives. There was no issue from the first two wives: (1) Albiera di Giovanni Amadori (1436–1464) and (2) Francesca di Ser Giuliano Lanfredini (1441–1475). Six children were born to each of his remaining wives: (3) Margherita di Francesco di Jacopo di Guglielmo and (4) Lucrezia di Guglielmo Cortigiano.

His children by (3) were Antonio (b. 1476), Maddalena (b. 1477, dying shortly after birth), Giuliano (b. 1478), Lorenzo (b. 1484), Violante (b. 1485), and Domenico (b. 1486).

His children by (4) were Margherita (b. 1491), Benedetto (b. 1492), Pandolfo (b. 1494), Guglielmo (b. 1496), Bartolomeo (b. 1497), and Giovanni (b. 1498).

Pier Francesco, known as Pierino da Vinci, a minor sculptor, was the son of Bartolomeo.

di Ser Giuliano Lanfredini, the daughter of a prominent lawyer. She was sixteen years old, and Ser Piero was thirty-six.

By this time the pattern of Ser Piero's life was established. Keen and hardheaded, he was reaching out for the highest positions open to him, and the Lanfredini connection was extremely useful. His grandfather, also called Ser Piero, had been appointed a notary to the Signoria in Florence and was a man of substance. He died in 1412. Now, fifty years later, another Ser Piero was hoping to obtain the same position and by 1469 he had already obtained it. In that year, as we learn from his tax return, he was a notary to the Signoria and was the head of a household of six people: his mother, his new wife, his brother Francesco and his brother's wife, Allexandra, and the seventeen-year-old Leonardo. He still had his house in Vinci but had another one in Florence. He was evidently doing well but his second marriage was proving as unfruitful as the first. His father had died, and the small estate at Vinci was being administered by Francesco. All Ser Piero's energies were being concentrated on legal matters. A few years later the poet Bernardo Cambi was celebrating his excellence in humorous verses:

> *Se fate una furnata*
> *Di buon procuratori,*
> *Non si lasci di fuori*
> *Ser Piero da Vinci.*

> If you were to make a batch
> Of good procurators,
> See that you wouldn't leave out
> Ser Piero da Vinci.

He was now a man of considerable prominence, close to the seat of power, wealthy and enterprising, with a large practice. He was the agent and legal adviser of many ecclesiastical institutions including the Abbey of the Benedictines, one of the oldest foundations in Florence, the Convent of the Servites, the Convent of the Sisters of Santa Clara, and he was also a notary for the Mercatanzia, the Guild of the Merchants, the most powerful of the seven guilds ruling over the mercantile destiny of Florence. He appears to have had offices all over the city, for each ecclesiastical institution would set aside a room for him. In October 1468 he rented for a nominal sum from the Benedictine Abbey a shop with a small storeroom, *una bottega con fundachetto*, opposite the Bargello, the palace of the chief magistrate, where trials were conducted, proclamations were issued, and criminals were punished. This shop appears to have been his principal office. While he specialized in the legal and financial affairs of churches, ab-

beys, and convents—notarial acts drawn up by him have been found in the records of eleven convents—he also possessed a private practice which may have been equally lucrative. In time he attracted the attention of the Medicis and became one of their chief legal advisers.

The notarial acts he drew up are dry as dust and can be read today only by determined specialists in the Florentine legal system of the fifteenth century. But they provide us with some useful information. Ser Piero knew legal Latin exceedingly well and he was clear-headed, down to earth, wholly mercenary. He fought for his clients and made them dependent on him. He was apparently a man who never suffered a moment of doubt or introspection, and in all this he was unlike his son, who knew no Latin until he was middle-aged, half despised money, and showed no interest in legal affairs until, at his father's death, he felt that he had not received his rightful inheritance and fought vigorously, using weapons not generally regarded as admissible, to secure his rights.

Leonardo inherited from his father a strong will, a clear brain, and a robust constitution. As the first and for a long time the only son, he occupied a position of great affection in the family. Ser Piero arranged for the boy to study with Verrocchio and since he was in a position to influence the church authorities to grant commissions to painters, he could and did use his influence to see that his son was awarded commissions.

In 1469, when Ser Piero opened his *bottega* opposite the Bargello, he also rented or bought a house on the Via delle Prestanze in the fashionable district close to the Signoria. Two years later he became the procurator of the Cloister of the Santissima Annunziata and shortly afterward became the agent and financial manager for the monks of San Donato. It was not only that he was an important man, a power to be reckoned with in legal and financial affairs, but he was also deeply immersed in political affairs. Cautious, level-headed, and exceedingly astute, he was on equally good terms with Benedictines, Dominicans, and Franciscans, who were at each others' throats. Lorenzo de' Medici died, and power passed from the Medicis into the hands of Girolamo Savonarola, a fanatical Dominican friar who ruled in the name of Christ the King and attempted to transform the Florentine Republic into a theocratic state. Ser Piero with his customary deftness survived all the abrupt changes of government, growing richer and more influential with every passing year.

In 1475 his wife, Francesca, died childless, and he promptly married for the third time. His next bride was Margherita di Jacopo di Guglielmo, who was seventeen years old. She brought him a dowry of 365 florins, and gave him four sons and two daughters over a period of

ten years. When she died, he took his fourth wife, Lucrezia di Guglielmo Cortigiano, who did better, for in a period of seven years she gave him a daughter and five sons, the last son being born when Ser Piero was in his seventies. Between 1476 and 1498 Ser Piero fathered twelve children, thus making up for lost time and more than twenty years of barren marriages.

There exists among the Leonardo drawings in the Royal Library at Windsor a single sheet on which Leonardo has drawn no less than thirty separate portraits and figures, using both sides of the paper. Some are drawn sketchily, others with great care, and they fall upon the page in a manner that suggests they were all made in a single prolonged sitting. We see the father with the beaked nose and the jutting chin, and near him a profile of a handsome, delicately featured youth with an abundance of curly hair. Below the youth is a young woman who closely resembles him and who may be his mother, Caterina. On the other side of the sheet the youth is drawn six times. Three of these drawings are clustered at the foot of the page and are balanced by three lion heads. One of these lions, in the process of becoming a dragon, is actually issuing from the youth's head. One lion, the most detailed, is carefully observed, and this is not surprising, for quite close to his home there was a lion cage erected by order of the Signoria in the belief that the republic would survive as long as the lions prowled there, just as the Romans to this day keep caged wolves in the shadow of the Capitol. Many years later Leonardo wrote in his notebook, "I once saw how a lamb was licked by a lion in our city of Florence, where there are always from twenty-five to thirty of them, and they bear young. With a few strokes of his tongue the lion stripped off the whole fleece covering the lamb, and having stripped it bare, he ate it."

For Leonardo the lion, *leone*, served as a rebus for his own name. When he drew the three lions and the three profiles at the foot of the page, he was writing his own signature.

The portraits therefore are self-portraits, and the young Leonardo, who appears here for the first time, was clearly interested in his own features to the extent that he could draw himself seven times on a single sheet of paper. The beautiful woman who resembles him and his father is drawn twice. In addition there is a drawing of a woman with a long patrician nose who may be his stepmother. Elsewhere on the sheet there is a Virgin suckling the Child with the infant St. John leaning against her knee and looking up at her, another quick sketch of St. John, and a carefully shaded drawing of a naked youth who is lunging forward, and this last is perhaps a recollection of a drawing exercise in front of a live model made in Verrocchio's studio. The naked youth is not well drawn and is curiously impersonal, while the other figures

crowding the page give the appearance of being weighted with deep personal significance.

Of the exact nature of Leonardo's preoccupations as he drew these thirty figures we can only guess. He is clearly saying something about the family relationships, his encounters with his family, his own place in the family. On the whole the drawing is calm and controlled; only in the large portrait of the father is there a hint of violence, while above the father there is an explosion of three grotesque figures, which are evidently variations on his father's face, one looking dragonish, another all beetling brows and razor-sharp nose, while the third has a mouth like a long, downward-curving slit. We might guess that the father had a savage temper which he could not always suppress. He looks like a Roman emperor, while the youth resembles a young Apollo.

The young Leonardo with the delicate profile and the unclouded brow appears again in the angel he painted into Verrocchio's *Baptism*. This, too, is what we might have expected, for artists tend to paint portraits of themselves even when they are portraying other people; it is not self-love or self-indulgence so much as the fact that they know their own faces best. So, too, in all his paintings of women, his Virgins and St. Annes, we shall see, as from a distance, a reflection of his own features, almost too refined and delicate for a man.

We should not be surprised by these self-portraits. All Leonardo's early biographers are agreed that beauty and grace were wonderfully combined in his features, that he moved about like a dancer, carried himself with a princely bearing, and possessed considerable physical strength, although some of the stories told about his physical strength look suspiciously as though they had been taken from the biography of Leon Battista Alberti. "The splendor of Leonardo's countenance, which was very beautiful, comforted every soul weighed down with sorrow," wrote Vasari, who never saw him but knew people who had known him. The *Anonimo Gaddiano* speaks of his *bellissimo aspetto*, his most beautiful countenance.

To say that he was *bellissimo* meant that he conformed to late Quattrocento standards of beauty, which are well known and accessible. Quattrocento Florence had almost invented the concept of standards of beauty. The Florentine ideal can be seen in the St. John of Masaccio's *The Tribute Money*, lithe and tall, with his commanding aspect, fine bones, and clear-cut profile. It can be seen, too, in Verrocchio's bronze statue of *David*, lean and sinewy, alive with intellectual energy, and moving like a dancer. Complications arise when we ponder the *David*, for it has often been suggested that Leonardo may have posed for the statue in Verrocchio's studio, and when seen in profile it bears a remarkable resemblance to Leonardo's self-por-

trait. Nor is there any reason why Leonardo could not have been asked to pose for the *David*, or even for the angelic Tobias in Verrocchio's painting of *Tobias and the Angel* now in the National Gallery in London. The likeness in both cases is in the hair, the eyes, the nose, and especially in the lips and chin, with the slightly jutting upper lip and the declivity beneath the lower lip and the small rounded chin, which suggests persistence and will power. In Quattrocento Florence we see a host of youthful St. Sebastians, young Davids, and adolescent John the Baptists all conforming to a certain acceptable standard of beauty, with curly hair and glowing eyes and lean bodies without any fat on them. Michelangelo's heavily built *David*, well fleshed and muscular, would appear later, coming as a shock to the Florentines, who realized that a new age had descended upon them. In terms of Quattrocento art Leonardo's features conformed perfectly to an established and well-known tradition. He was handsome in a particular way, which was the Florentine way, subtle, dramatic, somewhat feminine, with a certain gentle arrogance, an undeniable eagerness.

We know that when he walked the streets of Florence, people stopped to look at him. We know, too, that he wore the short rose-colored cloak, which was worn by the nobility. He appears to have dressed simply, for he showed in a passage incorporated in his *Treatise on Painting* that he was amused and faintly contemptuous of the extravagant fashions of his time:

> I remember in my childhood having seen with my own eyes men both great and small, with all the edges of their garments scalloped at all points, head, feet and side, and it even seemed such a fine idea at that time that they pinked[1] the scallops. They wore hoods of the same fashion, as well as shoes and scalloped cock's combs of various colors, which came out of the main seam of their garments. Furthermore, I saw the shoes, caps, purses, weapons, the collars of their garments, the edges of jackets reaching to their feet, the trains of their cloaks, and indeed everybody who would look well was covered up to the mouth with points of long, sharp scallops.
>
> At another period again the garments became so long that they had to be carried over both arms to avoid trampling on them; and then there came a time when they reached only as far as the hips and elbows and were so tight that they inflicted great torture, and many burst. And the shoes, too, were so tight that the toes were pushed over one another and became covered with corns.

We see those dandies in the paintings of Vittore Carpaccio, who was Leonardo's exact contemporary. They are dressed almost as frivo-

[1] Pinking was a kind of zigzag cutting.

lously as the courtiers of Louis XIV at Versailles, and yet they carry
themselves with a natural elegance, delighting in their peacock colors.
We see them again in Benozzo Gozzoli's *The Journey of the Magi*,
where the Medicis are seen riding in their most sumptuous garments
in an eternal cavalcade. Only the Florentines and the Venetians could
dress like popinjays without looking ridiculous. And although Leo-
nardo wrote somewhat contemptuously about the absurd and wonder-
ful fashions of his time, it is difficult to avoid the suspicion that on oc-
casion he dressed up in all his finery, like any dandy. That he favored
rose color, which was reserved for the nobility, suggests that he re-
garded himself as belonging to the nobility, by descent on his mother's
side. One day Cosimo de' Medici sent a friend, who was rich and un-
cultivated, on a mission to another city. The friend was nervous and
asked how he should disport himself. "Dress in rose color and say lit-
tle," Cosimo replied. Saying little was also the hallmark of the Floren-
tine nobility.

Young, elegant, radiantly handsome, Leonardo appeared to have
the best of all worlds. He lived in his father's houses on the Via delle
Prestanze and in Vinci, studied in Verrocchio's studio, rode horses
well, sang brilliantly, played the lyre, and like all the gifted young
Florentines of his time spent his nights carousing. He could go in and
out of Verrocchio's studio as he pleased, for he was never an appren-
tice. If he needed money, he could take it from his father or earn
whatever he needed by accompanying himself on the lyre for the en-
tertainment of any rich man who could afford his services. He was a
virtuoso performer of great skill, famous for the sweetness of his sing-
ing voice and for his improvisations on the lyre. His songs and compo-
sitions are lost; his extensive writings on the theory, practice, and
study of music survive only in fragments. He invented new musical in-
struments and adapted existing instruments, and it is certain that
music lay somewhere at the center of his life. He sculpted, painted,
and drew angelically. Vasari remarked that heaven bestowed on him
its most heavenly gifts: the difficulty lay in choosing which of his
many talents he would pursue in order to master them. It was a
difficulty he never completely resolved. Driven by a passion to learn
all the sciences and all the arts, and to discover everything that could
be known, he quite simply abandoned the idea of making a choice
and threw himself into studies so comprehensive that it could be said
of him at the time of his death that he had discovered more and
learned more than anyone before him. His ultimate aim was a very
simple one: to explore the machinery of the world, of man and nature,
until even in their remotest hiding places they had revealed their se-
crets.

In Verrocchio's Studio

Andrea di Michele Cioni, known as Verrocchio, was born in 1435, the son of a brickmaker who later became a customs inspector. He never married, supported the family of his sister Margherita, and usually complained in his tax returns that he was very nearly penniless. Nevertheless wealth came to him at intervals, and he obtained important commissions. He was a goldsmith, a sculptor, a wood carver, a painter, a musician, and a student of mathematics, especially of geometry and the newly developed science of perspective, and if he was not all these things in equal measure he was more than talented in all of them, and in his sculptures he showed himself to be one of the towering figures of the Renaissance. The *David*, the *Boy with the Dolphin*, the *Christ and St. Thomas* in the niche of Or San Michele, and the equestrian statue of Colleoni in Venice were works of genius, of power and individuality. In the statue of Colleoni he showed that it

was possible to surpass even Donatello's great equestrian statue of Gattamelata in Pisa.

Verrocchio was therefore among the greatest artists of his time, and Ser Piero demonstrated excellent judgment in arranging that Leonardo should study with him. If we imagine that Leonardo first entered the studio when he was ten years old, then it is all the more to the credit of Ser Piero, for Verrocchio, then twenty-seven years old, was still little known and going through a period of financial difficulties. The *David* and all his major works came later.

According to his contemporaries Verrocchio was "a much admired teacher of all the arts," and everything we know about him suggests a man who was genuinely fond of teaching and regarded his pupils as his own sons. Vasari tells us that he was never unoccupied, and would go from a painting to a sculpture and back again to a painting in the course of a morning, and in this way he would avoid growing stale while working continuously. This habit of working incessantly was followed by Leonardo, who also moved from one art to another like a man moving restlessly from one room to another. It was not that Verrocchio possessed a puritan conscience and was afraid of being lazy. It was simply that he believed that an artist must get on with his work and hoard every moment of his time.

Verrocchio was a thick-set man with round, heavy features that looked more Roman than Florentine. He had a broad forehead, slanting eyes, a determined mouth, a double chin, a short and powerful neck; he did not look like a man who would take nonsense from anyone. He was powerfully built, and could have been taken for a wrestler or a brickmaker. He was a strict disciplinarian who insisted that his pupils work at the utmost of their ability. Something of his character can be glimpsed from a story told by Vasari about the making of the equestrian statue of Colleoni:

> They invited Andrea [Verrocchio] to Venice to execute an equestrian statue to be placed in the Campo San Zanipolo. The master prepared his model and was taking the necessary measurements for casting it in bronze when, as a result of an act of favoritism, it was decided that Vellano of Padua should do the figure of the general and Andrea that of the horse only. Andrea no sooner heard about this than he broke the head and legs of the mold and returned to Florence in great anger without saying a word.
>
> The news came to him that the rulers of Venice were determined that if he ever came to their city, they would cut off his head. The master replied in a letter saying that he would take special care not to enter Venice, because, if they cut off his head, they would be unable to replace it, just as they were una-

ble to replace the broken head of the horse. In spite of this let-
ter, which did not displease them, he was induced to return to
Venice, and his fee was doubled.

Such was Verrocchio, who took pleasure in talking back to the
rulers of Venice and never suffered fools gladly. He was a tough, high-
spirited, earthy man with an abundance of intellectual fiber; and in
appearance and temperament he was poles apart from Leonardo.

In later years Leonardo once claimed that he had spent as much
time on sculpture as on painting. Unfortunately none of his sculptures
have survived, a matter that has often offended German scholars, who
have claimed for him many sculptures that could not possibly have
been made by him. Wilhelm von Bode, the director of the Kaiser-
Friedrichs Museum in Berlin, found a relief of the *Flagellation of
Christ* in the University of Perugia and boldly pronounced that it was
by Leonardo. He found a Venus in England, carried it off in triumph
to Berlin, announced that he had discovered an authentic Leonardo,
and was mortified to discover that the core of the statue consisted of
old copies of the London *Times* of about 1850. The search for Leo-
nardo's sculptures has not been rewarding.

Nevertheless a good deal of Leonardo's time in Verrocchio's studio
was spent in learning to sculpt. The evidence lies in his paintings,
which have a sculptural quality, and his own statement that he stud-
ied painting and sculpture with equal intensity. But if he learned from
Verrocchio he also learned from the works of the sculptor Desiderio
de Settignano, whose Madonnas have a special grace and tenderness
and were carved with quite extraordinary brilliance. He was little
more than thirty years old when he died in 1464, and it is unlikely that
Leonardo knew him, although he must have known his pupils, who
continued to carve Madonnas almost indistinguishable from Desi-
derio's. Bernardo Rossellino, who also died in 1464, made sculptures in
a rather similar style which was carried on by his brother Antonio,
who long survived him. Some small terra cottas in the Victoria and Al-
bert Museum in London have been claimed for Leonardo but are al-
most certainly by one or both of the Rossellino brothers.

There remain only two sculptures that can be credited with some
degree of plausibility to Leonardo. One is the marble *Portrait of a
Lady with a Bunch of Flowers* in the Bargello in Florence, long at-
tributed to Verrocchio, and the other is a terra-cotta bas-relief of an
angel, a little more than a foot square, now in the Louvre. The *Por-
trait of a Lady* is in Verrocchio's manner, monumental and somewhat
heavy, abrupt and disconcerting, but the hand that holds the posy to
the breast and the other that comes to support it, touching it lightly,
are not in the least characteristic of Verrocchio. These hands seem to

be independently alive; they have an exquisite grace and authority; they glide softly, like fishes. Nothing quite like those hands had ever appeared before and would not appear again until Leonardo invented them afresh in the *Mona Lisa*. It is as though the young Leonardo had set out to do a sculpture in the manner of Verrocchio and found it impossible to resist adding his own easily recognizable signature.

The terra-cotta bas-relief of an angel belongs to a different order of things, for the figure possesses an originality that is wholly satisfying and wholly perplexing. The angelic kingdom was dying; no one any longer was capable of portraying angels with conviction. From being figures of power and energy they had become merely decoration; they had been used so often, and to so little purpose, that no one any longer believed in them and artists generally made only the most perfunctory efforts to suggest their divine presence. Instead they were usually depicted as handsome youths or girls with wings mysteriously sprouting from their shoulders. In the later years of the Quattrocentro the angels were remarkable only for their physical beauty.

The small terra-cotta angel is not beautiful; the body is ungainly; one leg appears to be twice as long as the other; the heavy gown bunches around his waist and trails away in what at first appears to be the most improbable convolutions. But there is no denying the power, vigor, and majesty of this angel. Suddenly and unexpectedly we are presented with an angel who is truly angelic, truly credible, as monumental as the *Winged Victory of Samothrace*, as swift as the wind. An extraordinary feat of imagination has occurred, for the angel has been thought out afresh. Although he has the most beautiful wings, he scarcely uses them, but instead strides through the air, and it is precisely from this striding stance and the long trailing leg that he acquires the sense of vigorous movement encouraged by the draperies and ribbons curling behind him in calculated disarray. We are not asked to believe only in the physical beauty of this winged youth; we are asked to believe that he possesses angelic powers. Every detail, from the arms stretched out like a taut bow to the last rippling ribbon, which curls and explodes upon itself, suggests power. Decoration has been abandoned, and we are face to face with an angel in furious flight across the heavens.

Günther Passavant, the German scholar who was among the first to claim boldly that the terra-cotta angel must be the work of Leonardo on the grounds that no one else could possibly have carved it, was not aware that there existed in the Royal Library in Turin a silverpoint drawing touched up with water color which is certainly by Leonardo and just as certainly related to the terra-cotta angel. This silverpoint drawing is also clearly related to the painting of the angel which

Leonardo introduced into Verrocchio's *The Baptism of Christ*, and indeed the drawing is an essential link between the sculpture and the painting.

In the *Baptism* we see Christ standing ankle deep in the waters of the Jordan, his head bent and hands folded in prayer while John the Baptist pours water on his head from a golden bowl. In the distance the river flows between high banks, but here it is only a thin, pebbly stream. Two angels kneel beside the stream, one of them with a rather dull and heavy expression, the other of such entrancing loveliness that he appears to have nothing to do with the painting, to have entered unannounced, an uninvited guest who gazes with a look of wonder and surprise at the scene unfolding before him. From the point of view of the painter no more difficult task is imaginable, for all we see is the angel's back and a foreshortened face in profile, tilted upward. The angel's voluminous blue gown is so arranged that we are made aware of his springing energy; the underlining appears like a crimson gash; and the linen cloth intended to wipe the feet of Christ when he emerges from the Jordan, symbolic of a winding sheet, billows out and helps to draw attention to this small figure whose presence is curiously intimidating, as great beauty is always intimidating. This linen cloth, known as the *lention,* can be seen in all the Byzantine representations of the Baptism. There is a sense in which this cloth is central to the argument of the Baptism, as the bread and the wine are central to the argument of the Passion.

Everything leads to the angel's face. The linen cloth leaps toward it with something of the shape of a hooded cobra, the crimson gash curves around it, the planes of the blue gown are like steps leading up to it, and a tumbling fall of golden hair with bright rippling curls encloses it. The face expresses an extreme refinement and delicacy, an unearthly beauty. As painted by Verrocchio the figures of Christ, the Baptist, and the second angel belong to the earth. Heaven has entered at the lower left-hand corner.

This painting, which was made for the Church of the Monastery of San Salvi fuori la Porta alla Croce in Florence, was to have an extraordinary effect on Leonardo's development. Thereafter, in nearly all his religious paintings, there would be a divine or angelic figure kneeling beside flowing waters, very close to the waters, on a shallow ledge of desiccated rock. Divinity is associated with flowing water. We see the same ledge and the same waters in *The Virgin of the Rocks*, in the cartoon of *The Virgin and Child with St. Anne and the Infant St. John* in the National Gallery in London, and in the unfinished *Virgin and Child with St. Anne* in the Louvre. It is as though Leonardo had found a theme which would endure throughout his life. In one of his

very last drawings, a red-chalk St. John the Baptist sitting on
throne in the shade of trees, we see the waters swirling at his

Except for that angelic figure Verrocchio's *Baptism* has very
commend it. A rigid palm tree, lifeless rocks, a river resemblin
rigation ditch, a Christ who looks down in the mouth and a John the
Baptist without dignity form a singularly unattractive composition.
Leonardo has not really saved the painting: he has demonstrated its
total inadequacy. Vasari relates that Verrocchio was so chagrined by
Leonardo's angel that he never again held a paint brush in his hands,
a statement which is demonstrably untrue. It is far more likely that
Verrocchio complimented the young Leonardo on putting his stamp
on a painting that was otherwise disastrous.

The angel was a *coup de théâtre*, a work of the utmost virtuosity
and at the same time of consummate genius. By taking over a small
part of the painting, Leonardo had made it his own. In physical space
the angel occupies about one sixteenth of the picture, but he domi-
nates the whole of it.

Verrocchio chose his pupils well, and among those who worked in
his large studio on the Via dell' Agnolo, near the cathedral, were Pie-
tro Perugino, the master of Raphael, and Lorenzo di Credi, who pro-
duced unimaginative compositions but remained a great colorist.
Perugino was about six years older than Leonardo, while Lorenzo di
Credi was about the same age. Francesco Botticini and Francesco di
Simone were also among his pupils.

Although Vasari speaks of Verrocchio's "hard, harsh method,"
which was achieved more by "interminable study than by natural
gifts," we have sufficient evidence—and to spare—that he was an artist
possessing consummate gifts. Many of his drawings survive, and they
are all masterly, while no one in his time rivaled him as a sculptor. He
made his pupils work hard, saw that they learned how to prepare
their paints and hold a brush and how to carve stone and model with
clay, and gave them lessons in mathematics and perspective. Vasari
tells us that Leonardo proved to be adept at mathematics but was
chiefly interested in design, by which he meant drawing, and in relief,
by which he meant sculpture in all its forms. Many of Verrocchio's
drawings show women with dreamy expressions and downcast eyes
which have an oriental look about them; their hair is arranged in great
coils; and they have smooth rounded foreheads and no eyebrows. Ver-
rocchio had established a type which Leonardo would refine to the ul-
timate possible degree.

Leonardo's earliest surviving pen drawing is a landscape that is
rightly regarded by Leonardo scholars with reverence. Already, at the
age of twenty-one, he shows himself in complete command of his art.

In later years Leonardo drew many landscapes, but never again would he draw a landscape with quite this feeling of intimacy and breadth and grandeur. On a sheet of yellow-tinted paper he summoned up an entire valley, range upon range of mountains, a castle on a promontory, farms and cultivated fields, lakes and marshes, a river in flood with boats sailing on it, and huge rocks that seem to be quivering with life. All this is accomplished on a sheet of paper measuring 7½" by 11½". Ludwig Heydenreich once called it "the first true landscape in art," but this is unfair to many Flemish and Italian painters who preceded Leonardo and to countless Chinese artists of the Sung and Yuan dynasties. In the top left-hand corner of the drawing Leonardo wrote in his most careful mirror writing, "Day of St. Mary of the Snows, August 5, 1473."

The landscape depicted by Leonardo shows a typical scene in Tuscany. It has been suggested that it may be the area around Montelupo Castle with the Pisan hills in the distance, or it may be an imaginary landscape composed of many remembered elements. Yet it has an air of actuality, of something seen one day when he was walking in the hills. What is chiefly remarkable about it is a sense of spaciousness, the air pouring across the sky, the vigor of the rocks, the sense of flowing waters, and of a deep silence flowing in the valley, for no people, no animals, and no birds are visible—only the silent boats moving over the waters, which are surprisingly full and turbulent for the month of August.

On the left is a castle with battlemented walls and four towers set on a sheer cliff, dominating the valley. On the right is an abrupt and rounded rock formation, very gaunt, but gradually gentling into uplands where random clumps of trees give definition to the shape of the mountain. The time is about an hour before sunset, the eastern hills are clear, but heavy shadows are beginning to fall between the clefts of rock, and the trees have the shimmering look that comes when the sun is low, shining almost horizontally through the leaves. Between the castle and the rounded rock formation the valley opens out in a wide V, and through this we see the river flowing in a wide curve until, in the foreground, it forms a torrent racing over shallow falls. In the background, in the slanting sunlight, lie well-ordered and cultivated fields, rows of trees, another castle on a mountain, and the distant hills vanishing in the summer haze.

It is apparent that Leonardo's affection for the landscape and the shapes of rock and water are deep-rooted. Affection guides his pen and fills the air with a kind of trembling. He has not attempted to simplify the complexities of the landscape; on the contrary, he has seized on every fold and contour, every curve and dip and protuberance,

with the affection of a lover fondling the shapes of the beloved. It is so varied, so feminine, and at the same time so architectural that it proclaims a new way of looking at things. He is seeing the earth very tenderly and at the same time with a masculine respect for the heaviness and elaboration of rock formations, and he is seeing it, as it were, through a wide-angle lens.

It is worth pausing over this landscape because much of the future Leonardo is already contained in it, and because never again, so far as we know, did he draw so vast and comprehensive a landscape.

To the student of oriental art the drawing comes as a shock, for the Sung and Yuan landscape painters aimed at a similar vastness and comprehensiveness. Like Leonardo, they possessed an acute sense of the bones, flesh, sinews, and veins of the earth, as though it were a living thing. But what is still more surprising is that Leonardo, independently of all other Italian artists, had adopted in this drawing certain conventions which had their origin in China. He draws ships and trees exactly like a Chinese artist. A ship is sketched out in a single line; a tree is a kind of ideogram formed out of a vertical and a splash of quick horizontal lines, and according to the richness and density of the horizontals the tree acquires a life of its own while remaining essentially calligraphic. The great Japanese artist Toyo Sesshu, who was born in 1420 and died in 1506, and was therefore Leonardo's contemporary, drew trees and boats in this way, having, as in everything he did, accepted the existing Chinese conventions and pushed them to their farthest extent.

Sesshu—the name means "snow boat"—was a prodigious artist. His most famous painting, known as the Mori scroll, describes a journey made in China in 1468. The scroll is nearly sixty feet long and shows a vast landscape through all the seasons of the year. During the journey he painted Gold Mountain Island, a small craggy island at the mouth of the Yangtse River, covered with splendid monasteries and pagodas, with a mooring dock at the foot of the crag and the shapes of other crags looming in the distance. One of Sesshu's many paintings of Golden Mountain Island is illustrated in this book, not to provoke comparison with Leonardo's landscape but to show how Sesshu drew his boats and trees with a flick of the wrist or a few hurried, scratchy lines drawn horizontally. This method is surprisingly effective, for he is drawing what the eye sees: the hazy, flaring light coming from the tree, not the tree itself. Sesshu finally reached Peking, where he is said to have painted a fresco on one of the walls of an imperial palace, and soon afterward returned to Japan. He was middle-aged when he visited China, but he lived on for nearly forty more years, dying at the age of eighty-six.

Sesshu gave to Japanese art a majestic strength and a subtle flexibility. His line is springy, like steel wire; and like the Florentine artists who were his contemporaries he was fascinated by the strength of the bounding line. Also, it was a question of sensibility: he shared with Leonardo a certain detachment, an almost aristocratic refinement. He could paint nothing without making it monumental, and he possessed the gift for painting memorably, as though he clearly intended, like Leonardo, to startle. The viewer is never given the opportunity to escape from the spell.

That Leonardo should draw boats and trees in the manner of Sesshu would be a matter of some surprise if we did not know that the influence of the Orient had been felt in Florence for a hundred years. China reached out across the deserts of Asia, spreading its culture prodigally; the Orient lapped against the walls of Florence.

Between 1366 and 1397 no less than 259 Tartar slaves were sold in the slave market at Florence. This traffic in oriental slaves continued unrelentingly until the fall of Constantinople in 1453; afterward there came only a trickle. The Florentines preferred Tartar slaves to Rumanians, Greeks, or Slavs, perhaps because they were more obedient and less likely to cause trouble, and the Florentines were fascinated by the beauty of the Tartar women. Inevitably the male slaves intermarried with the Florentines and the female slaves were kept as concubines. From the great slave marts at Tana, Kaffa, and the island of Chios there came nearly every year shiploads of slaves to serve in Florentine households.

Since the Florentines bought more Tartar slaves than were bought in any other Italian city, we must seek for a reason for their strange commerce with the East. We find it, I believe, in the character of the Florentines, who rejoiced in everything that was exotic, foreign, unknown. They assimilated new ideas and new concepts with ease. They were fascinated by the vast unmapped regions of Central Asia. They possessed a singular ability to remain at ease among foreigners and strangers, and they were in no way frightened by the unfamiliar. They therefore welcomed the Tartars with open arms and were all the more delighted because the Tartars, though slaves, were quick-witted like themselves.

That Florence, rather than Venice, should have been more interested in acquiring Tartar slaves was due to the increasing power and wealth of the Florentine Republic. Slaves were sold for a high price, and the Florentines could afford them. Writing in 1472, Benedetto Dei, a friend of Leonardo, described the wealth of Florence in a taunting letter to the Venetians. He speaks of the thirty thousand es-

tates owned by noblemen and merchants, citizens, and craftsmen, yielding an annual income of 900,000 ducats.

> We have two trades greater than any four of yours in Venice put together—the trades of wool and silk. Witness the Roman court and that of the King of Naples, the Marches and Sicily, Constantinople and Pera, Broussa and Adrianople, Salonica and Gallipoli, Chios and Rhodes, where to your envy and disgust in all of these places there are Florentine consuls and merchants, churches and houses, banks and offices, and whither go more Florentine wares of all kinds, especially silken stuffs and gold and silver brocades than from Venice, Genoa, and Lucca put together. Ask your merchants who visit Marseilles, Avignon, and the whole of Provence, Bruges, Antwerp, London, and other cities where there are great banks and royal warehouses, fine dwellings, and stately churches; ask those who should know, as they go to fairs every year, whether they have seen the banks of the Medici, the Pazzi, the Capponi, the Buondelmonti, the Corsini, the Falconieri, the Portinari, and the Chini, and a hundred others which I will not name, because to do so would need at least a ream of paper.

Benedetto Dei had traveled widely; had worked for a while in Constantinople and journeyed through Egypt; was a scoundrel and a good storyteller, and a consummate Florentine continually extolling the virtues of the republic. But so much wealth and intelligence, so many beautiful churches and palaces, so many shops and estates and parklands inspired the envy of Florence's neighbors. Conspirators abounded. Not all the Florentines approved of the Medicis, who had ruled Florence heavy-handedly but with an outward show of benevolence since Cosimo de' Medici assumed power in 1434 and thereafter maintained himself in power by hand-picking the officials who in theory had been elected to serve the republic.

Yet it was Cosimo with his profound love for art and learning and with his determination to see that Florentine influence should reach across the whole length of Europe who was chiefly responsible for the Renaissance, the new way of looking at the world, the new feeling that the world was an inexhaustible treasure house to be explored, and people themselves were treasures to be explored without benefit of mythologies. With him there came a new hope, new adventures, new fevers. The young Leonardo working in Verrocchio's studio in the Via dell' Agnolo was exactly the right age and in the right place to take full advantage of the endless possibilities opening up to a Florentine artist serving under the patronage of the Medicis. Instead, he went his

own way, showed very little interest in the Medicis, and practiced his art as though they did not exist.

The Orient, which he never visited, left its mark on him. From painted jars and fragments of embroidery he derived a sense of oriental design. When he drew a dragon, it was remarkably like a Chinese dragon, and when he drew a landscape it was curiously like the landscapes of Sesshu. No statues of Buddha with their archaic smiles are known to have been in any Florentine collection, but the Tartar slaves brought small terra-cotta statues of Buddha and worshiped them. Throughout his life Leonardo was passionately interested in the arts of the East. "Map of Elephanta, which belongs to Antonello the merchant," he wrote in his notebook. Elephanta was an island off the coast of India honeycombed with caves, which were filled with statues and carvings, and the map could only be a map of the caves, for no town or city existed there. Sometimes Leonardo gives the impression of being a wanderer from the East who had settled in Florence by the purest accident and was restless and homeless, belonging nowhere. He had no particular loyalty to Florence; his only loyalty was to the world of art.

Three Masterpieces

On April 8, 1476, the Police of Public Morals, the Officers of the Night and of the Monasteries, opened the *tamburo*, where secret accusations against citizens of the republic were commonly placed, and discovered a document accusing five young Florentines of sodomy. The accusation was drawn up painstakingly, so that there should be not the slightest doubt about the identity of the criminals. It was not, of course, signed, but appears to have been written by someone who was intimately acquainted with the coterie of young men among whom Leonardo moved with the aim of bringing upon them the most terrible punishment, for in theory at least a man convicted of sodomy was punished by being burned at the stake. Clearly the accuser was vengeful and malicious, and he was not afraid to include the name of the scion of one of Florence's most patrician families. Significantly the name of Leonardo Tornabuoni, of the great family that produced Lu-

crezia Tornabuoni, the wife of Piero de' Medici, is placed last, in the place of honor.

The secret accusation, which was read in the presence of Tomaso di Corsini, the notary who supervised and recorded the accusations found in the *tamburo,* reads as follows:

> I notify you, Signori Officiali, concerning a true thing, namely that Jacopo Saltarelli, blood brother of Giovanni Saltarelli, living with him in the house of the goldsmith in Vacchereccia opposite the Buco; he dresses in black and is about seventeen years old. This Jacopo has been a party to many wretched affairs and consents to please those persons who exact certain evil pleasures from him. And in this way he has had occasion to do many things, that is to say, he has served several dozen people about whom I know a great deal, and here will name a few:
>
> Bartholomeo di Pasquino, goldsmith, who lives in Vacchereccia.
>
> Leonardo di Ser Piero da Vinci, who lives with Andrea de Verrocchio.
>
> Baccino, tailor, who lives by Or San Michele in that street where there are two large cloth-shearer's shops and which leads to the Loggia de' Cierchi; he has recently opened a tailor's shop.
>
> Leonardo Tornabuoni, called *il teri:* dresses in black.
>
> These committed sodomy with said Jacopo, and this I testify before you.

One would like to know more about Jacopo Saltarelli, accused of being a male prostitute with an extensive clientele and who lived so very close to the *tamburo,* a drum-shaped box in the Piazza della Signoria, that he seems to have been tempting fate. One would also like to know more about the anonymous accuser, who may have been a young priest, for he uses words like *misserue,* "miseries," when he means "wretched affairs," and *tristizie,* "sadnesses," when he means "evil pleasures." He uses delicate words for indelicate things and is well aware that he is doing so.

But if he wanted to see five young men burning at the stake, he was sadly cheated. The magistrates summoned the five accused, examined them, and concluded that they were innocent, absolving them on condition that no more anonymous charges were fed into the *tamburo, absoluti cum conditione ut ne retamburentur.* They received a conditional discharge. Bartholomeo the goldsmith and Baccino the tailor probably possessed little influence with the authorities, but Leonardo Tornabuoni could be expected to bring heavy influence to bear through his relatives at the Medici court, and Leonardo was not with-

out influence through his father. The matter was hushed up, but only temporarily.

On June 7, 1476, two months after the original denunciation, the charges were renewed. On that night the *tamburo* was opened, and the Police of Public Morals found an anonymous accusation written very much like the first, but this time in Latin rather than Italian—an almost sure sign that it was written by a priest. Jacopo Saltarelli, Latinized to Jacobus de Saltarellis, is accused of performing acts of sodomy with many persons, but mostly with the four persons who are named. There is a subtle change of emphasis. The accuser had previously given the impression that the four youths who enjoyed Saltarelli's favors had been chosen at random, among the many he failed to mention. Now the implication is that these four belong to Saltarelli's regular clientele, and are therefore the most guilty. They have not performed single acts, but many acts. They are therefore culpable to the highest degree.

Once again the magistrates summoned the accused, questioned them, and arrived at the same conclusion. Once again the clerk of the court entered the finding: *absoluti cum conditione ut ne retamburentur*. Apparently no further denunciations were received, for a search of the Florentine state archives has produced no more documents concerning the affair. Yet the charge was not dismissed. It was as though each of the accused received a conditional pardon.

Sodomy was a crime against God, against nature, and against man. Nevertheless it was so prevalent throughout Renaissance Italy, especially in Rome and Naples, that the Church had virtually given up its struggle against it. The most terrible penalties remained on the statute books, but were rarely invoked. In his own lifetime the painter Giovanni Antonio Bazzi, an artist of considerable brilliance and complexity, was known as *Il Sodoma,* "the Sodomite," and he wore this distinction like a badge of honor.

The Neoplatonists, who entertained themselves with long discussions of the Socratic dialogues, hoping to arrange a kind of marriage between Plato and Christ, found no stumbling block in the *Symposium,* which directly and indirectly celebrated homosexual love on the grounds that it was closer to divine love than any other. The *Symposium* was regarded very seriously, expounded at length, and likened to a fifth gospel. *L'amor divino,* as taught by Marsilio Ficino, the founder of the Platonic Academy in Florence, was colored with the Platonic acceptance of homosexuality; and many great scholars had their favorite pupils whom they loved to distraction.

Leonardo was neither a Platonist nor a Neoplatonist, had no connection with the Platonic Academy, and showed little interest in the

intellectual debates of the time. He showed even less interest in the elegant versifiers who attended the Medici court and wrote panegyrics in honor of Lorenzo in a debased form of Latin. He knew neither Latin nor Greek, and had no formal academic training, a fact that was later remembered against him. His study was art, and art alone. Verrocchio worked his students hard and saw to it that no branch of art was foreign to them. They were goldsmiths, metalsmiths, wood carvers, sculptors, setters of jewelry, makers of *cassoni*, gem cutters, designers of armor, painters of flags and banners, both those that appeared in religious processions and those that were displayed at ceremonial jousts; they made altarpieces and elaborate altar frames; they made church vessels and crucifixes, death masks and effigies; they designed vestments. Their hours were long; they were underpaid, or not paid at all; they lived above the shop on the Via dell' Agnolo, and being young and continually in each others' company, some of them inevitably formed homosexual attachments. Artists then as now were not notable for their sexual puritanism.

At the time when Leonardo was arrested, he was twenty-four years old. He was no longer Verrocchio's pupil but an assistant in the studio and a painter in his own right. According to the accusation, he was living with Verrocchio, but that may have meant only that he worked and had a bed there, while living whenever he pleased in his father's house. He was a free spirit, careless of his official duties and indifferent to official organizations. Thus we learn that in June 1472 his name is inscribed in the "red book" of the Company of Painters as one who has neglected to pay his subscription and later in the year there is another note saying that he failed to buy candles for the feast day of St. Luke, the patron saint of painters.

Whether or not Leonardo was guilty of the crime of sodomy, it is certain that he was arrested and that he suffered the shock and embarrassment that comes with being arrested and closely questioned. He was however in no real danger unless others came to testify against him, for the evidence of an anonymous accusation was not considered sufficient to bring about punishment. The law on this subject was clear. He could be punished on his own confession, or on the testimony of two witnesses who observed the crime, or on the testimony of four witnesses who spoke out of common knowledge. The danger therefore lay in the possibility that four witnesses might step forward and say that to their knowledge he had committed acts of sodomy. If this had happened, the best he could hope for was banishment from the republic and the worst was to be burned at the stake. A certain Piero di Jacopo, a coppersmith from Bologna, had in fact been burned

at the stake in Florence for committing an act of sodomy on a ten-year-old boy.

One day, many years later, in a mood of dejection, Leonardo wrote down some of his more somber thoughts. He wrote, "When I think I am learning to live, I am in fact learning to die." Next to these words he wrote another somber thought which seems to hark back to a scandal in his early manhood, "When I made the Lord God a youth, you threw me in prison. Now if I make him a grown man, you will do worse to me." Since he was unusually handsome and was continually drawing from nude models, scandal was something he inevitably learned to live with.

Meanwhile he continued to work, to study, to sculpt, to paint. He studied Masaccio's paintings in the Brancacci Chapel of the Carmine and ever afterward regarded them with awe, for these paintings stood at the fountainhead of Renaissance art. "Tomaso of Florence, known as Masaccio," Leonardo wrote, "showed by his perfect works how those who take for their standard anything but nature, who is the mistress of masters, weary themselves in vain." Nature, *maestra de' maestri*, was to remain his mistress during all the following years. He knew Botticelli and appears to have liked and admired him without sharing his attitude toward art.

If we set aside the angel painted by Leonardo in Verrocchio's *Baptism*, there remain only seven paintings, two of them unfinished, that can confidently be attributed to him during his first Florentine period. Some of his paintings have been lost, some were destroyed during the interminable wars of Italy, others may have been tossed into the bonfires lit by Savonarola to express his contempt for works of art, while others were sent abroad and may still be moldering in ancient monasteries or noblemen's houses, and still others perished by neglect. He was incapable of painting anything less than a masterpiece, and the loss is therefore appalling.

By all accounts Leonardo was a man who painted slowly, although he was capable of producing a finished drawing at incredible speed. The seven surviving paintings of the Florentine period consist of two Annunciations, two Madonnas, *The Adoration of the Magi, St. Jerome*, and the portrait of Ginevra de' Benci. About all these paintings there is an air of intellectual speculation and improvisation, as though he had not yet found his way but was deliberately seeking solutions to nearly insoluble problems. There is nothing tentative about these works. We are made aware of a mind powerfully exercised to portray events in a new way, supple and authoritative, probing relentlessly, already in the grip of the *ostinato rigore*, the unyielding rigor, which in the eyes of Paul Valéry was his dominant characteristic.

Even in what must be the earliest of his surviving works, *The Annunciation* in the Louvre, a long thin predella, only six inches high and twenty-three inches long, we observe a mind attempting to portray the angel and the Virgin, the sudden proclamation that God is within her, in terms of complex mathematical forms while at the same time breathing a springing life into the landscape. An ellipse formed by benches and garden walls encloses the figures, maintains them, gives them stability, a stability deliberately broken by a diagonal pathway which cuts across the painting and leads toward a clump of trees and beyond these to the distant mountains. Ten separate verticals anchor the composition, and there is a certain heaviness which we do not associate with Leonardo but with Quattrocento tradition. It is undeniably Leonardo before he takes flight, earthbound and rooted to his time. The colors have darkened with age and varnish, thus accentuating the heaviness and earthiness of the scene, which seems to be taking place a little before dusk with the long shadows falling. In the original it was dawn.

The Annunciation in the Uffizi is a much larger work, a little more than three feet high and more than seven feet long, glowing with bright color. There is the same general design: a walled enclosure, trees and mountains in the distance, a slanting road cutting across the painting, the angel kneeling in profile and the Virgin in three-quarter face, with her back to her father's house, receiving in trepidation the message that she has been blessed above all women. Beside the Virgin there is a marble table of an extremely ornate construction set on the edge of the garden, and this table, so preposterously and deliberately out of place in a garden, appears to be surmounted by a reading table that is in fact supported by a low garden wall. The more one examines the table, the more it appears that the painter is being willful, displaying his power to paint the unpaintable by exercising the utmost virtuosity. And although this marble table swells out in the lower part and thus appears to be anchored to the earth, and in addition a scent box has been placed on the top surface to give it weight and definition, nevertheless the table remains fragile and may at any moment flutter away like a butterfly.

In spite of the overpainting, in spite of the curiously wooden angel and the doll-like Virgin, there cannot be the least doubt that this painting is the work of Leonardo, and of Leonardo alone. He has given himself an impossible task: he will paint an Annunciation and place in the center of it one of those great ornamental caskets like the casket-tomb made by Verrocchio for Piero and Giovanni de' Medici. He will paint a garden with the luminous air swirling around it, and there will be many cypresses, and far in the distance there will be

mountains gleaming faintly in the early morning light. The angel will
be given powerful wings so that it becomes possible to imagine that
he is really capable of flight, and the Virgin will be represented wear-
ing a voluminous dark purple skirt with her knees spread immodestly
apart, and there will be an invisible line from the angel's hand along
the length of the bookrest to her womb, thus demonstrating that di-
vinity was about to enter it. He was inventing a new iconography, and
he succeeded brilliantly in establishing the Virgin and the angel in the
midst of an immense and perhaps imaginary parkland. Yet the paint-
ing is curiously irrelevant; there is no religious feeling; the youthful
painter is exercising his intellectual muscles; he is showing off.

Of the five paintings made in Florence during the following years,
four are authentic masterpieces. In *The Benois Madonna, The Adora-
tion of the Magi, St. Jerome,* and *Ginevra de' Benci* he showed that he
could paint with angelic freedom and responsibility, daring to do
things that were virtually impossible.

The Benois Madonna

Many strange things happened to Leonardo's paintings, but perhaps
the strangest thing of all happened to the painting now known as *The
Benois Madonna,* an early work of great charm and brilliant composi-
tion, now in the Hermitage Museum in Leningrad. Painted about
1478, it vanished from sight until the early years of the nineteenth
century, when it appeared, of all places, in Astrakhan on the shores of
the Caspian Sea, in the possession of a troupe of Italian actors. Such
was the story told by Mme. Louis Benois, who sold the painting to
the Hermitage, saying that it had been acquired in 1824 at Astrakhan
by her grandfather, a merchant called Shagochnikov. According to an-
other source it was first acquired by a Prince Kulagin, who sold it to
Shagochnikov. All through the nineteenth century it remained in pri-
vate hands. In 1908, Mme. Benois showed it to a number of experts on
Italian art, who were inclined to attribute it to a lesser artist than
Leonardo. It was a time when Leonardo was being vigorously studied;
and gradually the experts came to the nearly unanimous conclusion
that it could not have been painted by any other artist, that it fitted
perfectly into the little-known period of Leonardo's early works, and
was undoubtedly by Leonardo. Thus authenticated, it was shown in
1914 to Tsar Nicholas II, who agreed to its purchase by the Hermitage
for 150,000 rubles to be paid in installments. The first installment was
paid that year, and owing to wartime economic restrictions on the
purchase of works of art, no further installments were paid. The Octo-
ber Revolution of 1917 canceled the Tsar's indebtedness to the Benois

family, and the painting became state property. For a very small sum the Hermitage acquired one of its greatest masterpieces.

The story told in good faith by Mme. Benois is not altogether convincing. Troupes of Italian actors do not usually carry masterpieces around with them, and it is more likely that the painting was in the possession of the Jesuit mission consisting of a small handful of Italian priests known to have been in Astrakhan in 1824. Exactly how or when it came into the hands of Prince Kulagin or Shagochnikov remain unknown, and at this date it is no longer possible to trace the original deed of sale. From 1478, when it was painted, to 1908, when it was first shown in St. Petersburg, there passed 430 years of total obscurity.

The Benois Madonna is a small painting measuring no more than 19¼" by 12¼". It suffered some small damage when it was transferred from a wood panel to canvas, and the hands especially show signs of being repainted by someone who knew nothing or very little about the painting of Florentine hands; they are heavy and wooden, but they cannot distract from the perfection of the design. More harm was done by painting out whatever scene appeared in the window, now a sultry blue of indeterminate texture. There is considerable overpainting in the background, where it does little harm, and in the Child's legs, where it does a good deal of harm, but the general effect is of a painting in an astonishingly fresh condition, glowing and full of movement. The Virgin balances the child on her knees and shows him a flower, and that is all, and it is magical.

Here there is absolutely no sense of a virtuoso performance by the artist. The emotions of wonder and tenderness flow between the two figures, who are deeply aware of one another while at the same time immersed in the contemplation of the flower. Leonardo has painted a completely credible Virgin, who is perhaps fourteen years old, and the Child too is believably the Child, power flowing from the immense head with its Buddha-like calm. Thin gold halos announce their divinity, but these halos are unnecessary. In the painting everything appears to fall naturally into place; there is an air of inevitability about this small scene by an open window. All the decorative elements beloved by Verrocchio—parti-colored walls, marble tables, stairways, thrones, richly embroidered curtains—are scrupulously omitted. There is the flower, the richly costumed Virgin, the naked Child—nothing else.

The painting seems to suggest that Leonardo was breaking free from Verrocchio and finding his own way. For the first time he is completely in command, and there is some significance in the fact that his

first masterpiece should describe a scene of exquisite joy and tenderness.

The art critic Berhard Berenson, who combined a vast learning with immense cynicism, once amused himself by describing this most tender of Leonardo's Virgins as a child with a bald forehead, swollen cheeks, a toothless mouth, bleary eyes, and a wrinkled throat. This is not true. She is in fact wonderfully beautiful, playful, and charming, radiating a heavenly sweetness. There exists in the Louvre a preliminary sketch in black ink which evidently belongs to a series of studies made for the painting. This study by the sheer strength of the drawing —for its tenderness derives from its strength—must be included among his masterpieces.

On a sheet of drawings now in the Uffizi, Leonardo wrote down, as though to remind himself of past accomplishments, the words . . . *bre 1478 incomminciai le due vergini marie.* At some time, therefore, between September and December he began to work on two separate paintings of the Virgin. One of these may be *The Benois Madonna,* the other being *The Madonna Litta,* so-called because it belonged to the Marchese Pompeo Litta before being sold in 1865 to Tsar Alexander II, who acquired it for the Hermitage. From the childlike Virgin, Leonardo progresses to a Virgin who is a mature woman aware of her beauty while deeply contemplative. She is seen in profile, gazing down at the Child, who is suckling at her breast, and if the Child were believable the picture would be more successful. As it has come down to us, patched with overpainting, the picture seems to be lacking in all those qualities that are apparent in *The Benois Madonna:* playfulness, divinity, the sense of intimacy between the Virgin and the Child. The over-all effect is static, overdecorative, intellectual; the wonder and the tenderness are absent; there is no flow of feeling between the Virgin and Child. Many things have gone wrong since Leonardo painted it, and what has chiefly gone wrong is the Child's face, which is almost a caricature, with an enormous disembodied eye demanding attention, and there are two fingers like fungi pressing against a breast that looks like a loaf of bread. It is as though two separate paintings have somehow become fused together and they cry out to be separated. Time and the restorers have converted a painting of great beauty into a mockery, while the Virgin's face remains to remind us of Leonardo's extraordinary accomplishment.

Another Madonna, known as *The Madonna of the Carnation,* now in the Alte Pinakothek in Munich, has been ascribed to Leonardo, but would seem to be a pastiche of motifs taken from Verrocchio, Lorenzo di Credi, and Leonardo. The motifs fail to come together with verisimilitude. All those characteristics which we recognize as Leonardo's,

in particular the clear and flowing line, the unearthly calm, and the
sense of a divine presence, are notably absent in this portrait of a fat
German *hausfrau* decked up in an elaborate embroidered costume. If
we set this painting beside *The Benois Madonna*, it seems to vanish in
brilliantly colored fat. There is no clear and flowing line.

The Benois Madonna is the test stone. Here, in his own time, Leo-
nardo was saying the utmost that could be said about the Virgin. He
saw her very precisely and very simply, in a closed space, near a wall
and a window. But what would happen if the wall was thrown down,
if the Virgin was seen in the real world? In *The Adoration of the Magi*
Leonardo enlarged the boundaries, opened up the new world of expe-
rience, and produced his second masterpiece.

The Adoration of the Magi

The visitor who sets eyes on *The Adoration of the Magi* in the Uffizi
for the first time suffers from a feeling of bewilderment. It is not only
that this large panel—it is eight feet by eight feet—seems to be filled
with shadowy figures emerging from an orange-pink background, like
the glow of sunset, and all these figures seem to be falling like waves
upon the lightly sketched Virgin at the center, without plan or pur-
pose, but everything about the painting gives the impression of being
hurried and unfinished, more like a cartoon than a completed picture.
A vast confusion of faces, horses, stairways, trees, and broken walls
confronts the spectator. Order, the famous Florentine order, is absent.
We are in the presence of stairways that lead nowhere, a mound of
earth that has no shape, embattled horsemen fighting small skirmishes
that have nothing whatsoever to do with the three Magi who come to
present their offerings to the Christ child.

But gradually, as we look more closely at the painting, we begin to
discern an overwhelming unity and inevitability: the scattered ele-
ments, which at first seemed to have been selected arbitrarily, begin
to fall into place. We become aware of relationships and corre-
spondences; the background comes closer; logic prevails. A bomb is
dropped. Everything is uprooted and hurled into the air, and when
things fall they assume precise and logical patterns related to but
differing from the patterns they occupied previously. Something very
similar is happening in the painting. There has been an explosion of
spiritual energy, and the people are jolted, alarmed, terrified, happy,
wildly joyful, and swept outside of themselves by the appearance of
the Virgin and Child. In Botticelli's *Adoration* we see the dignitaries
of the Medici court assembled in order of rank, costumed in their
most elegant gowns, as they come to pay tribute to the Child in the

manger. They stand upright. They are not deeply moved, do not fling up their hands to protect their eyes from a blinding light, do not throw themselves to the ground. In Leonardo's *Adoration* we are made aware that an event of unprecedented and incalculable importance is taking place and the people are excited beyond measure.

Leonardo has created a new way of looking at the mystery. He has refused to accept the rigid, compartmentalized form established long before. Some conventions are accepted, others discarded. He accepts the convention that there must be two frontal figures at the extreme right and left, who help to anchor the design. He rejects the convention that the manger, the animals, and the shed roofed with wattles must occupy a central place in the composition and has relegated them to the upper right corner, sketching them so lightly that they are almost invisible. The Virgin is not enclosed. She has left the hut to sit on the edge of a grassy mound in the open air. She is there to show the Child to the tumultuous crowd and to bring him into the presence of the Magi. Yet, as Leonardo depicts her, isolating her in the center of the picture, she is herself an object of veneration.

The three Magi are clearly visible, and at the same time they are members of the vivid, ghostly crowd of worshipers. They are apart, and yet they are not apart. They, too, form part of that gathering of forces around the central image.

One of the Magi offers a chalice of myrrh. He kneels to receive the Child's benediction and rests one hand on the ground to steady himself. Another, much younger, kneels at a distance, holding up his chalice of frankincense for the moment when the Child's eyes will turn upon him, and he alone of the worshipers has an air of princely refinement. The third of the Magi is an old man who has already offered his gift and now lies prostrate, his face to the ground in humble adoration. Joseph, leaning over the mound, a man so weighed down with age that he can scarcely lift his head, has already taken possession of the gift of the third Magi. Joseph, too, is a break in tradition, for he is generally depicted as a man in his vigorous middle age.

The Augustinian friars of San Donato a Scopeto, who ordered the painting, entered in their house book a summary of the agreement made with Leonardo. This summary, written July 2–5, 1481, refers back to the original contract drawn up in the spring of the previous year. Some of the details are very curious. Leonardo was to be paid not in money but in property on condition that the property must be sold back to the monks on demand, and Leonardo was required to give a dowry to a woman who appears to have been related to one of the friars. He was to assume the entire cost of the paint, including the

cost of gold. It was not, on the face of it, a particularly rewarding contract. The friars wrote:

> Leonardo di Ser Piero da Vinci has undertaken since March
> 1480 to paint an altarpiece for our high altar. This he must
> complete between 24 or at most 30 months; and in the event
> that he has not completed it, he will have forfeited all he has
> done and we shall be at liberty to do with it as we please. For
> this altarpiece he is to receive a third part of a property in the
> Valdelsa which belonged to Simone, the father of Friar Fran-
> cesco. . . .

Such was the rather melancholy overture with its threats and forebodings. The working out of a long and complicated contract is merely hinted at. The friars reserve the right after three years to buy back the property for 300 florins, and meanwhile Leonardo is required to provide a dowry of 150 florins for the daughter of Salvestro di Giovanni. There were probably other conditions of lesser importance worked out in the appropriate legal form. The records show that they paid him a florin and a half for colors, sent him a load of fagots and a load of logs, and advanced 4 lire 10 soldi to buy an ounce of blue and an ounce of *giallolino,* pale yellow, which is puzzling, because almost no blue can be found on the painting. They also gave him 1 lira 6 soldi *per dipintura fece de l'uriuolo,* which can only mean "for painting the clock face." On the evidence, they were not paying him handsomely. On September 28, 1481, they sent him a barrel of red wine. No further payments are known, and it is likely that the friars were displeased with what they had seen of it and stopped payment altogether. Many years later Filippino Lippi was commissioned to paint an Adoration of the Magi for them. This painting survives. The composition has much in common with Leonardo's painting, but remains conventionally static. There is the grassy mound, the Virgin with the Child on her lap, the three Magi in the foreground, and the horsemen riding away in the distance. Altogether there are nearly fifty figures on the crowded canvas. They are not caught up in a wave of excitement, they are not astounded, they are not moved. They contemplate the Child with a mild interest and seem to be wondering what they are doing there. Filippino Lippi occupies the traditional place in the right-hand corner, wearing a billowing gown and waving his hand in the gesture of a man who wants you to see what he has created with so much ardor, patience, and common sense.

Filippino Lippi's *Adoration of the Magi* is a work that seems designed to prove that the conventional arrangement of the figures is absurd and meaningless, all the more absurd because it is devoid of passion and all the more meaningless because it is, within its own

limitations, well constructed and colorful. What is lacking is the *istoria*, the revelation, the world in movement. Those isolated figures might be pasted on the panel, and it scarcely matters in what order they appear. Lorenzo di Credi and Botticelli also painted creditable variations on the theme of the Adoration of the Magi, but they were always calm and dispassionate. The lightning has not struck. Leonardo painted the Adoration at the moment when the lightning strikes, at the moment when there comes into that assembly of quite ordinary people the realization that Christ is sitting there on the Virgin's knees and that destiny and history flow from his chubby fingers.

Unfinished, uncolored, almost unco-ordinated and uncomposed, *The Adoration of the Magi* is, in another sense, complete and fully colored and co-ordinated and composed. The starkness of vision demands exactly the treatment Leonardo gave to it, and the phantomlike horsemen are as real and vivid as the hollow-cheeked old men who gaze in wonder and fear at the most natural thing in the world—a baby on the lap of a woman. The splendor of the occasion is reinforced by a certain casualness. We do not ask why there is a mound of earth, and who these people are who crane so eagerly to see what is happening, or whether the soldiers are battling or jousting, or why there are stairways leading nowhere. Leonardo is saying "This is how I see it," and this is enough, because he sees it with freshness and the knowledge of holiness. The religious feeling is overwhelmingly present. When Botticelli constructs his Adoration, we are confronted with a pageant of Medici princes or an assemblage of Florentine noblemen, and it is not enough, because religious feeling is lacking. The phantom horsemen of Leonardo's imagination do not come from the same source as Botticelli's horsemen caparisoned with rich saddlecloths and embroideries. There is an urgency in their movements and they are up to mischief but it is spiritual mischief. They may be Herod's horsemen preparing to massacre, but this is doubtful, for they carry no swords. Whoever they are, they bring a sense of anxiety and uneasiness to the scene. They form a half circle around the mound; they threaten; they are not to be wished away.

We can watch the progress of Leonardo's thoughts as he grapples with the Adoration in five or six preliminary sketches. A pen and wash sketch in the Uffizi shows the ruined palace with the stairways leading nowhere, armed soldiers on horseback, a crouching camel, strange shadows, an air of menace. The paper is ruled, and in this early stage Leonardo is fascinated by problems of perspective. Another preliminary drawing in the Louvre sets the Virgin in the center, defines the two stairways, gives spears and pikes to the armored horsemen, abandons perspective, and narrows the focus. The Virgin was given no

place in the first drawing; in the second she towers over everyone. In the foreground, near the Virgin's feet, there is a curious passage which seems to resolve itself into a square-shaped stone and what appears to be a garment thrown down. We see the stone in an Adoration by Gentile de Fabriano painted in 1423. It was clearly intended that the stone should provide the date of the painting or the initials of the artist or both. The garment thrown down suggests that Leonardo had at one time thought of laying the baby on the ground, following a practice that was becoming an acceptable convention—the baby smiling up at the Magi who had come to worship him. Such an arrangement demanded that the rest of the painting must in some way be subordinated to the small horizontal object, and in a crowded canvas this presents obvious difficulties. In the Metropolitan Museum in New York there is a single sheet of paper with four drawings showing the kneeling Virgin adoring the infant Christ lying on the ground. It is possible that these drawings have nothing to do with the *Adoration* in the Uffizi but are preliminary sketches for another altarpiece altogether, and this is all the more probable because Leonardo on two of the sketches has indicated the final shape of the painting, semicircular at the top, which is completely at variance with the shape of the *Adoration.*

At the Musée Bonnat in Bayonne there is still another sketch for an Adoration with the Virgin kneeling, the baby on the ground, and seven worshipers standing in attitudes of reverence around the Virgin. In addition to the Christ child there is an infant John the Baptist, who bends down in the most charming manner to peer at the baby. But the drawing remains curiously lifeless with the figures posed too ceremoniously to be convincing. Yet this drawing, too, was one of the stages on the way to the final decision to break through the established conventions and to invent a new concept of the Adoration with its vast disorder and disembodied faces and tumultuous horsemen which appear to have sprung out of the ground. Here, finally, the focus is enlarged, and while the Virgin remains at the still center, the world in all its violence is seen wheeling around her. The Virgin remains suspended in equilibrium; the Child blesses; a horseman with wildly flowing hair rides past within a few feet of them; and there is the illusion that all humanity has gathered here, the good and the evil alike, and the Magi are no more and no less important than the crowds watching in joy and trepidation.

At the extreme lower right of the painting there stands a solitary figure who alone among the people in the foreground looks away, out of the painting. He wears a dark cloak, like a cloak of invisibility, and

the clean-cut features are etched in lightly. According to the conventions of the time, this can only be a self-portrait of Leonardo.

If all except one of Leonardo's paintings had to be destroyed, this is the painting it would be necessary to preserve. Here he is in command of the lightning, and here most clearly we hear the thunderclap.

St. Jerome in the Desert

Sometimes, in an almost inexplicable way, great masterpieces are found on rubbish heaps. Thus it happened that in 1928 some workmen cleaning up an old country house in England found in the dust on top of a cupboard a painting by William Blake, which had been lying there for more than a hundred years. The painting showed Blake in a red gown about to launch himself into the Sea of the Imagination; nearby the Nymphs move up and down a stairway to their hidden cave; and more mythological figures crowd the sea and the heavens. The painting had never been recorded; nothing at all was known about how it had found its way to the country house. It was indisputably one of his greatest works, and it had emerged out of a heap of broken glass and broken picture frames by the purest luck, for the workmen were about to throw the rubbish away.

So, too, with Leonardo's *St. Jerome in the Desert,* now in the Vatican Museum. It appears that it had once belonged to the painter Angelica Kauffmann, who also owned a head of John the Baptist believed to be by Leonardo. She died in November 1807 and her collection of paintings was dispersed, many of them going to Spain. The *St. Jerome* vanished, to reappear thirteen years later in a sale room in Rome without the head, which had been cut away. The part of the panel with the head had been used as the door of a small wardrobe. The purchaser was Cardinal Joseph Fesch, the uncle of Napoleon, an avid art collector who instituted a search for the part that had been sawed off. Five years later the head was found in a cobbler's shop, where it was being used as a wedge to support the bench. The head was inserted in the panel, the restorers went to work, and the complete painting was recognized as an early work by Leonardo. There was not a single document to authenticate the painting, but this scarcely mattered. It belonged to the category of paintings that do not demand authentication because they are so obviously painted by the master that no one dares to suggest otherwise.

Cardinal Fesch enjoyed the painting for only a few years. He died in 1830, and it passed into the possession of his heirs. In 1845 it entered the Vatican collection, where it has remained ever since.

We see St. Jerome kneeling beside a lion, one arm outflung, gazing

penitently and adoringly at a crucifix. He is naked except for a cloak falling loosely over his left shoulder; he is very old, and the deeply lined face and emaciated body have the dignity of age. Behind him lies the desert with the strange bulbous rocks that appear in *The Adoration of the Magi* in the distance, while closer at hand, much repainted, is a heap of rocks and what appears to be the entrance of the grotto where the saint spent the greater part of his life. One imagines that a cry has just escaped from the saint's lips. The lion's mouth is open, and he is roaring.

Except for some touches of gray and blue among the mountains, the painting is all orange-yellow and brown. It gives an effect of great brightness, the sun overhead leaving no shadows. In the pitiless glare of the desert the saint is isolated, totally removed from the world of men, alone with his God. At first sight he appears to be making an imploring gesture with his outflung arm, but if we look closely we see that he is holding a stone. From Vasari we learn that St. Jerome was often portrayed "contemplating a crucifix and beating his breast to drive away the lascivious thoughts that beset him in the wilderness." And no doubt this is what St. Jerome is doing, but this is only a part, and perhaps the lesser part, of what he is doing. The intensity of the adoring gaze does not preclude penitence (the stone in the hand), but Leonardo is portraying far more than a penitential act. On the saint's face there is the expression of a man at the moment before death or in a moment of illumination.

One day Eugène Delacroix, after studying the Leonardos in the Louvre, observed in his diary, "This man, whose manner is so characteristic, is devoid of 'rhetoric.' Always observant of nature and ceaselessly referring to it, he never copies it himself. The most learned of masters is also the most artless." It was a profound and true observation. What Delacroix meant by "rhetoric" is precisely what is lacking in the painting: there are no declamatory gestures, and there is no seeking after effect: instead, there is only the naked nerve, the urgency of penitence, the blindingness of the vision of God. Almost the painting is an abstraction of adoration.

By the early years of the fifteenth century the iconography of St. Jerome was already established in two very different forms. There was the bearded scholar, sometimes wearing a cardinal's hat, sitting in his well-furnished study with the lion at his feet, and there was the ascetic saint in the desert, nearly naked, with the bruised chest and wild eyes, with the skull nearby to remind him of his mortality, and the lion guarding him. Usually he is plump and bearded when depicted as a scholar, thin and beardless when he is depicted as a desert-dweller. Leonardo has found no place for the skull in his composition because

it is already visible in the saint's face. No one else had ever depicted St. Jerome with such a haggard appearance.

St. Jerome is one of the few paintings in which Leonardo demonstrates his knowledge of anatomy. The saint is bone, tissue, and muscle, with only a thin covering of flesh; the cheek and neck muscles are portrayed with exquisite accuracy; and the nearly naked body of an old man was conveyed with sympathy by a man who was still very young. Above all, he endows the saint with extraordinary power and dignity.

There would be, as far as we know, no more monochromic paintings. In the two paintings *The Adoration of the Magi* and *St. Jerome* he appears to have exhausted a medium perfectly suited to his temperament and his needs. Although a brilliant colorist, he appears to have been happiest when he was not under the imperious necessity of obeying the infinitely complex laws of color. In his next painting he would use color richly and yet sparingly, without excitement and with total discipline.

Ginevra de' Benci

In December 1469, at the age of twenty, Lorenzo de' Medici became the real power in Florence, following the death of his father, Piero, who had succumbed to gout at the age of fifty-three. Lorenzo was well built, with broad shoulders and a strong, wiry body; he held himself well, rode well, talked brilliantly, and wrote excellent poetry. He had a ruddy complexion, heavy eyebrows, a piercing glance, a flattened nose that looked as though it had been stamped upon by hobnailed boots, a mouth like a slit, and a heavy, underslung jaw. Formidably ugly, he possessed great intelligence and charm of manner, and his ugliness became beautiful.

We know him as Lorenzo the Magnificent, but this name is something of a misnomer, for there were at least thirty eminent men in Florence who were regularly addressed as *Il Magnifico*. But Lorenzo was magnificence incarnate. In spite of his physical defects—his gout,

his ugliness, his short-sightedness, his harsh and high-pitched voice—
he was the most glorious of the Renaissance princes, the most learned,
the most enamored of the arts, the most courageous, and the most
gifted as a ruler. Most Florentines loved him, and the few who
detested him vigorously belonged to the ancient families whose power
had been usurped by the Medicis.

Lorenzo was one of those men who set the style of an age. His very
youthfulness worked in his favor. He knew what he wanted, which
was to make Florence the intellectual and artistic capital of Italy, and
in this he succeeded brilliantly. His badge was three interlaced dia-
mond rings, and he was well aware of the many-colored magnificence
of diamonds. His motto was *Le Temps Revient,* by which he meant
that a new and splendid age was about to open.

Shortly after noon, on April 26, 1478, Lorenzo began to walk at a
leisurely pace from the Medici Palace to the cathedral, accompanied
by the young Cardinal Raffaello Riario. It was Sunday, the church
bells were ringing, and he was about to attend High Mass. His
younger brother, Giuliano, who was as handsome as Lorenzo was
ugly, left the Medici Palace a few minutes later accompanied by Fran-
cesco de' Pazzi and Bernardo di Bandino. Riario, Pazzi, and Bandino
were all members of a conspiracy dedicated to destroying the power
of the Medici by murdering the two brothers and they had already
arranged that the murders would take place simultaneously at the mo-
ment of the elevation of the Host during the Mass. The conspiracy
had been carefully worked out. Giuliano was stabbed to death—nine-
teen stab wounds were found on his body—and Lorenzo was stabbed
once but not mortally and was able to escape through the sacristy. For
about twenty minutes the cathedral was in an uproar with people mill-
ing about, shouting, and screaming. Meanwhile another group of con-
spirators was attempting to capture the Signoria. This proved to be
impossible in spite of the fact that the conspirators had succeeded in
bringing some Ferrarese freebooters into the city to fight for them.
Archbishop Salviati, who was also in the plot, was arrested, brought
before a drumhead court-martial, sentenced to death, and hanged
with five other conspirators from the windows of the Signoria.
"Within half an hour," wrote the chronicler, "twenty-six bodies were
encumbering the staircase of the Palazzo della Signoria, and half a
dozen more were dangling from its windows."

The conspiracy was a disaster, for the surviving conspirators were
hunted through the city by the enraged people and done to death. A
few escaped heavy punishment because they succeeded in hiding
long enough to appeal for mercy when the fury of the Medici had
subsided. One reached Constantinople in disguise, but the Medici had

many agents there and were on excellent terms with the Sultan. He was brought back in chains and hanged from the windows of the Bargello on December 28, 1478. His name was Bernardo di Bandino Baroncelli, and he was the man who repeatedly stabbed Giuliano de' Medici in the cathedral. He belonged to an old and well-known family, had fallen on hard times, and was desperate for money.

The murder of Giuliano resulted in commissions for at least two great artists. Botticelli was employed to paint on the walls of the Signoria a fresco showing the hanged traitors and Verrocchio was employed to make wax models of Lorenzo, life-size, to be placed in the Church of the Santissima Annunziata, in the Convent of the Augustinian nuns in the Via San Gallo, and in the Church of St. Mary of the Angels at Assisi. Leonardo's father was involved in the arrangements for placing the wax model in Santissima Annunziata, and Leonardo may have worked on all of them. He appears to have believed that he might receive a commission to do a painting of the hanged Bernardo di Bandino, for there has survived a drawing of the execution in his hand with an accompanying description of the colors of the man's clothes:

> A tan-colored small cap
> A doublet of black serge
> A lined black jerkin
> A blue coat lined
> with fur from foxes' throats
> and the collar of the jerkin
> faced with velvet
> stippled in black and red
> Bernardo di Bandino
> Baroncegli
> black hose

Leonardo writes in his usual mirror writing with great care and there can be very little doubt that Leonardo was present on that winter day and watched the hanging. We see Bernardo di Bandino in a rather sumptuous fur-lined blue coat, with his arms bound behind his back and a thick rope around his neck, and somehow Leonardo succeeds in giving him a certain memorable dignity. The fur-lined coat was exactly such a coat as would be worn on a winter's day.

We do not know where Leonardo was at the time of the conspiracy, and in all his writings there is nothing that provides even a hint of his feelings on the matter. He showed no interest in the Platonic Academy and very little in Lorenzo. But about this time we hear of important commissions that must have come ultimately from Lorenzo. Vasari mentions a cartoon of *The Fall* designed to be reproduced in

tapestry in Flanders for the King of Portugal. We are told that the tapestry would be woven in gold thread and silk, and would therefore, if it was ever made, be most lavish and expensive. We learn that Leonardo executed the cartoon in water colors *en grisaille*, and Vasari, who saw the cartoon when it was in the possession of Ottaviano de' Medici, speaks of the beauty of the date palm, the fig tree, the flowers, leaves, and branches, and he particularly observed that the dates were very round and they "were executed with great and wonderful art due to the patience and ingenuity of Leonardo." Since the tapestry was intended for a door hanging, we can guess at its proportions. Meadowlands, animals, the two trees, Adam and Eve in their nakedness. It has been assumed, on no evidence at all, that Raphael's *Fall of Man* in the Stanza della Segnatura in the Vatican is a free rendering of Leonardo's original cartoon. The cartoon is lost, the tapestry was never made, and there are no sketches in Leonardo's notebooks to give us any suggestion of its composition.

During these last years in Florence there occurred a significant change in Leonardo's living conditions. In 1480, for the first time, he no longer appears in his father's tax return, and in that same year Ser Piero left the house in the Via delle Prestanze and settled in another house in the Via Ghibellina in the San Pier Maggiore quarter. The reason may have had nothing to do with the size of his growing family, for we know that the Via delle Prestanze house was owned by a remarkable man called Giuliano Gondi, a merchant in silk, descended from a long line of worthy Florentines, and it had at last occurred to him that the time had come to pull down the house and erect a palace on the site. The eminent architect Giuliano di San Gallo was employed to design the new palace.

Giuliano Gondi, who belonged to a family that gave a gonfalonier and eighteen priors to the republic, was one of those respected Florentines always addressed as *Il Magnifico*. He was descended from Orlando di Bilicozzo, who was one of the councilors of Florence in 1197. Trading in silk and gold filigree, with depots all over Europe, he was both rich and powerful, and his three sons supervised his establishments in Constantinople, Naples, and Hungary. Ser Piero appears to have been one of his close friends and we know that Leonardo used the postal service of the Gondi establishment. Guiliano Gondi, Il Magnifico, died at the age of eighty in 1501 and his bones rested in the special chapel erected for him in the Church of Santa Maria Novella. On his tomb there were carved the arms of the Gondi family—a golden ax with a blue cord. Or, a battle-ax in saltire, tied by a cord, gules.

Although Ser Piero knew everyone in Florence worth knowing,

Leonardo appears to have known comparatively few people well, being studious and reclusive. Only two names of close friends are known. One was the singer Atalante Migliorotti, who became famous as a maker of musical instruments, as actor and singing master, and later settled down as an important official in the Vatican. He was known for the sweetness of his voice and for the range of his acting. He was a serious and dedicated artist. The other friend was anything but serious. He was gay, gentle, and improvident, and perhaps half mad. His name was Tomasso Masini da Peretola—Peretola is a small town near Florence—and he claimed to be the illegitimate son of Bernardo Rucellai, who was the brother-in-law of Lorenzo de' Medici. We know a little about him because Scipione Ammirato published a book in 1637 which includes an account of his life, the *Anonimo Gaddiano* mentions him once, and Antonio Francesco Grazzini, a writer of comedies and stories modeled on Boccaccio, wrote about him amusingly. Grazzini, a master of Tuscan prose, was better known as *Il Lasca,* meaning "the Cockroach," and Tomasso Masini was better known as Zoroastro, a name given to him by Cardinal Ridolfi later in life, apparently because he was an avid student of alchemy.

Zoroastro was a colorful figure, sharp-featured, wild-eyed, wearing a magnificent black beard which spread chaotically over his chest. Leonardo designed a dress for him which appeared to be made out of berries, and he was therefore nicknamed *Il Gallozolo,* the Berry Man. In Milan he was given another nickname—*L'Indovino,* the Soothsayer. He delighted in all magical things. Alchemy, chiromancy, astrology, physiognomy, and the casting of spells gave him pleasure. He was a great collector of dead men's bones, the ropes with which men had been hanged, the eyes of lynxes, the saliva of mad dogs, crucibles for the distillation of herbs, metals and stones, and herbs and seeds collected during different phases of the moon. He collected relics, and claimed that he possessed the collarbone of King Solomon, together with some swords and daggers used to commit murder and therefore possessed of phenomenal powers. He was a charlatan of sorts but he was also a good-hearted person, an excellent raconteur, and a man of principles. Some of those principles would naturally commend themselves to Leonardo, for Scipione Ammirato tells us that out of respect for created things "he refused to kill a flea for anything in the world." Like Leonardo he was a vegetarian; he dressed in linen to avoid having anything on his body that came from animals. Hence he wore no furs in winter, and possessed no leather belts or leather shoes.

Leonardo also knew some members of the Florentine nobility and he was especially close to the Benci family. One of his greatest paintings done shortly before he left Florence was a portrait of Ginevra de'

Benci. This painting was bought by the National Gallery in Washington from Prince Franz Josef II of Liechtenstein for six million dollars. It is quite small, being 15½″ by 14½″, but it has the power and energy to fill a room with its disturbing brilliance.

Of its provenance nothing is known except that it was first listed in the collection of a Prince of Liechtenstein in 1733, more than two hundred and fifty years after it was painted. Not until 1866 was it recognized as an authentic Leonardo. The surprising thing is that it took so long, for it is mentioned by three early biographers. The *Anonimo Gaddiano* says: "In Florence he painted Ginevra d'Amerigho Benci from nature and did it so well that it seemed not a portrait but Ginevra herself." A famous but anonymous historian of Florentine art, whose manuscript passed into the hands of Antonio Billi and has acquired his name, mentions only one portrait by Leonardo in the whole course of his work, and this is the portrait of Ginevra "painted with such perfection that it was none other than she." Vasari mentions the painting rather casually and describes it as "a beautiful portrait" before going on to more important things. It is possible that none of these biographers ever set eyes on it. If they had seen it, they would have had more to say.

Those who see the portrait, the pale face set against the dark olive-green juniper tree, the severe reddish-brown gown, the blue mist and lakes in the distance, are aware of a presence as unforgettable as the *Mona Lisa,* and for some of the same reasons. Like the *Mona Lisa,* she is proud, majestic, incapable of subterfuge, yet very vulnerable. She has exhausted all her hopes, all her despairs. She said of herself that she was "a mountain tiger," and the tigress can be seen in her, and the cold snows. She has been painted in the light of the dying sun somewhere in the Florentine countryside, perhaps on her father's estate. By the standards of her time she was not conventionally beautiful, and like the Florentine women of her day she has shaved off her eyebrows and her eyelashes, and therefore seems all the more vulnerable and all the more bold. Birdlike with her sharp nose, thin lips and heavily lidded eyes, she gazes out from the shadow of the juniper tree as though she has been startled by something she has just seen coming toward her.

Leonardo, when he painted her, knew what she had seen coming toward her, and portrayed her accordingly. By setting her against a large juniper tree, he was paying a conventional tribute to her name—in Italian juniper is *ginepro* or *ginevro*—but he was also giving her a crown of thorns by massing the dark spiky leaves around her head. She was a woman who had suffered much; she had been deathly ill, and had only recently left her sickbed; she had suffered torments of

anxiety during an ill-fated love affair with Bernardo Bembo, the Venetian ambassador at the court of Lorenzo de' Medici, and there were more torments when she learned that her aunt Bartolomea de' Benci had become one of Lorenzo's mistresses. Deeply religious, intensely sensitive, suffering many private griefs, the young wife of a middle-aged official who rose to high position—he became gonfalonier, the highest executive post in the city, and was later a prior, one of the six councilors who in theory were immediately under the gonfalonier—Ginevra de' Benci was a remarkable woman in her own right.

It happens that we know a great deal about her, far more, for example, than we know about Lisa Gherardini, once thought to be the model of the *Mona Lisa*. She was born in 1457, the second child of the banker Amerigo de' Benci. In 1474, at the age of sixteen, she was married in her parents' house to Luigi di Bernardo Niccolini, who was twice her age and whose first wife had died not long before. Niccolini's family business was cloth weaving, which was falling on hard times, and while he advanced to high office in the government, his business affairs were leading him almost to bankruptcy. In the summer of 1480 he reported in his tax return that "he had more debts than personal property," and that his wife, who had brought him a dowry of 1,400 florins, was ill and had been "in the hands of doctors" for a long time. This was the year when he became a prior and was seemingly still one of the most important people in the government of Florence.

Ginevra's illness may have been real—it was a time when plague was making great ravages, according to the diarist Luca Landucci—but it may also have been a psychoneurotic sickness brought on by the abrupt departure of Bernardo Bembo, who admired her, flattered her, paid court to her, and appears to have fallen deeply in love with her, employing two of his protégés, Cristofero Landino and Alessandro Braccesi, to write poems in her honor describing in somewhat veiled language the course of their love affair. The conventions of Renaissance poetry are fairly well known, and the poems, which survive, suggest that Ginevra was swept off her feet by the much older and more experienced Bembo, that she encouraged him, and that she became, if only temporarily, his mistress. Bembo was a cultivated man, a close friend of Marsilio Ficino, and a regular attendant at the meetings of the Platonic Academy. He was also a rogue who borrowed money unashamedly from Lorenzo de' Medici, although, as Venetian ambassador, he was supposed to be free of all financial indebtedness to the court to which he was assigned. He had a wife in Venice and a ten-year-old son Pietro, later to become a cardinal, secretary and confidant of the Medici Pope Leo X, and a prose writer of quite extraordinary virtuosity.

For Ginevra the love affair, coming at a time when her husband's
financial affairs were in disarray, had a shattering effect. She aban-
doned Florence, fled to her country villa, gave herself up to religious
meditation, and consoled herself with good works. Lorenzo de' Me-
dici, who knew all about the affair with Bembo and was well aware of
her indignation over his own affair with Bartolomea de' Benci, wrote
two sonnets to her in which he counseled her to live quietly in the
country and to give herself up to Christ. In one of these sonnets he
reminds her that when Lot's wife looked back on the city she was
turned to a pillar of salt:

SONNET CXLIX

As Lot fled with his family from the city
By divine justice consigned to the flames,
His wife, looking back at the great and just punishment,
Was transfixed, became a pillar of salt.

You fled—and it was a great marvel—
From the city given over to every vice.
Know, gentle soul, that your duty lies
In never again setting eyes on it.

To redeem you the eternal good Shepherd
Leaves his flock, O stray lamb,
And takes you joyfully in his arms.

Already at the gate Orpheus lost Eurydice,
When she was almost free, by gazing upon her.
Therefore never turn your gaze upon Hell.

Lorenzo de' Medici was generally a kindly man when he was
addressing women, but there is no doubting that he was writing heat-
edly and even angrily. What he was saying was "For God's sake stay
away from the city. It will kill you. Don't ever show your face here
again." It was both consolation and an order of banishment.

There survives a long letter written to her from Rome in August
1490 apparently by a junior secretary in the Florentine Embassy, who
was perhaps also a priest, for he signs himself only with his initials
and places a cross between them. It is an enchanting letter written to
a woman he evidently liked, admired, and owed some service. He
apologizes for not sending her various small things she had ordered,
explaining that he had asked someone else to send them and by a
series of miserable accidents nothing had been done about it, and he
attempts to divert her with an amusing account of a conversation with
Theodorina Cibo, the daughter of Pope Innocent VIII, and the Prin-
cess of Bisignano, on the subject of what makes a woman worth lov-

ing. He regrets that she was absent, for she would have added much
to the conversation, and he reminds her of her sonnet beginning with
the words "I beg for mercy, and I am a mountain tiger." This is the
only line of her poetry that has survived, and it is sufficiently remarka-
ble to suggest that her poems would have been worth reading. Her
unknown correspondent obviously knew her well, and knew all the
other members of her family, for he mentions their names and asks to
be remembered to them. Ginevra's sister Lucretia has recently given
birth to a child, and rather daringly he suggests that she should do
likewise "so that a race of such beauty and generosity shall not be ex-
tinguished," and remarks even more daringly that she has failed to do
so "from excess of haughtiness," *troppo insolentia.* The window opens
for a moment, we see her clearly, austere, reserved, remote, the moun-
tain tiger caged at last in her country villa, no longer busy with the
affairs of this world. She was thirty-three when this letter was written.
Fifteen years later she would become a widow. She died in or about
1520, when she was in her sixties.

When Leonardo painted her in 1481, it is likely that he went to live
in her country villa. We know that he was a friend of her elder
brother Giovanni de' Benci and was accustomed to borrowing his
books and maps, and the unfinished *Adoration of the Magi* was left in
his keeping in the great family house opposite the Loggia de' Peruzzi.
Ginevra had only just recovered from her long illness. It was autumn,
the trees turning yellow, and she was still weak and uncertain of her-
self, still bearing the marks of her sufferings, still pale, although she
has touched her cheeks with a little rouge. Leonardo painted her as he
saw her, penetrating deeply into the mind of the tigress. Death still
hung over her, and he painted this too. One imagines that she had to
be cajoled into attending the long sittings, and was often trembling.
The painting, as we have it now, is truncated, having lost seven or
eight inches of the lower part, which once showed her hands. It is
thought that a silverpoint drawing on pink paper now at Windsor rep-
resents a study of her hands resting just below the lacing of her bod-
ice, and on the drawing there is even an indication of the opening of
the bodice. In Leonardo's painting Ginevra is shown wearing a rust-
brown dress and her décolletage is relieved by a filmy gauze blouse
buttoned a little below the neck. The bright blue lacing of the bodice
wonderfully reflects the small patches of sky.

In black and white reproductions the painting has something of the
appearance of an overexposed passport photograph, but this is not the
fault of Leonardo. The coloring is superb, though muted; and there is
drama in the two-inch-wide black scarf falling over her shoulders, for
such scarves were worn by women to remind themselves of their faith

and their mortality. The flesh glows softly, as though lit from within; the *reflessi colorati*, the colored reflections, which were Leonardo's perpetual study in his later years, are now for the first time displayed abundantly in a painting where at first sight they do not seem to be displayed at all. The woman lives and breathes, has an inner life, possesses authority and vulnerability. She would possess more authority if there was more of her, for the loss of the hands inevitably diminishes her. We do not know how or when the portrait was damaged. It appears that some time in the seventeenth century someone added a strip an inch wide to the bottom of the painting, in this way adding to the bodice the necessary minimum which would give it form and substance. When the painting was bought by the National Gallery in Washington, the strip was removed on the dubious grounds that since the strip was evidently not painted by Leonardo, it had no right to be in the painting. By the same argument all the additions made by restorers should be expunged. In fact the added strip, which appears on all the early reproductions of the *Ginevra*, helps considerably to restore balance to a painting which looks strangely top-heavy in its present state.

On the back of the painting Leonardo painted a curious device: a curving sprig of laurel and a curving palm leaf enclosing a sprig of juniper, with the inscription VIRTUTEM FORMA DECORAT, which can be translated "Beauty adorns virtue." The laurel and the palm must refer to her gifts as a poet, and while it may be tempting to read into "virtue" the same meaning that it has today, it is more likely that it has the meaning of *virtù*, which in Renaissance times meant "a high nobility of character," not in any passive sense, but in the sense of achievement and great designs. From the back of the painting it is also possible to work out its original dimensions, for it is comparatively easy to calculate the original lengths of the laurel and the palm. The leaves press closely against the sides of the painting, suggesting that there was originally another inch on each side.

What the painting must have looked like in its original state we can guess by comparing it with another portrait of Ginevra de' Benci in the Metropolitan Museum in New York. The painter was Lorenzo di Credi, who was a few years younger than Leonardo. He had great skill and intelligence, and in many ways this portrait is more satisfying than Leonardo's. What it lacks is the magical confrontation, the sense of a revelation of character, the intimacy of her presence. Lorenzo di Credi has painted a believable young woman wearing a veil and a black dress, a rather ordinary young woman, reserved in manner, perhaps ill, holding in her hands the emblem and token she prizes above all other things—her marriage ring. Her lips are pursed, her thoughts

are melancholy, her head is surrounded with a crown of juniper thorns
almost as dark as her dress, and she is deliberately set in the land-
scape in a way that suggests her uneasiness and dissatisfaction with
her life, her coldness and neuroticism. The two paintings, Leonardo's
and Credi's, were probably done within a few months of each other.

Black and white reproductions do both paintings injustice, and this
is particularly true of Leonardo's, which is a thing of ravishing color,
very bright and sunlit, so that one expects it to glow in the dark. In
that memorable face there is an intensity and quivering life that are
almost frightening. Credi, too, was painting at the peak of his ability
and there exists no other painting of his half as appealing.

The Bencis were close to the court of Lorenzo, and it appears that
Leonardo himself about this time saw more of Lorenzo than he had
seen at any time since his youth when, according to the *Anonimo
Gaddiano*, "he lived with Lorenzo de' Medici who gave him commis-
sions and allowed him to work in the garden at the Piazza San
Marco," which contained a famous collection of antique statues. The
Anonimo is our only authority for the statement that Leonardo "lived
with Lorenzo," and it seems likely that this encounter was very brief
and left little impression on Leonardo. The *Anonimo* goes on to say
that at the age of thirty Leonardo "was sent by Lorenzo il Magnifico,
together with Atalante Migliorotti, to the Duke of Milan to present
him with a lyre, and he knew how to play it with rare distinction."

That Leonardo first visited Milan in order to present the duke with
a lyre is not in the least surprising. Lorenzo de' Medici was anxious to
preserve his alliance with Milan and he was in the habit of sending
expensive presents to allies with great fanfare, the ambassador being
accompanied with an impressive retinue. The gift of the lyre, which is
associated with peace, was a political act, and the choice of Leonardo
and Atalante as envoys was a brilliant one, for with the lyre went a re-
nowned lyre player and a well-known singer, so that the duke was en-
sured of an evening's entertainment which would not quickly be for-
gotten. A well-tuned lyre in Renaissance times was a gift worthy of
princes.

The *Anonimo* says that Leonardo was thirty years old when he took
the lyre to Milan. This suggests that the incident happened about
1482, and in fact Leonardo signed a contract in Milan in April 1483 to
paint an altarpiece for the Church of San Francesco. Such contracts
took a long time to prepare and draw up, there were endless discus-
sions with the church authorities concerning the design of the altar-
piece and methods of payment, lawyers were brought in, many copies
of the contract had to be made in Latin and translated into Italian for
the benefit of the artists involved, and a year might pass before the

artists settled down to work. Thus we may expect that there were many preliminary meetings and discussions between Leonardo and the churchmen. To attempt to discover the exact date when Leonardo came to live in Milan is as irrelevant as to attempt to discover the exact date when he entered Verrocchio's studio, for it is likely that there were many visits of shorter or longer duration, many tentative offers to be explored, many heart-breaking failures, for artists then as now were accustomed to seeing their best plans collapse at the very last moment.

And if, as the *Anonimo* says, Leonardo came to Milan with a gift for the duke in 1482, this can only mean that the gift was made to the Duchess Bona, who was acting as regent for the thirteen-year-old Duke Giangaleazzo, whose father had been assassinated six years earlier. Giangaleazzo was a handsome, likable boy with gentle manners and a sweet temper, completely under the domination of his mother and her handsome secretary, Antonio Tassino, who was on familiar terms with the duchess. Giangaleazzo had delicate health and was being spoiled to excess with the result that he was incapable of making decisions and would prove to be an incompetent ruler if he ever sat on the ducal throne, a fact well known to his uncle Lodovico, Duke of Bari, who was determined to supplant the young Duke of Milan and to seize power. Lodovico was living in Milan, and there were many who regarded him already as the real power behind the throne.

Leonardo spent the next seventeen years of his life in and around Milan, abandoning Florence and the world he had known for thirty years. He abandoned a mild tyranny for one that was much stronger, a rich and powerful city for one that was poorer and less powerful, a city that bred artists for one that borrowed them, a republic for a princedom. He seemed to be moving against the current, and yet it was not so. He was doing something that was perfectly natural in his time: as an artist he went where he believed his art would be appreciated and rewarded. On this subject the last word was spoken by Vasari: "The artist must go abroad and sell the goodness of his work and the reputation of his city, in the same way that professors sell that of their colleges. For Florence does with its artists what time does to all things: as soon as they are made, time seeks to destroy and consume them little by little."

LEONARDO OF MILAN

A Letter to the Duke of Milan

Milan in 1482 was a city that still bore the traces of its ancient impe-
rial grandeur. Once it was the capital of the Western Roman Empire
and from its gates viceroys and emperors rode out to take command of
vast areas of western Europe. Now, in the closing years of the
fifteenth century, it appeared to have regained under the Sforzas some
of its ancient power and dignity. For more than a hundred and fifty
years Milan and the surrounding territories had been ruled by the Vis-
contis, whose banner was a serpent. One tyrant followed another, but
the grandeur of Milan did not come from the tyrants. It came from an
industrious people and the wealth of the Lombardy Plain, from skill in
building and the making of armor and rich embroideries and canal
digging and shipping. The workmen possessed hereditary skills; they
were calculating and realistic. The Florentines thought in terms of
line, the Milanese in terms of mass. When Leonardo came to Milan,

he was entering foreign territory where Florentine lightness and grace were largely absent.

The dynasty of the Viscontis came to an end in 1447, the Sforzas took power, and little was changed. The first of the Sforzas was married to one of the Viscontis: in this way the Sforzas inherited the streak of madness and cruelty that were characteristic of the Viscontis. They also acquired their imperial manners and love of the arts. The Viscontis built the Castello, the huge fortress dominating the city. The Sforzas rebuilt it, made it twice as powerful and five times as intricate, so that it came to resemble a huge dynamo, of which many pieces were made out of filigree. In the same way the Viscontis began to build the huge cathedral, the third largest in Europe, but it was the Sforzas who carried it nearly to completion and added the delicate tracery of slender towers that gives to a vast, almost uncontrollable mass a certain grace and lightness. The city walls radiated force; the Castello was impregnable; the cathedral was a triumphant assertion of Christian faith. The people who hurried about in the shadow of the giant cathedral were proud of their city but they were not necessarily proud of the prince who ruled them from the red-walled Castello. They were often rebellious and always fickle. From 1484 to 1499 Milan enjoyed under Lodovico Sforza a period of settled prosperity and power, and then they spewed him out and wished he had never been born.

Everything about Lodovico appeared to be exaggerated. He was the Renaissance prince raised almost to the height of absurdity. He had the abrupt manners and murderous temper associated with the Sforzas together with a melting sweetness and gentleness when it served his purpose. He was brave in words and cowardly in action. He was ruthless against real and imagined enemies but succeeded in acquiring a reputation for decency and generosity. He was an arch-intriguer who brought about his own downfall by his incessant intrigues and by his shifting alliances. Many portraits of him survive, nearly all of them showing him in profile, and this for obvious reasons. In profile he looked powerful: a massive chin and heavy aquiline nose suggested dogged determination, authority, even intelligence. Full-face, with his low brow, small voluptuary's mouth, bull neck, and sagging jowls, he looked like a caricature. He was heavy-set and dark-skinned, hence his nickname *Il Moro*, the Moor, and he walked with a heavy swagger and smiled too frequently. There are many headwaiters who resemble him.

Unlike Lorenzo de' Medici, Lodovico had no pretensions to intellectual authority. He was incapable of discussing abstractions, or of writing poetry, or of evaluating a work of art. He was the sum of his

appetites, and his largest appetite was directed toward retaining and expanding his power. He was determined at all costs to dominate Milan and as much of Italy as he could lay his hands on. Paolo Govio described him as "born for the undoing of Italy." It was a fair description of a man who kidnaped the rightful Duke of Milan, kept him as a prisoner in the Castello, and ordered the boy's mother out of the city. When he usurped the title of Duke of Milan, he saw no reason to change the title of his unfortunate nephew. There were thus two Dukes of Milan, one with power, the other powerless. By his intrigues he brought misery to Italy, and especially to Milan and to himself. No tyrant excelled him in treacherous stupidity. He is remembered today because Leonardo spent some of the most productive years of his life in Milan when he was ruling it.

Outwardly the city was thriving. The lutemakers, the armorers, the twenty thousand men and women working in the silk factories, the boatmen on the canals, the farmers on the Lombardy Plain, the makers of perfume and millinery (the word derives from Milan) were living through a period of unparalleled prosperity. Genoa served as its seaport, and soon Genoa would be conquered and added to the small Milanese empire which reached up to the northern lakes and south to the borders of Tuscany. A cautious tyrant would have maintained the status quo. Lodovico was always reaching out and causing trouble. He wanted to be Caesar and wore a ruby ring incised with Caesar's portrait.

When Leonardo came to Milan, Lodovico was still being addressed as the Duke of Bari; he was not yet firmly in the saddle. The Milanese were learning to accept him. Leonardo's views on Lodovico were perhaps best unspoken. He signed a contract with the Church of San Francesco to paint the picture that came to be known as *The Virgin of the Rocks,* and for a few years very little is known about him.

For the first three or four years of his life in Milan, Leonardo lived in the house of Ambrogio and Evangelista Predis in the parish of San Vincente. He appears to have lived humbly and quietly. There is not the slightest evidence that during this period of his life he achieved any fame or notoriety: he was not received by the Duke of Milan, he was given no high appointments at court, he was not in demand as a portrait painter among the high officers and ladies of the court, he was not asked to design canals or military fortifications, and there is no record of him taking part in court festivities. The legend that he was greeted with open arms by the Duke of Milan when he first arrived has no justification. Later, many years later, when he was appointed *ingenarius* and *pinctor* to the duke and could and did enter the duke's presence whenever he pleased, and at the very least possessed direct

access to the duke's secretary, he lived in considerable state. But this
time was long in coming.

We may imagine him then living in poverty but not in penury, liv-
ing on the advance payments for *The Virgin of the Rocks,* with a few
pupils around him. One could live cheaply in Milan. Luxuries, of
course, were expensive, but he was a man who could dispense with
even the most necessary luxuries. Sometimes he may have earned
some money by singing and playing on his lute and by occasional em-
ployment as an adviser to the various church bodies concerned with
architecture, painting, and sculpture. As an artist, he was respected,
but little known. The famous Leonardo da Vinci, friend and councilor
of princes, the glorious painter, architect, engineer, and anatomist, had
not yet emerged. It is significant that until 1487 we know of only two
commissions given to him, both of them by the Church—the altarpiece
of the Church of San Francesco and a much smaller commission to
design the *tiburio* of Milan Cathedral, for which he was paid, al-
though the design was not carried out. If there had been many private
commissions, we would expect the happy possessors of his sculptures
and paintings to come forward and claim that they knew him at a
time when he was scarcely known. None came forward. All the evi-
dence goes to show that he lived obscurely far from the life of the
court.

There were, of course, many reasons for his obscurity. By birth and
by temperament he was an aristocrat, with an aristocratic impatience
of the market place. His art, as displayed in the dazzling portrait of
Ginevra de' Benci and the still more dazzling *Adoration of the Magi,*
was so far advanced for its time and so remote from acceptable Mila-
nese taste that it was not likely to find many purchasers. He had gone
beyond the boundaries of painting as it was then understood, and
needed time to think out the consequences of his discoveries, the new
directions it was necessary to take. Much of his obscurity was delib-
erate: the need to go underground, to go deep in himself, to remain
silent in order to discover his true voice.

Nor can we explain the vast discoveries he made in science in later
years without supposing that the groundwork was formed during
those early years in Milan. The city of Milan was his university: and
here he developed his skill and talents as a scientist.

We should remember, too, that he was a stranger in a strange city,
unaccustomed to Milanese ways, slowly adapting himself to his cho-
sen city. He spoke with the rough Florentine accent, which the Mila-
nese affected to despise. In Florence men said *groria* rather than *gloria;*
they were more guttural than the Milanese, spoke more vigorously
and harshly; and after nearly twenty years in Milan, Leonardo contin-

ued to spell in a way that showed he was thinking continually with words that sounded in his mind in the Florentine way. In the Latin contract for *The Virgin of the Rocks* he is called *dominus magister Leonardus de Vinciis florentinus,* and thereafter he is nearly always called *florentinus* as though it was an essential part of his name. And the longer he was away from Florence, the more Florentine he became.

That he knew misery in Milan is certain, for he wrote about it often in his notebooks, made a series of brilliant sketches describing its full impact, and wrote fables that can only be interpreted as bitter criticisms of the world as he found it. How deeply the misery worked its way into his soul we know from a series of drawings that have sometimes been regarded as allegorical exercises but were in fact attempts to come to grips with forces over which he had little control. The chief of these forces was *Invidia,* one of the seven deadly sins, which we usually translate as "envy." But "envy" is a mild word for something that the Church regarded with a special horror. It meant the brooding jealousy which could erupt in self-destructive violence or in violent attacks on the rich and the powerful, and it was especially prevalent among the poor. Leonardo made several drawings of Invidia, showing her as a haggard and naked woman riding on the back of a skeleton, and he added some lines which in their repetitive rhythms have the effect of poetry:

> Invidia is seen making a contemptuous gesture toward heaven, because if it were possible she would use her strength against God.
> She wears a mask of pleasing aspect on her face.
> She is shown wounded in the eye by a palm leaf and a sprig of olive.
> She is shown wounded in the ear by laurel and myrtle leaves, to signify that victory and truth offend her.
> She is shown with many lightnings issuing from her to denote her evil speech.
> She is shown lean and wizened because she is always wasting away with perpetual desire.
> She is shown with a flaming serpent gnawing at her heart.
> She has been given a quiver with tongues for arrows, because with the tongue she often offends.
> She is shown wearing a leopard skin, for the leopard out of envy slays the lion by guile.
> She holds a vase in her hand, full of flowers, with serpents and toads and other venomous things lying below it.
> She rides on Death, for Invidia never dies and has lordship over him.

Death is made with a bridle in his mouth and armed with
many weapons, which are all Death's instruments.

Leonardo, compiling his private allegories and returning again and
again to the subject of Invidia, gives the impression of a haunted man
in a state of almost blind rage. Invidia involves jealousy, envy, and
undiluted hate; it is not for weaklings. So he pictures it as a woman
with pendulous breasts astride the skeleton heaped with fagots, and
with her upraised hand she makes an obscene gesture to God with her
thumb and forefingers. In another drawing Invidia and Ingratitude
are shown as naked harpies astride a monstrous toad, while Death
with his scythe and hourglass comes stalking up behind him. In an-
other and perhaps later drawing Invidia and Virtue are seen springing
from the same pair of legs, with two heads and two torsos branching
out to form an embattled four-armed monster. Virtue is depicted as a
youth with delicate features and curly hair; Invidia wears her pleasant
mask. She has a serpent's tail and brandishes a firebrand to set light to
his hair, and from her mouth issues a serpent to strike at Virtue's face.
Virtue is far from virtuous. He attempts to gouge out her eyes with a
flowering branch and stabs her ear with an arrow. They will inevita-
bly destroy one another. Underneath, with undisguised bitterness,
Leonardo writes, "At the moment when Virtue is born, he gives birth
to Invidia against himself, and a body will sooner exist without a
shadow than Virtue without Invidia."

We are so accustomed to regarding Leonardo as the calm, inquiring
sage that we forget that he was capable of ferocious hatreds. His own
Invidia was evidently directed at the court of Lodovico and perhaps
also at the painters and sculptors of little worth who were being pam-
pered by the tyrant. There is a rawness in these drawings that comes
strangely from a man who was nearly always serene and self-con-
trolled. They were done fiercely and quickly under the stress of pow-
erful emotions, and though at first they seem innocent enough, they
are not what they seem to be. For a brief moment Leonardo lifts the
curtain and we see him in his misery.

Here at last he appears to be hinting that the journey to Milan
might have been a formidable error. He had left Florence to enter the
territory of a tyrant as dangerous as any that existed. Dante had long
ago given warning of such journeys. "What mean their trumpets and
their bells, their horns and their flutes; but come, hangmen, come vul-
tures."

In the light of these drawings we may come a little closer to under-
standing an extraordinary letter addressed by Leonardo to the duke.
The letter survives in a single copy in the vast collection of his papers
known as the Codex Atlanticus, written not in his own hand but in the

hand of a secretary to whom he was evidently dictating. It is often assumed that the letter was written from Florence, recommending himself for employment as a military engineer whose brilliant inventiveness would ensure victory to the duke in all his campaigns. There is internal evidence that it was written in Milan, not in Florence, and there is very little doubt that the letter was actually sent. Nor is there any doubt that Leonardo had for some time been studying military weapons and fortifications without ever having taken part in a war. His early military drawings smell of the lamp. He almost certainly knew Giuliano da San Gallo, the most eminent of the Florentine designers of fortifications, and he had evidently read Roberto Valturio's *De Re Militari*, published in Verona in 1483 in Latin and almost simultaneously in an Italian translation. We know that he possessed the book in both versions, for he made lists of the Latin words of some sections of the book opposite the equivalent words in Italian, as though he hoped to learn Latin military terms and was preparing to learn Latin for further study of the military art. Roberto Valturio's book is not a study of new inventions; it ranges over the whole of Roman history, quotes from all the accepted Roman historians and poets, and prints nearly a hundred woodcuts of engines of war. The book obviously made a very deep impression on Leonardo, who began quite seriously to experiment with imaginary designs of war machines. Thus a woodcut in Valturio's book of a scythed chariot—a very simple and not particularly interesting drawing—was transformed in the heat of Leonardo's imagination into something very different, though recognizably deriving from the primitive original. Leonardo's new scythed chariot was equipped with four rotating horizontal scythes in front, each blade being about six feet long, and in addition there were scythes issuing from the wheels while another quite useless scythe rotated behind the small chariot like a propeller. These scythes revolve on gears connected to the chariot wheels and are operated by a solitary rider whose gown billows behind him like wings; and indeed the rider resembles an angel—the angel of death. Another drawing shows the enormous scythes curving down from a geared pillar immediately above the chariot wheels. All around the chariot lie men whose legs have been cut off at the knees. These drawings can be dated about 1487, at least five years after Leonardo arrived in Milan.

What is most remarkable about these drawings is not their power and daring; it is their deeply personal character. They are expressions of ruthless terror, and they are inventions only in the sense that Piranesi's prisons are inventions. They are Invidia in action, a nightmare seen with astonishing accuracy and penetration.

On a page of Manuscript B now in the Institut de France, under a

drawing of a very simple scythed chariot, Leonardo wrote the following note, which is an elaboration of a passage he discovered in Valturio's work:

> These chariots armed with scythes were of various kinds and often did no less injury to friends than they did to enemies, for the captains of the armies, thinking to use them to throw confusion in the ranks of the enemy, created fear and loss among their own men. Against these chariots one should employ bowmen, slingers and spear-throwers, and throw all manner of javelins, spears, rocks and bombs, with much beating of drums and shouting, and those who act in this way should be dispersed so that the scythes shall not harm them. And by this means you will spread panic among the horses and they will charge at their own side in frenzy despite the efforts of their drivers and so cause great obstruction and loss to their own troops. As a protection against these, the Romans were accustomed to scatter iron caltrops, which brought the horses to a standstill and caused them to fall to the ground from pain, leaving the chariots without power of motion.

All this smells of the lamp, and we are far away from the experienced military engineer who would emerge later. Leonardo is looking up from Valturio's book and elaborating, exaggerating, dreaming. He can imagine terrible instruments of war, but only on paper. His machines would not work—it is inconceivable, for example, that the chariot with the revolving horizontal blades in front and the propellerlike scythes in the rear would ever function efficiently, and even if it did, it would, as Leonardo remarked in his note, be equally dangerous to friend and foe. Caltrops, too, would transform the exquisite machine into twisted metal.

It has been necessary to introduce Leonardo's letter to the duke in this roundabout way because the scythed chariot and other military designs of this period throw light on it. The heightened rhythms of his notes adapted from Valturio show evidence of intense excitement. The famous letter also shows signs of strain and depression. He is writing in a mood of profound despondency. He mentions all the arts of which he believes himself to be a master, and carefully and deliberately says very little about the one art in which he was the supreme master—painting. He wrote:

> Having, my Most Illustrious Lord, sufficiently seen and considered the proofs of all those who proclaim themselves masters and inventors of machines of war, and that the invention and working of these machines do not differ in any

respect from those in common use: I am emboldened without prejudice to anyone else to communicate with Your Excellency and acquaint you with my secrets, and then offering them to your best pleasure at an appropriate time so that I may demonstrate effectively all those matters which, in part, will be briefly noted below [and there are also many more, as different circumstances arise].*

1. I have designs for very light and strong bridges, capable of being transported very easily, and with them you may pursue and at any time [according to the circumstances] escape from the enemy, and others which are solid and indestructible by fire and battle, easy and convenient to lift and put down. Also plans for burning and destroying those of the enemy.

2. I know how, when a place is besieged, to remove water from the moats and to make an infinite number of bridges, covered ways and ladders, and other machines pertaining to such expeditions.

3. Item, if by reason of the height of the glacis or the strength of the place and its position, it is impossible during a siege to use the method of bombardment, I have a way to destroy a fortress or other stronghold, even if it were built on rock.

4. I have also designs for cannon, very convenient and easy to carry, with which to hurl very small things [stones and similar objects almost] with the effect of a hailstorm; and with the smoke of these causing great terror to the enemy, with great loss and confusion.

9. And if it should happen at sea, I have designs for many machines most suitable for offence and defence, and of ships that can resist the fire of the heaviest cannon and power and fumes.

Here the reader observes that 9 follows immediately on 4, thus indicating that the numbers were added later, and the question of the order in which he would introduce his inventions was a matter of some significance. Every word was being weighed, and words that did not add to the sense were being ruthlessly omitted. So far the handwriting is firm, and this appears to be the final draft of the letter before it was written out in the secretary's most careful hand for submission to the Duke of Milan.

At this point he paused to remind himself that he had much more to say about land warfare and it was not yet time to discuss war at sea.

* Brackets indicate words that were deleted in the original Italian manuscript.

When he resumed dictating, he spoke at great speed and the secretary had difficulty keeping up with him. He went on:

5. I have ways of reaching any [fixed and] designated place by means of mines and secret winding passages, and doing this soundlessly, even though it may be necessary to pass under moats or a river.
6. I can make covered chariots, safe and unassailable, which will enter [in] among the enemy with their artillery, and no [quantity] great multitude of men at arms will be able to shatter them. And behind them the infantry will be able to follow quite unharmed and without hindrance.
7. Item, in case of need, I will make cannon, mortars, and light ordnance in very beautiful and useful shapes quite unlike those in common use.
8. Where the operation of bombardment may fail, I can supply catapults, mangonels, *trabucchi,* and other machines of marvellous efficacy: and, in sum, according to the variety of circumstances, I can supply varied and endless means of offence.
10. In time of peace I believe I can give perfect satisfaction equal to that of any other man in architecture and in the construction of buildings both private and public, and in conducting water from one place to another [for offence and defence].

I can create works of sculpture in marble, bronze, or clay, and the same in painting, in which my work will stand comparison with that of anyone else, whoever it may be.

Also I could undertake the work of the bronze horse, which will bring immortal glory and eternal honor to the happy memory of the Prince your father and the illustrious house of Sforza.

And if any of the aforesaid seem impossible or unfeasible to anyone, I am most ready to make the experiment in your park or in whatever place may please Your Excellency, to whom I commend myself with all possible humility, &c.

Such was the letter written to the duke in a mood of exaltation and something akin to desperation. It was an age when men spoke openly of their glory, their fame, and the accomplishment of their towering ambitions, but even in that age Leonardo's self-praise was strangely disturbing, all the more so because it was lacking in precisely those qualities which would make it convincing. He lacks credentials. What is even more important is that he lacks the conclusive and convincing word which would reveal his authority. The design of portable bridges had greatly advanced during the fifteenth century, and there was nothing particularly novel in his first statement except that his

bridges are "indestructible by fire and battle," *inoffensibili da foco e battaglia.* Such a claim immediately arouses suspicions, for nothing is indestructible. In the second statement he claims to be able to make an infinite number of bridges, covered ways and ladders, *fare infiniti ponti, gatti e scale,* and the word *infiniti* is no more plausible than the word *inoffensibili.* In the third and fourth statements he claims to be able to destroy any stronghold whatsoever without bombarding it and to have devised a kind of cannon which fills the air with minute fragmentary objects like a hailstorm, causing terror and confusion among the enemy. To any Milanese military engineer—and the Milanese were the most practical people in Italy—such claims would be regarded as fantasies. In the statement marked 9 he declares that he has designed ships that can resist the fire of the heaviest cannon; they, too, are indestructible. He proffers no evidence, speaks in absolute terms, and demands that he should be taken according to his own evaluation. He speaks of "machines of marvellous efficacy," *instrumenti di mirabile efficacia,* and we begin to wonder whether those last three words are not simply variations on the theme of *infiniti* and *inoffensibili.* If the letter was designed to shock the duke into the realization that a military engineer of genius was prepared to offer him weapons of overwhelming force, the best that can be said is that it is unconvincing and the worst is that it is the raving of a madman. We are so accustomed to believing that Leonardo was a universal genius that the letter has been accepted at face value. We forget that the claims made by Leonardo are beyond reason and could be made only by a sick man in a state of manic exaltation.

There survives the draft of another letter written by Leonardo in 1487 which is similar in character but without the drumbeat excitement of the letter to the duke. He had been asked to offer a design for the *tiburio,* the tower erected at the crossing of the nave and transept, of Milan Cathedral. Many other artists were approached for the same purpose. Small sums of money were being granted by the cathedral authorities to defray the expense of making models. Thus we learn that Leonardo received 4 lire 6 soldi on July 30, 1487, 8 lire a week later, and five more payments during the remainder of the year. At some unknown date during the later part of the year he wrote a strange, strained letter to the authorities in which he compares an ailing cathedral to a sick man desperately in need of a doctor and asks to be appointed chief engineer and architect of the cathedral:

> My Lords, Fathers, Deputies. Just as it is necessary that doctors, guardians and nurses should understand what man is, what life is, and how it is maintained by the balance and har-

mony of its elements, while disharmony leads to its ruin and
destruction, so is one who knows these things well in a better
position to repair them than one who is without this knowledge.

The needs of the ailing cathedral are similar. What is needed
is a medical architect [*medico architetto*] who knows what a
building is, and on what rules the correct method of building is
based, and whence these rules are derived, and in how many
parts they are divided, and what are the causes that hold the
structure together and make it permanent, and what is the na-
ture of weight, and what is the desire of force, and in what
manner they should be combined and related. Whoever has a
true knowledge of these things will satisfy you with his intelli-
gence and his labor. . . .

There is a good deal more of the letter, with many hasty erasures
and second thoughts, and there is more than a suspicion that in some
curious way Leonardo was identifying himself with an imaginary ail-
ing cathedral in need of a doctor. The letter did not lead to a commis-
sion, and his design for the *tiburio* was rejected.

The letter to the cathedral authorities and the more famous letter to
the duke must be regarded as psychological documents. They tell us a
good deal about Leonardo's state of mind, the paranoid strain that ap-
peared suddenly at the end of a long period of failure and misery. The
letter to the church authorities may be dated in the late summer of
1487 and the letter to the duke a few months later at roughly the same
time that he was making those strange hallucinatory drawings of
scythed chariots compounded out of the works of Valturio and his
own nightmares. Invidia was driving him close to madness. The most
handsome and gifted of men was suffering what many other men have
suffered—a nervous breakdown. He was admitting defeat by pro-
claiming his imaginary triumphs. At some time in 1487 his wonderfully
clear and calm brain began to race without control and he lost his
grip on the world of reality. He recovered quickly, and in the years
that followed he began to assume his rightful place in society. Not for
another twenty-five years would there be another breakdown.

Those early years in Milan were probably the most terrible Leo-
nardo ever lived through. We know very little about them, perhaps be-
cause he did not want them to be known. For a moment we seem to
have a glimpse of him huddled in a long gown, walking along the
crooked lanes of Milan on a bitterly cold day. He has a letter in his
hand, he is on his way to the Castello, and there is a look of terror on
his face. The snow falls, we hear his footsteps fading away. We shall
not see that look of terror again.

The Virgin of the Rocks

On April 25, 1483, Leonardo signed the contract for the painting that has come to be known as *The Virgin of the Rocks*. Two other painters, the brothers Evangelista and Ambrogio de Predis, also signed the document, and it is clear that they acted as his assistants. Bartolomeo de Scalione, prior of the Chapel of the Conception of the Blessed Virgin Mary in the Church of San Francesco Grande in Milan, signed on behalf of the church and the chapel. There were many witnesses. The contract was of extraordinary complexity and covers eight closely printed pages in Luca Beltrami's collection of documents on the life and times of Leonardo.

This formidable contract was drawn up by lawyers after many months of discussion and negotiation. The intention was to define with absolute precision exactly the kind of painting that would be acceptable to the Confraternity of the Blessed Virgin Mary, but the painting

that finally emerged had very little to do with the specifications an-
nounced in the contract, which was largely written in Latin, a lan-
guage unknown to Leonardo at this time. Many things went wrong.
There were at least two lawsuits, and the painting became two sepa-
rate paintings, and both of them left Italy, where they belonged.
Leonardo, supremely indifferent to their demands, interpreted their
instructions as he saw fit, and produced a painting so rich and strange
that it has the effect, every time one sees it, of being seen for the first
time. His paintings were all masterpieces, but if there is any order
among masterpieces, this one must be accounted among the highest.

For what Leonardo accomplished in *The Virgin of the Rocks* was
the celebration of the Virgin in a way never previously attempted.
The Byzantine artists rigorously asserted the power and majesty of the
Virgin, as she stood in her blue gown against the golden walls of the
church. The Italian artists of the Trecento had emphasized her hu-
manity and grace, her role as mediator between the world of human
suffering and Christ. She was the giver of peace, the fountain of mer-
cies, the consoler. But there remained something more absolute that
had never yet been said in painting because it was almost beyond the
possibility of painting to say it. He painted her in her absolute purity,
because this was precisely what was needed in a chapel devoted to
her conception, by which was meant her Immaculate Conception. The
doctrine of the Immaculate Conception proclaims that the Virgin from
the instant of her conception was free from all stain of original sin.
According to this doctrine, which was finally promulgated in 1854,
widely accepted in the Catholic world from the time of St. Augustine,
but still bitterly debated in Leonardo's time, the Virgin acquires su-
preme power. Pure from the moment of conception, pure throughout
her earthly life, pure in the heavens to which she and Christ alone as-
cended bodily, by the very fact of her purity she asserts her domina-
tion, her endless empire over creation. Leonardo's task in the Chapel
of the Conception of the Blessed Virgin Mary was to paint the Virgin
in her absolute purity and to convey the power of purity radiating
from her.

It was a task almost beyond human comprehension, but he accom-
plished it with apparent ease that conceals innumerable difficulties.
Very few preliminary drawings have survived—a sketch of the angel's
face, sketches of the Child, studies for the folds of the Virgin's gown
are all that remain. In *The Adoration of the Magi* we can watch his
successive attempts to resolve difficult problems and his various
changes of direction. In *The Virgin of the Rocks* we are confronted
with a *fait accompli*.

We must imagine ourselves in the Chapel of the Conception in the

Church of San Francesco Grande in Milan. On the altar there stands an ornate frame, carved and gilded by the Milanese artist Giacomo del Maino. The frame, which was commissioned three years before the commission for the painting, is crowded with carved and gilded figures in the Milanese manner, sumptuously and excessively decorative, and but for the fact that the gold surface is broken up so that the light from the candles, falling on it, is reflected in all directions, it would be an intolerable burden for the paintings to carry. Altogether there appear to have been seven separate paintings in the altarpiece, but the dominant place was reserved for *The Virgin of the Rocks,* the remaining panels serving as additional adornment for a painting already too sumptuously adorned.

We enter a landscape only remotely related to the landscapes we know and far removed from the everyday world. We are high up in the mountains in a mysterious cavern formed by rocks which half resemble trees, and through the gaps between the rocks we have a vision of distant islands, lakes or seas, and abrupt mountains. In the foreground there is a spring, and the four figures are arranged on a ledge of rock overlooking the spring where it gushes out of the earth; and though we see very little of the spring we are aware of its presence and of its place in the iconographic scheme: for the spring is an image of perfect purity. Dominating the painting is the Virgin, her head inclined toward the infant John the Baptist and her right arm stretched out to embrace and protect him, while the left hand hovers over the head of the infant Christ. The Virgin kneels before Christ; the angel, who is the angel of the Annunciation, also kneels, his gown billowing, as though he had only that moment descended to earth. He is more than a simple messenger of God, for he, too, possesses vast powers. He is not placed there for decoration, or to protect Christ, or simply as an indicator, whose presence in any epic painting was demanded by Leon Battista Alberti in order that the viewer should be given an indication of exactly what was going on. He is there in his own right, his superb beauty being the measure of his superb power.

One cannot imagine the Virgin coming here, clambering over the rocks and climbing the mountain pathways on her way to the holy spring. Christ and the Baptist are naked; one does not wonder what has happened to their clothes. Nor does one ask oneself why the Virgin and the angel are so elaborately gowned. They have not come to the cave: suddenly they are there.

They are there, of course, because Leonardo has placed them there. He has painted a vision, something seen outside of time and outside of space. The landscape is such as might appear in visions, and there is about the whole composition a curious unreality which is almost over-

come by the fact that the figures are, as it were, anchored to the earth
by their shapes and postures. The angel's huge, enveloping gown
testifies to the substantiality of the gown, if not of the angel. The Vir-
gin's body has the shape of a plant growing out of the earth, and the
Baptist's knee weighs heavily down. The lower part of the painting
and the heavy rocks at the top provide the testimony of earth's endur-
ing weight and heaviness, but in the center of the picture, within a
quadrangle, mysterious operations are taking place which deny mor-
tality, deny the earth and its heaviness, deny sin, and give promise of
the absolute felicity which is the gift of the Virgin by virtue of her
perfect purity.

What is happening in that setting of incomparable majesty—a cathe-
dral not made by hands—is at once very simple and very complicated.
Involuntarily the eye fixes on the Virgin and follows her gaze to the
Baptist, and then continuing in a counterclockwise sweep comes to
rest on the Child. But just above the Child is the head of the angel.
The eye therefore halts at the angel, and may then either make the
leap toward the face of the Virgin or swing back like a pendulum over
the path already traveled. The eye must decide to jump or swing. It
cannot stay still for long. And both the leap and the pendulum swing
lead inevitably, as though by the force of gravitation, to the dreaming
face of the Virgin in the center of the painting. Her face dominates
everything, and even the blue waters and the blue mountains seem to
have been shaken out of the folds of her blue gown.

The mysterious operations occurring in the center of the painting
follow lines of force outlined in the folds of the gold lining of the Vir-
gin's gown. Absolute purity is not simple. Her power is manifested in
abstract shapes of great complexity. It is as though here, between the
throat and knees of the Virgin, power was being generated by the en-
gines of purity. While the Virgin is seen rigid from the knees up, with-
out any notable feminine characteristics except her grace, without
breasts, without the suspicion of breasts, almost without a recognizable
body, yet we are aware of her femininity and of the generative power
of her body. We are in a world where statements are being made indi-
rectly and by disclosing the opposite of what is intended. Thus it hap-
pens that all over the painting, and in the very shape of the grotto,
sexual symbols are consciously or unconsciously displayed to advance
the theme of absolute purity. Womb and phallus images are every-
where, and power is expressed through them, but the power that is
being expressed is the power of a divine purity which can scarcely be
defined in words and can be hinted at only in symbols.

Above all, it is necessary to imagine the painting in its original con-
text, in that heavy gilded frame and in the light of flickering candles.

The gold frame has the effect of extending the surface. The objects that seem now, in reproductions, to be too close to the frame—the angel's gown and wings, the holy spring, the figure of the infant Baptist —will seem less crowded when they are, as it were, carried over into the gold field. Candlelight will give a trembling to the figures. The spring will seem deeper, the billowing gown and wings will extend further, and the Baptist will be more at ease when there is more space around him. The Byzantine masters who set their figures against the vast spaciousness of gold mosaic knew what they were about, for the gold mosaic extended space to the uttermost. So here, in the Chapel of the Conception, the worshiper will see the Virgin through fumes of gold mist and she will seem to live and breathe with the pulsations of the candles.

Of all Leonardo's paintings *The Virgin of the Rocks* is the most visionary. It is as though he had been present in a dream or a vision at the moment when the supreme act of purity was being consummated. Suddenly he is transported to the grotto and finds himself standing on the farther side of the spring, invisible to the performers of the sacred rite. In an extraordinary passage in the Arundel Manuscript in the British Museum, Leonardo describes a character in an unfinished *novella* he had been writing over a long period of time as he comes to a mysterious cavern and hesitates on the brink of discovering some marvelous things hidden in the cavern. He wrote:

> Wandering for some distance among the shadowy rocks, I arrived at the opening of a great cavern and for a while stood in front of it as though stupefied, not having been aware of its existence. My back bent like a hoop, my left hand clutching my knee, my right hand shading my downcast and narrowed eyebrows, and often bending one way and then the other in an attempt to discern what was within, although all this was made impossible by the great darkness. And so, while remaining there for some time, there was suddenly awakened in me two emotions, fear and longing—fear of the dark threatening cave, and longing to see whether some marvelous thing lay inside.

For the purpose of the *novella* it would be necessary that something marvelous should be found, but it could not be more marvelous than what Leonardo had already found in the cavernlike grotto beside the mysterious spring. The Virgin in blue and gold appears like an apparition, all the more disturbing because her gesture is so precise and because it is evident that she is performing a rite which will affect all creation for all generations to come. In this quiet picture there is high drama, and while the drama does not appear to be as powerful as the drama of *The Last Supper*, it is in fact equally powerful, for at this

very moment the Virgin is fulfilling herself in the supreme act of pu-
rity by which Christ is charged with her own incarnate energy in the
presence of the two witnesses, the angel and the Baptist. But the
angel and the Baptist are more than witnesses; they are partakers in
the ceremony of purity. Just as in *The Virgin of the Rocks* we witness
the supreme act of purity, so in *The Last Supper* we witness the
supreme act of betrayal, which is the exact opposite of purity. The
two paintings therefore complement one another, throw light on one
another, and can be fully understood only in relationship to one an-
other.

Leonardo was a man of his time and he worked with the ideas and
concepts available at his time: among these was the complex and bit-
terly defended doctrine of the conception of the Virgin. It was not his
task to defend the doctrine but to assert it publicly; and although
there exists nothing in his notebooks to suggest that he enjoyed the in-
tricate formulations of Quattrocento theology, there can be no doubt
that he studied the theology of the conception in great depth, as later
he would study the theology of the Last Supper.

Like all great paintings, *The Virgin of the Rocks* is wholly original
while remaining partly derivative. The rock formations and Leo-
nardo's particular use of rocks as abstractions of psychological states
owes much to Mantegna, who could draw a Deposition of Christ
against a rocky background, and somehow the very shape of the rocks
would suggest an overwhelming grief. He was not, of course, the first
to convey emotions through the shapes of rocks and mountains, but he
was the first to study these shapes with a deep psychological under-
standing and resourcefulness, calculating to a hairbreadth the exact
dimensions and contours of granite or fissured limestone according to
the mood he wanted to suggest. A small painting by Mantegna now in
the Uffizi shows the Virgin with the Child on her knee sitting on a
rocky ledge in front of a quarry cutting into a mountain shaped like
an exploding pomegranate. Mantegna also produced an engraving
showing the Virgin in a grotto surrounded by a choir of angels.
Strange sculptured rocks and grottos were already being associated
with the Virgin, and Leonardo in *The Virgin of the Rocks* was paint-
ing within an established convention. But no one had ever painted a
grotto so majestic, or so filled with the spirit of divinity.

The unknown engraver and miniaturist known as the Master of the
Sforza Book of Hours made about this time an extraordinary engrav-
ing which is closely related to *The Virgin of the Rocks*. In a rocky wil-
derness, beside a lake, the Virgin is resting. The Child has climbed on
her knee, and the infant John the Baptist is worshiping them in an at-
titude which derives directly from *The Virgin of the Rocks*. Two an-

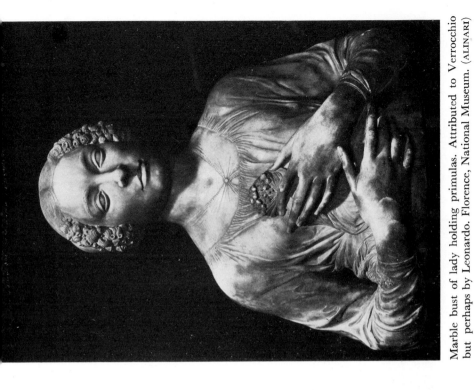

David by Verrocchio. Detail. Presumed portrait of Leonardo. Florence, National Museum. (ALINARI)

Marble bust of lady holding primulas. Attributed to Verrocchio but perhaps by Leonardo. Florence, National Museum. (ALINARI)

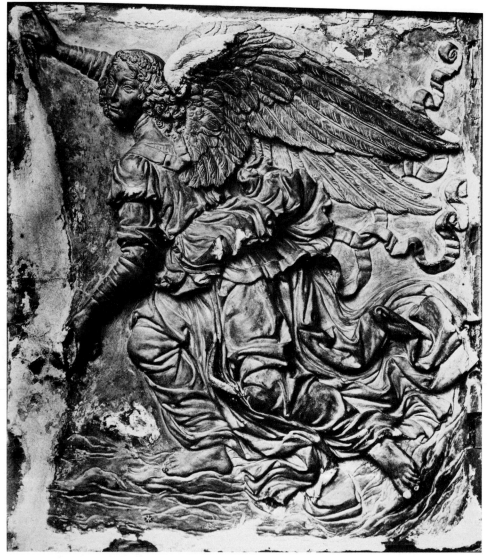

Terra-cotta angel. Attributed to Verrocchio but perhaps by Leonardo.
Paris, The Louvre. (GIRAUDON)

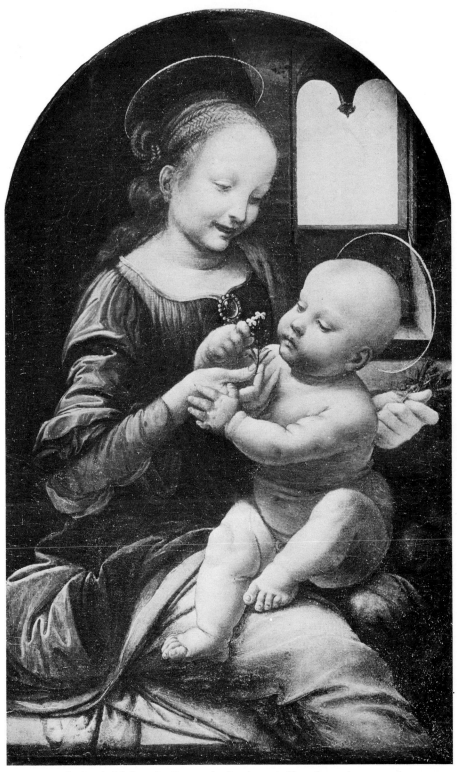

The Benois Madonna by Leonardo. Leningrad, Hermitage. (GIRAUDON)

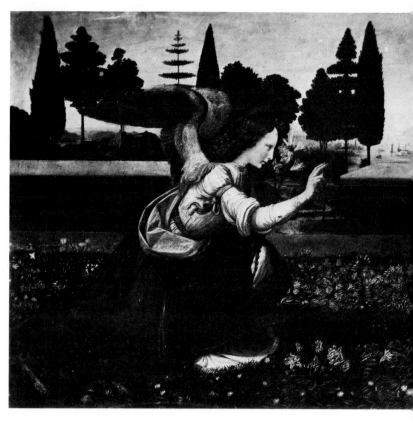

The Annunciation by Leonardo. Florence, Uffizi Gallery. (ALINARI)

The Annunciation by Leonardo. Paris, The Louvre. (DOCUMENTATION PHOTOGRAPHIQUE)

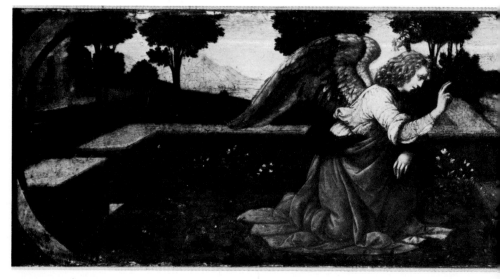

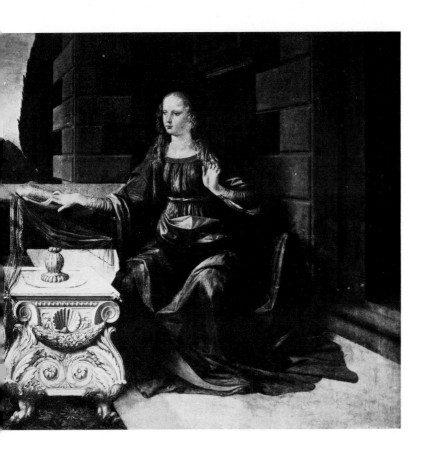

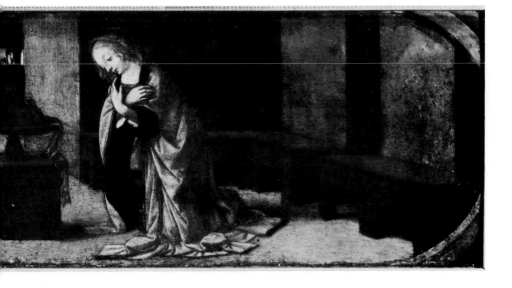

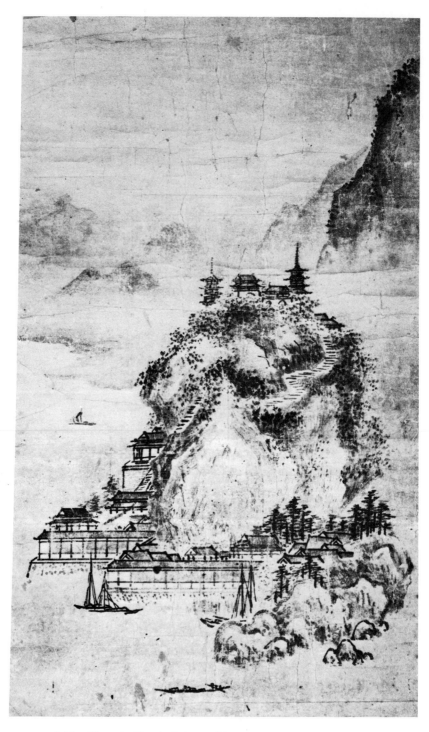

Golden Mountain Temple. School of Sesshu. (ALEXANDER ARTEMAKIS)

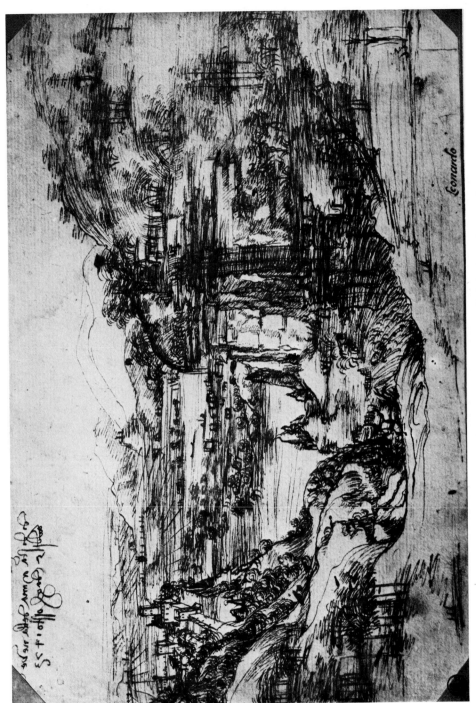

Arno Landscape by Leonardo. Florence, Uffizi Gallery. (ALINARI)

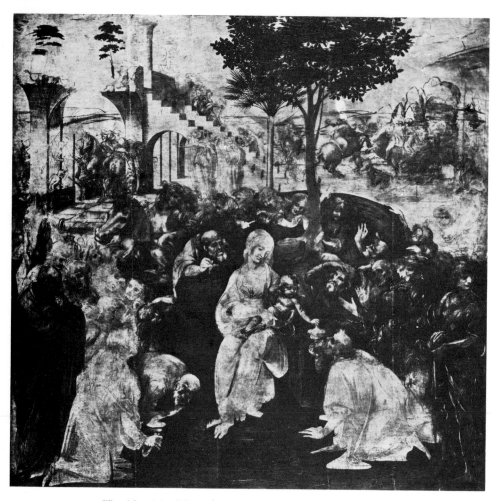

The Adoration of the Magi. Florence, Uffizi Gallery. (ALINARI)

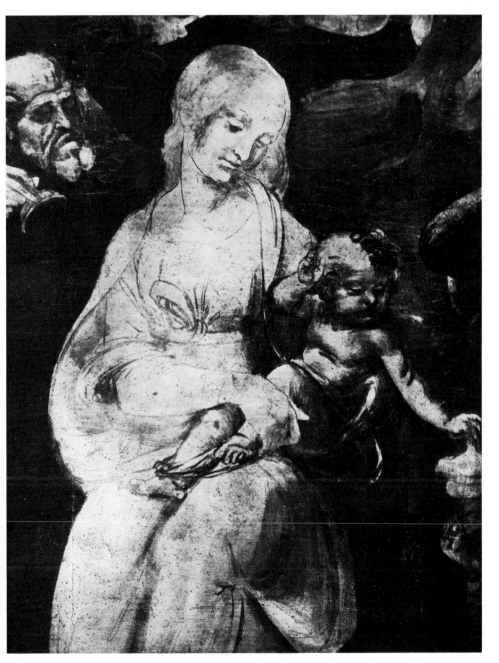

The Virgin in *The Adoration of the Magi*. (ALINARI)

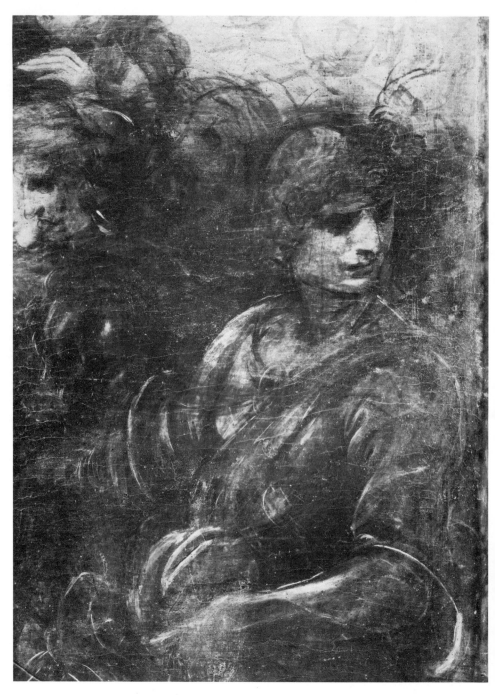

The Adoration of the Magi. Detail. Presumed self-portrait of Leonardo.

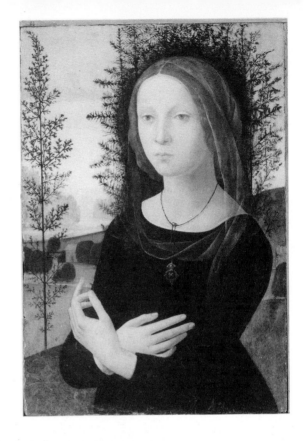

Ginevra de' Benci by Lorenzo di Credi. New York, The Metropolitan Museum of Art. Bequest of Richard de Wolfe Brixey, 1943. (PHOTOGRAPHIC SERVICES, THE METROPOLITAN MUSEUM OF ART.)

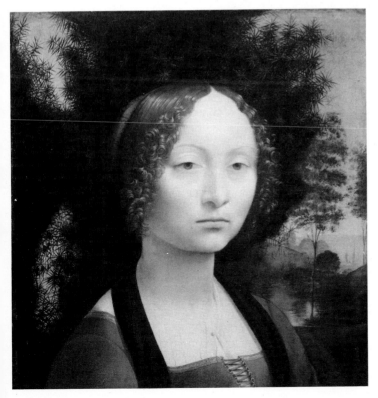

Ginevra de' Benci by Leonardo. Washington, National Gallery of Art. Ailsa Mellon Bruce Fund 1967. (WASHINGTON, D.C., NATIONAL GALLERY OF ART)

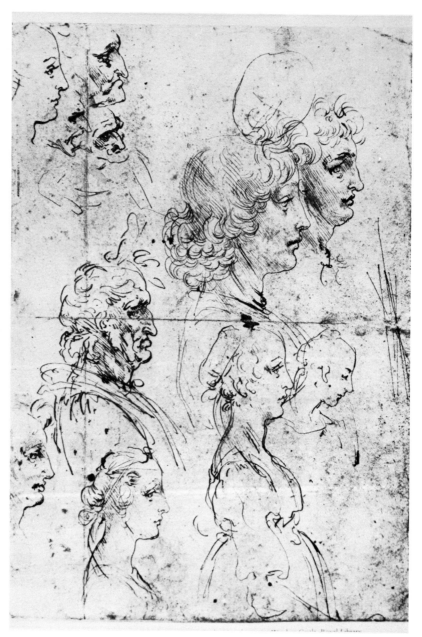

Family sketches by Leonardo. Presumed self-portrait upper center, his father below him on the left. Windsor, Royal Collection. (REPRODUCED BY GRACIOUS PERMISSION OF HER MAJESTY QUEEN ELIZABETH II)

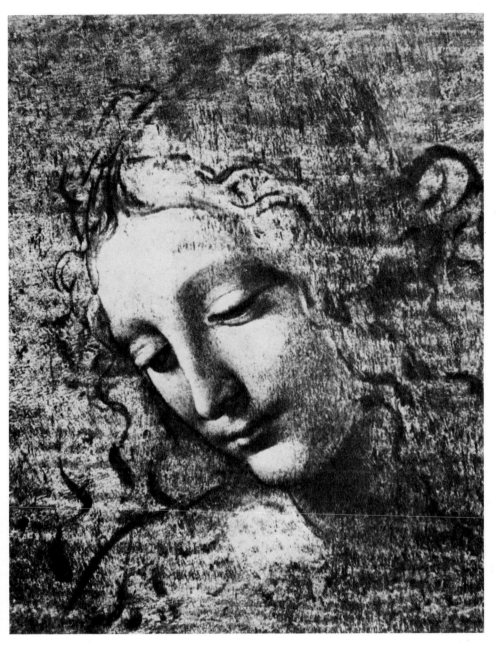

Head of Woman by Leonardo. Parma Gallery.
(REYNAL AND COMPANY)

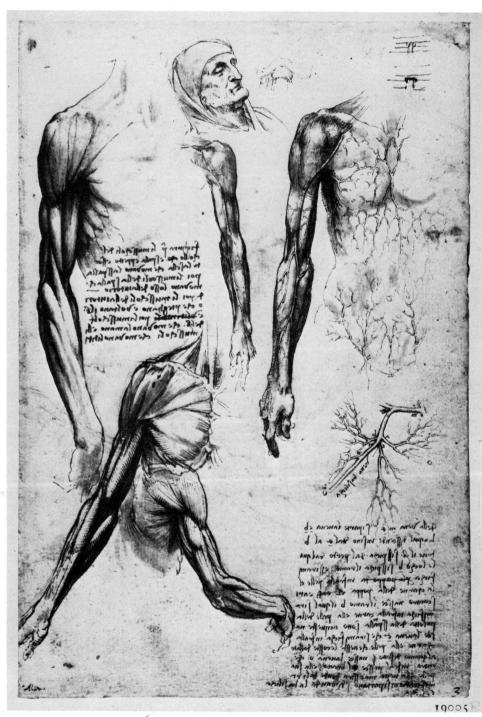

Anatomical drawing, with the head of an old man, by Leonardo.
Windsor, Royal Collection. (REPRODUCED BY GRACIOUS PERMISSION
OF HER MAJESTY QUEEN ELIZABETH II)

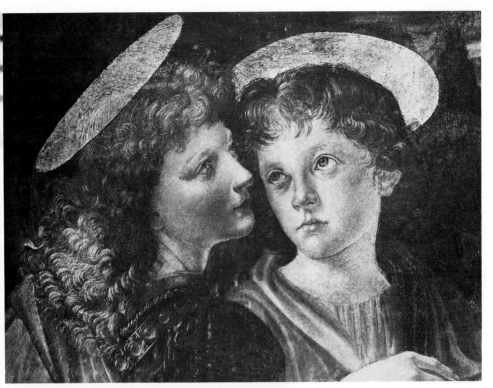

The Angel of Leonardo
and the Angel of
Verrocchio. (ALINARI)

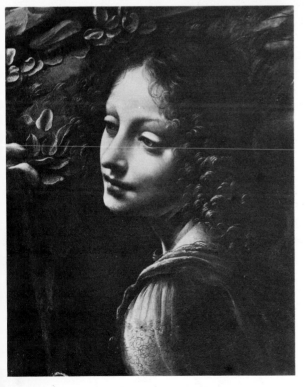

The Angel of Leonardo.
Detail from the *Virgin
of the Rocks*. London,
National Gallery.

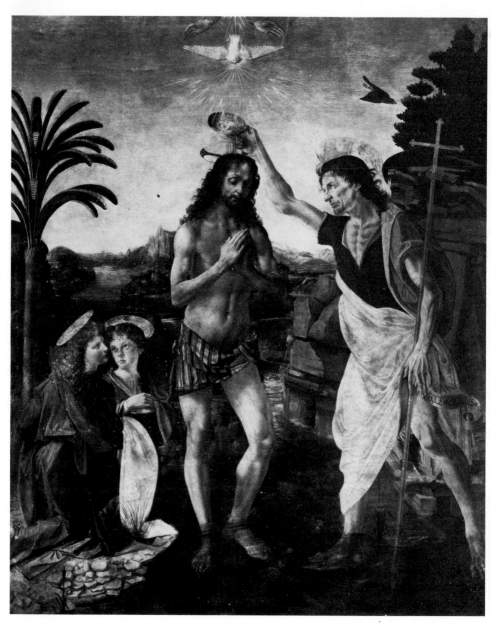

The Baptism of Christ by Verrocchio and Leonardo.
Florence, Uffizi Gallery. (ALINARI)

gels in long flowing garments are playing musical instruments on each side of the Virgin, as they do in the altarpiece of *The Virgin of the Rocks* as it was originally constructed. The engraving, which can be dated about 1490, was designed by someone who had seen Leonardo's painting and was imagining what would happen if the entire landscape opened up to reveal the Virgin and Child and adoring Baptist in a more ample setting of rocks and lakes. It is a very complicated and crowded engraving, and curiously satisfying. We see a walled city climbing up the side of a mountain, towers and fortifications, bays and inlets, a plowman at work in the fields, a peddler walking along a country road, ships sailing on the lake, small country houses exactly like those which can be seen today beside Lake Como, while high up on a rocky ledge, impassive and austere, St. Jerome with his lion and his books sits gazing out at the sunlit landscape like a king enthroned, reminded of his mortality by the presence of a skull and the serpent issuing from the skull's mouth.

This engraving, which appears at first sight to be almost too intricately fashioned out of absurdly unreal rocks, on a second and third look acquires the dimensions of a small masterpiece. The engraver has accomplished his purpose: he has invented a plausible wilderness of exotic rock formations beside a thriving city, and he has placed the Virgin, the Child, the Baptist, St. Jerome, the angels, and the lion within this landscape in such a way that their appearance gives an impression of inevitability. If we could look beyond the rocks in Leonardo's painting, this, or something like it, is what we would see.

The Master of the *Sforza Book of Hours*, having seen *The Virgin of the Rocks*, deliberately attempted to re-create the scene in a much wider perspective, placing it in the known world, with ships and men going about their affairs in the distance. Like a cameraman with a wide-angle lens, he has shown the entire landscape as far as the eye can see, while the Virgin in sharp definition occupies the foreground. It is even possible, and likely, that the engraving was based on one of Leonardo's preliminary drawings for *The Virgin of the Rocks*. The unknown Milanese Master has drawn a very Florentine Virgin, while the wide parting of her knees and the intricate elaboration of the folds of her gown are entirely in the manner of Leonardo. Nor should we be surprised by the presence of St. Jerome in an engraving celebrating the Immaculate Conception, for he was one of the Fathers of the Church who most insistently proclaimed the perpetual virginity of the Virgin.

When we examine *The Virgin of the Rocks* in its first setting, as the central painting in the altarpiece in the Chapel of the Conception in the Church of San Francesco Grande, we are faced with some very

surprising things. The church has long since been destroyed, and
nothing remains of the ornate, gilded frame designed and constructed
by Giacomo del Maino long before Leonardo set to work on the paint-
ing. Yet from the contract that still survives, though damaged and in
places scarcely legible, we can learn a good deal about the way the
painting looked when it was first unveiled. Perhaps the most surpris-
ing fact is the huge size of the frame, which must have been about six-
teen feet high, towering over the altar, which itself must have been
about four feet above the level of the floor. This huge frame was a
piece of architecture, heavy and substantial in the Milanese manner,
with carved polychrome figures decorating the uprights in a way we
would regard as wholly decadent. Carlo Pedretti's reconstruction of
the altarpiece, here published for the first time, deliberately omits the
seething mass of carved figures on the uprights in order to show its
basic structure. We must imagine the frame to be a blaze of gold with
here and there the flesh-colored faces of saints, angels, and *putti* peer-
ing out of it. In later years the Milanese would construct even more
elaborate altarpieces with angels darting hither and thither, with
saints ascending into heaven, and with choirs of cherubim wheeling
around the throne of God. Decoration of a peculiarly horrible kind
was taking the place of art, and one of the many ironies connected
with Leonardo is that one of his supreme masterpieces should have
been contained in such a monstrously overornamented frame.

What the Confraternity of the Conception of the Blessed Virgin
Mary wanted from Leonardo was a conventional painting of the Vir-
gin and Child in a rocky landscape, attended by two prophets and
blessed by God the Father, who presumably was to be seen floating in
the air high above her, attended by angels or cherubim. In the side
panels there were more angels, some singing, others playing musical
instruments. In the smaller panels there were sibyls and scenes from
the life of the Virgin. The Confraternity in the list of specifications
presented to the artists paid comparatively little attention to the
smaller panels, thus permitting a certain amount of freedom. But on
the important subject of the central painting they went to some length
to convey exactly what they wanted, even to precise statements about
the colors of the Virgin's skirt and gown. No doubt Leonardo had al-
ready presented them with some preliminary sketches, and they
clearly possessed a mental image of the completed painting. The
greater part of the contract is in Latin, but there survive two separate
lists of specifications in Italian which are identical except for some
very slight and inconsequential changes which may be due to the in-
accuracy of the copyist. The specifications should be quoted in full, if

only because they throw some light on Leonardo's way of disregarding them whenever it served the purposes of his art:

Jhesus

List of the ornaments to be made to the altarpiece of the Conception of the Glorious Virgin Mary in the Church of San Francesco in Milan.

First, we desire that the entire altarpiece, *videlicet* the capitals carved with figures, should be gilded except for the faces, with fine gold at a price of III lire X soldi per cent.

Item, Our Lady in the center: her mantle shall be of gold brocade and ultramarine blue.

Item, her skirt shall be of gold brocade over crimson, in oil, varnished with fine lacquer.

Item, the lining of her dress shall be of gold brocade and green, in oil.

Item, the seraphim placed as scene openers shall be in graffito.

Item, God the Father: his gown shall be of gold brocade and ultramarine blue.

Item, the angels shall be gilded and their pleated skirts outlined in oil, in the Greek manner.

Item, the mountains and rocks shall be worked in oil, in a colorful manner.

Item, the empty panels on the sides shall each contain IIII angels, differentiating one group from the other, *videlicet* in one panel singing, in the other playing instruments.

Item, in all the other capitals where Our Lady appears, she shall be ornamented like the one in the center, and the other unfinished figures shall be painted in various colors, either in the Greek or in the modern manner, to complete perfection, and likewise the architectural structures, mountains, roofs and floors as represented in the said capitals, and let everything be carried out in oil, correcting those carvings that are unsatisfactory.

Item, the sibyls decorating the panels provided with archways in the form of a portico shall be differentiated one from the other by dress and features, and they shall all be painted in oil.

Item, the cornices, pilasters, capitals, and all the carvings shall be gilded as previously stated, without any color in between.

Item, the central panel shall be painted flat to represent Our Lady with her Son and the Angels done in oil to complete perfection, including the two Prophets, which are to be painted flat with colors of fine quality, as previously stated.

Item, the predella shall be decorated like the other capitals above.

Item, all the faces, hands and legs that are exposed shall be colored in oil to complete perfection.

Item, the place where the Child is shall be gilded and worked in a weaving pattern.

I, Bartolomeo Scalioni, Prior, in witness of the above, signed.

I, Giovanni Antonio de Sancto Angello, signed.

I, Lionardo da Vinci, in witness of the above, signed.

I, Evangelista de Predis, signed.

I, Giovanni de Predis, signed.

The specifications were somewhat disorganized, but the general sense is clear. Of the sixteen clauses only six can be said to refer to the central panel, while another six refer to the ornamentation of the frame and four refer to the smaller panels. The critical statement concerning *The Virgin of the Rocks* comes toward the end with a brief summary of what should be included in the central panel: *la dona nostra con lo suo filliolo e li angelli fati a olio in tuta perfectione con quelli duy profeti.* This can only mean "Our Lady with her Son and the angels done in oil to complete perfection, with the two Prophets."

How it came about that Leonardo succeeded in convincing the members of the Confraternity that the Prophets could be dispensed with and that one angel should take the place of *li angelli* is unknown; nor, on the basis of the finished painting, is there any explanation for the introduction of St. John the Baptist unless he is viewed as the last prophet of the Old Law and the first of the New Law. It is likely that Leonardo simply went his own way, obeying the spirit rather than the text of the specifications, and perhaps pointing out that his own version was at least as satisfying in theological terms as the crowded canvas imagined by the members of the Confraternity. What they had wanted was God the Father among cherubim and seraphim above an image of the Virgin Immaculate and a Child who was perhaps standing on a rock glowing with gold leaf, with angels in attendance and two prophets in the foreground—perhaps twenty separate figures altogether. Leonardo, following his custom, cut through these complexities and painted his own singularly direct vision of the Virgin, her Son, the Baptist, and the angel in a setting of his own choosing. Nothing is said in the specifications about a grotto. Instead we are told that there are mountains and stones, suggesting that the Virgin was to be placed in a mountainous setting with a clear sky overhead.

Leonardo's choice of a grotto was a critical one, influencing the entire composition. Yet it would probably not have dismayed the

members of the Confraternity, who knew something we have long since forgotten. The Church of San Francesco Grande was built over catacombs, and the grotto high in the mountains resembled in a kind of mirror image the deep grottos beneath the earth.

According to the contract the work was to be completed by December 8, 1483, the feast of the Immaculate Conception. There was a stipulation that in case Leonardo should leave Milan before completing his share of the work, the Confraternity would pay him only for the work done and another artist would be summoned to complete it. It would appear that Leonardo was required to complete the central panel and to supervise the work on the smaller panels, which was to be done by the de Predis brothers, and he would also supervise the gilding and painting of the crowded figures of the frame. The artists were given seven and a half months to complete the altarpiece, and for this they were to receive 800 imperial lire in good Milanese currency.

In fact the painting was not finished until twenty-three years later, when there took place a final settlement of a long series of lawsuits. Many of the documents concerning the lawsuits are lost, and the surviving documents are so complex and can be interpreted so variously that nothing is gained by describing them. In 1506, *The Virgin of the Rocks* was hung in the altarpiece in the Chapel of the Conception, where it remained until toward the end of the eighteenth century, when it was moved from the Church of San Francesco Grande to the hospital of St. Catharine alla Ruota. One day in 1785 an enterprising dealer, Gavin Hamilton, who was also a painter and an amateur archaeologist, bought it from the hospital authorities and took it to England. In the following year he sold it to the Marquess of Lansdowne, the former Earl of Shelburne, who when Prime Minister had shown such a conciliatory attitude toward the American Colonies that he was thrown out of office. The painting remained in his possession until his death in 1805, and later passed into the hands of the Earl of Suffolk, who sold it to the National Gallery in London for £9,000 in 1880.

There is not the slightest doubt that the painting now hanging in the National Gallery is the one painted for the Confraternity of the Conception. It is in fact the only painting by Leonardo whose provenance is completely known, for we know where it was from every moment since it first hung in the chapel. Gian Paolo Lomazzo, the great theorist on the nature of art, saw it hanging there some fifty years after it was completed and gave a brief description of it in his *Trattato*:

> . . . where you will see St. John the Baptist on his knees and
> with folded hands, bowing to Christ and expressing obedience

and childlike reverence, while the Virgin in an attitude of joy-
ous meditation [*allegra speculatione*] gazes upon him; and the
Angel, with an expression of angelic beauty, is seen contem-
plating the joy that arises from this mystery with all its conse-
quences to the world. There is divinity and wisdom in the in-
fant Christ. The Virgin is kneeling and holding St. John with
her right hand, stretching the left hand forward, which is thus
foreshortened; and the Angel holds Christ by the left hand, and
Christ sits upright, gazing at St. John and blessing him.

It is, of course, a somewhat arid description of the painting, but this
is intentional, for Lomazzo goes to some pains to describe the move-
ment of the hands and says nothing about the extraordinary configura-
tion of rocks in the background. I suspect this was due to the fact that
the candles were so arranged that only these figures received their full
illumination and to the worshiper in the chapel the rocks formed a
shadowy and mysterious backdrop and were not as insistent as they
are today with the whole painting brilliantly lit. When the National
Gallery held a special exhibition on Renaissance art, *The Virgin of the
Rocks* was dropped down to floor level, so that the visitor had the illu-
sion of being able to walk into the grotto and to be enclosed in it. The
effect was startling, for instead of looking up at the Virgin from
below, one looked down at her and found oneself face to face with the
huge crags, which seemed to possess a crushing force and authority,
dominating the painting. But in fact the painting was intended to be
seen from below, in flickering candlelight, in a setting completely
different from the one offered by the National Gallery. The elaborate
gilded frame was gone; there was only the painting. One walked into
it, and walked away, and suddenly there came the realization that
now for the first time in many centuries we were seeing it as Leonardo
saw it in his studio and the painting was all the more powerful pre-
cisely because it was stripped of those associations which were foreign
to it as a work of art. Now for the first time we could peer at it very
closely, minutely examining those details which the eyes fail to ob-
serve because it is not intended that they should be observed, because
it is their purpose to melt into the design, and because great painters
amuse themselves with gay and happy improvisations for no better
reason than that they delight in the exercise of their skill. So it was
possible to observe the delicate transparent scarf winding around the
fleshy torso of the Baptist, the wonderfully rich folds of gold brocade
in the Virgin's gown, the angel's silvery sleeve so transparent that the
flesh could be seen beneath it, and the flowers springing from the
rocks. The painting has been brilliantly restored, and now has a fresh,
gleaming look, as though it came out of the artist's studio this morning.

So far we have spoken as though there is only one painting called *The Virgin of the Rocks*, but in fact, as everyone knows, there is a similar painting in the Louvre, which is a shade larger but equally impressive. Art historians have gone to phenomenal lengths in their discussions about which painting has priority and which is the authentic and which is the copy. French art historians are agreed that the Louvre painting has priority, while English art historians are generally agreed that priority belongs to the London version. The English would appear to have the better case, for the provenance of the National Gallery painting is known and very little is known about the provenance of the Louvre painting. Thousands of sheets of paper have been wasted on these discussions with no end in sight.

The problem is to learn why the discussion began. The historians demand that a choice should be made when no choice is possible, and when there is no reason to make the choice. What is more likely than that Leonardo fell in love with the composition, made one painting for the Confraternity and another for himself, and during the long progress of the lawsuit kept both of them? From all we know of him he was quite incapable of making a mechanical copy of his own work, and therefore there would inevitably be variations on the same theme, subtle changes of emphasis, new discoveries, new ideas, a new focus. In the National Gallery painting we are a little closer to the Virgin and the group around her, there is more blue, a sense of flowing waters, and it is springtime. The Louvre painting, with its flash of scarlet and russet, is autumnal, and there is little sense of flowing waters, perhaps because the painting has never been restored and the blues have grown dark with age. The two paintings are the same, but different. They spring from the same imagination and are poured from the same crucible and speak with the same voice. In these two paintings Leonardo came as close as anyone has come to painting the mystery of the Virgin and her Child.

The Great Horse

Work on *The Virgin of the Rocks* covered a period of twenty-three years and the painting therefore exists outside the strict chronology of Leonardo's life. It was woven into him, became a part of the fabric of his life and achievement. One would have expected that so great a painting would have become known even when it was unfinished; the cartoon would have been displayed; someone would have remarked on it; but although the records have been combed, we hear nothing about it until it was publicly displayed for the first time nearly a quarter of a century after the contract was signed. Even when it was displayed, it received comparatively little attention.

Partly, of course, this lack of attention arose from the nature of Leonardo's gifts and his reclusive character. He was studious and solitary, and did not suffer fools gladly. In later years poets compared him with Hermes, not the Hermes of Greek mythology, but the Egyptian

Hermes Trismegistus, "the thrice greatest Hermes," the lord of all wisdom and knowledge. The surprising thing is that the poets can have known very little about Leonardo's interminable researches recorded in his notebooks, for the notebooks were unavailable, unknown, unpublished. The Hermes quality was something they guessed or sensed in him, or perhaps it was conveyed to them through his paintings. Even those like Fra Pacioli, who claimed to know him well, spoke of him with bated breath as though he were almost divine. In those early years in Milan he seems to have been one of those who cling to the shadows.

At some date that can be roughly calculated as the spring of 1488, we observe an abrupt change. Quite suddenly he is appearing in public and drawing closer to the court of Lodovico Sforza. Exactly what happened, who introduced him to the court, and how it came about that a recluse should be transformed into a public man and under what auspices are unknown. One very likely explanation is that his painting caught the attention of Cecilia Gallerani, the mistress of Lodovico, a young woman of great beauty and intelligence. Leonardo painted her and went on to paint and draw other members of the ducal court.

Lodovico Sforza, who had bad taste in most things, had superb taste in women. Cecilia Gallerani had a pure oval face, large brown eyes, a straight and rather long nose, fine lips, and a slightly pointed chin. She was a highly cultivated woman of a noble Milanese family, wrote Latin and Italian with equal facility, recited her own poetry, discussed philosophy with professors of philosophy, and sought out intelligent persons wherever she could find them. Poets celebrated her generosity and her beauty, and many years later, when she was a middle-aged woman, Matteo Bandello celebrated her in his *Novelle*.

In an age of bluestockings Cecilia Gallerani was one of the most famous and most talented. She was far more intelligent than Lodovico, who visited her every day, took her advice on all matters concerning the court and even on political affairs, and appeared with her in public, rejoicing in her beauty. She was more than his mistress. Almost she was the conscience of Milan, the one person capable of informing him about the true condition of the city and seeing that he acted accordingly. She was his eyes and ears, and as long as she remained close to him, he behaved with a sense of reality. When he left her, he gave way to fantasies and showed himself to be weak-willed and indecisive.

He gave her jewels from the ducal treasury, settled on her a large estate at Sarrano, and established her in a great palace that stood just outside the Castello.

Today there can be very little doubt that the painting in Cracow
called *The Lady with the Ermine* is her portrait, for the ermine, by
way of the Greek word *galé*, provides a pun on her name. We see her
in a watchful and patient mood, very calm, very aware of her beauty,
cradling the sleek ermine in her arms with affection and tenderness as
though it was a household pet and she was long accustomed to it, and
the ermine is also watchful and protective, ears cocked, eyes wide
open, claws ready to attack; and what is chiefly remarkable about the
ermine is the intelligence displayed in its face. Some sympathetic
magic has occurred. In its sleekness and beauty the ermine is, as it
were, the image of Cecilia Gallerani as seen in the animal world. Like
Dürer's *Hare,* painted a few years later, which it resembles in the su-
perb rendering of the fur and the curiously human intelligence im-
planted in the animal, Leonardo's ermine seems able to think, to judge,
to ponder rationally. In one of his notes on the lives and habits of ani-
mals Leonardo describes the ermine as a model of *moderanza,* or
moderation:

> The ermine because of its moderation never eats but once a
> day, and it will rather let itself be captured by hunters than
> take refuge in a muddy hole, in order not to stain its purity.

Purity, in Renaissance times, was relative; it was perfectly possible
to think of Cecilia Gallerani as a model of purity and moderation. It is
even possible that Leonardo fell in love with her, for he wrote in his
notebook, "*Madonna Cecilia—Amantissima mia Diva—Lecta la tua
soaviss,*" which can be translated "Madonna Cecilia—my most be-
loved goddess—having read your sweetest letter." Certainly her large
brown eyes, as seen in her portrait, are full of tenderness.

Although parts of the painting, chiefly on the left side, show signs of
restoration, the face is remarkably well preserved. Milanese women in
those days wore their hair in single braids that fell down their backs,
sometimes almost reaching their feet, and we see a part of the thick
braid in the portrait. They wore many-colored costumes that blazed
like rainbows; the sleeves were slit to reveal rare damasks and embroi-
deries; richly decorated panels were let into the skirts; one side of the
dress was not necessarily similar to the other. So we see her in a cos-
tume she would have worn during the afternoon, not the more lavish
costume she would have worn at the entertainments and galas that
took place in the evening. She is at her ease, in décolletage, wearing a
gown that could be slipped easily off her shoulders, and her sensuality
is as evident as her intelligence. She wears a diaphanous veil edged
with russet lace the same color as her hair, and in addition there is a
thin black headband. The effect of the russet lace and the black head-

band is to give prominence to her eyes, which dominate the entire painting. Once we have looked deeply at her eyes, it is difficult to tear ourselves away.

It is a masterly portrait, and we are therefore not surprised to learn that Bellincioni, the rather tiresome official poet of the Milanese court, wrote a poem about it that takes the form of a dialogue between the Poet and Nature. "Why are you raging, and why are you envious?" the Poet asks of Nature, who replies that she is raging at Vinci, who has drawn down one of the stars out of the sky, and this star, the beautiful Cecilia, has obscured the light of the sun. It was the first of many poems written about his paintings in Leonardo's lifetime, and like most of them it was an exercise in superlatives.

The face evidently fascinated Leonardo, for she appears again as the angel in *The Virgin of the Rocks* and in a green and umber sketch known as *La Scapiliata*, where she is shown with bent head and half-closed eyes, like a Virgin gazing down on an invisible Child. *La Scapiliata* means "the woman with the disheveled hair," and there are in fact some curious dark wavy lines spinning away on both sides of the gentle, impassive face. We recognize Cecilia Gallerani by the pointed chin, the slightly pinched nostrils, the long eyes, the broad and rounded forehead. The nose is long and somewhat sharp. I am not suggesting that Cecilia Gallerani sat for the angel or even for *La Scapiliata*. An artist builds up a body of faces, expressions, and poses especially dear to him and delves into this collection when he needs it. In this way Cecilia Gallerani, Lodovico's mistress, could be transformed at will into the Virgin or an angel, for her face, once painted, entered into Leonardo's repertoire, the small and select repertoire of faces that haunted him for the rest of his life.

Once he had broken through the barrier that had separated him from the court, Leonardo found himself exceedingly busy. Gentile dei Borri, the leading armorer of the court, the man who designed the armor worn by Lodovico and his chief captains, discussed with Leonardo the making of an illustrated textbook showing how men on horseback and on foot defend themselves from each other. The book would take the form of a series of drawings demonstrating every possible eventuality on the battlefield in which cavalry and infantry were pitted against each other. Leonardo agreed; a book was made, and presumably there were many copies, for there were many cavalrymen and infantrymen who would benefit from the book, and there would be a special copy on vellum for Lodovico Sforza. Unhappily, all copies have perished, but a few drawings, evidently preliminary sketches for the book, have survived. Gian Paolo Lomazzo, writing about eighty years later, describes the book as though he had himself seen it, or as

though he had been given a detailed description by someone who had
seen it, and commented, "It is a great pity the work has not been
given to the public: it would have added glory to that wonderful art."
In the early years of the seventeenth century a copy of the book
passed into the collection of one of the Princes of Savoy, and nothing
more was ever heard of it.

Yet this book was of capital importance to Leonardo. For the first
time he was drawing horses and soldiers. The vast and grandiose
plans described in his letter to the Duke of Milan were exchanged for
much simpler and practical things: a charging horse, a soldier plant-
ing a spear in such a way as to rip open the horse's chest. Instead of
imaginary and intricate wars he was confronted with war in its mur-
derous essentials: hand-to-hand combat with spears, lances, and
daggers. Six or seven pages of his notebooks are covered with his
notes and drawings of spearheads in various ugly shapes. We turn the
page and discover a schematic drawing of the defensive walls of the
Castello with its moat and secret passageways. Here in the Castello,
on the parade ground, he was studying maneuvers, cavalry charges,
assaults, mock combat. He was seeing soldiering in the raw, not as it
appeared in Roberto Valturio's compendium of ancient Roman battles.
He was also seeing a vast number of horses and carefully studying
them. About this time, too, he was granted by Lodovico Sforza the
one thing he wanted above all other things—the chance to make the
giant statue of Francesco Sforza on horseback mentioned in a con-
cluding passage of the letter to the Duke of Milan. For many years
Lodovico had been hoping to see this statue erected.

Leonardo was not given the task outright. It was given to him tenta-
tively, and this meant that he would first have to demonstrate his skill
by making drawings and models, by showing his mastery of the sculp-
tor's craft, and by a prolonged study of the anatomy of the horse. It
was necessary for him to satisfy Lodovico that he could perform the
task in a way that would bring fame to the House of Sforza.

Leonardo threw himself into the study of the horse with the passion
of a man discovering a new empire. A large number of studies of
horses, some on blue-tinted paper, testify to his knowledge of horses
and his deep affection for them; and just as he painted the ermine
with a face of singular intelligence, so he drew horses that could al-
most speak. He not only drew living horses; he dissected dead ones.
His first book was a study of warfare between cavalrymen and infan-
try; his second book was the anatomy of the horse, illustrated with de-
tailed drawings and a commentary. The book is lost, but it is known to
have survived for about a hundred years in the collection formed by
Francesco Melzi, Leonardo's adopted son and legal heir, and then it

vanished from sight during the period when his manuscripts were being dispersed.

The anatomy of the horse was Leonardo's first known work in anatomy. Later there would come his study of human anatomy, which has survived in part. Only two pages of the anatomy of the horse have survived.

While Leonardo was drawing horses and dissecting them, there occurred an event which brought him into contact with a young woman whom he would immortalize. Duke Giangaleazzo, the rightful Duke of Milan, having reached the age of twenty, was married in January 1489 to Princess Isabella of Aragon, the granddaughter of King Ferrante of Naples and daughter of the Duke of Calabria, the heir to the Neapolitan throne.

Isabella of Aragon was just eighteen, well formed, elegant, regal, with clear-cut features and a winning smile. She was every inch a princess, very conscious of her position in the world, proud and imperious. She was descended from the Spanish royal House of Aragon, but she was also through her mother a Sforza. Both the Aragons and the Sforzas possessed violent, nearly uncontrollable tempers. She seems to have guessed that her marriage to Duke Giangaleazzo would be a tragedy.

But at first all the auguries looked promising. The duke's younger brother Ermes arrived in Naples in November 1488 at the head of an army of courtiers dressed in their most sumptuous garments, with heavy gold chains and jeweled plumes. There were four hundred people in the suite. There were galas and festivities to celebrate the coming of the Milanese, who paraded in their glory; and the Neapolitans wept to see the young princess depart. The journey to Milan in the dead of winter was long-drawn, with many stops on the way, and Bernardo Bellincioni described how he was nearly driven to his death by the rigors of the journey. At last, in the town of Tortona, the suite of the princess met the suite of Duke Giangaleazzo. There were more ceremonial processions, dances, and feasts. At one banquet every course was introduced by a mythological personage. First came Jason with the golden fleece, and then Apollo with the calf stolen from Admetus, and then Diana led Actaeon, who had been transformed into a stag because he saw her bathing, and then came Atalanta followed by the wild boar of Calydon, and Orpheus with his lute and the birds he had charmed. And so it went on for twenty courses until at last Thetis and her sea nymphs introduced the fish dishes, and shepherds crowned with ivy came with their pails of milk and cakes of honey.

Such mythological feasts were customary on important occasions. Poets addressed odes to the nymphs and gods as they entered the

banqueting hall and mythological creatures offered gifts to the nuptial pair. Lodovico was present. Indeed, he had himself arranged the festivities and dominated the proceedings.

From Tortona the two suites rode on to a Milan transformed into a fairyland, with banners and pennants and standards flying in all the streets to bring color to the dark Milanese winter. The great courtyard of the Castello was hung with blue curtains, the color of the Sforzas. The crimson and gold of Aragon hung over the entrance to the palace-fortress. The nuptial pair were led into the chambers reserved for them in one of the towers of the Castello. On the following day they were married in the cathedral, both of them dressed in white satin, and when they returned to the Castello they were given rooms hung in the same white satin. Throughout the following week there were continual divertissements, entertainments, jousts, and dances. Isabella of Aragon had come to Milan and the people rejoiced, though they could not have told exactly why they were rejoicing. Her young husband with his high-bridged nose and delicate features looked like a shadow beside her. He enjoyed luxury, loved horses and hounds and pretty women, possessed a sweet temper and gentle manners, and was quite obviously incompetent. He was a figurehead and Lodovico ruled in his name.

We hear nothing about Leonardo during these festivities, and we must assume that he spent the winter working on the statue of the horse and conducting his anatomical experiments. He was working slowly—too slowly for Lodovico, who grew impatient and ordered Pietro Alamanni, his ambassador in Florence, to ask Lorenzo to send another sculptor. Alamanni wrote on July 22, 1489:

> The Lord Lodovico intends to make a worthy monument to his father, and in accordance with his orders Leonardo da Vinci has been asked to make a model of a very large bronze horse with Duke Francesco fully armed riding it. Because His Highness desires to make something of superlative quality, he has directed me to write to you on his behalf with the request that you send him one or two artists capable of doing such a work. Although he has given the commission to Leonardo da Vinci, he appears to me to be far from satisfied that the sculptor is equal to the task.

The letter written by Pietro Alamanni was, in effect, a letter from the lord of Milan to the lord of Florence. Its intent was absolutely clear—Leonardo was out of favor, and it was urgently necessary that he be replaced by one or two Florentine artists of repute. Lodovico seems to have thought that Florence was a reservoir of artists who could be summoned at will. Leonardo would be paid off for the work

he had done, while his replacements would set about the work more effectively and more efficiently. Since most of the Sforza archives have perished, it is not surprising that Lorenzo's reply has vanished. Nevertheless we may guess at its contents. Lorenzo, writing in the flowery style reserved for communications between potentates, would be expected to say that a search for capable artists was being made but he could offer no hope of finding another Verrocchio. Inevitably there would be delays. The Lord Lodovico must be prevailed upon to exercise his patience.

For Leonardo the coming months were fraught with frustration. He had set his heart on making the horse and expected to accomplish it. At all costs it was necessary to ensure that he should be permitted to complete it. In order to do so, he would need to exert all his powers to influence the court officials and dignitaries who had the ear of Lodovico. In this he failed. Work on the horse was abandoned, and when we hear of him again he is serving in the much more lowly capacity of designer of machinery for festivities.

On January 13, 1490, a year after the marriage of Duke Giangaleazzo and Princess Isabella of Aragon, Lodovico decided to honor them with a special performance of a masque written by Bernardo Bellincioni with stage properties and perhaps costumes designed by Leonardo. Bellincioni has left a brief description of the event:

> January 13, 1490. A celebration was held in the Castello at Milan. It was called the Paradise and it was commanded by Signor Lodovico il Moro in honor of the Duchess of Milan. It was called the Paradise because Maestro Leonardo Vinci the Florentine created a Paradise with great ingenuity and art, and all the seven planets were seen to revolve, and they were represented by men who looked and were dressed like poets, and all these planets spoke in praise of the Duchess Isabella.

It can be seen from this description that the stage machinery was not very elaborate. There was some kind of revolving stage; seven actors dressed as poets advanced and delivered Bellincioni's verses to the duchess, and perhaps there was a painted backcloth. We learn from a long report written by the Ferrarese ambassador that the revolving stage resembled half an egg, *uno mezo ovo,* and was brilliantly lit with lamps representing the stars and signs representing the zodiac and niches, *fessi,* for the seven planets. No one has yet succeeded in showing how these elements—a revolving stage like half an egg, a blaze of lamps, zodiacal signs, and the seven planets represented by poets—were put together. Kate Steinitz wrote a long and learned essay on the subject, but she confused a later stage setting for

Poliziano's *Orfeo*, which introduces a mountain, with Bellincioni's *Paradiso*, where there is no mountain. An attempt has been made in films to suggest that Leonardo produced a vast and intricate machine like a merry-go-round on several levels adorned with dancing girls, but the filmed version has no relation to the original. The Paradise was only a small part of the festivities. The Ferrarese ambassador describes the reception of the guests, the coming of the Polish, Hungarian, and Turkish ambassadors, all dressed in exotic costumes, and accompanied by their retinues. They were all actors in disguise and they all made speeches to honor the fame and glory of Isabella of Aragon. The Turkish ambassador explained that it was not the custom of the Grand Turk to attend the festivities of Christians, especially in Italy, but such was the fame and glory of Isabella that he was compelled to attend, and as he spoke, he sat on cushions "according to the custom of his country." The ambassador from the Sublime Porte was followed by a knight representing the Holy Roman Emperor and there were more flowery speeches. Then came a knight representing the King of France. In between the speeches there were dances and masquerades, and much playing of pipes and tambourines. The Paradise came at the end. Bellincioni's text has survived. Jove addresses the seven planets and tells them he must descend to earth to honor the beautiful princess. He is followed by Apollo, Mars and Mercury, Venus and the Moon. The nymphs come to sing her praises, the Three Graces and the Seven Virtues follow, the Seven Planets add their chorus to the general rejoicing for the *diletta, gloriosa e bella* Isabella, who may have been wearied to hear her praises sung so unrestrainedly, knowing that it was all a charade ordered by Lodovico in an attempt to make her feel that she was the most important person in Milan, when in fact neither Duke Giangaleazzo nor Duchess Isabella possessed any power at all, and very little influence.

For Isabella the Paradise, with the libretto of Bellincioni and the stage machinery of Leonardo, may have been a foretaste of hell.

Lodovico appears to have been pleased with Leonardo's stage machinery. The commission to make the horse was still in abeyance. Not until April was Leonardo permitted to continue work on the horse. He wrote on April 23: *"Chominciai questo libro e richominciai il cavallo* [I have commenced this book and recommenced the horse]." It was a cry of triumph.

Now at last, with the full approval of Lodovico, he could go forward. In just over a year it would be ready for casting.

A large number of sketches for the horse have survived, but although Leonardo must have paid particular attention to the rider, Francesco Sforza, there are no detailed sketches of him. Clearly it was

necessary to make an idealized portrait of the warrior with just enough resemblance to the real man to suggest a likeness. His features and appearance were well known; many portraits had been made of him; and since he had died only in 1466 there were many people living who still remembered him. He was tall and thin, with deep-set eyes and bushy brows, a prominent nose, a hard mouth, a determined chin. His eyes were blue-gray, his skin was sallow, his hair was close-cropped. It was a face of no particular distinction, plebeian and forbidding. He had powerful shoulders and a waist that could be spanned with two hands. For some reason he nearly always wore a conical cap. He was a typical *condottiere* of his time, ruthless and mercenary, vain and treacherous.

To make a large equestrian statue, Leonardo had to come to grips with one overriding problem: how to balance it. If the forelegs were raised, there was the difficulty of finding sufficient support for the hind legs. If the horse was standing with all four legs on the ground or with a single foreleg raised, there was the danger of creating a purely static figure, as in Donatello's heroic statue of Gattamelata in Padua, where the horse has three feet on the ground and one resting on a ball, conveying an impression of calm and balance. Verrocchio's statue of Colleoni in Venice has one foreleg lifted off the ground; the horse has been reined in, but there is a suggestion of a plunging forward movement. From the recently discovered Madrid Codices we have learned that Leonardo's horse had one foreleg raised sharply and one hind leg was raised a little. The solution of the problem was accomplished with apparent ease. In fact his drawings show that he experimented in every conceivable direction; his horses were seen rearing, prancing, caracoling, with a foreleg resting on a stone or a tree trunk or a dying warrior. We also learn from the Madrid Codices that the rider was made separately, and Leonardo concluded that the tail could be cast separately and added later.

We now know, for the first time, what the horse looked like, but we are still in considerable doubt about the appearance of its tyrannical rider. He probably wore armor, sat bolt upright, held a baton in his right hand, and stared in front of him with the fixed gaze of a man conscious of his power and oblivious of everything around him. There exists an illuminated manuscript dated 1491 showing clearly an artist's rendering of the horse. In this painting the horse is rather static, and not, as one might have expected, plunging forward or prancing. The sculpture possesses a monumental calm; and one imagines that this was exactly how Lodovico, himself always nervous and restless, would have wanted it.

In the summer of 1490, Leonardo visited Pavia in the company of

Francesco di Giorgio Martini, an architect of some note. Ostensibly
the purpose of the journey was to advise and report on the design of
the cathedral, and in fact Leonardo drew a large number of designs
which survive in the Codex Atlanticus and Manuscript B. The design
of the cathedral at Pavia was a matter very close to the heart of As-
canio Sforza, cardinal-bishop of Pavia and brother of Lodovico. Final
decisions on the design had not been made, and the cardinal, who knew
nothing about architecture, was growing impatient.

The visitors, accompanied by a train of horses and servants, stayed
in the Osteria del Moro at the expense of the committee in charge of
building the cathedral. Martini stayed for ten days, but Leonardo
stayed longer, filling his notebooks. He had many reasons for coming
to this small city on the banks of the Ticino River. There was a fa-
mous university, there was the palace in a great park occupied by
Duke Giangaleazzo and Isabella of Aragon, and there was an ancient
and renowned equestrian statue in the cathedral square. The statue,
which was supposed to represent the Gothic King Gisulf on horse-
back, was regarded as one of the greatest of equestrian statues. It was
known as the *Regisole*, apparently a corruption of Rex Gisulf. What
gave it distinction was the sense of movement that came from the
raised hind leg and the straining muscles of the neck. Petrarch ad-
mired it, saying that all good judges regarded it as a masterpiece, an
opinion evidently shared by Leonardo, who wrote in his notebook:

> Of that at Pavia the movement more than anything else is
> praiseworthy.
> The imitation of the antique is more praiseworthy than mod-
> ern work.
> Can there not be beauty and utility? As appears in men and
> fortresses?
> The trotting gait is characteristic of the free horse.
> Where natural liveliness is lacking, it must be supplied by
> art.

He learned much from the *Regisole* and would apply this learning
to his own horse. This gilded bronze statue, the pride of Pavia, no
longer exists. It was destroyed by a revolutionary mob in 1796.

There were also lessons to be learned in the ancient university of
Pavia, where the professors were among the greatest in Italy. Pavia,
not Milan, was the intellectual center of Lombardy. It is often said
that Leonardo met Marcantonio della Torre, the great anatomist, dur-
ing this visit, but Marcantonio was still a boy. He did meet Fazio Car-
dano, the jurist and mathematician and profound student of perspec-
tive, who was teaching at the university. Cardano was passionately
devoted to hermetical science and the world of the occult; it was said

that when he walked abroad he was always accompanied by a familiar spirit who talked to him. Probably, like many professors, he had a habit of talking to himself. His son, Girolamo Cardano, became a mathematician, a doctor, and an astrologer; a single sentence in his voluminous works throws light on Leonardo's efforts to learn how to fly.

It is possible that Leonardo taught briefly at the university, found the students unruly, and excoriated them with the appropriate biblical cadences. Found among his papers is the reminder:

> Make a homily of the reproaches to be directed to unruly students.
> Peroration: But such as those may remain in the company of beasts, and those who seek their favor are dogs and other animals full of rapine, and in their company everlastingly hunting the fugitive, following the innocent animals who in their hunger in the time of the great snows come to your houses begging for charity, as from their masters.

There is no doubting Leonardo's rage, but it is not clear why the dogs of rapine are everlastingly hunting the innocent animals who come begging for charity. Rage often invokes mixed metaphors, and Leonardo may simply have been indulging himself with them.

The university had an excellent library; so did the ducal palace. Leonardo visited the palace, read the books and manuscripts in the library, and was consulted on the construction of the ducal bath. Long before the summer was over he returned to Milan to continue his work on the vast horse, which took the greater part of his energies.

Winter was the season of marriages and festivities. This winter two marriages were celebrated with great pomp. Lodovico, who was thirty-nine years old, married the fifteen-year-old Beatrice d'Este, the daughter of the Duke of Ferrara. At the same time the duke's brother Alfonso married Anna Sforza, the sister of Duke Giangaleazzo. Beatrice d'Este was a madcap, impudent and sweet-tempered by turns, with a bulging forehead, a retroussé nose, a petulant mouth, and a small but determined chin. She was not beautiful, like Gallerani, but she was high-spirited, graceful, and intelligent. Like Isabella of Aragon, she was a granddaughter of King Ferrante of Naples and possessed a Spanish pride, a fierce arrogance. Lodovico had chosen for his bride someone very much like himself.

The marriage of Lodovico and Beatrice d'Este took place officially at Pavia, where Lodovico and Beatrice spent their wedding night. Then, at the head of a great procession, they rode to Milan, which was only twenty miles away. Once more Milan was transformed into fairy-

land, blazing with lights and banners and many-colored hangings and embroideries. Leonardo's horse, not yet completed, was represented by an immense painting hanging down from the walls of the Castello. Lodovico wore cloth of gold, Beatrice wore white satin laced with pearls. As they drove along the streets the people shouted their names with fervor, delighted to see the ducal couple so obviously in love with each other. In the Via degli Armorai, the street of the armorers, there stood a double row of suits of armor, like an army on parade glinting in the cold winter sun.

There followed feasts and entertainments, jousts, balls, and processions, while ordinary life came to a stop and nothing was done that was not in celebration of Lodovico and Beatrice. (The marriage of Alfonso d'Este and Anna Sforza was lost within the more important marriage like a pebble lost on the seashore.) Lodovico and Beatrice were continually appearing in public, receiving tribute, listening to long speeches on their evident virtues, being acclaimed because they brought peace and harmony to Milan, and there were only a few who suspected that they were small, tragical figures who in their different ways—one by dying, the other by living—would bring about the destruction of the state. But in those winter days the rejoicing was real, heart-felt, totally sincere. Milan, beflagged and decked out in red, white, and blue—the Sforza colors—was very pleased with itself.

The art of the *fête* was practiced brilliantly in Renaissance times. Leonardo designed costumes, choreographed parades and receptions and cavalcades, and made heavy use of mythology and allegory. For Galeazzo da Sanseverino, the captain of the Milanese army, a tall and handsome man who owned one of the best stables in Europe, he designed gold trappings for his horse and a gold uniform for the rider, the gold cloth being embroidered with peacocks' eyes. Leonardo explained in his notebook that he had chosen this design "to signify the beauty which derives from the grace bestowed on one who serves well." He was a friend of Galeazzo da Sanseverino. He therefore designed trappings that would please him. Above his gold helmet stood a half globe, to signify his conquests, and above the globe a peacock with outspread tail, to signify his glory. Leonardo was inventing his allegories as he went along. He knew very well that peacocks were associated with vanity, for he knew the allegorical books as well as any man, but he chose to differ from them. The captain's shield was covered with a large flashing mirror "to signify that he who really wishes for favor should be mirrored in his virtues."

Galeazzo da Sanseverino rode at the head of a small army of *selvatichi*, wild men from the forests, dressed in strange tattered garments, and Leonardo had a special fondness for designing the clothes of

these ragged men. Galeazzo's brother Gaspare da Sanseverino appeared at the head of a troop of Moorish riders, roaring in a language that pretended to be Moorish, and all these riders raced up to the tribune where Lodovico and Beatrice were sitting and then a herald would make a studied speech acclaiming them. Later there were tournaments; the tilting matches lasted for three days. As everyone had predicted, Galeazzo da Sanseverino won the prize, a *pallium* of gold brocade that he received from the hands of Beatrice. The Ferrarese ambassador observed that during the prize-giving Lodovico was continually kissing his young bride.

During the following days it was observed that he sometimes slipped away from the Castello to see Cecilia Gallerani, his *maîtresse en titre*, who remained high in his affections. Beatrice heard of these secret meetings; there were quarrels; and the atmosphere of the court grew stormy until Beatrice succeeded in convincing her husband that there would be no peace in the family until Cecilia Gallerani was married off; and she became the Countess Bergamini. Lodovico continued to see her whenever Beatrice was away.

Leonardo painted Beatrice's profile, fascinated by her retroussé nose and her willfulness and also by the madcap quality that was her contribution to the life of the court. The portrait is all in the outline of the face. He gave her a hair net of pearls, a pearl necklace, and huge rubies. About the same time he painted a picture known as *Portrait of a Musician:* a man with a red skullcap, with a powerful and sensitive face, and melting eyes painted as only Leonardo could paint them. The musician is probably Galeazzo da Sanseverino, who was famous for the beauty of his singing voice, and who is about to sing the words written on the sheet of folded paper he holds in his left hand.

One walks with a certain assurance up to these two paintings which hang in the Ambrosiana in Milan, for they illuminate one another and reflect one another. They are sometimes attributed to Ambrogio de Predis, who was incapable of breathing so much life into these warm faces. The eyes of the musician and the modeling of his face belong to the same hand that painted the angel in *The Virgin of the Rocks,* just as the portrait of Beatrice belongs to the same hand that painted the profile portrait of Isabella d'Este, Beatrice's sister, now in the Louvre. Leonardo has not poured into these paintings all the power of his genius, for they are court paintings made for the occasion by a man engaged in many other pursuits who would have preferred to be studying than painting. But now he was a court painter and had to obey his masters.

Lodovico had insisted that the bronze horse should be completed quickly. On the evening of May 17, 1491, having made the model for

the horse and designed the molds, so that it was ready to be cast, Leonardo wrote in his notebook, "Henceforth I shall keep a record of everything concerning the bronze horse presently in the works [*al presente sono in opera*]." Just over a year had passed since he wrote that he was recommencing work on it. In that incredibly short space of time, in the midst of many pressing tasks, travels, and upheavals, he had completed it. There remained only the mechanical task of casting it.

In his eyes the bronze horse was his supreme achievement. Over it he had labored with a fierce devotion, drawing countless sketches and making countless experiments. Even his drawings of the molds were masterpieces, and one of his most wonderful and vivid drawings was for the mold of the horse's head.

He did not know and could not have guessed that all this work was in vain.

The Coming of Salai

One day in the summer of 1490, while he was in Pavia, Leonardo encountered an appealing ten-year-old boy and promptly adopted him. The boy had thick hair, which was naturally curly, a low forehead, large eyes with fine eyelashes, a somewhat sharp nose, thick lips, a delicately formed chin, and a short neck. His name was Gian Giacomo Caprotti, his parents were poor, and it was not difficult to arrange that the boy should enter his household as a servant. A small amount of money would be given to the parents, a legal deed would be drawn up, and thereafter the boy would remain with him until he came of age, the property of his master. The boy proved to be a talented thief, and Leonardo sometimes regretted employing him. Soon he was given the nickname of *Salai,* meaning "little devil," which derives by way of Luigi Pulci's ribald epic, the *Morgante Maggiore,* from Saladin. On July 22, 1491, exactly a year later, Leonardo wrote an account of the boy in his notebook:

Giacomo came to live with me on Magdalen's day 1490. Aged 10 years.

On the second day I had two shirts, a pair of hose and a doublet cut out for him, and when I put aside some money to pay for these things, he stole it from my wallet, and it was never possible to make him confess although I was quite certain.

1 lire.

[*In margin*] Thievish, lying, obstinate, glutton.

On the following day I went to supper with Giacomo Andrea, and the said Giacomo supped for 2 and did mischief for 4, for he broke 3 flagons, spilled the wine, and then came to supper where I . . .

Item, on the 7th September he stole a silverpoint worth 21 soldi from Marco, who was with me. It was of silver, and he took it from the studio, and after the said Marco had searched for it for a while, he found it hidden in the said Giacomo's box.

1 lire 1 soldi.

Item, on the 26th January following, when I went to the house of Messer Galeazzo da Sanseverino to arrange the pageant of his tournament, and certain footmen having taken off their clothes to try on the costumes of the wild men [*selvatichi*] for the said pageant, Giacomo went to the purse of one of them with the other clothes and took some money he found there. 2 lire 4 soldi.

Item, when I was staying in the house of Maestro Agostino da Pavia, I was given a Turkish hide to make a pair of short boots, and then Giacomo stole it from me within a month and sold it to a cobbler for 20 soldi, and with this money on his own confession he bought aniseed comfits. 2 lire.

Item, further on 2nd April, Gianantonio left a silverpoint on one of his drawings, and Giacomo stole it from him, and it was worth 24 soldi. 1 lire 4 soldi.

The first year—
A cloak, 2 lire,
6 shirts, 4 lire,
3 doublets, 6 lire,
4 pairs of hose, 7 lire 8 soldi,
1 lined doublet, 5 lire,
24 pairs of shoes, 6 lire 5 soldi,
A cap, 1 lire,
Laces for belt, 1 lire.

Leonardo, the careful housekeeper, learned in this way that Salai had cost him thirty-two lire thirteen soldi, and in addition the boy had stolen objects to the value of seven lire nine soldi. The question about what to do with him had to be resolved, and Leonardo resolved it in his own fashion—Salai remained in his service because the advantages

of having him in the house outweighed the disadvantages. For nearly twenty-six years Salai remained at his side.

By Leonardo's account Salai was "thievish, lying, obstinate, glutton." He was also handsome, vigorous, impudent, and charming. His upkeep was considerable, he demanded and received an unusually large wardrobe and a quite fantastic number of pairs of shoes. Quite clearly, he brightened the household with his gaiety and vitality and possessed the ferocious charm which many Italian children cultivate as a means of survival. He was self-indulgent and Leonardo evidently pampered him. He appears to have been simultaneously amused and incensed by the boy's behavior, and in his recital of the crimes committed by the boy there is no rancor. One imagines that after each crime Salai was punished with a beating, but one cannot be sure. It is possible, and even likely, that Leonardo tolerated even his worst crimes and was almost an accessory to them, amused and happy to see so much wild, uncontrollable energy in him.

But what precisely was the boy doing in the household? There arose in the nineteenth century the legend that Salai became an apprentice and was in fact introduced into the studio in order to learn painting. He was supposed to have acquired some facility in painting, and learned scholars debated which of the many paintings not by Leonardo but in his style were done by Salai. A particularly bad copy of the *Mona Lisa* was attributed to him, and even in our own century there have been scholars who cheerfully attributed to him a large number of paintings. Yet there is no evidence that Salai painted anything or even assisted Leonardo in grinding his colors. He was a charming little devil, and perhaps nothing more.

Nevertheless Leonardo developed a great affection for him and later gave him half the small property he owned in Milan, confirming the gift in his will. The painter and the charming boy were inseparable; they traveled together through Italy; and when in his last years Leonardo became the pensioner of King Francis I with a palace of his own at Amboise, Salai came to stay with him, and then returned to his vineyard and small house in Milan. That they were together for so long a time testifies as much to the enduring affection between them as to Leonardo's forbearance, for Salai continued to be a petty thief until he had grown to manhood.

The recent discovery of an unpublished manuscript by Gian Paolo Lomazzo in the British Museum raises another question. It had long been assumed that Leonardo was homosexual, or at least possessed homosexual tendencies, but apart from some vague hints by Vasari, there was very little to go on. Lomazzo, composing a dialogue between Leonardo and Phidias in a manuscript significantly titled *Libro*

dei Sogni, Book of Dreams, was the first to say outright that Leonardo
was homosexual and **the** first to include Salai among the well-known
painters of his time:

LEONARDO . . . These achieved true fame, Marco da
 Oglono, Andrea del Gobbo, Bartolomeo
 Clemento, Tullio Lonbardo, Cristoforo Vi-
 cenzo Verchio, Francesco Turbido, Antonio
 Boltraffio my disciple, together with Salai,
 whom in life I loved more than all the oth-
 ers, who were several.[1]

PHIDIAS Did you perhaps play the game in the be-
 hind, which the Florentines find so agree-
 able?

LEONARDO And how many times! Remember that he
 was a very beautiful boy, especially when
 he was fifteen years old.

PHIDIAS You are not ashamed to say this?

LEONARDO Why ashamed? There is nothing more
 praiseworthy among the *virtuosi* than this,
 and that this is true I can demonstrate by
 means of most excellent arguments.

And so he does in a well-worn fashion, reminding Phidias, who
scarcely needed the information, that homosexual love was more spir-
itual than heterosexual love, which was concerned with the propaga-
tion of the species and the base workings of the human body. Achilles
loved Patroclus more deeply than he loved any woman. Homosexual
love reaches out beyond the flesh; it is more generous and more satis-
fying to the artist. As for Salai, who was "most beautiful and seduc-
tive and full of grace, with lovely hair and lovely curls and well-
shaped eyes and mouth," he was almost perfection itself. So the
strange dialogue between Leonardo and Phidias continues with refer-
ences to the spread of homosexuality to Naples and the more prosaic
loves of Raphael. But the argument remains unconvincing; Lomazzo
adds no more information about Salai than he could have derived
from Vasari; we are left with the feeling that although he was very
knowledgeable about Leonardo's paintings, he knew very little about
Leonardo's private life and was merely repeating the gossip of Milan.
Strangest of all he places Salai in the company of many well-known
and respectable artists.

Leonardo appears not to have been highly sexed. His habits were

[1] Lomazzo originally wrote "who were infinite."

temperate. He preferred water to wine at table; he ate lightly, and asked of his body that it should be a well-trained instrument to do his bidding. He abhorred wantonness, saying that a man who does not restrain himself is on a level with the beasts. "You can have no greater and no smaller dominion than that over yourself," he wrote. Restraint, rigor, self-control were his watchwords. Like many highly disciplined men, he was puzzled and somewhat disturbed by the vagaries and caprices of sex. One day, writing about the movement of the lungs and describing how they would "suffocate" if there was no fresh air pouring into them, his mind jumped toward another kind of suffocation. He wrote, "Testicles, witnesses of coition," and there followed a paragraph about castration. It was a prodigious leap, which he made with ease. He had a good deal to say about castration. He observed that the testicles were the fomentors of animosity and ferocity in animals. He had seen a ram drive before it a herd of wethers, and a cock put to flight a crowd of capons. Bulls, boars, rams, and cocks became pitiably craven when they were castrated. From castration he made a quick leap to the sexual instrument itself with a famous paragraph introduced with the words: *Della Vergha,* Concerning the Rod. And it seemed to him that the rod possessed a strange and unpredictable life of its own, it was endowed with intelligence and conscious obstinacy, it could not be relied upon when needed and acted quite arbitrarily, it obeyed its own laws and took part in its own ceremonies:

> Concerning the Rod. It holds conference with the human intelligence and sometimes has intelligence of itself. When the human will desires to stimulate it, it remains obstinate and follows its own way, sometimes moving of itself without the permission of the man or of any mental impetus. Whether he is awake or sleeping, it does what it desires. And often the man is asleep and it is awake, and often the man is awake while it sleeps, and often when the man wishes to use it, it desires otherwise, and often it wishes to be used and the man forbids it.
>
> Therefore it appears that this creature possesses a life and an intelligence alien from the man, and it seems that men are wrong to be ashamed of giving it a name or of showing it, always covering and concealing something that deserves to be adorned and displayed with ceremony as a ministrant.

That Leonardo at the age of about fifty-six—for this entry in his notebook can be safely dated about 1508—should have felt that the male sexual organ deserved "to be adorned and displayed with ceremony as a ministrant" is perhaps less surprising than the strange leaps of his mind as they jumped from suffocating lungs to castration and then to the rod. He was being severely logical. There was a creature

possessing "a life and an intelligence alien from the man," and it was
not receiving the tribute it deserved. Men generally concealed it.
What if they adorned it and displayed it publicly?

Leonardo did not answer the implied question perhaps because so-
cial mores were outside the field of his interest. Both the male and fe-
male sexual organs fascinated him, and he made many drawings of
them. At a time when many believed that the distention of the male
organ was caused by wind, he declared that it was caused "by a large
quantity of blood," a fact he was able to prove on the dissecting table,
for he had dissected criminals who had been hanged and had rigid
and erect members. He was the first to demonstrate the exact nature
of sexual intercourse, and his coition drawing, in spite of a curious
misunderstanding derived from Avicenna about the two passages in
the penis—one transmitting animal spirit from the spinal cord and the
other transmitting sperm and urine—was far in advance of its time. He
drew ovaries and testes with great delicacy and dignity, and in only
one drawing does he suggest a kind of medieval horror of the sexual
organs. This is in a drawing of the extended vagina opening out like a
yawning abyss. Although he dissected many corpses, he appears never
to have been able to bring himself to make a careful and accurate dis-
section of the penis, perhaps because he left it until the last, or be-
cause he was too fastidious, or because he felt he knew all about it.

Psychologists and psychiatrists have woven many tangled theories
about Leonardo's attitude toward sexual intercourse. Nearly always
they have concluded that he was a homosexual, although it is much
more likely that he was bisexual, loving women and men equally,
passing lightly from one to the other, while possessing for the sexual
act itself a profound reverence. Something of that reverence can be
seen in a long-neglected passage in the Arundel Manuscript in the
British Museum, written about the same time as his description of the
rod, where he speaks in almost religious terms of the contract between
the man and the woman:

> A man wishes to learn whether the woman will consent to
> the demands of his lust, and as he learns that this is the case
> and that she desires him, he requests her participation and does
> what he intended to do. And he cannot discover this unless he
> confesses, and as he confesses he fucks [*e confessando fotte*].

There is nothing surprising in Leonardo's use of the word "confess" in
this context. It can only mean that confession was involved in the rit-
ual. Implicit in the argument is the idea that the man and the woman
"confess" to each other.

Leonardo's view of his own sexuality emerges clearly from the *Della*

Vergha fragment. It was a kingdom with its own laws and ceremonies, over which he felt he had little control, and at the same time he felt a certain amusement and a certain indifference while proclaiming in his notebook that it was absurd to conceal so powerful an instrument of generation. He does not write like someone passionately involved. It is something he has studied before going on to other things. He writes about it, as it were, from a distance.

Whatever his relations with Salai, it is abundantly clear that he delighted in seeing the boy dressed up in his finery, and Leonardo pampered him with clothes even when he was long past boyhood. On April 8, 1503, when Salai was about twenty-three years old, Leonardo wrote in his notebook:

> Memorandum. On this day I paid Salai 3 gold ducats which he said he wanted for a pair of rose-colored hose with their trimming; and there remain 2 ducats due to him—except that he owes me 20 ducats, that is 17 I lent him in Milan, and 3 at Venice.
>
> Memorandum. That I gave Salai 21 braccia of cloth to make a shirt, at 20 soldi a braccio, which I gave him on the 20th day of April 1503.

There are many more entries concerning Salai in the notebooks, usually in connection with clothes. Sometimes Salai was given money for current expenses, *per spendere in casa,* and sometimes too he was given errands to do. Yet he was never in the strict sense a servant. Bodyguard, gatekeeper, major-domo, adopted son, he occupied an ambiguous position in the household, and it may have been precisely this ambiguity that gave pleasure to Leonardo, who depended upon him for all those services that are not provided by servants. The legendary Leonardo, bearded and glowering in the Turin portrait, can only with difficulty be reconciled with the real Leonardo, forever studious and forever active, who took so much enjoyment in the presence of a charming, decorative, and impudent thief.

About this time Leonardo was engaged in drawing up designs for canal building and urban development, and these tasks involved extended journeys through Milan and the countryside. We may imagine Salai as his constant companion during these journeys, carrying pen, ink, writing paper, measuring rod, even bedding. It appears from Leonardo's notebook that Salai was also in charge of the cash box, presumably on the principle that money was best handled by a thief.

We know what Salai looked like, for his brilliant eyes gaze at us sidelong from many pages of the notebooks. But what did Leonardo look like? We have seen him in his brilliant youth, beautiful in person and aspect, graceful and well proportioned, as the *Anonimo Gaddiano*

describes him. By 1490, when he was thirty-eight years old and at the height of his powers, he had lost his youthful beauty and acquired the beauty of experience. The first troubled years of his life in Milan were over, and if he was not yet the ducal painter and the ducal engineer he was already a person of eminence, a friend or an acquaintance of many high officials including Galeazzo da Sanseverino, who commanded the ducal army and was famous for his singing voice, his elegance, and his handsome features. Leonardo had free use of Galeazzo's stables and many of his studies of horses were drawn in them. The poets were beginning to sing his praises. Throughout all this period he was being described as *Leonardo fiorentino*, the man from Florence, the stranger who uprooted himself to live in a foreign land.

Two drawings of Leonardo in his middle age survive. One is a quick sketch by a pupil on one of those many pages in the Royal Library at Windsor on which Leonardo has been drawing horses' legs. In the sketch Leonardo wears a skullcap, he has a broad forehead, the eyes are large and bright, he has a straight nose and a sparse mustache that curls away at the corners of his mouth, and the beard indicated by a few curling lines is not especially luxuriant. This sketch (Windsor 12300) is a spirited rendering, made by a pupil who evidently possessed some talent, and underneath it, by the same hand, there is a full-face portrait of a young man with a snub nose and an impudent expression, who wears the same kind of skullcap, from which there emerges a loose cluster of curls. No one knows who made these drawings but they clearly belong to the period when Leonardo was working on his studies of the horse and can be dated about 1508. The expression is vigorous and alert, and the artist has admirably conveyed Leonardo's vivacity.

There exists in the Louvre a drawing of an unbearded man, attributed to Leonardo. In the catalogue it is described as "the head of an old man." In fact, the man is not particularly old, no more than fifty or fifty-five, and his age is the least important thing about him. In its depth and brilliance,·in its power and formidable beauty, it must be accounted among the most masterly drawings of Leonardo or of his school. The eyes have the solidity and blaze seen in the *Portrait of a Musician,* the thinning hair is drawn casually, almost as an afterthought, and the ear is structurally the same as the ear of *St. Jerome of the Desert.* Indeed, in style and feeling, this drawing of an old man is remarkably close to *St. Jerome,* but where the saint is caught up in an intensity of prayer, the man in the drawing is caught up in an intensity of thought.

I believe this drawing to be a self-portrait made by Leonardo about 1505, when his style had moved toward a new monumentality. These

fine-drawn features, the forehead, nose, upper lip, and mouth, and the soft hair curling down to the shoulders, can be easily reconciled with the portrait in profile in the Ambrosiana. The declivity under the lower lip is exactly what we might expect, and we should be no more surprised by the rugged strength of the chin than by the eyes like blazing coals or by the forehead knotted with thought. Above all, the drawing has the quality of self-consciousness readily observed in the self-portraits of painters. "The painter paints himself [*Il pittore pinge se stesso*]," wrote Leonardo. So he does at all times and all places, whatever he is painting, but for the confrontation with himself in the mirror and on the canvas he reserves his utmost care and judgment, and his utmost powers. Compare Dürer's self-portraits of 1498 and 1500 with his portraits of other people: the self-portraits leap off the canvas, while the portraits of others lie comfortably on the canvas in the shelter of the frame. No other portrait by Leonardo emerges with such startling suddenness from the page, so raw, so naked, with such psychological penetration or with so much alertness. He is the man who is never wearied, who will think all thoughts to the end of the road. "Death sooner than weariness [*Prima morte che stanchezza*]," he wrote once. He spoke of himself as a man who allowed the material things of the world to fall into his open hands like melting snow, but he prized only the gift of serving. "Hands into which ducats and precious stones fall like snow: they never became tired of serving. I was never weary of being useful." In the Louvre drawing we see him at last naked, without his beard.

The greatest living authority on Leonardo, Dr. Carlo Pedretti, once said that he found himself gazing often at the Louvre drawing, half suspecting that it was Leonardo but never quite bringing himself to believe it because it was impossible to escape from the familiar portrait of the bearded Leonardo. Yet there are at least half a dozen reasons why at some periods of his life Leonardo would have shaved off his beard—to avoid being recognized when he was traveling on military expeditions, or because of illness, or to please a woman, or out of weariness, or to surprise a friend, or to please himself. Leonardo spent a good deal of his time traveling on private errands, exploring the Alps and the regions around Lake Como, making long journeys into the countryside in order to map the river systems. At such times a luxuriant beard could be an unmitigated nuisance, scarcely endurable. Men in the Renaissance generally shaved, as men do today, and for the same reasons. Michelangelo and Leonardo, the two towering figures of the Renaissance, were bearded, but they were the exceptions. Priests and lawyers wore beards, but most Italian men were clean-shaven.

In the Accademia in Venice there is a famous ink drawing by Leonardo of a human figure within a square and a circle. He has two pairs of arms and two pairs of legs; the four arms and four legs are so wonderfully constructed that they give the appearance of being completely convincing, as though a new kind of man had suddenly emerged. The majestic body is deliberately drawn to demonstrate perfect physical proportions, and there is a lengthy note explaining the system of proportions as Leonardo saw them. Although Leonardo was concerned with the proportions of the human figure and there was not the slightest need for him to do an elaborate portrait of the man, he went to considerable pains to draw the features of a man of commanding aspect, with a furrowed forehead, straight nose, wide mouth, jutting chin, and thick curling hair reaching to his shoulders; and this face, so lifelike and so commanding, bears a close resemblance to the Louvre drawing, though it clearly belongs to an earlier period. The drawing of the human figure can be dated about 1490, about fifteen years earlier than the drawing in the Louvre. The two portraits therefore fit well within the time span: first, the powerful, mature figure in his middle or late thirties and the less powerful but still dominating portrait of a thinker in his early fifties. And in both there is that formidable intensity of self-awareness and intelligence. Yet the drawing of the human figure is not in the strict sense a portrait so much as an idealized representation of a Renaissance man who happened to bear a certain resemblance to Leonardo.

We know the mind of Leonardo, for he had the habit of revealing himself continually in his notebooks. "Obstacles cannot bend me," he wrote. "Every obstacle yields to effort." "The senses are of the earth, and reason stands apart from them in contemplation." And again: "Let your work be such that after death you become an image of immortality: as in life you become when sleeping like the hapless dead." He was driven by what he called *ostinato rigore*, the obstinate rigor, that refuses to believe that there are any limits to the power of the human intelligence. It is precisely that rigorous intelligence that is revealed in the figure in the Accademia and the drawing in the Louvre, while the sketch made by the pupil reveals his sweetness and serenity.

At the time when he was drawing the Accademia figure, he was at the height of his powers. Soon he would be painting *The Last Supper* and sculpting the great horse.

ON THE HIGHEST MOUNTAIN

The Last Supper

The Last Supper no longer exists as a painting. It belongs to that special category of monuments, like the Golden Pavilion at Kyoto, which have been destroyed by time and resurrected by human hands. The Golden Pavilion was burned to the ground, and there remained only a heap of ashes. Today the Golden Pavilion still astounds visitors with the perfection of its proportions and the beauty of its design. So it is with *The Last Supper*. What we see or think we see in the refectory of the church of Santa Maria delle Grazie is not the painting left to us by Leonardo. The painting has vanished; the icon remains.

The painting vanished very early and had a very short life. Antonio de Beatis, the secretary of Cardinal Luigi of Aragon, saw it in December 1517 and wrote in his diary that it was "beginning to decay." Vasari, who saw it in May 1556, spoke of it as "so badly affected that nothing is visible except a mass of blurs [*macchia abbagliata*]." Gian

Paolo Lomazzo, who last saw the painting in the years before 1568, when he went blind, described it in his *Trattato* published in 1584 as "totally ruined [*la pittura è rovinata tutta*]." Decayed, ruined, nothing but a mass of blurs, it continued to exist because it was necessary that it should exist. It succumbed to many deaths and many resurrections. There is hardly a scrap of Leonardo's painting left on the wall, but undeniably Leonardo's painting is still there like a vast shadow that refuses to move although the sun continually changes its course.

We know a good deal about the history of the painting after it was ruined. When Jonathan Richardson saw it shortly before Michelangelo Bellotti began work on it, he observed that all the apostles on the right hand of Christ had been defaced while all those on the left-hand side were faded except for one which retained, like Christ, something of the original coloring. He observed, too, that there were patches on the wall where no paint adhered. Richardson published his book *An Account of Some of the Statues, Bas-reliefs, Drawings and Pictures in Italy &ca with Remarks* in 1722. Four years later Bellotti completed his restoration, varnished it, and pronounced that he had revived the original work. By 1770 it had deteriorated again and the Dominicans of Santa Maria delle Grazie decided that the time had come for another restoration. They employed a certain Giuseppe Mazza, otherwise unknown to history, to do the work. By chance the Irish painter James Barry happened to visit the refectory while the work was going on. What he saw or thought he saw was the final destruction of *The Last Supper*. "The glorious work of Leonardo is now no more," he declared, and went on to describe the savage blows that were being dealt to it by an incompetent artist:

> I saw the last of it at Milan; for in passing through that city on my return home I saw a scaffold erected in the Refettorio, and one half of the picture painted over by one Pietro Mazzi; no one was at work, it being Sunday, and there were two men on the scaffold, one of whom was speaking to the other with much earnestness about that part of the picture which had been re-painted. I was much agitated, and having no idea of his being an artist, much less the identical person who was destroying so beautiful and venerable a ruin, I objected with some warmth to the shocking ignorant manner in which this was carried on, pointing out at the same time the immense difference between the part that was untouched and what had been repainted. He answered, that the new work was but a dead colour, and that the painter meant to go over it all again. Worse and worse, said I: if he has thus lost his way when he was immediately going over the lines and features of Leonardo's figures, what will become of him when they are all thus

blotted out, and when, without any guide in repassing over the work, he shall be utterly abandoned to his own ignorance. On my remonstrating afterwards with some of the friars, and entreating them to take down the scaffold and save the half of the picture which was yet remaining, they told me that the convent had no authority in this matter, and that it was by order of Count de Firmian, the Imperial Secretary of State.

In fact, the convent did have some authority in the matter, and Barry's intervention was successful to the extent that the scaffolding was removed by order of the new prior, Paolo Gallieri, himself a painter. A court of inquiry was established, Giuseppe Mazza attempted to defend himself, and for a few years we hear nothing more about restorations. In 1796, French soldiers were using the refectory as a stables. Eight years later Carlo Amoretti, the first to write a detailed account of Leonardo's life based on documents, stood in front of it and he was able to recognize the general design only when he stepped back and looked at it from a distance. In 1821 and 1855 there were new attempts to restore the painting. Then, apparently, there was a hiatus, and the next attempt to carry out a complete restoration was made by Luigi Cavenaghi at the beginning of this century. In 1924 the work was done all over again by Oreste Silvestri. In August 1943 the refectory received a direct hit during an American bombing raid, but *The Last Supper*, protected by sandbags, survived. In June 1947 there was a renewed attempt at restoration. The painting was almost invisible under a layer of greenish mold, and it seemed hopeless to expect that anything could save it. Nevertheless the attempt was made in the belief that there still remained some authentic touches by Leonardo's hand. Mauro Pellicioli, working with the Instituto Centrale del Restauro of Rome, produced a modern version, strangely evanescent and without definition, which seems to have been dragged up from the bottom of the sea with the salt and the sea slime still clinging to it.

At least eight, and perhaps a dozen, separate efforts were made to restore the painting, and inevitably every restoration partook of a further act of destruction. Each time the painting was killed; each time the painting refused to die.

When Goethe saw *The Last Supper* in May 1788 toward the end of his memorable journey to Italy, he saw the Mazza version, and when thirty years later he wrote his famous description of the painting in which he attempted to expound the psychological meaning of every gesture made by Christ and the apostles, this too was based on the Mazza version. On his table he had propped up a copper engraving made by Raffaello Morghen in 1800. He was therefore seeing a

Morghen version of the Mazza version and describing with considerable detail and complexity a painting that was only distantly related to Leonardo's original. Every age produced its own version, but the engravings and copies produced during the high tide of Romanticism were the least worthy of respect. Leonardo was as far as it is possible to be from a Romantic artist.

By a happy chance we have a contemporary account of Leonardo at the time he was painting *The Last Supper*. It was written by Matteo Bandello, a priest who became a writer of *novelle*, and a man who possessed a precise memory and a delightful way of telling stories. He wrote as follows:

> In the time of Lodovico Sforza Visconti, Duke of Milan, some gentlemen came to visit the Convent delle Grazie belonging to the Dominican friars and they used to sit very quietly in the refectory, gazing at the marvelous and very famous *Cenacolo*, which was then being painted by the excellent Leonardo Vinci the Florentine, who took great pleasure that everyone who came to see his work should freely express his opinion. It was his habit, as I myself have witnessed and observed on several occasions, to come here in the early hours of the morning and mount the scaffolding, for the *Cenacolo* is somewhat high above the ground; he was accustomed (I say) to remain there brush in hand from sunrise to sunset, forgetting to eat or drink, painting continually. Then he might stay away for two, three or four days without setting hand to it, or he would remain in front of it for one or two hours and contemplate it in solitude, examining and criticizing to himself the figures he had created.
>
> I have also seen him (as caprice or fancy took hold of him) departing in the middle of the day when the sun was in Leo from the Corte Vecchia, where he was working on his stupendous clay Horse and he would come straight to Delle Grazie; and he would climb the scaffolding, seize a brush, apply a brush stroke or two to one of the figures, and suddenly depart and go elsewhere.
>
> In those days Cardinal Gurcense the Elder was lodging in the Convent, and one day he happened to enter the refectory to take a look at the *Cenacolo*, at a time when the gentlemen mentioned above were assembled before the painting. Leonardo saw the Cardinal and came down to make reverence to him, and was most graciously received and greatly commended. Many subjects were discussed, especially the excellence of the painting; and several of those who were present expressed their regret that none of the ancient paintings which have been so highly extolled by good writers have survived, otherwise we would be able to decide whether the painters of our time were equal to those of antiquity.

The Cardinal asked what salary the Duke was paying him, whereupon Leonardo replied that his usual salary was two thousand ducats, and in addition there were the gifts and presents that the Duke lavishly bestowed on him. The Cardinal said this was a goodly sum, and left the *Cenacolo* for his own rooms and did not return. Then Leonardo began to tell the assembled gentlemen about the great honor that princes always pay to excellent artists, and went on to tell a pretty story on this theme. I, being present during this discourse, noted it in my memory so firmly that it was still present in my mind when I wrote my *Novelle*.

Italian scholars have had no difficulty identifying Cardinal Gurcense. He was a Frenchman, Raymond Perauld, who held the rich bishopric of Gurk in Carinthia, and was a favorite of the Emperor Maximilian. He is known to have visited Milan in January 1497. As for Matteo Bandello, we know that he was then living in Milan with his uncle, who was Father-General of the Dominicans. In 1497 he was about seventeen years old, and he was of an age to remember vividly the appearance and manner of Leonardo, yet we cannot be sure that Leonardo received two thousand ducats a year from Lodovico Sforza. The duke's largesse was notoriously uncertain and unpredictable. Writing in 1570, Gaspare Bugati, the author of *Storia universale*, says that Giorgio Merula d'Alessandria was paid 300 scudi a year, while "the excellent Florentine painter Leonardo da Vinci, who painted the miraculous *Last Supper* at the Grazie, received fifty scudi." Historians are likely to know the salaries enjoyed by historians, and Bugati may well have known the income of Merula, who wrote histories as well as essays. Whether Leonardo received 50 scudis or 2,000 ducats—scudis and ducats having the same value—must remain unknown until Lodovico Sforza's account books are discovered. Whether 50 or 2,000, it was a small price to pay for a masterpiece.

The years Leonardo devoted to *The Last Supper* were years of perpetual crisis. In 1494, when Leonardo began the painting, Lodovico allied himself with the King of France and invited the French army into Italy. Giangaleazzo Sforza, the husband of Isabella of Aragon, died of a mysterious disease in October, and the French army swept into Italy and conquered the Kingdom of Naples. In February 1495 the King of France was crowned King of the Two Sicilies in Naples, and in May, Lodovico received the investiture of the Emperor Maximilian, and thus found himself in alliance with the two most powerful rulers in Europe. He saw himself as the man of destiny, playing Maximilian against Charles VIII, the pope against the doge, Savonarola against the Medicis. Savonarola ruled Florence "in the name and

under the guidance of Christ," while the Medicis were in flight. A Borgia pope, Alexander VI, ruled over the papal states, the Venetians marched westward, and the smaller states like Mantua and Ferrara trembled like frogs in the presence of crocodiles. In January 1497 Beatrice d'Este died, and Lodovico Sforza lost his nerve. In the following year Savonarola was burned at the stake and Charles VIII died, to be replaced by Louis XII, who was even more determined to rule over Italy. The chessboard was being swept clean, and a new game was about to begin.

All this while Leonardo worked on *The Last Supper,* studied mathematics, physics, anatomy, and the dynamics of flight. We shall not understand the painting unless we set it in its own time amid wars and foreign invasions and endless betrayals; and we shall not understand his passion for pure inquiry until we remember that it was also dictated by events: it was both an escape from the horrors of the present and a relentless attempt to come to grips with the reality that lay behind the follies of his age.

We have seen that very little, if anything, remains of *The Last Supper* as he painted it. It has been scraped away and painted over and scraped away again. A ghost of a ghost, it confronts us with unanswered questions. The most important of these questions is: What did it look like in the few years when it remained on the wall of the refectory as Leonardo painted it, before it flaked away and suffered its interminable restorations?

There are a few clues, not as many as one could wish, but more perhaps than one could have hoped for. There are a few words written by Leonardo in his notebook, one or two stories told about him, some preliminary drawings and sketches, and some early copies, notably one by Solario in the Brera and another by Marco d'Oggiono in the Louvre. Copies made after 1550 are obviously quite useless, for painters were seeing the world in an entirely different way, and we shall learn very little from the famous engraving made in 1800 by Raffaello Morghen, which became the acceptable Romantic version of *The Last Supper.*

In one of his notebooks, now in the South Kensington Museum, Leonardo wrote a summary of the postures he expected to find in the apostles:

> One was drinking and left his cup in its place as he turned toward the speaker.
> Another twists the fingers of his hands and turns with stern brow to his companions.
> Another with outspread hands shows the palms and shrugs his shoulders up to his ears and gapes in astonishment.

Another speaks in the ear of his neighbor and the listener turns toward him to lend an ear, holding a knife in his hand and in the other a loaf half cut through.

Another, holding a knife in his hand, turns and upsets a glass on the table.

Another rests his hands on the table and stares.

Another leans forward to look at the speaker and shades his eyes with his hands.

Another draws back behind one who is leaning forward and sees the speaker between the wall and the man who is leaning.

Of these nine attitudes five are incorporated in the finished painting. Leonardo was seeing the apostles in action; all of them must reveal themselves in significant gestures and the separate gestures must flow into one another. He wrote in his *Treatise on Painting*, "A good painter has two chief objects to paint, man and the intention of his soul; the former is easy, the latter hard because he has to represent it by the attitude and movement of the limbs."

The difficulty of finding suitable models for the apostles was probably far less than the difficulty of finding the appropriate gesture. Leonardo wandered through Milan, searching for those decisive gestures, noting them in the small notebook that hung from his girdle, attempting to weld all the disparate elements into a coherent whole. Nearly all the hands point in the direction of Christ, some with conviction, others nervously. The hands, as always with Leonardo, seem to possess a life of their own, lighting up the whole table like candles.

Leonardo was an earnest student of faces and went to great pains to find the most perfect models. According to Giambattista Giraldi, he searched for a long time in the Borghetto, the slums of Milan, for the face of Judas. Giraldi wrote in 1554, when there were still a few people alive who could remember Leonardo at work on the painting:

As soon as he was prepared to paint any figure, Leonardo considered first its quality and nature, whether it should be noble or plebeian, gay or severe, troubled or cheerful, good or evil; and when he had grasped its nature he set out for places where he knew that people of that sort gathered together and diligently observed their faces, their manners, their habits, their movements; and as soon as he found anything that seemed suited to his purpose he noted it in pencil in the little book which he carried at all times at his girdle. My father, who took great interest in these things, told me thousands of times that Leonardo employed this method in particular for his famous painting in Milan.

But there were, of course, simpler means of discovering what he wanted. He had only to go to Lodovico's court, or among the clergy, or walk down any street to discover faces suitable for *The Last Supper*. He wanted faces of power and beauty, found them, and drew them with extraordinary brilliance. His drawings of James the Greater and Philip, now at Windsor, are among the greatest of his portraits, for they express not only power and beauty but also the refinement of sanctity. He drew St. Bartholomew, who has leaped to his feet at the end of the table, a robust and hard-featured man without a trace of sanctity in him, but he has an alertness and intelligence that cannot be seen in any of the other apostles. He drew Judas three times: dark-featured, ugly, hook-nosed, with large, curiously flat ears that cling to the side of his head. He has an impressive malignity. All these portraits are at Windsor, and there must have been separate studies of all the apostles. What is certain is that the features of James, Philip, Bartholomew, and Judas, as he drew them, were incorporated in the final painting, for these drawings have an air of finality. About a hundred separate studies must have been made, and altogether we have about a dozen. In his notebook he would sometimes remind himself of faces and hands he had seen. "Christ—the young count, the one with the Cardinal of Mortaro," or "Alessandro Carissimo of Parma, for the hand of Christ." The search for the faces of Christ and Judas presented the greatest difficulty. Vasari, writing more than fifty years later when the painting had already faded beyond recovery, told at second or third hand stories that had been current in Milan and lost nothing in the telling:

> They say the Prior was in a great hurry to see the picture finished, thinking it strange that Leonardo would pass half a day at a time lost in thought. He would have desired him never to lay down his brush, as if he were digging a garden. Seeing that his importunity produced no effect, the Prior complained to the Duke, who was tormented at such length that he finally sent for Leonardo and courteously entreated him to finish the work. Leonardo, knowing that the Duke was intelligent and discreet, talked fully about the painting, something he had never bothered to do with the Prior.
>
> Thus he spoke freely about his art, saying that men of genius are really doing most when they work least, for their minds are occupied with their ideas and the perfection of their conceptions, to which they afterwards give form. He told the Duke that two heads remained to be done: that of Christ, the likeness of which he could not hope to find on earth, and he had not yet been able to create in his imagination the perfection of heavenly grace. The other head that remained to be done was that

of Judas, and this had caused him much thought, as he did not think he could depict the face of a man so depraved as to betray his benefactor, his Master, the Creator of the World. But he was willing in this case to seek no further, and for lack of a better, he would do the head of the importunate and tactless Prior.

The Duke laughed heartily, saying that Leonardo was quite right. The poor Prior was utterly confounded and went back to digging in his garden, leaving Leonardo in peace. The artist indeed finished his Judas, making him a veritable likeness of treachery and cruelty. The head of Christ, as I have said, was left unfinished. The nobility of this painting, in composition and high finish, led the King of France to attempt to take it home with him. Accordingly he sought out architects in an attempt to construct a cradle for it in iron and wood, so that it could be transported without injury, without regard to the cost. Nevertheless the King was thwarted by the fact that it was painted on the wall, and it remained with the Milanese.

There are several things in Vasari's account worth noting. He does not say that the prior's face was used for Judas, although he half implies it. He has Lodovico Sforza firmly on the side of Leonardo, although we have evidence that the duke shared the prior's impatience with Leonardo's slow work, and was severely annoyed by it. We know, too, that the prior was an intelligent and good-natured man, and it would scarcely have occurred to him that a painter must paint "as if he were digging a garden." But although the story cannot be wholly true, neither can it be wholly false. Legend has embroidered on it, and Vasari has worked it up from accounts that were probably given to him by Francesco Melzi, Leonardo's adopted son and heir to his possessions, who did not meet Leonardo until some years later.

If we want to see the painting of *The Last Supper* as it originally appeared, it is necessary to dismiss the artistic theories that came later and go back to the source. Ideally, the best method would be to remove the paint on the walls of the refectory and discover the drawing underneath. Very little harm would be done, for as we have seen there remains only the faintest residue of Leonardo's paint on the walls. Alternatively it should be possible by means of laser beams to distinguish the lines of the drawing from the overlay of paint. Happily, there remains one source to which very little attention has been paid—an engraving attributed to the Master of the *Sforza Book of Hours*, made within two or three years of *The Last Supper*, when the paint was still fresh.

The engraving comes as a shock to modern eyes because in many ways it offers an image curiously different from the one to which we are

accustomed. The room is smaller, not square but hexagonal. Christ is enclosed within the hexagon. Christ himself is a larger and more monumental figure than we are accustomed to, his head more deeply inclined. James the Greater draws back, lifts up an imploring hand, and bends his head in such a way that it can be said that "his shoulder shrugs his ear." John, too, has made a greater inclination of his head. These inclining heads give a greater sense of movement near the center of the picture: the waves of figures lap close to Christ and do not touch him.

In smaller and greater details we can observe unexpected differences from the canonical version provided by Raffaello Morghen. Christ's left hand is open, as it lies on the table, but the right hand has the forefinger crossing the palm, so that three fingers remain to represent the Trinity. They are pointed at Judas, who is seen in a position that corresponds closely to the Windsor drawing. Christ is a towering figure, majestic, serene, untroubled; and the inclination of his head does not suggest sorrow so much as a kind of salute to the assembled disciples in answer to their cries and protestations. This heroic Christ is totally different from the Man of Sorrows depicted by Morghen. We are closer to the imperious and conquering figure depicted in many medieval paintings and most notably in the mosaic in the Cathedral of Cefalù. His head blocks out the light from the window, and if he stood he would almost reach the ceiling.

The tablecloth, too, is very different. It is unpatterned, there are severe folds, and it cuts across the engraving with solemn finality. Just below Christ there are the words written in Latin: "Amen, I say unto you, One of you shall betray me." Below the table, at the extreme right, a dog crouches low with its tail curling in the air. To our modern tastes the inscription and the dog are both offensive, and it is tempting to believe that they were introduced by the engraver and lack the authority of Leonardo. We could believe this more readily if we did not know that Leonardo's notebooks contain a large number of studies of dogs, and this dog can be found in them in exactly the same position. As for the inscription, we may feel that it is out of place, that it says nothing we did not know before, that Leonardo with his exquisite refinement would have refused his assent to so obvious a statement being written across his painting. Yet in the London version of *The Virgin of the Rocks* we can still read the word *Ecce* [Behold] on the scarf of the infant John the Baptist.

The engraving by the Master of the *Sforza Book of Hours* has received less attention than it deserves. It has usually been regarded as a rather hackneyed work, unworthy of its subject, dry and cold. Nevertheless the engraver was a man who knew his craft. He was con-

fronted with an almost insuperable problem, and performed his task much better than we give him credit for. If we imagine that he was seriously attempting to render *The Last Supper* in line, as he saw it and as others saw it, and if we accept the fact that seems to me demonstrably true that he was among the five or six master engravers of his time, we may find ourselves approaching his work less cautiously. He is hard and stark, where Raffaello Morghen is romantically soft and tender. But it was not Leonardo's purpose to be soft and tender in describing *The Last Supper*. A betrayal has taken place; a bomb has fallen. And what we see is the scattered debris left by the bomb. We see the actors in a moment of terror, all except one of them frozen into immobility.

La pittura è rovinata tutta. Ruin is implicit in the very nature of the painting, which is about the ruin of Christ.

Lomazzo tells an extraordinary story about Leonardo's difficulty in painting the face of Christ, suggesting that it was left blank or lightly sketched in. Here is Lomazzo's story as it is recounted in Richard Haydocke's admirable translation published in 1598:

> Having finished all the other Apostles, he presented the two Jameses with such perfection of grace and majesty that endeavoring afterwards to express Christ, he was not able to perfect and accomplish that sacred countenance, notwithstanding his incomparable skill in the art. Whence being in a desperate case, he was forced to seek the advice of Bernardo Zenale concerning his fault, who used these words to comfort him: "O Leonardo, this thine error is of that quality that none but God can correct it; for neither thou, nor any man living is able to bestow more divine beauty upon any figure than thou hast upon these Jameses. Wherefore content thyself, and leave Jesus imperfect, for thou mayest not set Jesus near those Apostles." Which advice Leonardo observed, as may appear by the picture at this day, though it be much defaced.

Lomazzo's story is generally regarded as fictitious, but since he is nearly always accurate and truthful, it would be more reasonable to imagine that it was at least partly true: that Leonardo had the greatest difficulty painting the face; that it was painted last; that he was never completely satisfied with it. Certainly the young Christ in the Brera, a much restored pastel study of a romanticized and sentimental Jewish youth with soft and heavy lids, is far removed from the Christ who finally appeared on the walls of the refectory. The Master of the *Sforza Book of Hours* offers a portrait of a commanding Christ charged with the energy of the Incarnation. It is far more likely that

Leonardo painted a commanding Christ rather than the gentle Christ who appears in Raffaello Morghen's engraving.

Of the original texture of the painting we know little. One fragment of information is provided by Fra Luca Pacioli, who watched the painting coming to birth and saw it when it was fresh on the wall. He wrote in *De Divina Proportione* that the figures of *The Last Supper* were so lifelike that they could be compared "with the grapes of Zeuxis and with the veil painted by Parrhasios which Zeuxis tried to draw aside." The story was told that the grapes of Zeuxis appeared to be so real that the birds pecked at them, and there was also a story that the young and brilliant Parrhasios when in competition with Zeuxis drew a curtain or veil which Zeuxis attempted to pull back, thus showing that he would be fooled like everyone else. Pacioli's statement tells us that the figures of *The Last Supper* were rounded and vividly three dimensional to a quite extraordinary degree and that the monks sitting at the refectory tables could feel that they were looking not at a representation of the Last Supper but at the Last Supper itself. Something of that three-dimensional quality is conveyed in the engraving by the Master of the *Sforza Book of Hours*.

Today we see a painting that seems to have been immersed for centuries in the sea, encrusted with shellfish and barnacles and the bones of strange sea creatures, grayish-blue and shadowy. We see a kind of shadow play with the apostles in stylized attitudes of fear, bewilderment, and surprise. It needs an effort of the imagination to reconstruct the original painting and to see it as it was: brilliantly colored, bathed in sunlight, the life-size figures standing out in three dimensions, the faces glowing with life and the gowns rich with color. Crimson tapestries gleamed on the walls. The arrangement of the figures was pedimental, and the painting can therefore be compared with the west pediment of the temple of Zeus at Olympia, where Apollo stands at the center in an attitude of command, one arm outflung, but very quiet and self-contained, for he has no need to demonstrate his powers to still the raging chaos around him.

So it is in *The Last Supper*, where Christ resembles the advancing prow of a ship, and the terrified apostles like white-capped waves are hurled back by the superhuman power of his presence.

The Proud and the Humble

The Last Supper was finished by the autumn of 1497, and Leonardo could now look forward to a period of uninterrupted and leisurely study. More than any other painting this one established him as a master of masters. He was now famous all over Italy, and cultivated in Milan as never before. He did not know and could not guess that his orderly life would soon undergo a sudden alteration and that the dynasty of the Sforzas would be overwhelmed by a series of catastrophes. Soon *The Last Supper* would be ruined; it would die on the wall; and the horse too would be ruined and vanish without a trace. But in those last years of the fifteenth century, in the sunset glow of Sforza rule in Milan, he achieved a contentment he had never previously known.

He was happy in his friends. In 1496 there entered his life a friendly, garrulous, and highly intelligent Franciscan father who

thereafter became his constant companion. His name was Fra Luca Bartolomeo de Pacioli, and he was born in Borgo San Sepolcro. He had two brothers, Zunipero and Ambrogio, who both became Franciscan monks. He was born about 1440, and was ordained when he was about twenty-five years old. He was in his early thirties when he gave lectures on mathematics at the university of Perugia. Afterward he led a wandering life, for we find him teaching in Zara in what is now Yugoslavia, in Rome, and in Naples. A painting by Jacopo de' Barbari, now in the Museo di Capodimonte in Naples, shows him giving a lecture in full Franciscan uniform, wearing a cowl and a long black gown, with a knotted rope for a belt, and on the table in front of him lies a book, a pair of compasses, an inkstand, and a slate on which he has just drawn two triangles within a circle with a piece of chalk. The face that peers from behind the cowl is alert with intellectual vitality, wide-eyed, thin-lipped, with a powerful nose and jutting jaw. Beside him, almost crowded out of the painting, and perhaps added as an afterthought, stands the famous Guido Ubaldo, Duke of Urbino, dressed in silken panoply. The duke was one of his many patrons.

In 1496, Fra Luca came to Milan under the patronage of Lodovico Sforza, who appointed him professor of mathematics at the university of Pavia and at the academy in Milan. He was then working on his most important work, a study of mathematical and geometrical proportions called *De Divina Proportione*, which he completed in the following year. One manuscript copy was presented to Lodovico Sforza, a second to Pietro Soderini, later to become gonfalonier of Florence, and the third to Giangaleazzo da Sanseverino. The book was finally published in Venice in 1509.

De Divina Proportione is a curious work, garrulous and very personal, splendidly illustrated with designs of extremely complex geometrical structures by Leonardo, and in addition there are designs for an alphabet in very large type constructed on geometrical principles. In dignity and power they are perhaps the finest letters ever designed, and although Fra Luca does not say who designed them while half implying that he designed them himself, there is little doubt that Leonardo was responsible for them. Geofroy Tory, an engraver, wrote an essay on artistic principles called *Champ Fleury*, which was published in Paris in 1529, ten years after Leonardo's death. In it he asserts on excellent authority that they were indeed designed by Leonardo:

> Fra Luca Pacioli of Borgo San Sepolcro, belonging to the order of the Friars Minor, and a theologian, has written in vulgar Italian a book entitled *Divina Proportione*, and has essayed to draw the Attic letters, but says nothing about them, nor does

he give any explanations; and I am not surprised, for I have
heard from some Italians that he purloined the said letters from
the late Messire Leonardo da Vinci, who died recently in Am-
boise, and was a most excellent philosopher and admirable
painter and, as it were, another Archimedes.

It was the fashion of the time to borrow unashamedly, and Fra
Luca, who printed a large portion of Piero della Francesco's treatise
on proportions in a book that bore his own name on the title page,
was a notable borrower. He could also on occasion be generous in his
praise of the people he borrowed from or who did him great service.
Leonardo's wonderfully precise geometrical constructions were espe-
cially praised in the book. "The sixty geometrical drawings for this
work were made by Leonardo's ineffable left hand [*ineffabile sinistra
mano*], well schooled in every mathematical exercise. He writes in
reverse, so that it is impossible to read him unless you use a mirror or
hold the reverse side of the page to the light, as is my custom."
Evidently Fra Luca was permitted to read the notebooks, and he ap-
pears to have been one of the few who did so during Leonardo's life-
time. He was very proud of Leonardo's friendship, and when in the
tenth chapter of *De Divina Proportione* he wrote about pyramidal
forms, he reminds the reader that "these figures, together with all the
others in this book, are from the hand of our aforesaid compatriot
Leonardo da Vinci of Florence, whose designs and figures truly no
man can surpass."

It was more than hero worship on the part of an aging mathe-
matician. He had found in Leonardo precisely what Leonardo had
found in him: an inquiring mind devoted to mathematical order, a
sense of rigor, a detachment from the things of this world, together
with a human warmth and true friendship. About this there can be no
doubt at all. *De Divina Proportione* is written awkwardly, tiresomely,
incompetently. He stops himself in the middle of a sentence, pauses to
listen to the echo of his own voice, and then starts off again on an en-
tirely different subject. A man can have a powerful mind and be a bad
writer; he can be a good speaker and write like a schoolboy. Leonardo
would not have been dismayed by Fra Luca's incompetence as a
writer, and he clearly cherished his Franciscan friend for other rea-
sons than his ability to write some of the most sodden prose that ap-
peared in the Renaissance. Leonardo, who once called himself "a man
without letters," wrote with style. Fra Luca would not have known
what style was. It did not matter, for they enjoyed each other's com-
pany and were happy together.

Fra Luca thought best in mathematical terms, and he enjoyed pep-
pering his prose with mathematics. In one of the many tributes to

Leonardo in his work he observed that the horse was 12 ells high, corresponding to 27 feet. Then to emphasize the height he drew two parallel lines on the large page and explained that it was 37 and ⅘ as high as the distance between the lines, and he appears to have been much more interested in the height and weight of the horse than in the horse itself. He wrote:

> Leonardo da Vinci, who has justified his name in sculpture, gesso, and painting against all rivals, as in the marvelous equestrian statue which is 12 ells high, that is, 37 and ⅘ times as high as the line *ab;* and the entire weight of it amounts to two hundred thousand pounds, counting the ordinary ounce as one twelfth of each pound. This statue was dedicated to the memory of your late undefeated father and is far removed from any jealousy of the statues of Phidias and Praxiteles on Monte Cavallo.

It was characteristic of Fra Luca to draw those lines on the page to measure out the height of the enormous horse. There was something of the schoolmaster in him; he enjoyed demonstrating, he enjoyed the sound of his own voice, he enjoyed giving praise. He gives the impression of a man who was overwhelmed by his good fortune in encountering Leonardo and in being a member of the court of Lodovico. His excitement and pleasure are manifest. He has many claims to fame. He wrote the first general work on mathematics. He published the first accurate description of double-entry bookkeeping. He was among the first to design noble lettering, even though he clearly worked with the assistance of Leonardo, and without him we would not have the magnificent designs for complex solid structures which are among the chief ornaments of *De Divina Proportione*. As he seeks to find the divine proportions of all things, he is always down to earth. So he goes hunting after the perfect proportions of fortress walls, battlements, and bastions, but also of bedchambers, stables, baths, latrines, fountains, windows, porticoes, palaces, streets, market places, lettering. Nothing human is alien to him. In the midst of it all he will pause and talk about the stonecutter at Borgo San Sepolcro who was his relative and a great warrior and lose himself in his reminiscences. He was perhaps the closest friend Leonardo ever had.

For Leonardo these were years of excitement, of mounting fame, and extraordinary accomplishment. He was the court painter and master of ceremonies, sculptor and military engineer to the Duke of Milan, but these were his less important duties compared with the duties he gave himself—research in anatomy, hydraulics, and the nature of flight. At this time he was living in the same palace as Isabella

of Aragon. He had his pupils around him and wanted for nothing. Suddenly in 1495, or perhaps a year later, he lost someone who was very dear to him. We know the name of the woman—Caterina. We know that she had been in the hospital and that he had visited her there, and that on January 29, 1494, he gave her twenty soldi, for all this is written down in his notebook. But we do not know her full name, or in what relation she stood to him. It is possible and even likely that the woman was his mother, who would have been about sixty in 1495. He wrote in his notebook:

EXPENSES FOR CATERINA'S BURIAL

For 3 pounds of wax	s. 27
For the bier	s. 8
A pall over the bier	s. 12
For carrying and placing the cross	s. 4
For carrying the dead	s. 8
For four priests and four clerks	s. 20
Bell, books, sponge	s. 2
For the gravediggers	s. 16
For the ancient one	s. 8
For the license from the officials	s. 1
	106
For the doctor	s. 5
Sugar and candles	s. 27
	138

The list of expenses is worth examining, for it offers some clues about the person being buried. In his own will, written some twenty-three years later, Leonardo asked that "ten pounds) of wax in thick tapers" should be given to each of the three churches in Amboise celebrating his funeral; it was therefore his desire that the services should be brightly lit. In the same will he writes that Maturina, his serving woman, shall receive a black fur-lined cloak, a roll of cloth, and "two ducats paid only once," which would suggest that he was not uncommonly generous to his servants. About a third of Caterina's burial expenses went to candles, and it is unlikely that Leonardo would have spent so much for a serving woman, nor would he have paid for so many priests and clerks to take part in the burial. The evidence would seem to point decisively to a person who was much closer to him and more beloved than a serving woman. It could have been a mistress or the widow of a dead friend left in his charge. But the only woman called Caterina known to have been close to his heart was his mother. We would not be surprised to find her visiting her son in Milan, and being taken ill, and being placed in a hospital. Nor is there anything

in his whole life that would suggest that he had anything but continuing affection for the woman who gave birth to him.

Soon after the death of Caterina, there were two more deaths that profoundly affected Leonardo and everyone else in Milan. The first took place on November 23, 1496. Bianca Sforza, Lodovico's natural daughter and the joy of his life, died suddenly of a raging fever. She was not yet fifteen and had recently married Giangaleazzo da Sanseverino. Lodovico was inconsolable; the court was plunged into mourning; the world without the presence of that sweet-tempered child looked suddenly grim. She was buried in Santa Maria delle Grazie. Worse was to come. A little over a month later there was a death that shattered Lodovico and drove him nearly insane.

It was the custom in Milan to hold a *festa* to celebrate the beginning of the New Year. Although the court was in deep mourning it was decided this year to celebrate the *festa* in the Castello with the utmost splendor, if only to drive out the melancholy that infected everyone's spirits. Lodovico and Beatrice urged their guests to come in their most alluring costumes. There were the usual footmen dressed up as Turkish mamelukes, Greek *stradiotti*, Swiss lancers, and Scottish archers; there were youthful pages dressed in parti-colored livery with the arms of Sforza-Visconti emblazoned on their breasts; heralds and trumpeters; musicians, candlemen, and serving girls. The guests were led through a long succession of rooms: the Room of the White Doves, the Golden Room, where the ducal hunt was painted on the walls, the Purple Room hung with purple silk and blazoned with gilded coats of arms, and the Black Room, which had been designed by Bramante and served as a cloakroom for the ladies. There was a feast, where the meat courses were served on gold plates and the fish courses were served on silver plates. While they ate, the guests were entertained by singers in the musicians' gallery, and by full orchestras, and in the lull between the musical interludes clowns, dwarfs, and buffoons paraded through the vast dining room. After each course the footmen replaced the napkins, knives, and saltcellars. Afterward came the sweets, which took the form of statues made of marzipan, pistachio, and almond paste. Then there were dances, and these were interrupted by displays of fireworks and entertainments devised by the courtiers especially charged to produce the most extraordinary scenic effects. Beatrice danced through the night. She had spent part of the morning praying at the tomb of Bianca Sforza in Santa Maria delle Grazie. She was obviously unwell, was eight months gone with child, and should have been nowhere near the dancing floor. At dawn she had a miscarriage. A stillborn baby girl lay beside her, while Lodovico attempted to summon her back to life although she was visibly dying. Isabella of Ara-

gon came, and for a while the two duchesses of Milan whispered to-
gether, very quietly, holding hands. And when the dawn came,
Beatrice was dead.

Although he professed to be a vigorous and fearless tyrant, Lodo-
vico was in fact a weak-willed and fearful man who relied largely on
the advice of others. One of those upon whom he relied for advice
was Beatrice, who had a quick, uncomplicated, independent mind. He
felt lost without her, and his grief was terrible. He spent the whole day
and night beside his dead wife, refused to eat, wept continually, aban-
doned himself to despair; and though he revived sufficiently to organ-
ize and to attend the funeral, giving instructions on exactly how many
candles were to be carried, and the size of the black and purple hang-
ings over the altar, and exactly what the mourners should wear—he
himself wore a torn black gown of rough material—he was still insane
with grief when the funeral was over. He saw no one, secluded him-
self in a room hung with black draperies, screamed and cursed,
prayed, fell into a long stupor, sang hymns, and acted as though he
was demented. For two weeks, according to the ambassadors who sent
long reports to their governments, Lodovico neither slept nor ruled
the state nor said an intelligent word. At his orders a hundred torches
burned continually before the altar of Santa Maria delle Grazie. Just
below the altar Beatrice was buried.

He took to coming daily to the church, and twice a week he dined
with the monks in the refectory. He bestowed on them gifts of rich
brocade and silver vessels together with the income of one of his pri-
vate estates; and he became deeply religious, and was strangely quiet
and gentle in public. A few months later his mistress, Lucrezia Cri-
velli, gave birth to a boy, who was christened Gian Paolo. The birth of
another illegitimate child encouraged him to feel that God was mer-
ciful and that even now, in spite of all his faults, he was under divine
protection. The people of Milan were less certain: they felt that the
deaths of Bianca and then Beatrice portended ill for the Sforza dy-
nasty.

Six months after Beatrice's death, on June 29, 1497, Lodovico sum-
moned the ducal secretary, Bartolommeo Calco, and dictated a set of
instructions to Marchesino Stange, the chief executive official in his
court, concerning the work he wanted done by Leonardo and by a
Milanese sculptor and architect called Cristoforo Solari, nicknamed *Il
Gobbo*, the Hunchback, to convert Santa Maria delle Grazie into a
family mausoleum, or at least into the church that would serve as the
mausoleum for all present and future Sforzas. It was a long list of re-
quirements, many of them concerning inscriptions and medallions in

honor of himself and of Beatrice in various parts of Milan. The more important requirements were:

> *Item,* see whether Il Gobbo, in addition to the sepulcher, can make part of the altar during the present year, and find out if he has all the necessary marble for it. If more is needed, send to Venice or Carrara for it.
>
> *Item,* so that the sepulcher may be finished all at once, see that Il Gobbo is set to work on the covering and attends to all the other parts, so that when the *navello*[1] is completed, the rest of the sepulcher will be ready.
>
> *Item,* urge Leonardo the Florentine to complete the work he has begun at the Refectory of the Grazie, so that he may start with the other wall of the same Refectory, and have him sign a contract obliging him to finish the work within the stipulated time.

Cristoforo Solari is forgotten now, but in his own day the Milanese prized his work highly. Vasari tells the pleasant story that Michelangelo overheard some visitors from Lombardy talking about his statue, the *Pietà*, in St. Peter's. One of them asked who had done it, and another replied, "Our Il Gobbo of Milan." Furious, Michelangelo came during the night and carved his own name on the statue lest anyone else should think it was done by the hunchback of Milan.

Very little knowledge about Solari's sepulcher has survived, because it was broken up and dispersed in 1564 as a result of doctrinal decisions reached at the Council of Trent. We know that Leonardo was called in as an adviser, and he made a number of detailed sketches. The Sforza sepulcher was exceptionally gaudy and ornate, with blazons, columns, marble canopies, with recumbent figures of Lodovico and Beatrice lying side by side, and with a relief carving of the Entombment at eye level, as we learn from a certain Pasquier Le Moine, a French priest who accompanied Francis I's expedition to Italy in 1515. Leonardo, abandoning simplicity, lent himself to the sumptuous ornamentation of the tomb.

Although *The Last Supper* was still unfinished, it was very close to being finished. Lodovico appears to have been contemplating the hope that Leonardo could be induced to do another painting on the wall opposite *The Last Supper*, on which Donato Montorfano had already painted a Crucifixion, a fresco of no special merit. It is possible that he intended that Leonardo should paint one of the side walls, and it is very likely that he had already discussed with Leonardo exactly what he wanted, and equally likely that Leonardo, with *The Last Supper*

[1] *Navello* was the term used for a boat-shaped or trough-shaped sarcophagus.

still unfinished, was in no hurry to embark on a new painting which would consume so much of his energies.

Montorfano's *Crucifixion*, retouched and repainted, survives. The artist's inadequacies become all the more evident when contrasted with Leonardo's painting. Then, as now, it seems a very sorry representation of the Crucifixion, without the least excitement. The artist had little feeling for landscape and he was incapable of suggesting the grandeur of the event. The three crosses neatly fall into place below the three lunettes. Two white horses stand equidistant from the central cross and dominate the painting. Behind the crosses there stands a vast Renaissance palace, which could have been designed by Bramante and is intended to represent Jerusalem. It is not so much that the painting has little merit as that it seems totally out of place in the refectory, and very little harm would be done if it was scrubbed off the wall. Since he had decided to transform Santa Maria delle Grazie into a mausoleum and a private monument, Lodovico ordered that portraits of himself and Beatrice d'Este kneeling at the foot of the cross should be painted into the picture. This was done. Vasari, writing in 1568, believed that Leonardo painted the portraits of Lodovico, Beatrice, and their two sons. "While he was working on *The Last Supper* in the same Refectory where, on the end wall, there is a painting of the Passion in the old manner, Leonardo portrayed Lodovico himself and his eldest son Massimiliano and on the other side the Duchess Beatrice with the other son Francesco, both of whom later became Dukes of Milan, and all of them beautifully painted." Lomazzo, writing in 1584, when he was blind, came to the same conclusion: he was quite certain that Leonardo painted these portraits. They faded quickly; soon most of the paint had flaked away; but the legend that there were once four portraits of members of the ducal family painted by Leonardo on Montorfano's *Crucifixion* persisted. In 1943, after the bombing of Santa Maria delle Grazie, the broken and faded paint on the portraits was removed and it was at last possible to see the red ochre outline drawing on the wall. On the basis of this drawing it was not difficult to conclude that Leonardo could have had nothing to do with the painting of the portraits.

For Leonardo the concluding years of Lodovico's reign were difficult and dangerous. Like all tyrants, Lodovico was unpredictable, and in these days he was more unpredictable than ever. He was wracked by grief, and at the same time intensely aware of the uncertainties of his position. Prices were rising, the people were murmuring against him, the days of his great popularity were over. He made great plans and nothing came of them; ordered works of art and for-

got to pay for them; and continued to settle estates on the Church and
on his mistresses. His extravagances were ruining the state.

Leonardo was also living extravagantly. Salai demanded expensive
clothes, and Leonardo paid for them. Thus we find in his notebook,
under the date April 4, 1497, a detailed statement of the cost of sup-
plying Salai with a cloak of silver cloth trimmed with green velvet:

4 braccia of silver cloth	L 15	S	4
green velvet trimming	L 9		
binding		S	9
loops		S	12
for the making	L 1	S	5
binding for the front		S	5
stitching			
	L 26	S	5

This was an appalling amount of money to spend on a cloak, and
Leonardo rather characteristically added it up wrongly. He added
later, in chalk, the words "Salai stole the soldi," suggesting that Salai
ran off with the loose change.

Meanwhile little money was coming in. Appeals to the duke or the
duke's secretary for moneys due to him were unavailing. He wrote
and tore up an urgent plea for money, which is all the more moving
because only a torn fragment remains:

> Lord, knowing the mind of Your Excellency to be occu-
> pied . . .
> to remind Your Lordship of my small matters . . .
> I should have remained silent . . .
> that my silence should be the cause of making Your Lordship
> angry . . .
> my life in your service I hold myself ever ready to obey . . .
> Of the horse I shall say nothing because I know the times . . .
> to Your Lordship my salary is now 2 years in arrears . . .
> with two masters whose salaries and board I have always
> paid . . .

There was a good deal more of it. In another draft of a letter
Leonardo speaks more directly and coherently about his poverty, ex-
plaining that he had to stop work on one of the duke's commissions in
order to provide himself with a livelihood and feed his family:

> I regret very much to be in want, but I regret still more that
> this has been the cause of the interference with my desire,
> which has always been to serve Your Excellency. I regret very
> much that having to earn my living has forced me to interrupt

the work which Your Lordship entrusted to me and to attend to small matters.

Nevertheless in a short time I hope to have earned so much that I may be able with a tranquil mind to carry it out to the satisfaction of Your Lordship to whom I commend myself; and if Your Lordship thought I had money, then Your Lordship was deceived because I have to feed six mouths for 36 months, and have received 50 ducats.

It may be that Your Excellency did not give any further orders to Messer Gualtieri, in the belief that I had money . . .

Although pleading poverty, Leonardo was not destitute. There was income from his inventions, the machines he built, surveys he made, paintings for private persons and for churches. We hear of a projected altarpiece for the Church of San Francesco in Brescia, for which he may have been given an advance payment, and we know he was a close friend of Francesco Nani of the Franciscan Order in Brescia and drew his portrait in his notebook. He had at this time a multitude of friends but few patrons. One of his friends was Iacomo Andrea da Ferrara, an architect and the author of a commentary on Vitruvius. Luca Pacioli, writing in 1498, said that Iacomo Andrea and Leonardo were like brothers. We know very little about this architect, who left his name on no buildings in Milan, but we know that he was a man of great courage. Loyal to the Sforzas, he remained in Milan after its occupation by the French, took service with the invaders, and plotted against them. He was caught, placed on trial, and sentenced to death. Archbishop Pallavicini attempted to intercede for his life, but without success. Iacomo Andrea da Ferrara was publicly beheaded on May 12, 1500, and his body was quartered and placed on four different gates of the city. Leonardo did not plot against the French; instead he took service with them.

Leonardo was by nature cautious—cautious with his life, cautious with money. He took no part in political movements or in theological disputes, the two most dangerous occupations of his time. He had very little interest in history, and knowing only the rudiments of Latin and no Greek, he possessed only a superficial knowledge of classical authors. There were vast areas of knowledge closed to him. This did not concern him in the least. The task he had given himself was to understand the world as it is, to examine afresh, to survey, to plumb all the secrets of nature, and to paint gloriously.

For this reason he needed to travel, and he traveled extensively. In March 1498, Lodovico, having recovered sufficiently from his grief, set out on a grand tour of his possessions. Leonardo, as one of the duke's military engineers, accompanied him. At Genoa, where a breakwater

had been severely damaged in a storm, he made some notes on the strength of the iron bars that had been twisted out of shape by the violence of the storm. His notebooks are crammed with jottings of this kind. He notes the real, the actual; there are few theories.

When Leonardo returned to Milan, there took place, unknown to him, an interesting exchange of letters between Isabella d'Este and Cecilia Gallerani, who had been married off to Count Lodovico Carminati Bergamini, a complaisant husband who permitted her to return whenever she pleased to the arms of Lodovico. Isabella d'Este was the sister of Beatrice and the wife of the lord of Mantua. She was a notable connoisseur of paintings, and a woman of great charm and persistence, as Leonardo was to learn later. Niccolò da Correggio, the perfect courtier, called her "the first woman of the world." This was a tribute to her charm, her learning, and her good taste, for Mantua was a small principality, a perpetual pawn on the political chessboard, and she had neither power nor influence on the course of events. As a lover of paintings and an admirer of Leonardo she wanted to borrow Leonardo's portrait of Cecilia Gallerani. She wrote on April 26, 1498:

> Having today seen some beautiful portraits by the hand of Giovanni Bellini, we found ourselves discussing the works of Leonardo and felt the desire to compare them with these paintings. And then we remembered that he painted a portrait of you from life, and so we have sent a horseman to you, begging you to entrust it to him, so that we may not only compare these works but also so that we may have the pleasure of seeing your face. As soon as we have made the comparison, we shall return it to you.
>
> ISABELLA D'ESTE

Cecilia Gallerani replied in a letter of exquisite tact, pretending to be delighted by the invitation to lend a painting, which she might not see again for many months. The painting had been made when she was at least ten years younger and she no longer resembled the youthful portrait. She wrote three days later:

> Most Illustrious and Most Excellent Lady and by me Most Honored
>
> I have read what Your Highness has written to me about wishing to see my portrait, and would send it with even greater pleasure if it were more like me. But Your Highness must not think this proceeds from any defect of the Master, for in truth I do not believe there can be found another painter equal to him, but only because the portrait was made when I was of a tender age. Since then my image has completely changed, so much so

that if you saw the picture and myself together, you would never dream it was meant for me.

Nevertheless I beg Your Highness to accept this proof of my good wishes, and not only this portrait but I myself am ready to do everything possible to gratify your wishes, being your most devoted slave, and I commend myself to you an infinite number of times.

<div align="center">

Your Highness's servant,

SCICILIA BERGAMINI VISCONTA

</div>

The elegance of Cecilia's reply shows the manner of person she was. There are good reasons for believing that she was playing games. Isabella d'Este had a plain face, and only her most devout courtiers would have called her beautiful. Cecilia was, and remained, a raving beauty. She was doing everything she possibly could to please Isabella, to set her at ease. She was almost remorseful of her own beauty and at the same time she rejoiced in it.

Leonardo painted the portrait of Lucrezia Crivelli, another mistress of Lodovico. The painting is now lost. We know Leonardo painted her because he kept in his notebook three Latin epigrams about the painting. The epigrams are conventional, but two lines stand out for their marmoreal quality:

> *Rara huic forma data est; pinxit Leonardus; amavit Maurus;*
> *pictorum primus hic; ille ducum.*

A rare beauty is shown here; Leonardo painted her; the Moor loved her; one the first of painters, the other the first of princes.

But the rare beauty has vanished; no portraits of her survive; she exists only in the enchanted dream world full of those Madonnas and Christ childs and beautiful women that are known to have been painted by Leonardo and were devoured by time, fire, war, and accident, the enemies that were always lying in wait for him. He had no power over the future and it was not his fault that so many of his works were lost or ruined.

Meanwhile he continued to live in the apartments set aside for him in the Corte Vecchia, the old Visconti palace overlooking the cathedral. The palace was once the seat of the Milanese consuls. Matteo Visconti, the first of the Milanese tyrants, transformed it into a fortress, with towers and moats, and he worshiped in the nearby Church of San Gottardo with its dizzying spire. In Leonardo's time the Corte Vecchia was a rather mysterious place, inaccessible to the public, inhabited by high officers of state and ducal pensioners; the moat had been filled in; the towers were leveled; the palace became a labyrinth

of splendidly furnished apartments built around two immense court-
yards. Although it was no longer the center of power, for all power
emanated from the Castello in the west of the city, it represented the
royal presence in the heart of Milan. Above all, it was the official resi-
dence of Isabella of Aragon, Duchess of Milan.

Leonardo's apartments were in the second courtyard, in the south-
east corner, in the shadow of the magnificent octagonal spire of San
Gottardo. His apartments consisted of at least four rooms on two
floors, and were sumptuously furnished except for the studio, which
may have been furnished very simply to avoid distractions. One room,
the largest, was a reception room; the workroom was probably also a
dining room; the studio was probably upstairs to take full advantage
of the northern light; there may have been servants' quarters under
the roof. We know something about the arrangement of the rooms be-
cause Leonardo wrote a curious note at a time when he was con-
structing in great secrecy the model of a flying machine based on his
study of a bat's wings. He was immensely impressed by the wonderful
maneuverability of bats and he had reached the conclusion that they
were more worthy of study than birds. He proposed to construct the
model in the large upstairs room after carefully boarding the window,
and then he would take the machine onto the roof and put it through
its trials. The roof in this place was hidden from the workmen work-
ing high up on the cathedral because the spire of San Gottardo ob-
structed the view. He wrote in his notebook:

> Cover up with boards the large room above, and make the
> model large and high; and this may be placed on the roof
> above, which would be more suitable in all respects than any
> other place in Italy. And if you stand upon the roof at the side
> of the tower, the men at work upon the *tiburio* will not see you.

He wanted secrecy for the best of reasons: the experiment might
fail. He clearly intended that the first flight should be a kind of gliding
flight from the roof of the southeast corner of the Corte Vecchia into
the courtyard itself. Few people would observe it, and those who saw
it would be sworn to secrecy. Here in the very heart of Milan, in a
place "more suitable in all respects than any other place in Italy," he
hoped to prove that human flight was possible.

While he was conducting this experiment and many other experi-
ments, he was also painting his neighbor, the widowed Isabella of
Aragon, Duchess of Milan.

Mona Lisa and Isabella of Aragon

There exist a very few paintings—Jan van Eyck's *Arnolfini Wedding* and Van Gogh's *Sunflowers* are among them—which have become so familiar that it is almost impossible to see them with fresh eyes. Like the *Mona Lisa*, they have become a part of us; they have entered into the depths of our consciousness, where they are almost lost to us, and when we dredge them up we have no feeling of surprise. Familiarity has almost destroyed them. They are like the features of our brothers and sisters, or like the old furniture in the room; we have known them so long that we would be hard put to describe them. We know the *Mona Lisa*, and do not know her. For most of us she exists in an agreeable limbo, remote and inaccessible, and yet so close to us that we can be tolerant when crude jokes about her, sometimes very vicious jokes, are made by artists who have grown weary of her or by advertisers who know that the people who read advertisements recognize her instantly.

The *Mona Lisa* is a special case of a painting which has become virtually invisible. Like the *Sunflowers,* it was once electric with vitality, but we are not aware of any shock: the electricity has been turned off by the deadening effects of familiarity and also by the heavy yellowish varnish that obscures her face so that we seem to see her through a veil or a mist. Even when we are very close to the painting, and perhaps especially when we are very close, there is the sensation of being in the presence of an illusion, of something that cannot possibly exist, and has no right to exist outside our imaginations. Seen close up, the face of the *Mona Lisa* dissolves into a myriad of intricate cracks due to the weathering of the painted surface. Seen from a distance, the face dissolves in chiaroscuro. It is difficult to find the middle ground, where the face can be seen to perfect advantage, exactly in focus. And how to dissociate the face from the legends that have accumulated around it?

It is as though there exists a kind of conspiracy to prevent us from seeing it, even when we stand before it in the Louvre. We are intimidated by the sheer mastery of the painting, and we are also intimidated by the name Leonardo. We recognize that it is unique in a very special way. If it were decreed that all the paintings in Europe save one must be destroyed, we know which one would have to be saved. If by some miracle the painting was put up for auction, we know that it would be bought for a price far greater than any price paid for any known painting. Fifty million dollars? A hundred million dollars? And suddenly we realize that these staggering sums are meaningless, and at the same time the incalculable value of the painting also serves to separate us from the painting.

One of the inevitable effects of familiarity is to stupefy the sense of judgment, so that we see in her what we want to see. Walter Pater, who, as we shall see, made a far more accurate estimate of her than most of those who have attempted to describe her character, regarded her as the embodiment of an ancient earth goddess, who has assumed mortal dress, and known suffering and survived many deaths. "She is older than the rocks among which she sits; like the vampire, she has been dead many times, and learned the secrets of the grave; and has been a diver in deep seas, and kept their fallen day about her; and trafficked for strange webs with Eastern merchants. . . ." Lord Kenneth Clark, impatient with Pater's romanticism, calls her "worldly, watchful and well-satisfied," a description that might be more appropriate for one of Ingres' odalisques. In four words he reduces her to bourgeois insignificance. It is not fair, but it is a useful antidote to many imaginative excursions. Yet Lord Clark himself could describe the painting as imaginatively as Pater. One day, as the director of the

most important art gallery in England, he was permitted by the
Louvre authorities to see the *Mona Lisa* being taken down from the
shadowy place where it hangs and then carried into the sunlight. The
effect was to bring out the brilliance and subtlety of the painting. He
describes the wonderful transformation that took place:

> The presence that rises before one, so much larger and more
> majestical than one had imagined, is no longer a diver in deep
> seas. In the sunshine something of the warm life which Vasari
> admired comes back to her, and tinges her cheeks and lips, and
> we can understand how he saw her as being primarily a master-
> piece of naturalism. He was thinking of that miraculous sub-
> tlety of modelling, that imperceptible melting of tone, plane
> into plane, which hardly any other painter has achieved with-
> out littleness or loss of texture. The surface has the delicacy of
> a new-laid egg and yet it is alive: for this is Pater's 'beauty
> wrought out from within upon the flesh little cell by cell'—a
> phrase which more than any other in that famous cadenza
> expresses Leonardo's real intention.

Lord Clark was one of the enviable few who have seen the painting
in full sunlight. It is a pity that no color photographs were taken at
the time, so that we could see it in its freshness when the surface had
the delicacy of a new-laid egg. Then, at least, it might have been pos-
sible to break through the veils of familiarity.

Nor did the writer entirely escape from the liturgical prose indulged
in by nearly everyone who writes about Leonardo. *"The presence that
rises before one . . . majestical . . . miraculous subtlety . . . imper-
ceptible melting . . ."* They are good coins, but they have been
rubbed smooth by long usage. We are still far away from that fresh
explosive look at the painting in a blaze of sunshine.

The first reference to the *Mona Lisa* was made by Vasari. He wrote
his account of Leonardo about 1550, more than thirty years after the
master's death, at a time when there were still many people alive who
remembered him. I must quote his description of the *Mona Lisa* at
some length because it raises some intriguing problems:

> Leonardo undertook to paint, for Francesco del Giocondo,
> the portrait of Mona Lisa, his wife; and after he had lingered
> over it four years, he left it unfinished; and the work is now in
> the possession of King Francis of France, at Fontainebleau.
> Whoever wished to see how nearly art could imitate nature was
> readily able to comprehend it when he saw this portrait; for in
> it were counterfeited all the minutenesses that are able to be
> painted with subtlety, seeing that the eyes had that luster and
> watery sheen which are always seen in life, and around them

were all those rosy and pearly tints, together with the eye-
lashes, that cannot be represented without the greatest sub-
tlety.

The eyebrows, also, by reason of his having shown the man-
ner in which the hairs spring from the flesh, thicker here, more
scanty there, and curving according to the pores of the skin,
could not be more natural. The nose, with its beautiful nostrils,
rosy and tender, appeared to be alive. The mouth, with its
opening, and with the ends united by the red of the lips to the
flesh tints of the face, seemed in truth to be not colors but flesh.
In the pit of the throat, if one gazed upon it most intensely,
could be seen the beating of the pulse. And truly we may say it
was painted in a way to make every brave artist tremble and
lose heart.

He also made use of this device: Because Mona Lisa was
very beautiful, he employed, while painting her portrait, people
to play and sing for her, and jesters to keep her merry, to put
an end to the melancholy that painters often succeed in giving
to their portraits. And in this work of Leonardo there was a
smile so pleasing that it was more divine than human. They
thought it a marvellous thing because it was not other than
alive.

There is something strangely wrong about Vasari's description of
the *Mona Lisa*. Perhaps he never visited Fontainebleau, never saw the
painting, and was writing about something that was reputedly "a mar-
vellous thing" without knowing enough about it. There are no eye-
lashes and no eyebrows in the *Mona Lisa*. He says the painting is
unfinished; it is wonderfully finished. These are three mistakes, and
they are vital. Vasari appears to have been describing a painting of a
face seen from a little below, with rosy and tender nostrils and a
vividly delineated throat, where the pulse could be seen throbbing if
you looked at it most intently. Vasari attaches great importance to this
pulse, and uses the word *intentissimamente*. No one looking at the
Mona Lisa would think of looking at the throat for the pulse or at the
nose for the delicate pink nostrils, for only one nostril is visible and
this one in shadow. What has gone wrong is quite simple. He is not
describing the painting now known as the *Mona Lisa*.

Vasari may have confused one painting with another, his notes may
have got mixed up, or a description of the painting received from
France and written for him by one of the many Italian artists working
in the French court may have been faulty due to sheer carelessness.
Even the briefest description of the painting by someone who had ac-
tually set eyes on it would have included a reference to the extraor-
dinary effect produced by the jagged mountains in the distance, or to

The Virgin of the Rocks with Child, the Infant John the Baptist, Angels, and St. Jerome by the Master of the Sforza Book of Hours. London, The British Museum. (BRITISH MUSEUM PHOTOGRAPH)

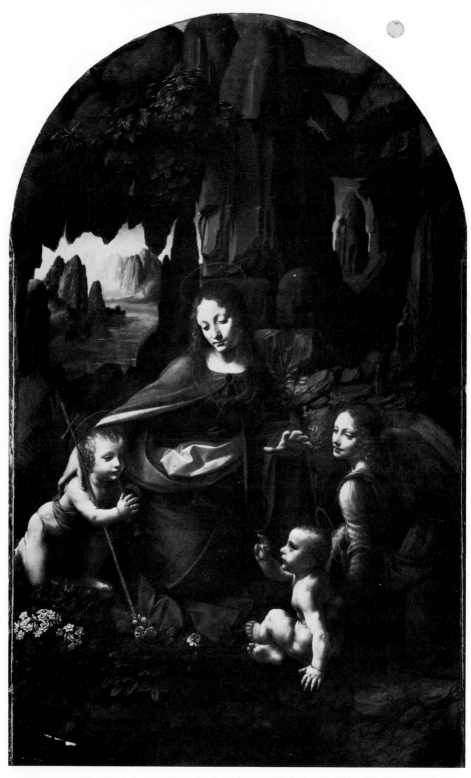

The Virgin of the Rocks by Leonardo. London, National Gallery.

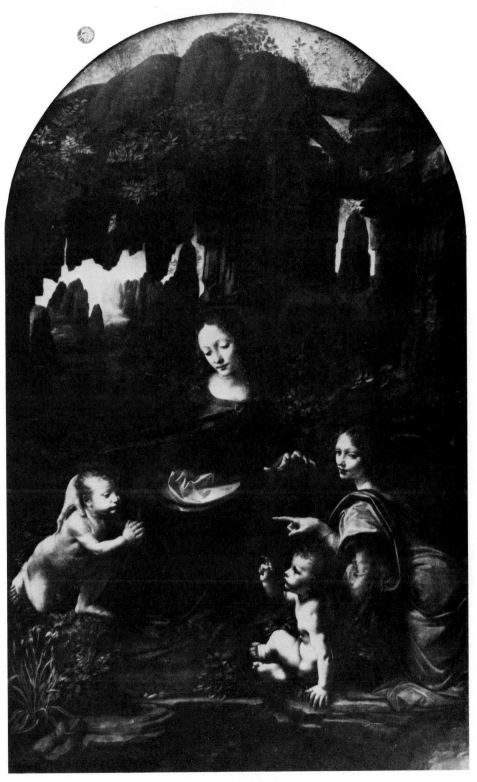

The Virgin of the Rocks by Leonardo. Paris, The Louvre.
(DOCUMENTATION PHOTOGRAPHIQUE)

Detail from the London *Virgin of the Rocks* by Leonardo. London, National Gallery. (REPRODUCED BY COURTESY OF THE TRUSTEES, THE NATIONAL GALLERY, LONDON)

Another detail from the London *Virgin of the Rocks* by Leonardo.
London, National Gallery. (REPRODUCED BY COURTESY OF THE TRUSTEES,
THE NATIONAL GALLERY, LONDON)

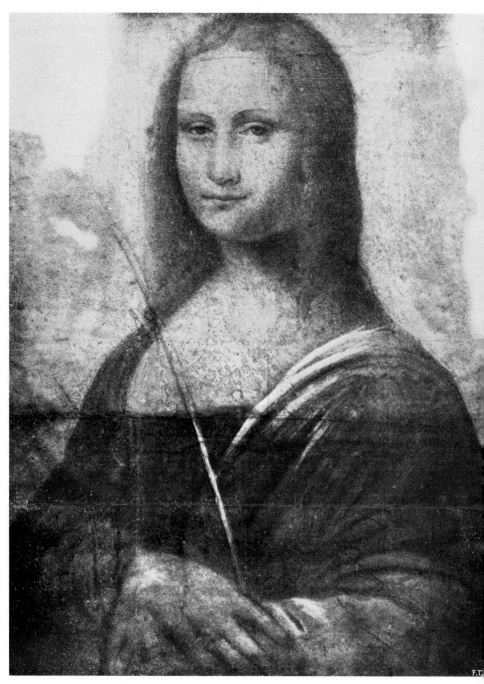

Portrait of Isabella of Aragon in black chalk by Leonardo, as it appeared in an art magazine published in Italy about 1889. Now heavily restored, it is in the Hyde Collection at Glens Falls, New York. (COURTESY DR. CARLO PEDRETTI)

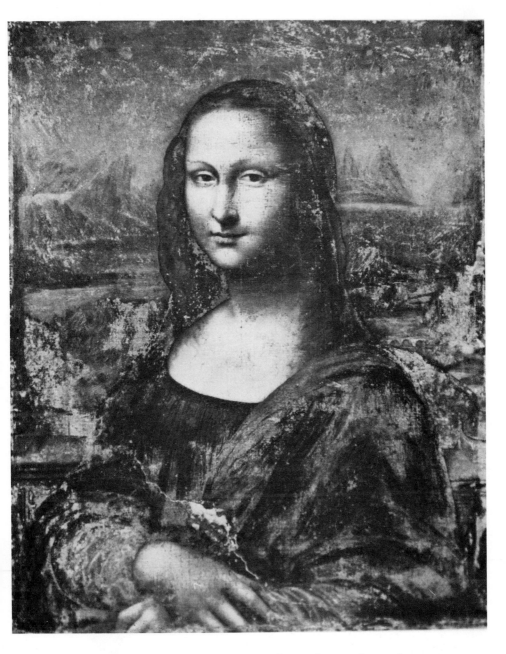

Portrait of Isabella of Aragon in oils by Leonardo, now in a private collection in Switzerland. (COURTESY DR. CARLO PEDRETTI)

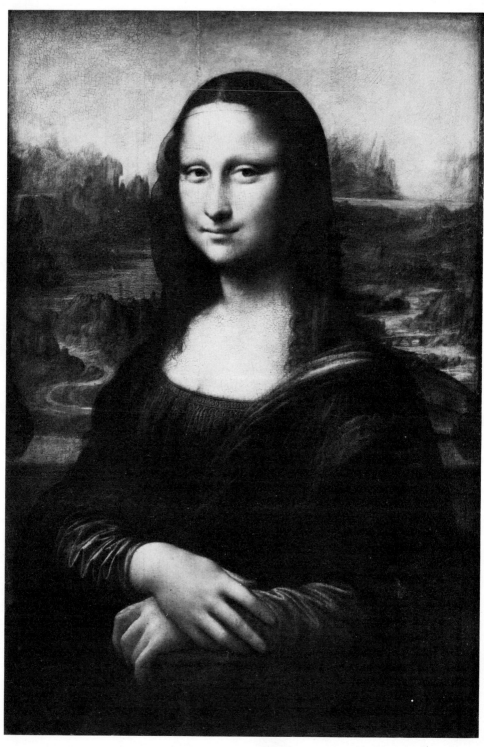

Portrait of Isabella of Aragon, known as the *Mona Lisa*, by Leonardo.
Paris, The Louvre. (DOCUMENTATION PHOTOGRAPHIQUE)

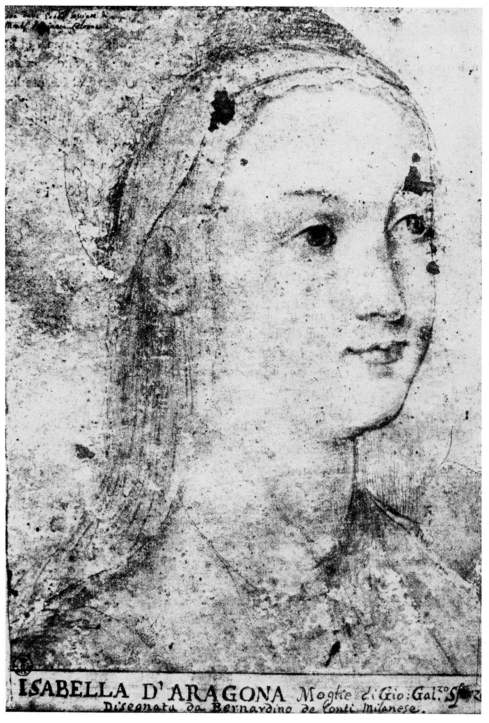

Isabella of Aragon by Bernardino de Conti. Florence, Uffizi Gallery.
(VALERI, LA CORTE DI LODOVICO IL MORO)

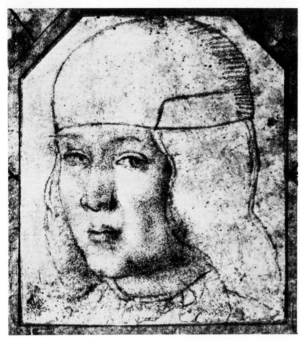

Francesco
Sforza, son of Isabella
of Aragon and
Giangaleazzo Sforza,
attributed to Leonardo.
Florence, Uffizi Gallery.
(VALERI, LA CORTE DI
LODOVICO IL MORO)

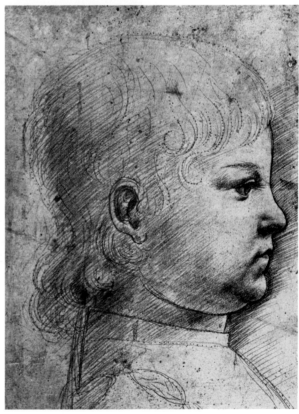

Massimiliano
Sforza, son of Lodovico
Sforza. Milan, Brera.
(ANDERSON)

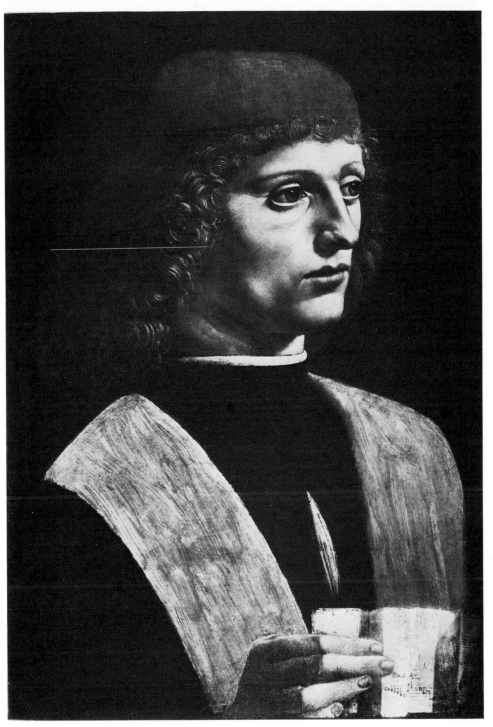

A Musician by Leonardo. Milan, Biblioteca Ambrosiana. (ALINARI)

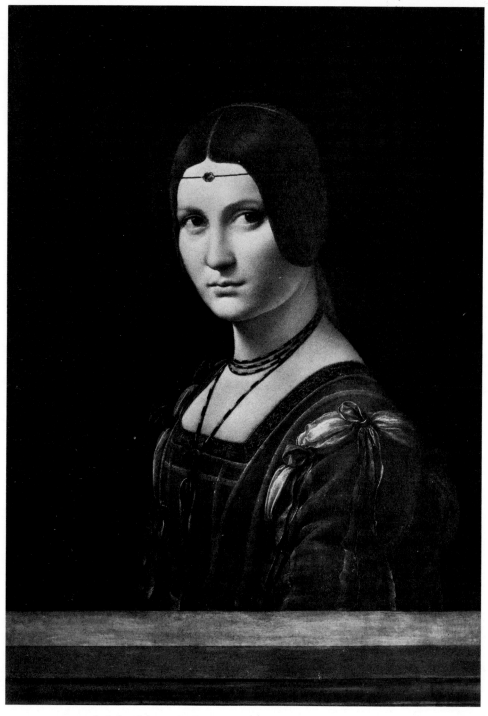

Isabella of Aragon by Leonardo. Paris, The Louvre. (ALINARI)

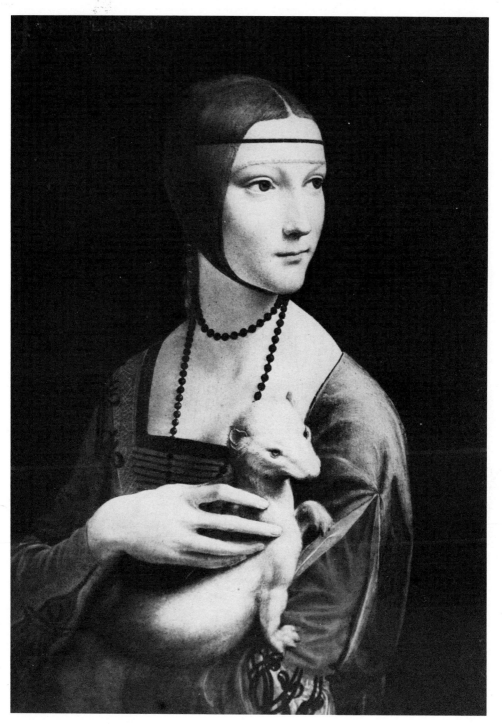

Cecilia Gallerani by Leonardo. Cracow, Czartoryski Museum. (PRAEGER)

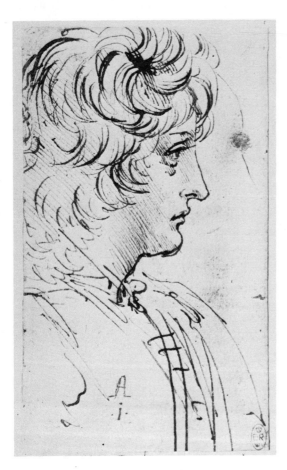

Presumed sketch of Salai
by Leonardo. Windsor, Royal
Collection. (REPRODUCED BY
GRACIOUS PERMISSION OF HER
MAJESTY QUEEN ELIZABETH II)

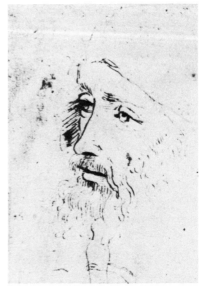

Presumed portrait of
Leonardo made by one of
his pupils in a notebook.

Castello Sforzesco. From Münster's Cosmographia.

Outline sketch of *The Adoration of the Magi.*

Invidia by Leonardo.

the sheer beauty and nobility of the face, or to the softness and delicacy of the folded hands. But no, he is concerned to tell us how well Leonardo painted eyelashes and eyebrows and how brilliantly he conveyed the watery sheen of the eyes, which have no watery sheen, and are soft and inquiring. The smile, "so pleasing that it was more divine than human," seems to be an afterthought. The actors, jesters, and singers employed to keep her amused are not entirely convincing. What has gone wrong has gone terribly wrong. Vasari may have heard something about the *Mona Lisa* at a third or fourth remove and suffered the consequences of stories that disintegrate in the telling. If only he had remembered the mountains!

He remembered a name—Mona Lisa, the wife of Francesco del Giocondo. There is no doubt that she existed, for a certain Lisa Gherardini was married at the age of sixteen to Francesco di Bartolommeo di Zanobi del Giocondo, a thirty-five-year-old silk merchant in 1495. Francesco del Giocondo, twice a widower, rose to some minor official positions in Florence and, according to the *Anonimo Gaddiano*, Leonardo made a portrait of him, now lost. The Gherardinis were an old and well-established family; the del Giocondos were *nouveaux riches*. Antonio Maria di Noldo Gherardini, Lisa's father, appears to have fallen on bad times, for he declared in a note to the tax authorities in 1480, shortly after Lisa's birth, that he would be unable to provide her with a dowry. Nevertheless she married well and continued to have a place in the small close-knit society life of Florence. If Leonardo painted a portrait of her husband, he might be expected to paint her portrait as well. But Vasari's curious description of the *Mona Lisa* leads us inevitably to two conclusions: (1) Leonardo may have painted the portrait of Mona Lisa del Giocondo; (2) the *Mona Lisa* in the Louvre is a portrait of someone else.

Scholars who have attempted to solve the mystery find themselves in the dilemma of the detective who finds the body in a sealed room with a stab wound in the back but no trace of a weapon. The room is locked from inside; there are no photographs of the dead person in the police files; there are almost no clues.

Modern researchers in Italy are inclined to dismiss Vasari's identification of the *Mona Lisa* with Mona Lisa del Giocondo and to advance the superior claims of more exalted persons. As long ago as 1903, Benedetto Croce suggested that it might be a portrait of Constanza d'Avalos, Duchess of Francavilla, who in 1503 defended the island of Ischia against the warships of Louis XII. A heroine in her own right, sister and wife of heroes, a cultivated woman of great charm and beauty, she established her court in Ischia, and among those who fell in love with her and sang her praises was the young poet Enea Ir-

pino of Parma, whose collection of sonnets survives in manuscript in
the Biblioteca Palatina in Parma. In these sonnets Irpino sometimes
imagines himself walking through the duchess's picture gallery and
pausing somewhat breathlessly to describe the immortal beauties
crowded on the walls. It is an imaginary picture gallery, and some-
times he appears to be inventing the paintings while at other times he
remembers paintings he has seen. He writes with an exquisite ten-
derness and grace largely borrowed from Petrarch, and the incon-
gruous result is that the paintings all seem to be the same painting,
and they seem to melt and vanish before our eyes. All the sitters are
sublime and infinitely beautiful, and many of them are widows, for
whom Irpino had a special affection.

Constanza d'Avalos, the widow of a soldier, is described as sitting
for Leonardo in her widow's weeds "under her beautiful black veil
[*sotto il bel negro velo*]." In another sonnet he describes her "im-
mense beauty [*immensa sua bellezza*]," her eyes "filled with noble
zeal [*colmi d'alto zelo*]," and goes on to speak rather indelicately of
her "beautiful neck and breast [*il bel collo e 'l petto*]." He concludes
the sonnet with an evocation of the illustrious painter:

> *Quel bon pittor egregio, che dipinse*
> *tanta belta sotto il pudico velo*
> *supero l'arte è se medesmo vinse.*

> This great and famous painter who depicts
> so much beauty under the modest veil,
> triumphs over art and vanquishes himself.

There can be little doubt that *vinse* is intended as a pun for Vinci. In
the following sonnets he speaks of *il Vincio* and *mio Vincio*, the crea-
tor of "supernal beauties," *bellezze si superne,* and we are left in very
little doubt that Irpino has conjured up a portrait by Leonardo of his
protectress, the Lady of Ischia. But the fine eyes, the neck, the breast,
and the veil are not enough to identify the portrait, and unfortunately
she shares the veil with many other widows described by Irpino. Con-
stanza d'Avalos was born in 1460, and at the very earliest Leonardo
could not have painted her before 1498, when she would have been
thirty-eight years old. Nor is there any evidence that she was ever in
Milan or that Leonardo ever visited her in Naples or Ischia.

Constanza d'Avalos received the absolute devotion of Irpino, but
there were other women to whom he gave an equally absolute devo-
tion. One of these was Isabella of Aragon, "the glory of Aragon in a
black gown [*La gloria d'Aragona in negra vesta*]." She was, of course,
another widow. She, too, possessed "a noble zeal" and wore "a black

and chaste veil," *un negro e casto velo*. She was divinely beautiful and has her proper place in the imaginary picture gallery. Unfortunately the more we study Irpino's gallery of portraits, the more it becomes apparent that he is merely adopting a poetic convention. It seems likely that none of the pictures he describes ever existed.

The trail that led to Irpino's portrait gallery comes to an end. Nevertheless Irpino was right, but only by accident. There are many clues pointing to Isabella of Aragon.

It is not generally known that two preliminary studies of the *Mona Lisa* in Leonardo's hand have survived. One is a drawing in black chalk on tinted paper in the Hyde Collection at Glens Falls, New York. The head and shoulders are the exact size of the Louvre painting, and although the drawing in its present form has been heavily restored to make it look more like the painting, there is not the least doubt that the drawing is by Leonardo. Happily there survives a photograph taken about 1889 before the restorer went to work. We see a young woman who is recognizably the same woman as the *Mona Lisa*, but much younger. She carries a long curved wand, symbol of grace and sovereignty, but otherwise she assumes the same posture. She is about eighteen, with rounded cheeks, resolute, hopeful. What appears to be dark blond hair falls to her shoulders, she wears the faintest of smiles, her eyes have the steady and somewhat disquieting gaze of the *Mona Lisa*. She has, too, the curious indentation at the corner of the right eye, which makes this eye appear so elongated. She has no eyelashes and only a faint trace of eyebrows.

The New York cartoon in its original state was a full and rounded work, ready to be pricked out and transferred to the panel. The composition had been worked out in all its essentials. The placing of the hands, the great sweep of the gown over the shoulder, the ample *décolletage*, the massive and monumental structure are all present: what is missing is the look of experience, the refinement of the features that comes after adolescence. When the restorers retouched the drawing to make it resemble the Louvre *Mona Lisa* more closely, they remodeled the lips, made the hair longer, added a spray of leaves to the lily, and so altered the original that from being a work of art it became a pastiche, and from being beautiful it became ugly. An original Leonardo was transformed into a *fin-de-siècle* monstrosity. Nevertheless the original drawing survives, if only in a photograph.

In the second study, now in a private collection in Switzerland, a transformation has taken place, for the girl has become a woman, color has been added, the background of blue mists and mountains gives extraordinary depth to the painting, and we are in the presence of a finished work of art, even though the bottom of the painting has

been greatly damaged and the colors of the robe have turned choco-
late with age. The luminosity and modeling of the face are such that it
is inconceivable that anyone but Leonardo could have painted it, the
subtlety of the shading being perhaps even more brilliantly accom-
plished than in the Louvre *Mona Lisa*. The eyes are brown, the lips
are red, the hair has a reddish glint, the expression is one of alertness
and some sadness muted by a sense of conscious dignity. In this ver-
sion she is not in the least matronly. Four or five years have passed
since, while maintaining exactly the same pose, she was depicted in
the black chalk drawing. She is a woman of about twenty-two, quiver-
ing with an intense inner life, and there is now more than a hint of ar-
rogance and fine breeding. Already in the lightly painted background
we discern the strangely shaped mountains, some like blue thrusting
icicles, others like hammer heads, which appear in the Louvre *Mona
Lisa*. The head is framed between two columns, which should not
surprise us, since all the early copies of the Louvre *Mona Lisa* show
these columns. In the earlier picture her head and shoulders fill the
frame. Now the painter has drawn back a little, given her air to
breathe, a setting overlooking the mountains of Lake Como, a balus-
trade, a distant downward view of a bridge which can still be seen
near Lecco under the soaring La Grigna Mountains. It is a painting of
a person precisely seen, at a precise place, in a precise moment of
time.

There exists in the Uffizi a drawing by Bernardino de Conti, a
Milanese artist, of Isabella of Aragon made in a rather similar pose
but showing only the head, the neck, and a trace of the shoulders. The
arching forehead, the sweep of the brows, the long nose, the shape of
the lips, and the well-modeled chin are very close to the Swiss *Mona
Lisa*. In the drawing she is very imperious, as befits a duchess of
Milan descended from kings of Aragon and Naples. She is also a little
younger. If the Swiss *Mona Lisa* shows Isabella at the age of twenty-
two, then the drawing by Bernardino de Conti shows her at the age of
about twenty, scarcely out of her adolescence.

We may now ask whether there was any likelihood that Leonardo
should have been asked to do a painting of Isabella of Aragon, or
whether at any time he had the opportunity to do so. He could hardly
have avoided knowing her, because he lived in the same vast palace in
the Corte Vecchia as she did when he was working on the horse, and
by January 1489, when Isabella of Aragon married Giangaleazzo
Sforza, the rightful Duke of Milan, he was already in high favor in the
Milanese court. Isabella was then eighteen, her husband was twenty.
It was very likely that Leonardo would be asked to do a drawing
of her before the wedding and shortly after her arrival in Milan. The

marriage was happy, she adored her husband, though he was weak-willed, and gave him three children, Francesco, Bona, and Ippolita. He died under mysterious circumstances shortly after being visited by King Charles VIII of France in October 1494. After this brief marriage she never married again.

The painting now in Switzerland was probably painted in 1495, while the *Mona Lisa* in the Louvre was probably painted in 1498–99. But all of Leonardo's paintings had long gestations and it is impossible to give precise dates to them. He may have been working quietly on the painting for the rest of his active life.

He made a drawing of Isabella's son, Francesco, which is now in the Uffizi. It is a delicate drawing of a very arrogant young prince, but the delicacy of the drawing does not conceal a profound psychological insight. After April 1497 the boy was kept in the Castello under Lodovico's watchful eye, while Isabella lived with her two other children in the Corte Vecchia. Francesco was now the rightful Duke of Milan, and Lodovico was determined that the boy should never ascend the ducal throne. Isabella had to live with the knowledge that Francesco might die as mysteriously as her husband, and there was nothing she could do about it.

Since Leonardo lived so close to her, and was the court painter, it was inevitable that they should meet and that he should paint her. He may have sung to her and played music for her, and when Vasari spoke of Leonardo inviting musicians to play and sing for her to keep her merry, and jesters to keep her amused, it may be that this was the last surviving relic of something that really happened. Isabella of Aragon, of all women in Milan, with a husband who was probably murdered and a captive son, needed to be made merry.

We know that she was a woman of great pride and great spirit. She was more mature than Beatrice d'Este, who being more impetuous once knocked her playfully to the ground, to the consternation of a foreign envoy who reported there was violent quarreling between them. In fact, they genuinely liked each other and were happy together.

Leonardo knew her on many levels: as a courtier, as a painter, probably as a singer, and certainly as a consultant on any engineering problems that confronted her. He wrote in his notebook with the design of a pump: "*fatto per la stufa over bagnjo della duchessa isabella* [made for the stove or bath of the Duchess Isabella]." Yet it would not be politic to be seen too much in her company, for in Lodovico's eyes she was an enemy, though he was forced to treat her well. As for Leonardo, he painted her again in the painting known as *La Belle Ferronnière*, now in the Louvre, which is clearly the same face

disguised by an entirely different hairdo. In this, the fourth surviving picture of Isabella of Aragon, she appears in red and gold, the colors of Aragon.

It is the same face, the same forehead, the same nose and chin, and we would recognize her better if the contour of the face was not subtly modified by the jewel on her forehead and if some later painter had not plastered her hair over her ear, for X rays show that the hair originally swept above the ear. So close and tight-fitting is her hair that she appears to be wearing a kind of helmet. She is very grave, very earnest, very proud; and her gravity is reinforced by the deep darkness of the background. Above all, we see the similarity in the eyes, which are large and luminous, tender and probing, and there is a familiar inward curving of the flesh where the eyes meet the cheek. This is not so powerful or memorable a portrait as the *Mona Lisa*. A certain brooding petulance darkens the picture, which was called *La Belle Ferronnière* because a cataloguer at Fontainebleau imagined it was a portrait of one of the mistresses of Francis I. There is no reason to doubt that it is, except for the hair, entirely the work of Leonardo. It may have been intended as a gift to her father, the Duke of Calabria. The *Mona Lisa* breathes power and authority, even though power and authority have been taken from her. *La Belle Ferronnière* shows some nervousness and weakness at a time when she was still a powerful figure, before the death of her husband destroyed all her hopes of happiness. She once signed herself *Isabella d'Aragona unica in disgracia*, and all her sorrow is in those words.

The claim that Isabella is the *Mona Lisa* depends upon the curious fact that Leonardo depicted her three times in the same attitude over a period of about ten years, first as a young virgin, then as a woman of the world, and then in the Louvre painting as a widow, for that dark veil can only mean that she has been widowed. If the *Mona Lisa* was painted about 1498, then it would fit perfectly into the time scheme provided by the two earlier pictures. Suddenly everything falls into place, and we begin to see in that face, so wise and so ravishing, something we had only half suspected, a certain austere Spanishness, grief for vanished glories, the knowledge of being born to high estate. She is descended from kings, and she knows it. Her mother was a Sforza, her father would inherit the throne of Naples, and she herself would rule for many years over the duchy of Bari. Enthroned among the mountains, separated from the world, she gazes out at a world she knows only too well with all its load of suffering and murder; and in her somber gaze there is defiance at all the evil spells the world can cast on her.

But the painting we see in the Louvre is far removed from the

painting as it left Leonardo's hand. Once the sky was a clearer blue, the brown eyes glowed, the lips were red, the gown was the rich green silk which can still be seen in Luini's paintings of the Virgin, and the overgown was of richly textured brown silk. The face had the color of warm flesh in sunlight, and the dark veil falling over her hair and billowing over her left shoulder was vivid and clean-cut against the misty distance. All the tones were brighter and sharper, so that she gave the impression of standing out boldly in front of the mountains, while today she seems to be melting into them. Time and varnish have failed to destroy her loveliness, but they have dulled the palette and softened the features.

The fading began very early. Cassiano del Pozzo, a Roman antiquary who befriended the young Nicolas Poussin and was often the bosom companion of Rubens, visited the French court in 1625 and later wrote about the paintings he had seen. He gives a curious account of the *Mona Lisa:*

> A portrait as large as life, in a carved walnut frame, half-length, being a portrait of a certain Gioconda. This is the most finished work of the painter that one could see, lacking only speech, for everything else is there. It represents a lady of 24 to 26 years old, seen from the front, not altogether in the manner of Greek statues seen full face, and there are certain tender passages on the cheeks and around the lips and eyes that are more exquisite than anyone could hope to achieve. The head is adorned with a very simple veil painted with great finish. The dress is black or dark brown, but it has been covered so badly with a certain varnish that it cannot be observed too well. The hands are extremely beautiful, and, in sum, in spite of all the harm the picture has suffered, the face and the hands are so beautiful that whoever looks at it is brought under its spell. Note that this lady, although she remains beautiful, is almost without eyebrows, which the painter has not recorded, as though she had none.

On the whole Cassiano del Pozzo was an accurate observer, who never troubled to describe a painting he had not seen. He described the *Mona Lisa* as we see her today, casting a spell from behind her mask of varnish. She smiles the mysterious smile of the undefeated, and we might have guessed that she was a princess reduced from her high estate to becoming a mortal, all the more proud because she was mortal, all the more a goddess because she is so warmly human. The people who come in the hundreds of thousands to see and adore her are not mistaken, for they see in her their own pride and their own beauty, and all their lives they have known her in their dreams.

While Leonardo painted her, he was working as usual on a hundred other things. He was filling his notebooks, studying optics, botany, and the structure of bats' wings; with Fra Luca Pacioli he was studying perspective and drawing the polyhedrons that were made into woodcuts to illustrate *De Divina Proportione*. He was also the decorator in chief of Lodovico's palaces. Among his more arduous duties was the decoration of a large room in the north tower of the Castello with an extraordinary design of interlacing roots, trees, branches, and leaves surmounted by the ducal arms. It was a work of astonishing virtuosity, which Leonardo apparently enjoyed for its intricacy and symbolism. Discovered at the end of the last century and then abominably "restored" by an incompetent artist, this painted room even today gives the impression of a forest glade. At intervals during the spring and summer of 1498 Leonardo worked on the room. Gualtero, a high officer in the ducal service, wrote a memorandum to Lodovico on April 21, 1498:

> My Most Illustrious and Excellent Lord.
> On Monday the great room of the Asse, that is, of the tower, will be cleaned out. Master Leonardo promises to finish it entirely for September, and says it may be used in the meantime because the scaffolding he will put up will leave space for everything below.

The word *Asse* means "scaffolding," and it appears to have been a room that had long been out of use and was now being restored. New scaffolding was being put up for the benefit of the painter and his assistants, and Leonardo, who liked to invent portable scaffolding, had apparently arranged to put it up in such a way that the room could be used while the painting was going on.

The room was known as *la camera grande de le Asse*, which may be translated as "the great hall of the scaffoldings." Restorations made in 1956 have shown that Leonardo went to special pains to show the tree trunks breaking through the rocky ground above powerful roots. He was therefore painting more than a forest glade; he was proclaiming the vigor of the roots, the life of the trees, the generative forces of nature, asserting their presence even in the most artificial and luxurious surroundings. Other halls and chambers were decorated with emblematic designs of serpents, eagles, fleurs-de-lis, doves, flames, lions, battleaxes, waves, interlaced rings, the serpent of the Visconti, the cross of Savoy. Heraldry dominated. In *la camera grande de le Asse* heraldry took second place to thickly luxuriant trees.

Trees and growing things were much on his mind that autumn. He was a man who had never possessed any land or property of his own,

and now at last he became, by order of Lodovico, the owner of a plot of land near the Porta Vercellina, not far from the Castello and very close to the Church of Santa Maria delle Grazie. This land was probably in payment for services rendered rather than a gift, for Lodovico was not a man who gave presents except to his relatives and mistresses. It was a very small plot of land, amounting to sixteen perches, about 220 yards by 55 yards, and included a vineyard formerly owned by the Convent of San Vittore. On October 2 the notary Antonio de Bombello drew up a lengthy deed in Latin by which the land passed into the possession of Leonardus Vincius *pictor* by order of "the most illustrious prince and most excellent lord Lodovico Sforza," and the deed extended for many pages and many witnesses attested to it.

This small vineyard was the only property Leonardo ever owned. Later a small house was built on it, and there was a road leading directly from the vineyard to the Church of Santa Maria delle Grazie. Here at last among his own vines he found his own roots.

The Artist and His Studio

We would know considerably less about Leonardo if it had not been for the Milanese painter Gian Paolo Lomazzo, who went blind and was therefore reduced to writing about art instead of making it. They called him *Il Brutto* because he was ugly and strange-looking, with a bulbous forehead, glaring eyes, a heavy nose, and thick lips. He had been a pupil of Gaudenzio Ferrari, a painter of some eminence who had known Leonardo, and it appears that nearly everything Lomazzo knew about Leonardo he got from Ferrari, whose works are still prized and still collected.

Lomazzo, who was about thirty-five when he went blind, is something of a phenomenon—a painter who wrote a voluminous seven hundred-page treatise on the nature of painting, sculpture, and architecture, and then followed it with a shorter treatise that was an attempt to summarize his conclusions. The first book was entitled *Trattato*

dell' Arte della Pittura, Scultura, et Architettura, and was printed in
1584, when he was forty-six years old. The second book was entitled
Idea del Tempio della Pittura and was published six years later. The
first five chapters of the *Trattato* were translated into English by Rich-
ard Haydocke and published in England in 1598. There is some evi-
dence that Shakespeare read it.

Lomazzo belongs wholly to the Cinquecento and his mannered style
derives from his age. What he had given himself was the breath-tak-
ing task of creating a philosophy of art based on the study of the five
men he regarded as the supreme artistic geniuses of his time. They
were Leonardo, Michelangelo, Raphael, Titian, and Gaudenzio Fer-
rari. And while it is impossible to share his devotion to Ferrari, we ex-
cuse him for all the information he has provided about the other tow-
ering figures of the Renaissance. Lomazzo was exceedingly intelligent
and knowledgeable, wrote well within the mannerist tradition, had
seen most of the works of art he described, and was the proud posses-
sor of enough cabbalistic learning to permit him to jump over hurdles
of logic at his pleasure. In the course of his prolonged and intoxicated
study of the nature of art, he tells stories and anecdotes about Leo-
nardo which are always convincing and nearly always illuminating. He
remembered many things that Vasari forgot.

He remembered, for example, that Leonardo trembled when he sat
down to paint, having such a respect for the grandeur of the art and
its perfection that he never felt that he could reach the heights. Lo-
mazzo's words were carefully chosen and need to be studied carefully.
He wrote, *"Così Leonardo parea che d'ogni hora tremasse, quando si
ponea a dipingere, e però non diede mai fine ad alcuna cosa comin-
ciata, considerando quanto fosse la grandezza dell' arte, talchè egli
scorgeva errori in quelle cose, che a gli altri pareano miracoli* [It ap-
pears that he trembled every time he sat down to paint, and therefore
never finished anything he began, being so impressed by the grandeur
of the art that he found errors in those things that appeared miracu-
lous to others]."

What is interesting is that this prayerful trembling should be as-
sociated with a feeling of insufficiency. He was dissatisfied—"found er-
rors"—in paintings that appeared to others to be wonderfully con-
ceived. *Scorgeva* means more than simply finding errors; almost it is as
though he went in search of them. *Tremasse* is more than trembling; it
means "shaking under violent emotion." In all this Leonardo was fol-
lowing the example of Alberti, who demanded the same intense trem-
bling emotion from the artist. It was as though a work of art de-
manded the utmost intelligence and ability of the artist and at the
same time it was necessary for him to place himself in an almost

trancelike state of inspiration, which Lomazzo, following the Neopla-
tonic philosophers, describes as the *nobil furia,* the noble fury. It is
not, of course, fury as we understand the word today: it involves a
concept of inspiration which is not very far removed from being in a
state of artistic grace.

Lomazzo is equally illuminating when he discusses the more earth-
bound Leonardo, curious about all things, curious about death, and
fascinated by executions, which he sometimes attended in order to
watch the facial contortions of the doomed men in their death throes,
especially "the contractions of their eyebrows and the wrinkles of
their foreheads." He apparently made many drawings of executed
men, but only one has survived. This is the famous drawing showing
Bernardo di Bandino Baroncelli hanging from a rope. From the draw-
ing it appears that the murderer of Giuliano de' Medici suffered no
pain and died instantly, for his face is impassive.

Lomazzo has much to say about Leonardo's "grotesques." He does
not use the word "grotesque." He calls them *figure brutte e mon-
struose, con bellissimo e diverso garbo,* brutish and monstrous figures
drawn with the most exquisite and various charm. Leonardo's "brutish
and monstrous figures" had a long history; according to Vasari one of
his earliest paintings was of a monster. It is not surprising that Leo-
nardo should be charmed by ugliness, for the absolute ugliness he
seemed to be searching for was merely the obverse of the absolute
beauty he searched for in his religious paintings. He drew monstrous
men and women as he found them. They are rarely caricatures, for he
drew what he saw, sometimes exaggerating or embellishing them. He
also made a number of erotic drawings which appear to have survived
for about a hundred years before they chanced to fall into the hands
of a priest, who burned them.

Renaissance artists drew and painted erotic scenes with the same
delight as the Greeks and Romans before them. For them, since
scarcely a single erotic painting had survived from antiquity and the
Mysteries of Pompeii were still unknown, it was a new world to be ex-
plored with enthusiasm and hurriedly, as though to make up for lost
time. The naked human body could now be seen in churches: the
Crucifixion and the Deposition had given it ecclesiastical authority. In
the Renaissance palaces we hear of rooms hung with erotic paintings;
eroticism had become an acceptable subject for art. Sometimes it as-
sumed ugly forms by being intellectualized; the artist, in disgust of
sex, might imagine monstrous genitalia springing from a human face
or some other part of the body; such paintings belonged not so much
to the category of erotic art as to anti-erotic art. They were designed
to shock, to hurt, to wound. Lomazzo tells us that he saw two draw-

ings by Leonardo, done in Milan, showing beautifully formed youths sprouting sexual organs from their faces:

> One of them was a most beautiful youth with his member on his forehead and without a nose and with another face on the back of his head, with a virile member below the chin and the ears attached to testicles, and this double head possessed the ears of a fawn. And the other monster had the member just above the nose and his eyes were at the side of his nose, and all the rest of him was perfectly beautiful. These two designs by his hand belong now to Francesco Borella, the sculptor.

Lomazzo's testimony on such a matter remains irrefutable: he knew Leonardo's style and would not have identified a work by Leonardo if it was not. He himself possessed drawings, paintings, and sculptures by Leonardo, which he collected assiduously and which were later sold to the Emperor Rudolf II and vanished from sight. He owned a small clay head of a Christ child which shows "a childishness and purity combined with a certain something of wisdom, intelligence and majesty, and all this air of a tender child possessed of the wisdom of age formed an excellent work." He was sure it was modeled by Leonardo, and we have no reason to dispute his claim. Indeed, there exists a drawing by Leonardo of just such a child based quite obviously on a clay model, which may well have been the sculpture owned by Lomazzo. And when Lomazzo informs us about those two extraordinary designs of youths with sexual organs sprouting from their faces, we must believe him, for he was in his time the greatest authority on Leonardo's work.

The two drawings owned by Francesco Borella were almost certainly executed during Leonardo's early years in Milan, about the same time that he made the *Invidia* drawings.

Lomazzo liked to tell stories about Leonardo. In one of these stories he describes how Leonardo invited some peasants to a feast, entertained them with jokes and made them laugh uproariously, and all this so that he could register the lines of laughter on their faces:

> He did not intend to reproduce it on canvas: it was simply a drawing, for which he chose certain persons whose faces seemed to him to be the most suitable. One day, wanting to introduce some laughing peasants into a picture, he arranged with the help of friends to select them, and after meeting them he invited them all to supper. Then he sat down close to them and began to tell them the maddest and most ridiculous stories in the world, so that they all nearly split their sides with laughing. While doing this, he kept observing them most diligently, studying their gestures and whatever ridiculous things they

were doing. He impressed them on his mind, and after they had gone, he retired to his room and drew them so perfectly that everyone who looked at it laughed aloud, just as if he had heard Leonardo's stories at the feast.

Lomazzo came at a time before Leonardo began to wear the robes of the great mage. In his eyes there was the human Leonardo who gathered a crowd of peasants around him and told them side-splitting stories, and there was also the nearly divine Leonardo who painted like an angel, produced anatomical drawings that were works of art, made birds that flew through the air, and seemed to be generating masterpieces with apparent ease. He describes paintings that have since been lost or destroyed or were never finished, like the *Leda*, "entirely nude, with the swan on her lap, her eyes modestly downcast," of which some copies of copies survive, and a *Pomona*, which was especially notable because Leonardo had given himself the task of painting three overlapping veils. His philosophy of painting was very close to Leonardo's. "Painting," he wrote in the *Trattato*, "is an instrument of the memory, the intellect, and the will. It is a sign and form conceived by men to represent all natural and artificial things, to represent the angels and saints and God himself, insofar as he can be represented." Leonardo himself might have demurred at the last qualifying phrase. He believed that painting was an absolute.

Although Lomazzo tells us a great deal, he does not tell us all we would like to know. He made no attempt to form a comprehensive list of Leonardo's paintings. Although he was permitted to see Leonardo's books on anatomy, painting, perspective, and mathematics, he was apparently not permitted to look at them for long, for he speaks about them only in the most general terms. He knew very well and described accurately paintings that remained in Milan, but knew very little or nothing at all about the paintings Leonardo left behind in Florence or later made in Florence. He saw Leonardo through Milanese eyes, or rather through the eyes of Gaudenzio Ferrari and the other Milanese painters who had known Leonardo. And strangely he has very little to tell us about Leonardo in the court of Lodovico.

Nevertheless, with Vasari, Lomazzo is our chief authority for many things that happened in Leonardo's life. He sees only Leonardo the painter: the scientist, the engineer, the botanist, the geographer, the inventor are absent. Leonardo might not have disapproved, since he regarded painting as the supreme art, the ultimate tribute of man to his Creator.

If we could enter Leonardo's studio, what would we find? There are some things we know we would not find—no easels, no palettes, no

tubes of paint, for these came later. The Renaissance artists of Italy were curiously unself-conscious and they have provided us with very few portraits of themselves at work. The portrait of the artist at work, though common enough in Flanders and Germany, had no attractions for Italy, with the result that we have only the sketchiest knowledge of what the studio looked like and how the artist behaved in it. The word "studio" in the modern sense did not exist, and when Isabella d'Este spoke, as she was continually speaking, about acquiring paintings for her studio, she was talking about the paintings in her picture gallery. The Italian painters spoke of their "workshops," using the same word that served for sculptors, goldsmiths, stonemasons, rope-makers, apothecaries, and coffinmakers.

In a famous passage Leonardo himself seems to give the impression that his studio was simply a comfortable, well-appointed room as distinguished from the studio of a sculptor, which was covered with chips of stone and stone dust and was thoroughly dirty, while the sculptor powdered with dust looked like a baker or someone who had been out in the snow. As for the painter, "he sits in great ease in front of his work, well dressed, moving a very light brush bearing attractive colors, and he is adorned with such garments as he pleases. His dwelling is full of fine paintings, and clean, and often filled with music or the sound of various beautiful books being read, and people listen to them with pleasure without having to listen to the shattering sound of hammers and other noises."

This passage occurs in a formal speech made by Leonardo before the court of Lodovico Sforza in which he compared the art of painting and of sculpture, to the great advantage of painting. The speech, as we shall see later, was not intended to be wholly serious. He deliberately exaggerated, spoke amusingly and charmingly, and so obviously weighed the scales in favor of painting that modern scholars have sometimes forgotten that he was not always serious, and when Michelangelo heard about the speech, he was enraged. But in fact Leonardo was talking very lightly, in his most courtly fashion, demonstrating his gift of subtle and good-humored self-mockery. The popular picture of Leonardo was of a rather remote, fastidious, and aristocratic man who lived in considerable comfort and was very likely to paint in surroundings of some luxury, while musicians played or books were being read, while the painter himself dressed elegantly according to his station, and while servants waited silently in the shadows to do his bidding.

But in fact Leonardo did not paint in this way, although he did nothing to dispel the legends that grew up around him. He was—he had to be—severely practical, and in his advice to painters, as distin-

guished from remarks delivered to a fashionable court on the superiority of painting to sculpture, he draws an entirely different portrait of himself. His advice to painters was that they should be solitary, detached, and humble. "Alone you are all yourself; with a companion you are half yourself," he wrote in his precepts. He did not mean that men should live in monkish seclusion; he was saying that a man painted best alone, without distractions, and therefore without the distraction of music or the presence of someone reading books. In his view there was nothing more distracting than someone chattering while you are trying to work. He also wrote that painters worked best in small rooms, for a very large room itself was a distraction.

If we attempt to think out afresh from what we know about Leonardo's habits and his formidable powers of concentration what kind of studio he would choose, we might conclude that he worked in a rather small, bare room with a number of unobtrusive mechanical gadgets to assist him in his work, with a northern light. The window would be circular, because he believed that a circular window offered a more concentrated light, and he was especially horrified by the distortions produced by square windows with crossbars. Inside the studio there would be a solitary chair, a mirror, a stand for setting up wax models, which he used frequently, some sheets of glass squared off because he liked to look at objects through glass, and since he was a man with a passion for botany we would expect to see many flowers. We would also expect to see far more ropes, pulleys, and mechanical gadgets than are customary in a modern artist's studio.

In fact we know a good deal about Leonardo's studio because on one occasion he made a quick sketch which survives in the manuscript known as Ashburnham I. We see a raised floor made of plain boards, a circular window set in a rectangular frame which can be pulled up and down by means of a pulley with the handle affixed within reach of the artist, who sits on a three-legged stool in front of the painting which can also be pulled up and down by means of a pulley. There is a slot in the floor boards, so that the bottom part of the painting descends while he is working on the top part. In a brief note Leonardo comments, "The painter who imitates nature should have a window he can raise or lower. The reason is that sometimes you will want to finish a thing you are drawing close to the light." This was not, of course, the only reason: the height and direction of the light were of paramount interest to him. In the drawing at the side Leonardo shows how the painting can be hinged down, so that the back of it forms a kind of table. He appears to have been quite serious about this transformation act by which the back of a painting becomes a supper table or a bench. "Every evening," he wrote, "you can let the work down

and close it above, so that late in the day it assumes the shape of a chest, and when closed up serves the purpose of a bench." As usual, he was concerned with what he called *commodita*, by which he meant all the various uses to which things could be put.

Perhaps the main significance of the sketch lies in the double floor and the circular window which slides up and down, like the canvas he is painting. His mechanical mind was not left outside the studio door.

In his mind there was machinery in all things, even in the very act of painting, which involved a complicated set of muscles and a brush that acted as a kind of lever. The universe, the earth, the human body, every blade of grass was a machine. Wherever possible, he would take them apart and put them together again to see how they worked.

But sometimes—and this happened more often than we might expect—the mechanical, logical world falls away and in its place there is a phantasmagorical world of horrors, grotesqueries, macabre masks, jokes, riddles, and stories that seem totally out of character. The man who wrote so delicately about the nature of flowing water, who studied the theory of flight, and who liked to abandon himself to the most abstruse speculations, also wrote down the mildly scatological stories he heard during the day and enjoyed rather childish riddles. He is also known to have made many erotic drawings which were later burned, to the great loss of erotic art. Over many years he enjoyed composing rebuses, sentences made out of pictures or even single words made out of pictures. Thus Leonardo was expressed by a lion in flames—*leone ardeschi*, and there are of course endless possibilities to the game. Sometimes, too, he would indulge himself in sophomoric verses, as when he wrote on the first page of one of his notebooks beneath a galaxy of monstrous human faces:

> Se 'l Petrarca amò si forte il lauro,
> fu perchè gli è bon fra la salsiccia e i tordi,
> e i' non posso di lor ciance far tessauro.

> If Petrarch had so great a love for laurel,
> it was perhaps because it was good between the sausage
> 　and the thrush,
> and I can have no high opinion of this tittle-tattle.

This was, of course, a kind of nonsense verse written between waking and sleeping. It was happy and silly, and he appears to have enjoyed both the happiness and the silliness.

Sometimes, too, he would joke on public occasions. It was the custom at this time, in the court and in the universities, to hold debates on such perennial subjects as "Is Tyranny the Best Form of Govern-

ment?" or "Whether a Widow Is Preferable to a Maid," or "Whether Poetry Is Superior to Music." Such a debate was called a *duello*, being essentially an argument between two people who deliberately exaggerated their arguments and employed rhetorical flourishes to win over their audiences, and sometimes there would be a speech which would be debated from the floor. We are informed by Luca Pacioli that on February 8 a *duello* was held in the Castello in Milan in the presence of Lodovico Sforza and his court, and the two speakers were Leonardo and his close friend Andrea da Ferrara, whom Pacioli describes as "the faithful disciple of Vitruvius, who knows everything there is to be known about military art." We are not informed what Leonardo spoke about, but since he is described by Pacioli as "one who surpasses all others in sculpture, casting, and painting," it may be assumed that he spoke on these subjects.

Now it happens that in Leonardo's *Trattato della Pittura*, which contains the earliest known compilation of his writings on painting, there exists a long section on the superiority of painting to sculpture which reads exactly as though it was a lecture delivered before some august body that expected to be intrigued and titillated by a firework display of arguments.

We watch the author playing with the theme, and it is clearly not intended that he should be taken with complete seriousness. He exaggerates charmingly, plays to the gallery, portrays himself as a man of aristocratic tastes, and employs irony with practiced skill. He knows that painting and sculpture are *sui generis* and therefore cannot be compared in the sense that one can be pronounced superior to the other, but he advances his arguments with the air of a man who has not the slightest difficulty comparing the incomparable. We may imagine the *duello* taking place at night by the light of smoking braziers in the Great Hall of the Castello, with Lodovico Sforza and his court dressed in their most sumptuous garments all craning up to gaze at the man who wore a fur-lined gown, for it was bitterly cold, and who spoke with a voice of complete and absolute authority. Standing behind a lectern and reading from his carefully prepared manuscript, which later would be presented to Lodovico Sforza, Leonardo embraced the subject of the superiority of painting to sculpture with the panache of a man who knows very well that he is loading the dice. He began with the customary salute to the high and mighty prince, Duke Lodovico of the House of Sforza, patron of the arts and most munificent ruler of the Milanese people, and then proceeded with his speech, which was quite long and must be quoted at some length:

> I am myself a practicer of the art of sculpture as well as that of painting, and I have practiced both arts in the same degree.

I think, therefore, that I am in a position to offer an impartial opinion as to which of the two demands more intelligence: the more perfect demands the greater talent, and is to be preferred.

First, sculpture demands a certain light, that is, a light from above, and painting carries everywhere with it its own light and shade. Sculpture owes its importance to light and shade. The sculptor is aided in this by the relief inherent in sculpture, and the painter places his light and shade, by the very conditions of his art, in the places where nature would naturally produce it. Nor can the sculptor vary his work with a variety of colors; painting is fulfilled with color.

The perspectives of the sculptor do not seem to be true at all; while the perspectives of the painter encompass aerial distance even to a hundred miles beyond the picture. The sculptor lacks aerial perspective; he can neither represent transparent bodies nor reflections, nor bodies as lustrous as mirrors, and other translucent objects, neither mists nor cloudy skies, nor an infinite number of objects it would be tedious to enumerate.

Sculpture has the advantage that it is provided with a better resistance against the ravages of time, but a painting made on thick copper, covered with white enamel, then painted with enamel colors, put into the fire and baked, is more durable than sculpture.

A sculptor may say that when he makes a mistake, it is not easy to correct it. It is poor reasoning to try and prove that the irremediability of an error renders the work more honorable. But I say to you that it will prove more difficult to mend the mind of the master who commits such errors than to repair the work he has spoiled.

There is thus no comparison between the intelligence, skill and analysis required in painting and that required in sculpture. In sculpture there is no difficulty with perspective, because of the limitations of the material, not because of the limitations of the artist. If the sculptor says he cannot replace the material removed from the stone that envelops his work as the painter can replace whatever he loses, I reply that he who takes away too much understands too little and is not a master, for he who has control of the measure of his work will not remove what should not be removed, and thus we say that the error lies with the master, not in the material.

Painting is a marvellous artifice, based upon the most subtle observations, of which sculpture is wholly lacking, since it demands only casual analysis.

To the sculptor who says his science is more permanent than painting, I reply that the permanence belongs to the material in which the sculpture is made, not to the sculptor. The sculptor should not claim this as his glory, but leave it to nature which created the material.

The sculptor's art brings greater fatigue to its creator than the art of the painter. It is, however, mechanical and less fatiguing to the brain. Compared with painting, it requires little thought, because the sculptor is always removing material while the painter is always adding to it. Also, the sculptor is always removing a single material while the painter is constantly adding colors made of different materials.

The sculptor attends only to the contours that encompass his material, while the painter attends to the same outlines, but in addition he must demonstrate his knowledge of light and shade, color and foreshortening, and in these matters nature helps the sculptor. Shadow, light and perspective are subjects the painter must learn by the force of his intelligence, identifying himself with nature, while the sculptor finds these matters already determined for him.

If you say there exist sculptors who understand what the painters know, I reply that sculptors who understand painting are painters, and when they do not know, they remain sculptors. Painters always need to understand sculpture, which is to say, they must understand nature with its light and shade and foreshortening. And so many return to nature because they have no training in the theories of light and shade and foreshortening, and they therefore portray what they see by copying, thus depriving themselves of science or reasoning, studying nature under the specific conditions they see in front of them.

There are some who look at nature through sheets of glass or through thin cloth, and they trace outlines on the surface of the transparent medium, and then, according to the rules of proportion they make profiles, and then they fill up the space within the outlines with light and shade, as they observe the position, quality and shape of the highlights and the shadows.

These, then, are to be commended if they know how to paint from their imaginations and to create the effects of nature, while employing these methods to avoid fatigue and in order not to be deficient in the true imitation of what ought to be a precise following of nature. But this invention may not be commended in the case of those who do not know how to paint without it, nor how to reason about nature through the intelligence, and such laziness is destructive of their skill, nor do they ever learn how to produce good works without these aids. They are always poor and mean in invention and narrative composition, which is the final aim of this science.

Sculpture is not a science but a mechanical art, for it causes the brow of the artist to sweat and wearies his body; and for such an artist the simple proportions of the limbs, and the nature of movements and poses, are all that is essential, and there it ends, and shows to the eye what it is, and it gives the ob-

server no cause for admiration, as painting does by virtue of the science that enables us on a flat surface to see vast landscapes and far-off horizons. . . .

In this way, speaking *ex cathedra* and in complete command of his subject, Leonardo dismisses the art of sculpture as something fit only for intellectual pygmies. The sculptor becomes merely a hewer of stone who never suffers from intellectual fatigue and confronts nature with nothing more than a pale imitation of itself. Can the sculptor show you the smooth and colored pebbles at the bottom of rivers, and the plants nestling among them? Can he show you cloudscapes and the stars in the firmament? He can depict warriors in battle, but can he depict the dust rising from the horses' hoofs? The argument is amusing because at no point is Leonardo willing to accept that the sculptor possesses any intellectual advantages. He is limited by the nature of his material. The painter, conversely, is the artist without limitations, who is not anchored to earth, and who can paint the invisible, or the distant, or the imaginary. The argument would be more convincing if we did not know that Leonardo at great expense of spirit and intellectual energy had made the horse in honor of Francesco Sforza.

Since the horse still existed and since everyone in the audience was well aware of its existence, Leonardo's sermon on the insufficiency of sculpture as an art was clearly a *jeu d'esprit*, an adventurous inquiry into the nature of the sculptor's limitations real or imaginary. Lomazzo tells us that the manuscript of the speech which had been given to Lodovico Sforza was still in existence in his own day. The speech was well known, and fifty years later, when the whole atmosphere of art was changing and Michelangelo was in the ascendant, it was still being discussed. Benedetto Varchi, a Florentine scholar and historian, quoted some passages from it in a letter to Michelangelo, who replied in a forthright fashion:

> No painter ought to think less of sculpture than of painting, and similarly no sculptor less of painting than of sculpture. By sculpture I mean that which is fashioned by the effort of cutting away, that which is fashioned by the method of building up being like unto painting. It suffices that as both, that is to say sculpture and painting, proceed from one and the same faculty of understanding, we may bring them to amicable terms and desist from such disputes, because they take up more time than the execution of the figures themselves. If he who wrote that painting is nobler than sculpture understood as little about the other things of which he writes—my maidservant could have expressed them better.

Such was Michelangelo's verdict on Leonardo's *jeu d'esprit*. The letter was written in the spring of 1547, when the horse was forgotten and Leonardo himself was also being forgotten. In the last sentence Michelangelo was angrily dismissing the entire body of Leonardo's writings, which he had never read.

As Lomazzo recognized, Michelangelo and Leonardo were poles apart, looking at art in different ways and under different lights. With Leonardo there is the sense of lines converging on the heart of the mystery; there is a concentration, a sudden crystallization. Michelangelo's lines do not converge: they open wide: he would paint all mysteries, all history, heaven, purgatory, and hell. And where Leonardo's efforts are directed toward an intense spirituality beyond the flesh, Michelangelo's efforts are directed toward a spirituality that includes the flesh, delights in the flesh, celebrates the flesh. So it happened that Michelangelo's chief study throughout his long life was the painting and sculpturing of naked youths, while Leonardo's chief study was the painting of the mysterious faces of women.

The Fall of the Dukedom

Around noon on April 7, 1498, King Charles VIII of France—that singularly unprepossessing monarch with spindly legs, enormous nose, thick lips, and prognathous jaw—hurried along a corridor in his palace at Amboise, eager to see a tennis match that was being played in the garden below. He was twenty-eight years old, and in the normal course of events he could look forward to a long and exciting reign, for he believed he had been chosen by God to lead the Christians against the infidels and to reconquer the Holy Land. He was half running in an ungainly fashion, when by some mischance his head struck a door, causing only a slight wound. He took his seat on the tennis court, watched the players, chatted with them, and complimented them. Suddenly, at two o'clock, he fell in a dead faint. He was carried into the palace and laid on the royal bed. He never recovered consciousness and before midnight he was dead. His death was a calamity for Italy.

His successor was Louis XII, who was thirty-six years old, handsome, and well mannered, a skilled tennis player and wrestler, and only slightly less cultivated than his father, the poet Charles of Orleans, whose poems are still read with pleasure. But he was also exceedingly ruthless and contemptuous, and he particularly detested Lodovico Sforza. His grandmother had been a Visconti; he regarded the Sforzas as his enemies, and immediately after his accession to the throne he began to make preparations to invade the duchy of Milan. In these plans he was aided by a remarkable man, Georges d'Amboise, the son of a royal chamberlain, whose ambitions exceeded those of his master, who wanted all of Italy and France. Georges d'Amboise wanted to be pope and was not prepared to let anything come in his way. If necessary, he would attack the Vatican with armed force and proclaim himself pope. The papacy was his consuming ambition, his hope, his consolation, his dream.

Georges d'Amboise was at this time nearly forty years old, bald, fleshy, red-faced, with a somewhat heavy and somnolent expression which was misleading, for he possessed a quick and agile mind, always knew what was happening, and would suddenly cut through the arguments of his advisers with a single sharp and decisive word. He had enjoyed a spectacular career. A favorite of the court and a boon companion of the young prince who was now King of France, he was made Bishop of Montauban at the age of fourteen. A few years later he was raised to the more important bishopric of Narbonne. At thirty-three he became Archbishop of Rouen, where he was renowned for his piety, the splendor of his table, the magnificence of his vestments and jewels, and for his cunning.

French kings were accustomed to invade Italy, and sometimes these invasions took the form of royal processions with very little fighting and a good deal of entertainment. A march through Italy was an occasion for feasts, spectacles, fireworks displays, jousts, the expropriation of estates, and occasional massacres. The French aristocracy acquired new titles, new experiences, new mistresses, new diseases. They were aware of Italy as a happy hunting ground and behaved accordingly.

At the root of these expeditions was a curious contempt for the Italians mingled with a kind of awe. Italy was divided into innumerable principalities often at war with one another, on the brink of chaos. The benefits of nationalism were apparently unknown to them. The French were also aware that Italians possessed an ancient and deep-rooted civilization and that the Italian Renaissance was producing a formidable gallery of artistic geniuses.

The expedition was mounted with great care under three generals: Louis of Luxembourg, Stuart d'Aubigny, and Gian Giacomo Trivulzio,

a renegade Milanese nobleman who had been banished by Lodovico and vowed revenge. He was a swarthy, hot-tempered, violently ambitious soldier, who had fought in twenty campaigns and won nearly all of them. He looked like a butcher and possessed no personal distinction. He was the senior general in command of the army, and he was also a conspirator of note, wily and treacherous, preferring sometimes to fight in the dark rather than in the open. Accordingly, he had already arranged through his agents to capture Milan from within. His army consisted of 13,000 foot soldiers, 6,000 horsemen, and fifty-eight cannon. It crossed the Alps, descended on Alessandria, captured and sacked the town, and then marched on Milan. Lodovico Sforza panicked. After removing 240 bags of treasure from the treasury in the Castello and seeing that they were loaded on thirty mules, he fled on horseback to Lake Como, the first stage of a journey that would take him to Innsbruck and the court of the Emperor Maximilian, his sole remaining ally. The defense of Milan was entrusted to Bernardino da Corte, the son of a ducal footman. The Castello was the strongest fortress in Europe, defended by 3,000 mercenaries with enough food, guns, ammunition, and money to hold out for three months. But when Trivulzio appeared at the head of his army, he already knew that Bernardino da Corte could be bribed to surrender the fortress. Milan fell without a shot being fired; the people came out in the streets to welcome the invaders; and Trivulzio entered the city in triumph. He had hoped to keep the French soldiers outside the walls, but they forced their way in and gave way to an orgy of plunder that lasted nearly a week. Leonardo, who would later come to know Trivulzio well, staying in his house and receiving commissions from him, soon learned that the clay horse was being used for target practice by the Gascon archers, and there was nothing he could do about it.

When Lodovico Sforza learned that the Castello had been surrendered by a former footman for a bribe, he shouted, "Since Judas there has never been such a traitor!" But in fact the real traitor was Trivulzio, who offered the bribe.

The French had set their army marching in July; they had taken their time; Milan had fallen on October 6. Shortly afterward Louis XII arrived on the scene and attended the magnificent entertainments accorded to a victorious king. Ambassadors hurried from every corner of Italy to seek alliances with him or to inform themselves of his intentions. Suddenly a messenger came from France with news of the birth of his daughter Claude, and he left Milan abruptly, leaving the duchy in the hands of Trivulzio, who ruled so harshly that the people who had jeered at Lodovico wanted him back. Milan came out in open rebellion when Lodovico put himself at the head of an army of Italian,

Swiss, and German mercenaries. On January 25, 1500, the French took flight.

Leonardo had left Milan a month earlier, when the French repressions were at their height. With Salai, Fra Luca Pacioli, and one or two servants, he slipped away from the city and went to Mantua. He had no love for the French, who destroyed his horse and gave way to large-scale looting. His own residence may have been looted and fired. Lomazzo tells us that Leonardo's *Treatise on the Anatomy of the Horse* was lost in the flames. On December 14, 1499, he had sent his savings, amounting to six hundred gold florins, to be deposited at Santa Maria Nuova in Florence, and immediately afterward had set out with his companions to Mantua, knowing that he would be well received by Isabella d'Este.

Such a journey at such a time was fraught with dangers and difficulties. The roads around Milan were being patrolled; there were spies and counterspies; brigands infested the countryside. He reached Mantua safely, was entertained by Isabella d'Este, drew her portrait, and appears to have promised that on the basis of the drawing he would make a painting of her. The drawing, now in the Louvre, is delicately colored and brilliantly conveys Isabella's imperious character, waywardness, and intelligence. He appears to have remained only a few days in Mantua before continuing his journey to Venice. Nor was Venice at this time an especially safe place. In August 1499 the great Turkish admiral Kemal Reis had destroyed the Venetian fleet off Sapienza and the Venetians were in danger of being overrun by the Turkish army.

It was said and widely believed that Lodovico Sforza, fearing that the Venetians and the French would soon attempt to dismember the duchy of Florence, had sent a special emissary to Constantinople to encourage the Turks to attack the Venetian fleet. If so, he was at least partly responsible for the disaster off Sapienza.

Leonardo, arriving in Venice at a time when the Turks were already ravaging the countryside, found himself inevitably consulted on the best methods of defense. He was well known as a military engineer, an expert in armaments, a wide-ranging theoretician on military matters. He studied the maps, surveyed the countryside, and came to the conclusion that the best defense lay in flooding large areas of the mainland by opening the dykes. There survive four drafts of the opening paragraph of a letter he wrote to the rulers of Venice:

> My most illustrious Lords.
> As I perceive that the Turks cannot invade Italy by any
> part of the mainland without crossing the river Isonzo . . . and

although I know it is not possible to devise any means of protection that can be made to endure for any length of time, I cannot refrain from bringing to your attention the fact that a small number of men with the help of this river might be able to do the work of many, seeing that where these rivers . . .

Many years later, when he was in exile in France, Leonardo remembered the dam with the movable sluice gate he had erected at Friuli. Edmondo Solmi has suggested that Leonardo's notes on divers, underwater attacks on ships, and methods of destroying ships on the water may date from the time of his brief residence in Venice, but in fact these notes belong to an earlier period.

Leonardo evidently spent a good deal of time in Venice among artists and musicians. It is believed that he met Giorgione and Titian, who were both in their early twenties and already famous. He certainly met the lutanist Lorenzo da Pavia, who briefly described in a letter to Isabella d'Este his meeting with Leonardo:

> Most illustrious Lady,
>
> I send you by the bearer a large lute in the Spanish fashion, made of walnut wood, in its natural color, that truly seems to me the best that will ever be heard. I have been ill. I have not been able to finish the black and white lute. I will make it like this one, in the Spanish fashion.
>
> Leonardo da Vinci is in Venice. He has shown me a picture of Your Highness, which is very natural and appears to me as perfect as it can be. This is all I have to write you by this messenger. Assuring you once more of my respect, I write myself Your Highness's faithful servant,
>
> LORENZO DA PAVIA
> Venice, March 15, 1500

Called *Il Gusnasco*, Lorenzo da Pavia was one of the greatest lutemakers of his time, and there is some significance in the fact that the only person known to have met Leonardo in Venice was a musician. Giorgione, also a lutanist, and of all men the closest in spirit and sensitivity to Leonardo, is known to have seen some of Leonardo's works and he could only have seen them during this brief visit to Venice. In the Church of San Rocco in Venice there is a painting usually known as *Cristo e il Manigoldo* (Christ and the Ruffian), which shows Christ carrying the cross and being confronted by a half-naked ruffian carrying a whip, who seems to be pounding on Christ's shoulder. There is no doubt that it is the work of Giorgione, but there is considerable doubt about the meaning of the painting, which clearly bears a relationship to *The Last Supper*. Here, too, there is the shock of recog-

nition, the sense of an overwhelming betrayal, a Judas-like figure set against the dreaming and sorrowful Christ. As always, Giorgione appears to have painted something he saw in a dream, something very bright, seen only for a moment, and wholly irrational. And yet this painting gives all the appearance of being derived from Leonardo or of being a collaboration between the two painters. There are other paintings by Giorgione that seem to be Leonardoesque in the highest degree—*The Old Woman* in the Accademia at Venice, the *Laura* in the Kunsthistorisches Museum in Vienna, and the young woman in *The Tempest.* Writing the second edition of his *Lives* after visiting Venice and studying the surviving works of Giorgione, Vasari wrote: "Giorgione saw and greatly admired some things of Leonardo, which were richly toned and exceedingly dark, and he made them his model and imitated them carefully in painting in oils."

While Venice was dreading a Turkish attack, Milan was seething with rebellion against the French. Trivulzio was a ruthless military governor; the Gascon soldiers were looting the city; the rumor that Lodovico Sforza would soon march and attack the French stirred the imaginations of the Milanese, who were sorely oppressed by the invaders. On February 3, 1500, Trivulzio marched his army out of Milan to Novara, and two days later Lodovico entered the city in triumph. He was greeted as the savior, the man who had singlehandedly saved Lombardy from disaster. He enjoyed his triumph, spoke disparagingly of the French, and promised to drive them out of Italy. He spoke too soon. The French retreated when he attacked Novara on March 22. Lodovico thought they were on the run, forgetting that they had well-trained troops and vast resources of money and treasure, thousands of Swiss mercenaries and the best captains in Europe. When the French mounted a counterattack on Novara, news was brought to Lodovico that his own Swiss mercenaries refused to fight. It was said that Lodovico slipped out of Novara in the disguise of a Swiss pikeman. He was quickly captured. On April 17, 1500, he began the long journey to the fortress prison in Loches in the Loire Valley. There, eight years later, he died in his cell, despised by the French and forgotten by the Italians. There remained on the walls of his cell a few sentences in which he lamented his fate.

To Leonardo in Venice it was given to write Lodovico's epitaph, which was jotted down hurriedly on the cover of one of his manuscript books. In five lapidary sentences, which could have served on a funeral monument, he described the fate of Lodovico Sforza and his chief assistants and advisers: Galeazzo Visconti, the captain of his

forces; Giovanni da Rosate, astrologer, physician, and chief minister; Bergonzio Botta, the ducal treasurer:

> The governor of the Castello made prisoner. Visconti dragged along the ground and his son slain. Gian della Rosa robbed of his money. Bergonzio would and would not and then fortune fled. The Duke has lost his state and his possessions and his liberty, and none of his works were brought to completion by him.

The words on Lodovico Sforza are not unfeeling: he was saying tersely and brilliantly what the historian Guicciardini would say in a long rambling page: *"Il duca perso lo stato e la roba e libertà, e nessuna sua opera si finì per lui."*

But Leonardo, too, had lost his state and his possessions. He was free to pursue his many arts but he was adrift in a world that was becoming increasingly dangerous.

THE RESTLESS YEARS

A Foreigner in Florence

Leonardo's task was to gather up the threads of a life that had been broken by the fall of Lodovico Sforza. Inevitably his thoughts returned to Florence, which he had not visited for eighteen years. The journey to Venice being largely unproductive, he turned westward to Florence accompanied by Salai and Fra Luca Pacioli. He reached Florence before April 24, 1500, for on that day he withdrew fifty gold florins from his account at the hospital of Santa Maria Nuova.

During his long absence Florence had passed through a period of turmoil. The peaceful rule of Lorenzo de' Medici was followed by the violent and erratic rule of the Ferrarese monk Girolamo Savonarola, whose prophecies of doom stunned the Florentines into submission to his will. Christ was proclaimed ruler of Florence; in fact the city was ruled by a singularly wild and undisciplined man who issued his harsh proclamations from a whitewashed cell in the Convent of San Marco.

Hating the Borgia pope Alexander VI, Savonarola made a dangerous alliance with King Charles VIII of France. Hating the arts, he celebrated "the Fire of Vanities," which consumed all paintings that did not celebrate Christ or the saints. He was tyrannical by nature and by design, and his bigotry was reinforced by the pope's violent condemnation of his rule. In 1498 the Florentines turned against him and burned him at the stake. He died bravely, still believing in his prophecies and visions.

In Florence a new generation had emerged and another was about to burst on the scene. Domenico Ghirlandaio was dead, but his pupils Michelangelo and Francesco Granacci were brilliantly discovering the new forms of the Cinquecento. In 1498, Michelangelo began to work on his monumental *Pietà* in Rome; the smooth, intricate modeling does not conceal the monumental power of the composition. Verrocchio's pupils Lorenzo di Credi and Perugino were also inventing new forms, and Perugino in particular would have a deep influence on Italian painting through his pupil Raphael. Fra Bartolommeo's *Last Judgment*, painted for the hospital of Santa Maria Nuova, was completed about 1500. Monumentality was now the fashion. It was as though men felt instinctively that the beginnings of the Cinquecento needed to be guarded by titanic presences.

Leonardo, too, was evolving a style of increasing monumentality. We have seen it emerging in the figures of *The Last Supper* and long before that in the Angel in *The Virgin of the Rocks*. The monumental cartoon of *The Virgin and Child with St. John the Baptist and St. Anne,* now in the National Gallery in London, is among his supreme achievements.

Concerning the nature and mystery of Christ, Leonardo had very little to say. He never painted a Crucifixion, a Deposition, or an Entombment. At a time of betrayal he painted Christ betrayed. But it was not Christ so much as the Virgin who received his devotion, and we know that he painted many more Virgins than the few that have survived. He never paints her alone, but instead surrounds her with her family. He rarely follows the accepted iconography; instead he invents his own. In the cartoon in the National Gallery he describes a sacramental event, but we are not sure what it means. Mysterious messages are being conveyed, glances are exchanged, blessings are pronounced, and we are aware that divinity is performing an act of creation. A new world, a new universe, is coming to birth in the lap of the Virgin, while at her feet we see the flowing waters of a holy spring.

If we examine the cartoon closely, we discover very soon that it is closely related to *The Virgin of the Rocks*. The various elements, sepa-

rated in the early painting, are now brought together to the point of fusion. We are among the rocks again. The Virgin and St. Anne are enthroned on a rock; the young Baptist leans against a rock; rocks and mountains are dimly seen in the background. We are drawn so close to the holy family that we are scarcely aware of the setting. St. Anne dominates by the power of her presence, gaunt and aged, with the appearance of an ancient prophetess, and still bearing the visible signs of her former beauty, although her eyes are cavernous. The movement is counterclockwise, from St. Anne to the Virgin, and then to John the Baptist by way of the Child; but between the Child and the Baptist there comes the huge unfinished hand pointing heavenward, thus breaking the flow with an abrupt vertical movement. This hand, which appears to be an afterthought, has the effect of a totally unexpected transition. All the circular movement in the upper half of the drawing is anchored by monumentally heavy verticals—knees, legs, and hanging draperies—in the lower half. Never before had Leonardo depicted draperies so monumental that they looked as though they were carved in the living rock.

Partly, of course, this is due to the medium he employed, which was black chalk heightened with white on brown paper, with some light color washes chiefly in the foreground. So subtle are the effects of chiaroscuro that at first sight it appears to be a painting austerely colored but nevertheless filled with a great variety of tones. As it hangs today in a small room especially designed for it in the National Gallery, in a dim light, the cartoon conveys a haunting, shadowy magnificence. The figures appear to be larger than life. In fact, they are much smaller, and the entire cartoon is only 4′7″ by 3′4″. The curators of the National Gallery have done well by it; they created a small chapel for it. Alone among Leonardo's works this cartoon has been given a setting commensurate with its greatness.

We have no evidence that the cartoon was ever transformed into a painting, nor do we know exactly when it was drawn. It appears to belong to a series of cartoons made after his return to Florence in April 1500, following three months of wandering in northern Italy; and there is about this cartoon something of the quality of an offering given in thankfulness for his safe return to his homeland. In spirit it is deeply Florentine. A very similar cartoon was exhibited in Florence not long after his return, as we learn from Vasari, who records that the people came in crowds to see it and to marvel over it:

> When he returned to Florence, he found that the Servite brothers had commissioned Filippino to paint the altarpiece of the high altar of the Church of the Annunciation; whereupon

Leonardo said he would gladly have done such a work. And when Filippino heard this, he withdrew, like the good fellow he was. And so that Leonardo could paint it, the friars took him into their house and bore the expenses of himself and of all his household. Thus matters went on for some time, and he did not make even a beginning.

At last he made a cartoon of Our Lady and a St. Anne and a Christ; it not only filled all artists with wonder, but when it was finished, men and women, young and old, continued for two days to crowd into the room where it was being shown, as if attending a solemn festival, in order to gaze at the marvels of Leonardo, which caused all these people to be amazed.

For in the face of the Virgin there can be seen whatever of the simple and beautiful can by simplicity and beauty confer grace on the Mother of Christ, since he wished to show that modesty and that humility which are looked for in an image of the Virgin who, with an immense pleasure and gladness, gazes at the beauty of her Son, whom she tenderly holds on her lap. Meanwhile, with a most courteous glance, she looks down at St. John, the little boy, playing with a lamb, not without a smile from St. Anne, who is overflowing with joy as she beholds her earthly progeny becoming divine—a conception worthy of the intellect and genius of Leonardo.

Vasari also tells us that this cartoon found its way to France, which may be his way of telling us that he did not know what happened to it. It is very possible that he was describing the cartoon now in the National Gallery, adding the lamb for good measure, confusing the cartoon with the painting of *The Virgin and Child with St. Anne* now in the Louvre. Vasari, although often confused about details, generally tells a straightforward story, and we have no reason to doubt the story about the large crowds which came to see the cartoon.

The history of the cartoon can be traced with fair accuracy. Francesco Melzi, the young nobleman who became the heir to Leonardo's estate, brought it to Milan after Leonardo's death, and some time later it appears to have passed into the collection of Bernardino Luini, who copied it, added the figure of St. Joseph, and produced a painting which has the merit of showing us the colors that Leonardo would probably have used—rich orange-reds and emerald green for the gowns—but otherwise showed little understanding of Leonardo's intentions. About 1696 the cartoon was seen in the collection of Conte Arconati in Milan, where it remained until 1722. Then it reappeared in Venice in the collection of Conte Sagredo. Robert Udny, the brother of the British ambassador, bought it from Conte Sagredo in 1763, and sixteen years later it came into the possession of the Royal

Academy in London, where it remained in obscurity until 1962. In that year it was presented to the National Gallery by the National Art-Collections Fund from money raised by public subscription and by a special grant of £350,000 from the British Government. The Royal Academy, which originally paid only a trifling amount for the cartoon and kept it out of public display for nearly two centuries, received a total of £800,000, which it ill deserved.

The visitors who come into the darkened room in the National Gallery are hushed and silent. They see a sheet of heavy paper covered with a lumpy glaze, with four or five small pieces torn out of it and with nail marks showing along the bottom edge. The upraised hand is drawn roughly; the feet are sketched in rapidly. Leonardo has evoked divinity to the point that it is possible to believe that the Virgin, the Child, St. Anne, and John the Baptist are truly present. *The Virgin and Child with St. Anne* in the Louvre is a lesser work and derives from it.

Although he was working at the height of his powers, Leonardo's stay in Florence was fraught with difficulties. He was a man who had gone into voluntary exile and returned to find his own people changed almost beyond recognition. His father was still alive; there were half brothers and half sisters he had never known; and the Signoria ruled firmly and unimaginatively, as though the flame lit by the Medicis had died down and as though Savonarola had never existed. It was not perhaps the best place to work in, but where to go?

Milan offered few prospects. It was being ruled by Georges d'Amboise, now a cardinal, thirsting to become Pope and exerting all his undeniable gifts of diplomacy to increase the power of Milan. Leonardo's horse had vanished, but the cardinal was in possession of the mold. Ercole d'Este, lord of Ferrara, thought the mold worth acquiring and wrote to his agent, Giovanni Valla, in Milan to ask whether there was any possibility of obtaining it as a gift. He wrote:

> Seeing that there exists in Milan the mold of a horse that Lord Lodovico intended to have cast, made by a certain Messer Leonardo, an excellent master of such things, we believe that if we were granted the use of the mold, it would be a good and desirable thing serving to make our own horse.
>
> We desire you immediately to seek an audience with the Most Reverend and Illustrious Cardinal Rohan and acquaint him of our desire, begging His Reverence, if he does not need it, to kindly give us the mold so that we can make our own casting. And if he has no need of it, we would not be depriving him of anything he holds valuable, for we are persuaded that he cares very little for this work.

You may also add that this would be most agreeable to us for
the aforesaid reasons, and we would be singularly pleased and
grateful to him, bearing in mind that the mold, now in Milan,
is, as you have told us, falling every day into ruin because it is
not being taken care of.

If the Most Reverend Monsignor should gratify us in this
matter, as we hope, then we shall send people to bring the
mold here with the utmost care and dexterity, so that it will
suffer no damage. And do not fail to employ all your good
offices to ensure the agreement of His Most Reverend Lordship,
to whom we offer our services and recommend ourselves.

Ferrara. September 19, 1501.

Giovanni Valla sought an audience with the cardinal, and he may
have known that he had been given an impossible task. The cardinal
never surrendered anything. It is possible that he wanted the mold for
the King of France, but it is just as likely that he wanted to keep it in
Milan, under his own eyes, so that he could decide the matter in his
own good time. So for the moment it remained in his possession, and
Giovanni Valla later wrote to his master, Ercole d'Este, saying he had
failed in his mission. He wrote:

Today I was received in audience by the Most Reverend
Monsignor Rohan concerning the mold of the horse erected by
the Lord Lodovico, and in effect His Lordship said that as far
as he was concerned, he agrees that it should be given to Your
Highness, but as His Majesty the King has himself seen it, he
dare not grant the request without previously informing the
King. I would suggest to Your Highness that a letter written to
Bartolommeo de Cavaleris requesting his intervention with the
King would result in His Majesty's agreement with your wishes.

24 September 1501

With this letter Leonardo's horse passes out of history, for nothing
more was ever heard of it.

Georges d'Amboise, intoxicated with power, ruled Milan like a feu-
dal monarch. The Milanese were being tamed into docility by men
who spoke in the accents of the Loire Valley. Milan offered few pros-
pects for Leonardo, who began to think of serving a more powerful
monarch than Louis XII or the pope of Rome. This was the Sultan
Bajazet II, the sovereign lord of the Ottoman Empire, who in the
early summer of 1502 sent ambassadors to Rome in the hope of re-
cruiting Italian architects and engineers for various urgent projects in-
cluding a design for a bridge across the Golden Horn. The Turks were
well aware of Italian pre-eminence in engineering. Leonardo, who
was fascinated by Turkey, heard of the sultan's desire either because

the presence of the ambassadors in Rome was soon known in Florence or because he had heard of it previously through the Gondis. He wrote to the sultan, offering his services as an adviser and consultant on all matters of architectural and naval engineering. The letter written by Leonardo to the sultan during that summer survives in a garbled translation into Turkish found by the German scholar Franz Babinger in 1952 when he was examining the archives of the Topkapi Seray in Istanbul. In the letter Leonardo offers to design windmills, a drawbridge, an automatic device for pumping out the hull of a ship, as well as a bridge that will span the Golden Horn.

> Here follows the copy of a letter sent from Genoa by the infidel called Leonardo.
> I, your servant, having pondered the problem of the mill, have with God's help succeeded in finding the solution. By means of an artifice I will build a mill that does not use water but only the wind in a way that will take less than a mill at sea. Not only would it be more convenient for the people but it would grind wherever it is set up.
> Furthermore, God—may he be exalted!—has granted me an artifice in the shape of a machine that draws water from the ships without rope or cable, and is self-operating.
> I, your slave, have heard that you have the intention of building a bridge from Galata to Istanbul, but you have not done so for want of a skilled designer. I, your slave, know how to do it. I would raise an arch in such a way that it would be impossible for anyone to walk over it by reason of its height. I have devised a catamaran which will permit the piles to be driven in after the water is removed. I would so construct it that a ship with its sails up would be able to pass beneath it.
> And I would construct a draw-bridge so that, whenever one wishes, one could cross over to the Anatolian coast. But since the water is in continual motion, the banks may be worn away. Therefore I shall employ an artifice to guide the flow of water at the bottom, so that the banks suffer no harm. The Sultans who come after you will be able to do this at little expense.
> May God grant you to believe these words, and may He convince you that your slave will be forever at your service.
> This letter was written on the third day of July.
> It has been here for four months.

There are a good number of things that have gone wrong in this letter, and most of them appear to have gone wrong when Leonardo's Italian was translated into Turkish and strait-jacketed into the formal terms suitable for submission to the sultan. Yet even here, in a translation at three removes from the original, we recognize however faintly

the authentic commanding tone of Leonardo and also perhaps the air of mystification he felt necessary when dealing with a great potentate. The secretary's notation, "It has been here for four months," suggests that the sultan never saw the letter, which was simply filed away and forgotten.

In one of Leonardo's notebooks—the same one in which he wrote his classic epitaph for Lodovico Sforza—he drew a design for the bridge of quite extraordinary beauty, and in his neatest, most impeccable handwriting he added the words, "Bridge from Pera to Constantinople. 40 braccia wide, 70 braccia high above the water, 600 braccia long, that is, 400 over the sea and 200 over land, thus forming its own buttresses."

The design looks like a modern bridge with absolutely clean lines, a gentle slope, and double ramps, like a swallow's tail. It is in fact modeled on a bird that has settled down over its nest and folded its feathers. Until Professor Babinger's discovery of the letter in the archives of the Topkapi Seray, this design in Manuscript L had always puzzled commentators, who wanted to know why Leonardo was designing a bridge so far from Italy.

We know now that he was quite prepared to make the journey to Constantinople to serve the sultan. He had lost his roots in Italy. In a spirit of doubt and anxiety he was eager for adventures outside of Italy in a country he knew only from his wide reading. Instead he went to serve the one man he was least likely to understand or serve well—Cesare Borgia, the treacherous and self-serving son of Pope Alexander VI, who hoped to conquer Italy for himself and the papacy.

In the Service of Cesare Borgia

There was a time when the noble family of Melzi owned almost the entire inheritance of Leonardo. Today the family owns exactly one document that belonged to Leonardo, for all the rest have been dispersed, stolen, or given away. The surviving document, written on vellum, is Leonardo's special passport signed by Cesare Borgia. It reads:

> Caesar Borgia of France by the grace of God Duke of Romagna and Valentinois, Prince of Andria, Lord of Piombino &c. Also Gonfalonier of the Holy Roman Church and Captain General. To all our lieutenants, castellans, captains, condottieri, and subjects, who may have knowledge of these presents. You are hereby ordered and commanded on behalf of our most excellent and well-beloved friend, the architect and engineer general Leonardo Vinci, bearer of these presents, who has received

our commission to inspect all the strongpoints and fortresses in
our dominion, so that he may, according to their necessity and
his counsel, provide for their maintenance. He shall be given
free passage and be relieved of all public tax, both for himself
and for his party, and shall be welcomed amicably, and may
make measurements and examine whatever he pleases. For this
purpose they are to provide him with as many men as he requi-
sitions, and grant him all the help, succour and favour he may
demand, for it is our will that every engineer in our dominions
shall be bound to confer with him and follow his advice. And
let no man dare to do the contrary, if he does not wish to incur
our extreme displeasure.

<div align="right">CAESAR</div>

This passport was dated August 18, 1502, and there was consid-
erable significance in the date. Italy was once more in convulsions. In
July the King of France had descended into Italy. In alliance with the
pope, Alexander VI, he was determined to destroy the Kingdom of
Naples and to acquire whatever spoils were available. Cesare Borgia
was leading the papal armies and carving out for himself a vast princi-
pality in central Italy. He had just captured Urbino by the simple ruse
of demanding soldiers from the Duke of Urbino, saying he intended to
attack Camerino. The duke, who was an ally of the pope, suspected
nothing. Suddenly three armies descended on Urbino from the north,
south, and east, and the duke was forced to flee to Mantua. Cesare
Borgia installed himself in the brilliant palace at Urbino among the
books written on vellum, the silk tapestries, and the innumerable
paintings that had once belonged to Duke Guidobaldo Montefeltro.
Tall, handsome, cultured, infinitely treacherous, Cesare Borgia was
still on the whole behaving rationally. By the end of that same year he
would be giving way to murderous rages, killing people who had
served him well, so that all of Italy would be inspired with the terror
of his name.

Leonardo's employment by Cesare Borgia and the affectionate
terms in which he is described on the passport have always puzzled
students of Renaissance history. He is not simply described as "our
well-beloved architect and engineer general," which might, as it
would today in some European countries, be simply a conventional
term of address. Instead he is described as *nostro prestantissimo et
dilectissimo familiare architetto et ingegnere generale,* where *pres-
tantissimo* has the connotation of "resoundingly eminent" and *dilectis-
simo familiare* almost means "the most beloved member of my fam-
ily," or rather, since Cesare Borgia was using words for their effect, he
was declaring that Leonardo was close to him in body and soul and

possessed his entire trust. A prince was talking to a prince. Leonardo had entered the Borgia court and was one of the chief courtiers.

How had he entered it? There are no documents to show how Leonardo came to Urbino, but it would seem likely that he joined the Florentine embassy which was received by Cesare Borgia early in the morning of June 25 in the ducal palace. The embassy was led by Francesco Soderini, Bishop of Volterra, and his pale young secretary, Niccolò Machiavelli, who was a friend of Leonardo and would become an even closer friend in the following years. Machiavelli was greatly taken by the young Cesare Borgia and well aware of the danger he presented to Florence. "The duke is a man of splendor and magnificence," he wrote. "He has confidence in himself, treating the greatest enterprise as though it were a small thing. In his search for glory and the increasing of his dominions he will deny himself everything, taking no rest, regarding fatigue and danger alike with contempt. His soldiers love him, and he has chosen the best in Italy. Altogether he is a successful man—and one to be feared." At that moment the fate of all Italy was in his hands.

It was not surprising that Cesare Borgia would have looked with approval at Leonardo, knowing his reputation as a painter, architect, and military engineer. Nor is it surprising that Leonardo should have looked with approval at Cesare Borgia, then twenty-seven years old, a man of great charm and determination, and to all appearances infinitely more capable than Lodovico Sforza. In an age of tyrants one served those who were most intelligent, and Cesare Borgia could speak intelligently on every subject under the sun. So we may imagine that Leonardo served him willingly, delighting in his new-found occupation of surveyor-general of strong points and fortresses. There was nothing in his passport to suggest that he was asked to make armaments for the papal armies, to advise on military strategy, or to command soldiers in battle. We may imagine that Leonardo arrived in Urbino on June 25, accompanied Cesare Borgia in his travels during the following weeks, and only after some considerable time received his appointment of engineer general to the papal forces, for such appointments would not be made casually at a first meeting.

About Leonardo's journeys during this period we know almost nothing. Reputable scholars, determined to fill up the occasional gaps in Leonardo's history, have imagined that he was already in the service of Cesare Borgia at the time of the treacherous attack on Urbino and rode at his side, was deeply immersed in Cesare Borgia's conspiracies, and took part in his wars. Leonardo's notebooks provide more pacific evidence of his activities. He writes, "Columbarium at Urbino, July 30, 1502," which shows that he was in Urbino on that date. He writes

again, "On August 1, 1502, the library at Pesaro," and about two weeks later, "On St. Mary's day in the middle of August, Cesena, 1502." He notes that he arrived at the nearby Porto Cesenatico at about ten o'clock in the morning of September 6, and having examined the existing fortress he observes that it was not well defended from artillery because it had no projecting bastions. Cesena interested him. He made a drawing of the fortress, sketched a Cesena cart, and was sufficiently intrigued by the shape of the hook used by the wine growers of Cesena to support their grapes that he made a sketch of the hook and the grapes hanging from it. There are more remarks about libraries and grapes than about fortresses. He was clearly making a leisurely progress.

During this period, probably during the latter part of September, he painted for Cesare Borgia an extraordinary map of the town of Imola. It is an astonishingly beautiful work in water colors, and it has the merit of being the first map of a town constructed with the use of a magnetic compass set on a surveyor's table, thus enabling the map maker to achieve complete accuracy. The town walls are tinted silvery gray, the moat around the walls and the nearby river are tinted blue, the roofs are red, and the public places are yellow, and it is all done so delicately and at the same time so accurately that the observer has the illusion that he is flying over the town at a great height and if he came down he would see people moving about in the streets.

Leonardo's map of Imola is contained within a great circle divided into sixty-four degrees. Eight points of the compass are mentioned, and in the margins, in his most beautiful backward script, he notes the distances from Imola to the nearby towns of Bologna, Castel San Pietro, Forli, and Bertinoro, with their exact directions according to the points of the compass. Carlo Pedretti has shown that when Raphael, having been appointed Superintendent of Antiquities, wrote his famous letter to Leo X a few years later, he described at some length the method of making maps with the aid of a magnetic compass on a surveyor's table and it seems likely that he owed his knowledge of the method to Leonardo.

Quite obviously this map, which is now in the Royal Collection at Windsor, was not the one presented to Cesare Borgia, who could not be expected to read reverse script, even though it was written very clearly. It was the preliminary sketch in all its freshness, which Leonardo kept for himself, giving a fair copy to Cesare Borgia.

In spite of all the high-sounding phrases in the passport signed by Cesare Borgia, there is nothing to suggest that Leonardo was anything more than an inspector and adviser on fortifications. His task was "to inspect all the strong points and fortresses in our dominion, so that he

may, according to their necessity and his counsel, provide for their maintenance," by which it was meant that he was being asked to study the fortresses and advise on the means of strengthening them. We know of only three fortresses that were certainly visited by him at this time, and only one of them, Imola, possessed great strategic importance. It is therefore unlikely that Leonardo's intervention had the slightest effect on the course of the war Cesare Borgia was waging. Although he was a commissioned officer attached to Cesare Borgia's staff, Leonardo's position was more decorative than functional. And if, as it seems reasonable to suppose, Leonardo owed his appointment to his friend Machiavelli, who became briefly a member of Cesare Borgia's suite, then it is equally reasonable to suppose that Leonardo was playing a double game, advising the tyrant while writing secret reports to the Florentines and storing up knowledge that would be useful to Florence in the event of an attack by the same tyrant. Leonardo was perfectly capable of playing the role of a spy. Machiavelli also played this role, with Machiavellian cunning. And in fact only two years later Leonardo was able to put the knowledge he had acquired as Cesare Borgia's inspector of fortresses to use. He acted as adviser on fortifications to the lord of Piombino, Jacopo IV Appiani, who had lost his city to the papal army. When he recovered it, he asked Machiavelli for assistance in strengthening his fortress, and Machiavelli promptly sent Leonardo to his aid.

There were, of course, many other reasons why Leonardo should have thought it proper to serve under Cesare Borgia. He may have been fascinated by this young upstart who was reputed to be the handsomest man in Italy, the one man who showed promise of being able to dominate all of central Italy. It is certain that they met and it is even possible that they understood one another. Cesare Borgia was force personified, and Leonardo throughout his adult life had been a student of force in all its innumerable aspects.

Although Leonardo invented a large number of military machines and recorded them in his notebooks, nothing came of them. But his study of fortifications was something else altogether. His modifications and suggestions were followed, for he studied fortifications with the same passion with which he studied painting, anatomy, and the theory of flight. He hated war, which he called *pazzia bestialissima*, most bestial madness, but there is a sense in which a fortress is the least warlike of military installations. A fortress is a house defended, peaceful until attacked, and therefore a civilizing influence. Cesare Borgia was not a civilizing influence, and he had very little use for fortresses. Significantly, in October 1502, when he was shut up in Imola by a re-

bellion of the *condottieri,* he lived in the fortress which became his place of refuge.

Early in that same month Machiavelli was sent by the Florentines as an envoy to Cesare Borgia. His instructions were precise: to admit nothing, promise nothing, concede nothing. For three months he remained close to the prince, studying him minutely, and employing all his diplomatic skills to prevent the threatened attack on Florence; the experience of those months led him to write his enduring portrait of the completely conscienceless tyrant, which he called *The Prince.* Most likely it was during this period that Leonardo drew his beautiful map of Imola.

In *The Prince* Machiavelli described the ultimate tyrant, utterly merciless to his enemies, inspiring the utmost fear in his friends, committing acts of treachery as though they were his daily bread. Machiavelli himself was present at Senigaglia, where there took place on the last day of the year what was usually regarded as Cesare Borgia's supreme act of treachery. He came to this small town with his army, professed the greatest friendship with the *condottieri* who held the town, entered it with their permission, and then set about massacring the men to whom he had professed the utmost friendship. The *condottieri* in command of the town were strangled. It is just possible that Leonardo was in Senigaglia when all this happened.

Leonardo detested war but invented many engines of war in the quietness of his study; these engines remained unknown until his manuscripts were discovered, and there is no evidence that any of them were ever made or used. He detested tyranny but served tyrants. He detested bruised and mangled bodies but spent long and exhausting hours on his anatomical studies, complaining bitterly about the stench and the sight of the corpses. He was the most fastidious of men, and he willed himself to do things he hated to do, because they were useful to humanity. There are no ambiguities here. He served tyrants because in his age there was no alternative. He invented engines of war and took care that they were never used. He cut up corpses in a spirit of pure inquiry, knowing that it had never been done with the precision he demanded and that it was essential to do it if medicine was to make any headway. He wrote that killing was always "an atrocious act." Of tyrants he wrote that they take the greatest pleasure in dealing out death, suffering, hard labor, terror, and banishment to every living thing, and that the best that can be hoped for is that the earth will open up and destroy them. He had no illusions about tyranny. In his writings he continually strikes an elegiac note: why were not men as free as the birds he let loose from their cages?

Leonardo himself was free. By February 1503 he was back again in

Florence, free of whatever shackles had bound him to Cesare Borgia. He settled down to his new life in the company of Salai. He was evidently painting again. He noted that on April 8, 1503, he lent "Vante the miniaturist" four gold ducats and Salai acted as the messenger, giving the money personally to the artist. "Vante the miniaturist" was Attavante degli Attavanti, a painter of considerable repute. On the same day Salai asked for and received three gold ducats in order to buy "a pair of rose-colored stockings with their embellishments." This was a staggering sum to pay for stockings—Leonardo's salary was thirty-three ducats a month when he was living in Rome some years later—and the stockings must have been woven of the finest silk and the "embellishments" may have included semiprecious stones. Twelve days later Leonardo gave Salai twenty-one yards of cloth at a cost of thirty ducats. The cloth was for making shirts, which must have been made of the finest weave imaginable. Salai was being permitted to indulge his excessive passion for fine clothes. Cesare Borgia had given Leonardo a mantle, which was probably of cloth of gold: this too ended up in Salai's wardrobe.

These gifts to Salai and the loan to Attavante tell us that Leonardo was living a settled life in Florence, receiving commissions and the promise of commissions for his paintings. But this quiet and settled life was suddenly interrupted by order of the government. One of the interminable wars with Pisa had broken out; the Pisan fortress called La Verruca had fallen to the Florentines; and Leonardo was sent to examine this small romantic fortress high up in the hills which possessed a singularly unromantic name, for *verruca* means "a wart." He drew a map of the Arno passing through Pisa with the mountains colored brown, the sea and the river blue, and he also drew a close-up view of the steep and rugged cliffs of the mountain with the fortress perched on top. A certain Pier Tosinghi, a field commissary of the Florentine army, described Leonardo's visit in a letter written to the government in Florence on June 21, 1503:

> Leonardo da Vinci, himself and company, came here and we showed him everything, and we think he likes La Verruca very much, being well-fitted to his taste. Afterward he said he was thinking of having it made impregnable. But this is something to be put aside for the time being, for the main need is at Librafatta, which is not a small undertaking, nor one to be underestimated. La Verruca should be repaired now to provide proper protection and then it can be equipped to the required perfection.

Pier Tosinghi was clearly a man of sensibility who was a little impatient of Leonardo's obvious pleasure in this remote crag that looked

down on the Arno Valley. It was exactly to the master's taste, an eyrie high in the sky, resembling the strange jutting mountains around Lake Como and surmounted by a keep, an armory, and a thick defensive wall. Leonardo's sketch of the mountain was found in the Madrid Codices.

About a month later, on July 24, 1503, Francesco Guiducci, who had taken over the position of Pier Tosinghi, described some new developments of the long-cherished Florentine plan to divert the waters of the Arno so that they would not pass through Pisa but instead fall into the marsh of Stagno near Livorno. Florentine warships were blockading the river mouth, but blockade runners were still bringing supplies to the beleaguered city. Leonardo, from the army camp outside Pisa, examined the problem and apparently came to the conclusion that even if they did not succeed in diverting the river, they would at least have to build a canal and this would itself protect the Florentines in the hills from the assaults of the Pisans. The letter written by Francesco Guiducci *ex castris*, from the camp, hints at heated discussions:

> Yesterday Alessandro degli Albizzi together with Leonardo da Vinci and certain others were there, and they studied the plan with the commanding general, and after much discussion and considerable difference of opinion they reached the conclusion that the work would be very suitable, whether it actually succeeded in turning the course of the Arno or only went as far as the construction of a canal that would at any rate prevent the hills from being menaced by the enemy.

We learn from the historian Guicciardini and from letters in the Florence archives that an attempt was made to divert the Arno but it came to nothing. Many thousands of ducats were spent in the enterprise and they were all wasted. We also learn from the account books of the Signoria that Leonardo's journey to the headquarters of the Florentine army on the Pisan front with six horses and a piper to lead the way cost 56 lire 13 soldi. No other payments to Leonardo for military services have been found in the account books. He returned to Florence and continued to work there. He was living in considerable style, as we know from the list of extremely expensive clothes he had made before leaving for the camp near Pisa. The clothes were left in a box in a monastery to await his return. The list was written on the back of the drawing he made of La Verruca.

The list is important, because it suggests that at this time he had no fixed abode and was still uncertain about his future plans. Suddenly in October he was offered a commission to paint a battle scene on one of the walls of the Sala del Gran Consiglio in the Palazzo Vecchio. He accepted the commission and immediately paid his dues to the Com-

pany of Painters including a special payment for the feast day of St. Luke. Six days later, on October 24, he was given the keys to one of the great rooms in the monastery of Santa Maria Novella and began to work on the cartoon. This was the only commission known to have been granted to him by the Signoria. The actual contract is signed by Machiavelli and both the cartoon and the painting have vanished, but a number of documents and many preliminary sketches have survived.

The chosen subject was the battle of Anghiari, a subject ideally suited to his gifts, his love of horses, his knowledge of anatomy, his sense of violent and splendid movement.

Before setting to work on the Anghiari battle scene Leonardo carefully studied the historical records of the battle written in Latin by Leonardo Dati the historian. Machiavelli's assistant, Agostino Vespucci, carefully inscribed this account in an Italian translation into Leonardo's notebook, abbreviating it a little. Machiavelli himself thought there had been no battle, only a brief skirmish. Leonardo Dati believed there had been a hard-fought, day-long engagement with heavy losses on both sides. The puzzling thing is that there were so many different accounts of the battle since there were people still alive who must have taken part in it. The battle of Anghiari took place on June 29, 1440, a little more than sixty years before Leonardo began the painting.

Leonardo Dati's account of the battle, as it appears in Leonardo's notebook, should be quoted at length because it was obviously the prime source of the composition:

> Florentines:
> Neri di Gino Capponi
> Bernardetto de' Medici
> Niccolò da Pisa
> Conte Francesco
> Micheletto
> Pietro Gian Paolo
> Guelfo Orsino
> Messer Rinaldo degli Albizzi

Begin with the oration of Niccolò Piccinino to the soldiers and exiled Florentines, among whom were Messer Rinaldo degli Albizzi and other Florentines.

Then let it be shown how the first mounted his horse in armor and how the whole army followed him.

40 squadrons of horse.

2,000 foot soldiers went with him.

In the early morning the Patriarch climbed a mountain to reconnoiter the country: the hills, fields and valleys watered by a river, and saw Niccolò Piccinino approaching from Borgo San

Sepolcro with his men and a great cloud of dust, and having discovered him, returned to his camp of his own people and spoke to them. And having spoken, he prayed to God with his hands joined together, and saw a cloud from which St. Peter emerged and spoke to the Patriarch.

500 cavalry were sent by the Patriarch to hinder or check the attack.

The foremost troops were led by Francesco, the son of Niccolò Piccinino, and he was the first to arrive and attack the bridge held by the Patriarch and the Florentines. Beyond the bridge on the left he sent infantry to engage our men, who succeeded in repelling them. Their leader was Micheletto, whose lot it was that day to be in command of the army.

At this bridge a tremendous battle took place; our men were victorious and the enemy was beaten back.

Then Guido and Astorre his brother, the lord of Faenza, with many men re-formed and renewed the combat, and hurled themselves upon the Florentines with such force that they recaptured the bridge and advanced up to the tents. Against them came Simonetto with 600 horse to fall on the enemy, and for the second time he drove them back from the place and recaptured the bridge, and behind him came more men with 2,000 horse, and so for a long time the battle raged backward and forward. Then the Patriarch, to throw the enemy in confusion, sent forward Niccolò da Pisa and Napoleone Orsino, a beardless youth followed by a great company of men. And thus there came about another great feat of arms: and at the same time Niccolò Piccinino pushed forward with his remaining forces and once again caused our men to give way, so that if the Patriarch had not hurled himself into the fray and by word and deed sustained the spirits of the commanders, our men would have taken to flight. The Patriarch then had some artillery mounted on the hill and with these he made havoc of the enemy infantry: and the disorder was such that Niccolò gave orders to withdraw his son and all his soldiers, and they fled toward Borgo. Then there began a great slaughter of men, and none escaped except those who had fled earlier or who had concealed themselves. These feats of arms continued till sunset, when the Patriarch decided to recall his men and bury the dead, and afterward he set up a trophy.

Such was the document laboriously transcribed in Leonardo's notebook in a scholarly hand. It begins with a list of the Florentine generals and concludes with Rinaldo degli Albizzi, the archtraitor, the great feudal chieftain of vast areas of Tuscany who hoped to bring Florence to her knees. The commander of the Milanese forces was Niccolò Piccinino, born in Perugia of humble origins, a *condottiere*

who sold his sword to the highest bidder, remarkable for his intelli-
gence and his savagery. He was a small, wizened man, almost a
dwarf, and his greatest ambition, never accomplished, was to be lord
of Perugia. The commander of the Florentine forces was Micheletto
Attendulo. The papal legate, Lodovico Scarampi Mezzarota, Patriarch
of Aquileia, led the papal forces who were in league with the Floren-
tines.

The account presented to Leonardo was an official document in-
structing him on what to paint and what not to paint. "Begin," says
this formidable document, "with the oration of Niccolò Piccinino."
This meant that at the extreme left of the painting Leonardo was
commanded to paint the figure of Piccinino haranguing his troops, or
at the very least to give serious consideration to painting it. There fol-
lowed a series of incidents that lent themselves admirably to a very
large wall painting. The Milanese army coming up in a cloud of dust,
the patriarch praying to St. Peter and receiving a vision of the saint,
the attack on the bridge, the patriarch hurling himself into the fray as
the Florentines fell back, the final rout of the enemy, the burial of the
dead, and the erection of a trophy. It was intended that some or all of
these incidents should be included in the painting. Leonardo did ex-
actly what he did when confronted with the specifications for *The Vir-
gin of the Rocks*. He concentrated, simplified, reduced, omitted. It was
almost inconceivable that he would be able to produce a credible St.
Peter in a cloud, and nothing remotely resembling this vision of St.
Peter appears in the many sketches he drew of the battle scene. What
appears to have fascinated him was the prospect of painting the be-
ginning, the middle, and the end of a battle in three continuous
scenes so that the observer, looking along the whole length of the wall
over an expanse three times larger than *The Last Supper*, would have
the illusion that he was actually taking part in the battle. There would
be a river winding across the battlefield, Borgo San Sepolcro would be
seen in the distance, huge banners would float over the armies, the
outlines of tents would cut sharply against the sky, and on various reg-
isters the observer would see groups of cavalry and groups of foot sol-
diers fighting ferociously, especially on the bridges. Somewhere, too,
there would be the small, walled village of Anghiari, once a Roman
camp.

There exists in the National Gallery of Ireland, in Dublin, one of
those panels painted on Florentine chests or *cassone* with a repre-
sentation of the battle of Anghiari. The painting forms a kind of trip-
tych. On the left Piccinino is haranguing his troops outside a walled
town which is clearly Borgo San Sepolcro. The huge serpent banner of
the Sforzas is flying, the horsemen are at ease, the pikemen are stand-

ing in ranks, and there is an air of total unconcern about the battle
which is being waged a few yards away on the further side of a small
river, which is very shallow, for we can clearly see a horse wading
across it up to its hocks. Here, beyond the river, in the center of the
painting, the battle is being waged between the Milanese and Floren-
tine horsemen who are fighting at close quarters. The Florentine
banner, the lily on the white ground, is flying proudly, and the serpent
banner is being lowered to the ground. Only one man appears to be
hurt, lying spread-eagled in the foreground, like a man who has been
trampled by a horse. Machiavelli's comment on the battle in his *His-
tory of Florence* that "it lasted for four hours, but only one man died,
dying not from wounds inflicted by enemy weapons or any honorable
means, but because he fell from his horse and was trampled to death"
seems here to be confirmed. The battle, which takes place between
two bridges and two arms of a curving river, resembles a joust, and
the painter evidently did not take it seriously. In the third portion of
the triptych we see the Milanese marching away with their banners
flying, while simultaneously the Florentine forces march toward the
bridge. In the distance two women are calmly drawing water from a
well, totally indifferent to the follies of the warriors. About a hundred
small figures are crowded on the small painting, but one has the im-
pression that nothing of any importance is taking place. The painting
was made by a remote follower of Paolo Uccello, who had apparently
never witnessed a battle.

Nevertheless this *cassone* panel tells us a good deal. We have a
glimpse of the landscape of the upper Tiber; we see the bend of the
river with two small semicircular bridges; we encounter the armored
horsemen with their gaudily striped saddlecloths and we remember
that the cavalrymen of that period dressed like peacocks and that the
foot soldiers still fought with pikes. We learn, too, that the river was
very shallow and the heat blazed out of a cloudless sky.

Although this painting by a follower of Uccello is the work of a
third-rate artist, it suggests that any large painting of the battle would
have as its centerpiece the sudden assault of armored cavalrymen be-
tween the two bridges. On the left there must be the haranguing of
the soldiers and the Milanese advance, in the center there must be the
battle in all its intensity, and on the right there must be the rout of the
Milanese and the triumph of the Florentines. From Leonardo's surviv-
ing sketches and from the painting known as *The Battle of the Stand-
ard*, which survives in many copies, it appears to have been his inten-
tion to create a wall painting which was not wholly dissimilar to the
painting on the *cassone*. He would give it depth and urgency, he
would arrange and balance the elements, he would pour life into the

air and into the faces and bodies of men, and he would paint horses of heroic size and vigor. The *cassone* in Dublin is a provincial work; the painting in the Sala del Gran Consiglio would have the imperial quality which he gave to all his undertakings.

So he worked contentedly and laboriously, immersed in his art and his studies, and from time to time he would have to waste his energies in warding off the importunities of those who urgently demanded paintings from his hand, forgetting that *The Battle of Anghiari* was an absorbing task and his studies were equally absorbing. He was fifty-one, and his time was beginning to run out.

The Importunities
of Isabella d'Este

Isabella d'Este, Marchioness of Mantua and wife of Francesco Gonzaga, the tyrant of Mantua, was a woman with an insatiable appetite for works of art. Although she prided herself on her beauty and was accustomed to receiving poems in praise of her good looks from her court poets, she was rather commonplace in appearance, and this was her tragedy. She possessed great charm and dignity, her eyes were dark and sparkling, her fine yellow hair reached to her shoulders, and she had a dazzling complexion. Unhappily, she had an absurd and rather lumpy nose, a weak chin, and was short and plump. She had none of the incandescent vitality of her sister Beatrice. She was a bluestocking, knew *The Eclogues* of Vergil and many of the epistles of Cicero by heart, and could speak learnedly about many things she had never understood. Among the things she could never understand was the slow and deliberate pace of artists.

The Mantuan painter Luca Liombeni was employed to decorate her *studiolo*, the little study attached to the Castello in Mantua where she read, worked, and entertained her more studious guests. Luca Liombeni worked slowly, and this infuriated her. On November 6, 1491, when she was in Ferrara, she dashed off a brief note to him:

> Since we have learned by experience that you are as slow in finishing your work as you are in everything else, we send this to remind you that for once you must change your character, and that if our *studiolo* is not finished on our return, we intend to put you in the dungeon of the Castello. And this, we assure you, is no jest on our part.

Nor was it, for she was perfectly capable of carrying out her threat. Artists drove her to paroxysms of impatience, and she in turn sometimes drove the artists close to madness. She ordered Perugino to paint for her walls an entire panorama of classical mythology: the painting must include Zeus, Medusa, Venus, Europa, Pallas Athene, Venus, Polyphemus, Apollo, Daphne, Pluto, Persephone, Neptune, Amor, Diana, and many other gods or half-gods, together with attendant fauns, satyrs, nymphs, and cupids. She sent him a drawing showing how they should be placed on canvas and a piece of string that measured the height of the principal figure of Andrea Mantegna's painting, which would be standing beside it. "Do hurry," she wrote. "The quicker you do it, the more I shall be pleased."

Andrea Mantegna, a man as hard as the rocks he loved to paint, was another of her victims. He was dangerous when aroused, and she therefore treated him with more than her usual kindness. He gave her, among many other paintings, his miraculous *Death of the Virgin*, now in Madrid. She was determined to have paintings by Leonardo and continually wheedled, cajoled, and made outright demands for paintings by him without much effect.

On March 27, 1501, Isabella d'Este wrote to Fra Pietro de Nuvolaria, her close friend and a most important ecclesiastical dignitary, imploring him to use his good offices to acquire for her a painting—any painting—from Leonardo. She wrote as follows:

> Most Reverend Father—If Leonardo the Florentine painter is in Florence, we pray Your Reverence to discover what kind of life he is leading, that is, if he has begun any work, as we have been informed, and what kind of work it is, and if he intends to remain there for some time. Your Reverence may then sound him out about whether he is willing to paint a picture for our studio, and in regard to this, if he accepts, we shall leave the subject and the time to him, and should he prove obdurate, try at least to induce him to paint for us a small picture of the

Madonna, devout and sweet, according to his manner. And also ask him to send another sketch of our portrait, for His Highness, our consort, has given away the one he left with us, and for all this we shall be grateful to Your Reverence and to the aforementioned Leonardo.

Fra Pietro de Nuvolaria was a man who delighted in doing errands for the *marchesa*, and within a day or two of receiving her letter he had called on Leonardo, carefully examined a cartoon the artist was working on, and discussed the possibility of acquiring a painting for her. As she had suspected, Leonardo proved to be obdurate. He had not the slightest intention at this time of satisfying her wishes, nor was he inclined to make a copy of the drawing he had made of her, which her husband had thoughtlessly given away. Her request is interesting, for it means that Leonardo must have kept copies of his drawings both for his own records and so that he might on rare occasions produce further copies for his sitters. Her tone is very cavalier. "Ask him to send another sketch," she says, as though it was the simplest thing in the world to acquire a replacement.

Her hopes went unfulfilled. It must have taken three or four days for her letter to reach Florence from Mantua. At the beginning of April Fra Pietro wrote to Isabella d'Este, warning her to expect nothing, and in the course of the letter he described a cartoon, which was a first sketch for the painting *St. Anne, the Virgin and the Infant Christ with a Lamb* now in the Louvre. Fra Pietro writes graphically, so that she would have a good idea of the picture, and he hopes to send her better news in the future. Here is his letter:

> Most illustrious and most excellent Lady.
>
> I have Your Excellency's letter in hand and shall do what you ask with the utmost speed and diligence, but from what I can gather the life of Leonardo is changeful and extremely unpredictable [*varia et indeterminata forte*], so that he seems to live from day to day. Since he has been in Florence he has worked only on a sketch of a cartoon depicting a Christ Child about a year old straining from his mother's arms, seizing a lamb, and apparently attempting to embrace it. The mother, half rising from the lap of St. Anne, holds the Child and tries to pull him away from the lamb, the sacrificial animal symbolizing the Passion. St. Anne, rising a little from her seat, seems to want to prevent her daughter from taking the Child away from the lamb, and this perhaps symbolizes the Church, which does not wish the Passion of Christ to be impeded.
>
> These figures are life-size but fill only a small cartoon, for they are all seated or bending over, and one is placed in front of the other, on the left side; and this sketch is not yet finished. He has done nothing else except that two of his apprentices [*gar-*

zoni] are doing portraits and from time to time he puts his hand to them: he is working hard at geometry and is most impatient with the brush [*impacientissimo al pennello*].

I write this only so that Your Excellency shall know that I have received her instructions. I shall continue my efforts and shall report on them immediately there is any news, commending myself to Your Excellency and praying that God shall keep you in his grace.

Fra Pietro did precisely what he promised to do, for on the following day he succeeded in seeing Leonardo, discussed the question of a painting for Isabella d'Este, and found that Leonardo, though claiming to have abandoned everything for mathematics, was in fact working on an unfinished *Virgin and Child* for Florimond Robertet, and once more there is a graphic description of Leonardo's work:

> Most illustrious and most excellent Lady,
>
> During Holy Week I became acquainted with the intentions of Leonardo the painter through his pupil Salai and several other of his friends, and in order to advise me more fully about his plans they brought me to his house on Wednesday in Holy Week. To sum up, his mathematical experiments have so distracted him from painting that he cannot endure to use a brush. Nevertheless I endeavored first of all to plead Your Excellency's cause, employing all my skill. Then, seeing that he seemed well-disposed to gratify Your Excellency's wishes, I spoke to him with complete frankness and we came to the following conclusion: that if he should be able to release himself from the King of France without incurring displeasure, as he hopes, then within a month at the latest he will serve Your Excellency in preference to anyone else.
>
> In any event, as soon as he has furnished a little picture for Robertet, the favorite of the King of France, he will immediately paint the portrait and send it to Your Excellency. I have left two good pleaders with him. The little picture he is working on is a Madonna sitting, as if she meant to wind a spindle, while the Child, with his foot over a small basket, has picked up the yarn winder and gazes attentively at the four arms which make up the shape of a cross, smiling eagerly at the cross and holding it fast, not wishing to give it back to his mother, who is trying to take it away from him. This much I have succeeded in arranging with him.
>
> I preached my sermon yesterday. God grant that it will bring forth good fruit, for there was a very large audience.
>
> Florence, April 4, 1501.
>
> FRATER PETRUS DE NUVOLARIA
> Vice-General of the Carmelite Order.

Fra Pietro reveals himself in his letters: a little pompous, very much the busybody, hurrying about the city on his manifold errands with an eye for the main chance. He has taken Leonardo's measure, he is sure he will accomplish his purpose, for he knows exactly whom to see, who to bribe, and how to arrange that others inside Leonardo's family will be induced to promote the claims of the *marchesa* when he is absent. "I have left two good pleaders with him," he writes, and we can guess that Salai, always in need of money and comfits, was one of them. Fra Pietro is observant, but not very observant. He is permitted to see the unfinished painting of *The Virgin and Child with a Yarn Winder,* which is lost but which we know from copies. We see the Virgin blessing the Child with an expression of sorrow and wonderment, and also with a kind of musing delight in the fact that he should be playing with something as simple as a yarn winder. That the yarn winder takes the form of a cross and that he will die on the cross have not yet penetrated her consciousness. The Child's knowledge is balanced by the Virgin's innocence and devotion, her dimly felt awareness that a sacramental act is being performed, and it is all mystery, enchantment, and prophecy.

The surviving copies—one in the collection of the Duke of Buccleuch in London, another in the R. W. Reford collection in Montreal, and the third in the collection of Prince Rupert of Bavaria in Munich —are lacking in all those elements we have come to expect from Leonardo: the intense relationship between the figures, the subtlety of the coloring, and the grandeur of the design. The copyists have painted the several parts with reasonable accuracy, but they have failed to impart the sense of the whole. Yet the viewer looking, for example, at the Buccleuch painting, cannot fail to see the work of Leonardo at one remove.

Certainly the painting presented to Florimond Robertet was an authentic Leonardo. Robertet was a singularly cultivated man, a born secretary of state, industrious and prudent, speaking German, Italian, Spanish, and English, vigilantly pursuing the interests of France. He served Charles VIII, Louis XII, and Francis I with a calm, devious, and unrelenting intelligence. He was born in humble circumstances in the rugged hills of Montbrison in central France and first gained prominence in the court of Anne of Brittany, then an independent state. Thereafter his rise was spectacular. He married well, his wife brought him a dowry of 100,000 livres, he arranged the marriage of his brother-in-law to the noble Angoulême family, and was himself ennobled, becoming Baron d'Alluye, de Bury et de Brou. He was the king's secretary, treasurer of the royal purse, roving ambassador, collector of works of art on a prodigious scale. The city of Florence once

presented him with a bronze statue by Michelangelo. In Milan he held court like a prince of the blood royal and was called "Florimond the good" because he was gentle and sweet-tempered. He was one of the richest men in Europe and could afford to be good. So he remained, serving the kings of France wisely, until he grew old and infirm and half blind, and to the very end of his long life he remained the king's chief adviser.

The Virgin and Child with a Yarn Winder passed into his possession and then disappears without trace. Rich men are sometimes prodigal of their possessions, and he may have given it away, or it may have survived until the Revolution, when French castles were sometimes put to the torch. In Milan his word was law, and if Leonardo agreed to paint the picture for him, then we may be sure he received it.

Fra Pietro's letter is interesting for many reasons, and one of those reasons is that we can almost hear Leonardo's tone of voice as he declares that he cannot endure to hold a brush in his fascination for mathematical experiments. Fra Pietro claims that he spoke to Leonardo skillfully and with great frankness and claims that he extracted a promise, or nearly a promise, of a painting. Leonardo had said only that if he could be relieved of his duties to the King of France, then perhaps "within a month at the latest" he would execute the portrait demanded of him. He, too, could play the diplomatic game, and all the more effectively because he was the sole creator of his works of art, could choose his time and place, and was not circumscribed by affairs of court. When Fra Pietro speaks of his skill in advocacy, we are permitted a smile, for he was dealing with someone infinitely more skillful. When Leonardo declared that he would paint for Isabella d'Este "in preference to anyone else" he was demonstrating only his politeness, not that he intended to paint for her. For good or ill he was in the service of the French king, who was far more powerful and demanding than the *marchesa.*

Poor, persistent, tiresome Isabella! Over the years she continued to demand that Leonardo should paint for her, to no avail. She sent Manfredo de Manfredi, the Ferrarese envoy and ducal orator, to Leonardo with instructions to deliver her letter to him and obtain a reply. He wrote to her on July 31, 1501:

> I delivered Your Excellency's letter to Leonardo the Florentine with my own hand, telling him I would take charge of any letter he might wish to send Your Excellency in reply and I would see that it was faithfully delivered to you. He replied that he would send an answer shortly and hoped to be able to oblige Your Excellency. But since no letter came, I sent again to ask his intentions, and he replied that all he could say for the mo-

ment was that he has begun to do what Your Excellency de-
sired. That is all I have been able to obtain from the said
Leonardo. If in any other way I can serve Your Excellency, you
have only to command your faithful servant, and I continue to
recommend myself to you. *Quae foelix ac diu benevaleat.*

Leonardo's silences could be alarming, but there were ruses by
which he might be made to speak. Isabella thought up an excellent
ruse. She wrote to her agent, Francesco Malatesta, on May 3, 1502,
concerning some vases that had once belonged to Lorenzo de' Medici
and were now on sale. If Leonardo could not be induced to paint for
her, he could at least act as her artistic adviser, and she therefore
asked Malatesta to consult some competent person "such as Leonardo
the painter who used to live in Milan, and is our friend, if he is still
living in Florence, and consult him as to their beauty and value."
Malatesta took more than a week to carry out the commission and
wrote to her on May 12:

> I have shown them to Leonardo Vinci, the painter, as Your
> Excellency so instructed me. He praises all of them, especially
> the crystal vase, which is all of one piece and very fine, and has
> a silver-gilt stand and cover: and Leonardo said he never saw a
> finer thing. The agate one also pleases him because it is a rare
> thing and of large size, and is all in one piece, excepting the
> stand and the cover, which are silver-gilt, but it is cracked.
> The amethyst vase, or, as Leonardo calls it, the jasper one, is
> transparent and has a variety of colors, and has a massive gold
> stand studded with so many pearls and rubies that they are val-
> ued at 150 ducats. This greatly pleased Leonardo as being
> something quite new and because of the diversity of its marvel-
> ous colors. All four have the name of Lorenzo Medici engraved
> on them in majuscule lettering.

Rather tentatively, Malatesta enclosed some suggested prices for the
vases: the crystal vase, at 350 ducats; the jasper vase set with pearls
and rubies on a gold stand, at 240 ducats; the agate vase, at 200
ducats; and the jasper vase on a plain silver stand, at 150 ducats. With
the letter he enclosed colored drawings of the vases. It is unlikely that
Isabella bought any of the vases, for she had already spent a great
deal of money that year in a state visit to Venice and in attending Lu-
crezia Borgia's wedding. These letters, however, are valuable because
they show Leonardo's delight in exotic vases. When Malatesta says
"This greatly pleased Leonardo as being something quite new and be-
cause of the diversity of its marvelous colors" we almost hear the voice
of Leonardo as he examines them.
It is quite possible that Isabella possessed no interest in these exotic

vases: what she wanted above all was to remain in contact with Leonardo and somehow to acquire a painting by him. Her husband, Francesco Gonzaga, also sought out the advice of Leonardo.

Gonzaga often came to visit Florence, and it was his habit on these occasions to stay in the large and palatial house of his agent, Agnolo Tovaglia, a rich Florentine merchant. The house, called the Villa Tovaglia, was set in a large garden on the slope of a hill. Gonzaga was so delighted with the house that he thought of building a similar house in Mantua, and asked Francesco Malatesta to find an architect and provide him with architectural drawings. Malatesta sought out Leonardo, who obligingly visited the house, made the drawings, and gave them to Malatesta, who wrote to Gonzaga:

> I am sending Your Excellency the drawing for the house of Agnolo Tovaglia, which has been made by the hand of Leonardo da Vinci who, as your servant, commends himself to you and to Her Ladyship.
>
> Domino Agnolo says he will be coming to Mantua in order to judge who is the better architect, Your Excellency or himself: although he is certain who will be the best because *facile est inventis addere* and because the prudence of Your Excellency is not to be compared with his. And the above-mentioned Leonardo says that in order to make a perfect thing in the most satisfactory way, the surroundings should be transported to the place where Your Excellency desires to build it.
>
> I did not commit Leonardo either to coloring the drawings or to make ornaments of greenery, such as ivy, box, cypress and laurel, which can be found here, because I felt this was unnecessary. However, should Your Excellency so desire, the aforementioned Leonardo offers to do it either in painting or in a model, as Your Excellency desires.

This letter, dated August 11, 1500, tells us a good deal about Leonardo's habits as an architectural consultant. It was a comparatively small assignment which took a good deal of time, and it was purely speculative with no immediate rewards. He did what was required of him, and then waited. He had observed correctly and in the most delicate terms that the whole idea was preposterous, because a villa designed for the Tuscan countryside would always look wrong when set down in the Mantuan countryside. He was an environmentalist, and it was clearly his feeling that it would be necessary to redesign Tovaglia's villa when, if ever, it was copied in Mantua.

Nothing came of the idea, and Gonzaga himself appears to have lost interest in the project for many months. In April 1502, Malatesta wrote to Gonzaga, saying he had discussed the whole matter with

Agnolo Tovaglia, who instead of sending a model of his house to Man-
tua was more inclined to send the architect, Lorenzo da Monte Aguto,
who had redesigned it. This architect, who is described as having
done some work for Lorenzo de' Medici, is unknown to history. Leo-
nardo appears to have washed his hands of the matter. In time the villa
passed into the hands of Francesco Guicciardini, the great historian of
Florence.

But if Leonardo had washed his hands of the villa, he continued to
have dealings with Tovaglia himself. Most of them were inconclusive
and a waste of time. As agent of the Mantuan court, Tovaglia contin-
ued to badger him for paintings for Isabella d'Este. On May 14, 1504,
Isabella wrote to Tovaglia about an idea for a new painting that had
suddenly occurred to her. Tovaglia was to inquire whether Leonardo
would paint it for her. In addition there was another letter in her own
hand addressed to Leonardo, which Tovaglia was to place in the
hands of the maestro. The letters are amusing, for she tells Tovaglia
what arguments to use, while in her own letter she employs other ar-
guments, flatters Leonardo, beguiles him with promises of payment,
and seems to be dancing around him and taunting him to make the
picture she so much desires.

To Tovaglia she wrote, remembering that Leonardo was busily
working on *The Battle of Anghiari:* "If he should excuse himself be-
cause of the work he has commenced for Their Excellencies of the
Signoria and says he has no time, then you can make the reply that
this will serve for recreation and the elevation of his spirits when,
made weary by the historical picture, he takes an hour or so for his
own convenience and pleasure."

As usual Isabella d'Este was confusing her own convenience and
pleasure with Leonardo's. Her letter to Leonardo was a little master-
piece of blandishment:

> Domino Leonardo Vincio the painter.
> Messer Leonardo. Understanding that you are now estab-
> lished in Florence, we entertain the hope of obtaining what
> we so much desire—to possess something from your hand.
> When you were in these parts you made a charcoal drawing of
> me and promised you would soon be making a portrait head of
> us in color. But since this appears almost impossible, since you
> have not the means of transporting yourself here, we pray you
> to exchange our portrait for another picture, for which we
> would be even more grateful. Make us a figure of Christ about
> twelve years old, which would correspond to his age when he
> disputed in the Temple, the painting to be done with that

sweetness and subtlety of air (*dolceza et suavita de aiere*), which your art possesses with a peculiar excellence.

If this our utmost desire should be satisfied, you know that beside whatever payment you wish, we shall be so grateful to you that we shall think only of how to oblige you and we shall attend to your convenience and pleasure, and while awaiting your favorable reply, we attend to your pleasure.

Isabella d'Este uses the imperial "we" as though she were the Empress of all the Indies. Her demands must be met; it is inconceivable that they will not be obeyed. But, alas, Leonardo had other things on his mind besides pampering a woman who was continually pampering herself, and Tovaglia knew it. He visited Leonardo, gave him the personal letter from Isabella, and learned only what he knew before—that Leonardo was unlikely to paint for her a twelve-year-old Christ. Nearly two weeks later, on May 27, he wrote a rather apologetic letter to Isabella d'Este, informing her that Leonardo was otherwise engaged and could not be expected to produce anything for her for some time, perhaps for a very long time. He wrote:

I have received Your Excellency's letter together with the letter for Leonardo da Vinci, to whom I presented it, urging and counseling him with effective arguments that he should in every way oblige Your Excellency with the painting of the young Christ, according to your request.

He promised me he would do it during such hours and occasions as were left to him from the work undertaken for the Signoria here. I shall not be remiss in pressing the aforementioned Leonardo and also Perugino in regard to the other painting: both give fine promises and appear to share a great desire to serve Your Excellency, and yet I do not doubt that we shall have a competition in tardiness: I do not know which one in this competition is superior to the other, although I am sure Leonardo will be the victor. Nevertheless I shall behave toward them with an extreme diligence.

Tovaglia knew Leonardo too well to suggest that there was any real hope, although, to keep her happy, he offered her some firm hopes in the beginning, only to dash them at the end. Leonardo will be the victor, *vincitore*, in this competition; the pun evidently delighted him; he put as good a face on it as he could.

Isabella came to possess an important and immensely valuable collection of paintings, but there was not a single painting by Leonardo. All her striving came to nothing. Her small, wiry, bullet-headed husband attempted to help her, also without success. Only one of Leonardo's paintings finally entered the Gonzaga collection. This was *la*

Scapiliata, the woman with the disheveled hair, which was given to Federico, Isabella's son, by Count Niccolò Maffei, and which appears in the sale catalogue of 1627 with an attribution to Leonardo. In this way Federico acquired without striving what Isabella strove for over many years.

She made one last effort to acquire a Leonardo painting in the spring of 1506 during her visit to Florence to attend the feast of the Annunciation. Leonardo was not to be found—he was engaged in various calculations concerning the flow of water and studying the flight of birds in a small villa at Fiesole. She did, however, meet Alessandro Amadori, Leonardo's uncle, who offered to act as a go-between. On May 3, 1506, when Isabella was back in Mantua, he wrote to her:

> Here in Florence I act at every moment as the representative of Your Excellency to my nephew, Leonardo da Vinci, and I never cease urging him with every argument in my power to satisfy Your Excellency's desire that he should paint the figure you demanded from him and which he promised you several months ago, as in the letter to me which I showed to Your Excellency. This time he has promised me he will truly begin the work soon to satisfy Your Excellency's desire, and he enjoins me to commend him to your favor.
>
> And if, before I leave Florence, you will specify your preference with regard to one figure or another, I will do everything to ensure that Leonardo satisfies your preference, for it is my greatest desire to oblige Your Excellency.
>
> Your servant
> ALEXANDER DE AMATORIBUS

From Sacchetta, where she had been driven by the outbreak of the plague at Mantua, Isabella wrote to Leonardo's uncle enthusiastically, complimenting him on the dexterity of his approach to Leonardo and his help in satisfying her wishes; she hoped he would continue his good offices and secure for her the painting she so ardently desired.

Nothing came of it; nothing could come of it; her importunity worked to her disadvantage. She had asked too often, too much. He had long ago finished with painting portraits, and he had not the least desire to serve under this stern woman who thought nothing of throwing painters in prison if they failed to produce works of art exactly when she wanted them.

The altarpiece of *The Virgin of the Rocks*. A design proposed by Dr. Carlo Pedretti. (COURTESY DR. CARLO PEDRETTI)

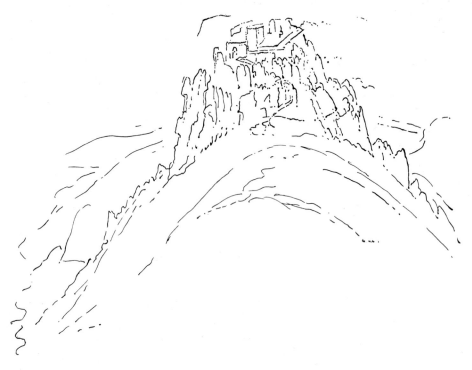

La Verruca by Leonardo. (TRACED BY DR. CARLO PEDRETTI)

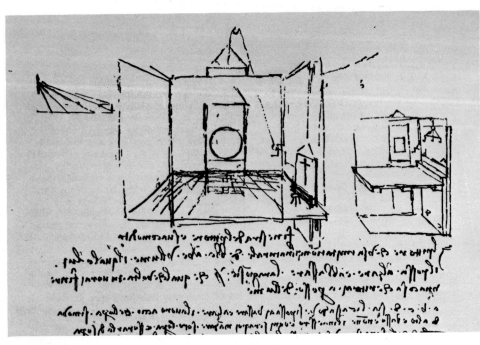

A sketch of his studio by Leonardo.

View of Rome, showing the Vatican and the Belvedere, as it was
in the time of Leonardo. New York Public Library Collection.

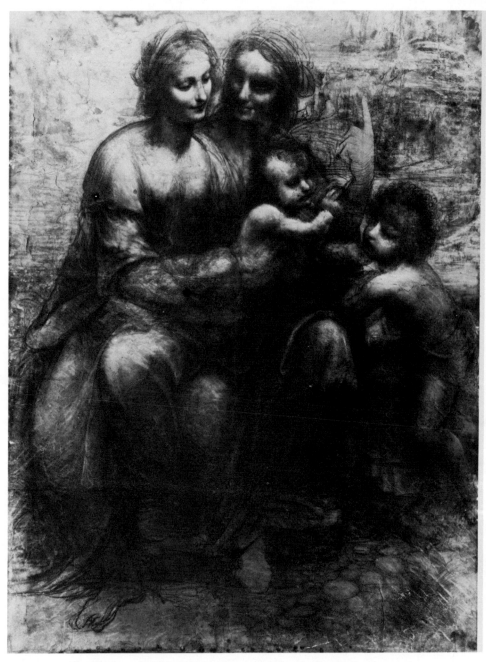

The Virgin and Child with St. Anne and John the Baptist by Leonardo. London, National Gallery. (REPRODUCED BY COURTESY OF THE TRUSTEES, THE NATIONAL GALLERY, LONDON)

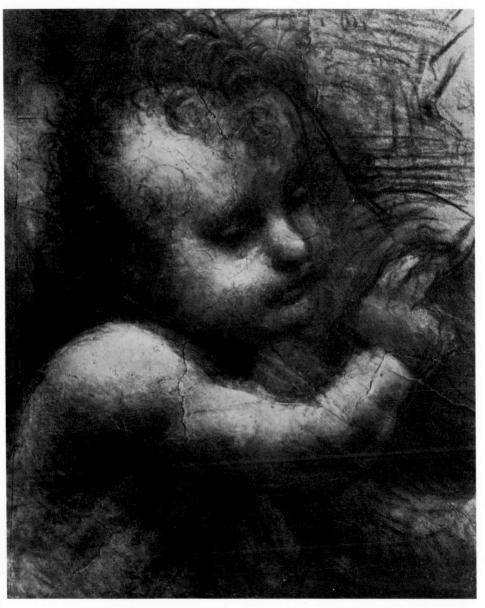

Detail of Child by Leonardo. ()

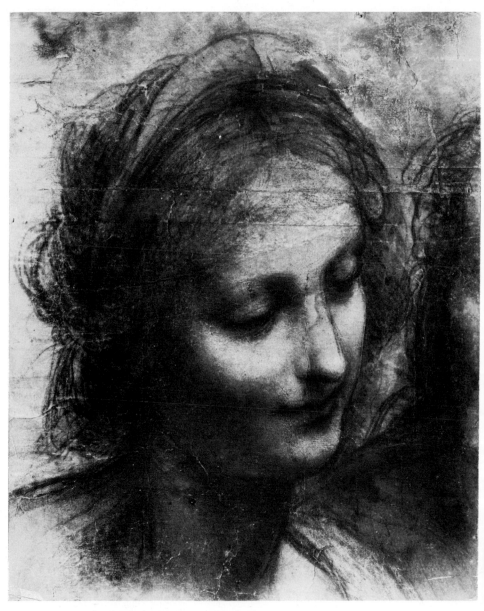

Detail of Virgin by Leonardo. (reproduced by courtesy of the trustees, the national gallery, london)

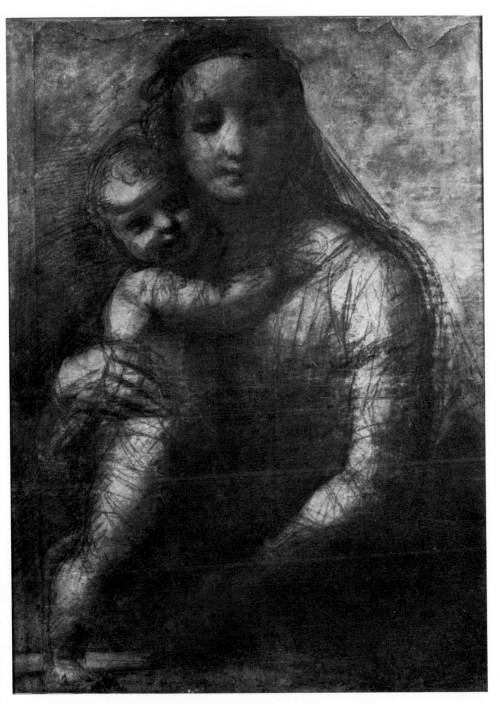

Virgin and Child by Raphael. London, The British Museum.
(BRITISH MUSEUM PHOTOGRAPH)

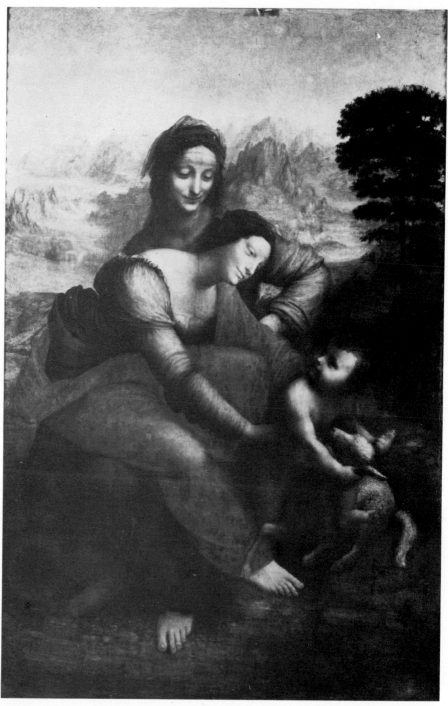

The Virgin and Child with St. Anne and a Lamb by Leonardo.
Paris, The Louvre. (DOCUMENTATION PHOTOGRAPHIQUE)

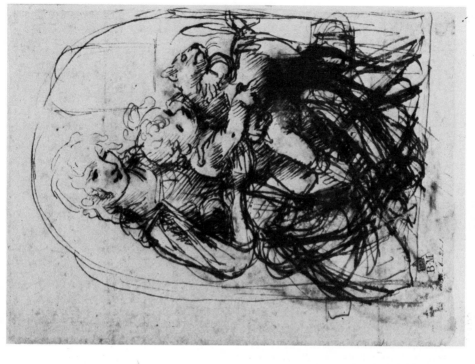

Sketch for *Virgin and Child and a Cat* by Leonardo. London, The British Museum. (BRITISH MUSEUM PHOTOGRAPH)

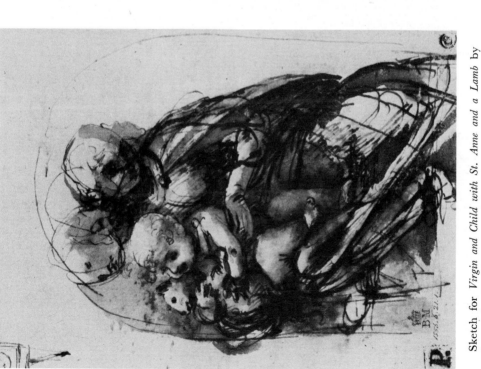

Sketch for *Virgin and Child with St. Anne and a Lamb* by Leonardo. London, The British Museum. (BRITISH MUSEUM PHOTOGRAPH)

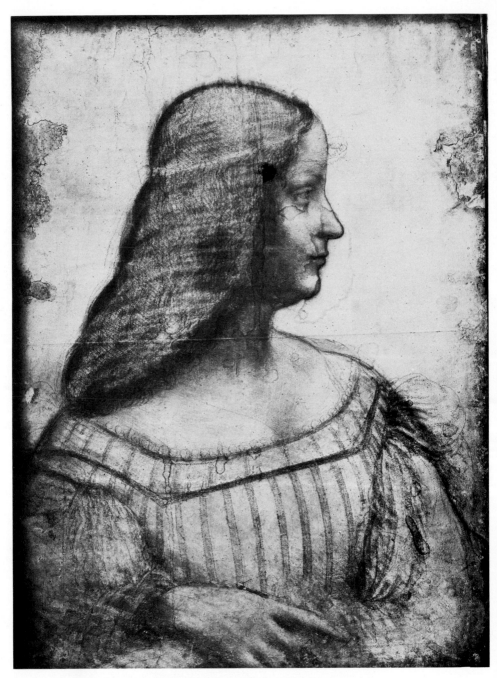

Portrait of Isabella d'Este, lightly colored, by Leonardo.
Paris, The Louvre. (ANDERSON)

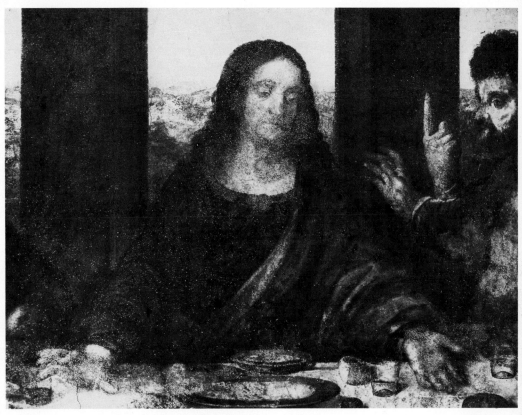

The Christ of *The Last Supper*. Milan, Santa Maria delle Grazie.
(ALINARI)

The Last Supper by the Master of the Sforza Book of Hours. (New York Public Library photograph from A. M. Hind, *Early Italian Engraving*)

The Last Supper by Leonardo. Milan, Santa Maria delle Grazie. (ALINARI)

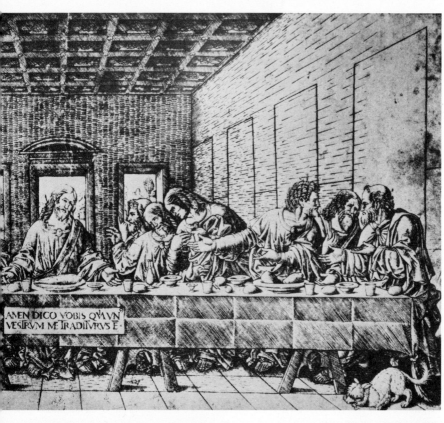

AMEN DICO VOBIS QVA VN
VESTRVM ME TRADITVRVS E

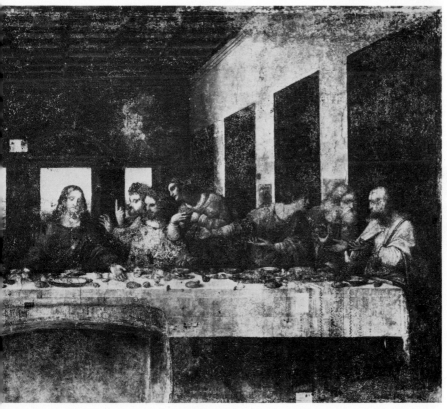

The Battle of Anghiari, painted by an unknown artist of the Florentine School
(COURTESY OF THE NATIONAL GALLERY OF IRELAND)

Unfinished copy of central scene in *The Battle of Anghiari*,
attributed to Raphael. (PRAEGER)

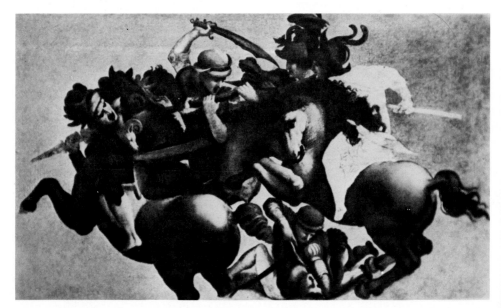

Copy of central scene in *The Battle of Anghiari* by Rubens.
Paris, The Louvre. (GIRAUDON)

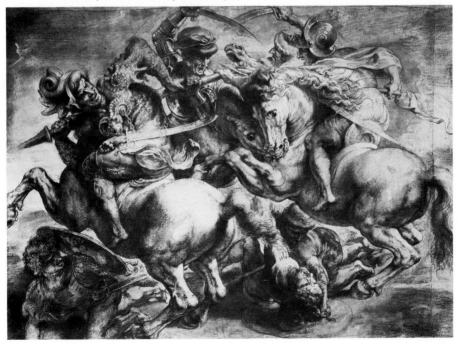

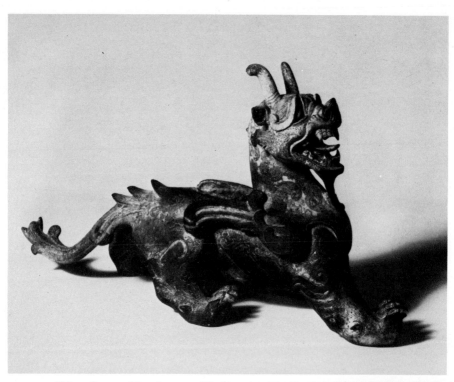

Chinese Dragon. Han dynasty. Washington, The Freer Gallery of Art.

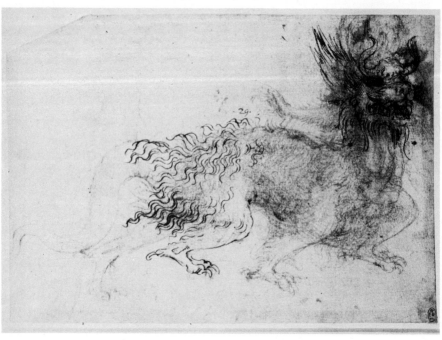

Dragon by Leonardo. Windsor, Royal Collection. (REPRODUCED BY
GRACIOUS PERMISSION OF HER MAJESTY QUEEN ELIZABETH II)

The Portrait of the Father

The year 1504 opened auspiciously in Florence with the commission to decide where Michelangelo's *David* should be placed. This commission was attended by the greatest artists of the Renaissance and it met in extraordinary session on January 25, 1504, after long and careful preparation. *David* was regarded as the very soul of Florence, the crown of Michelangelo's achievement, the emblem of a republican people who had rid themselves of the tyranny of Savonarola and thought mistakenly that they had rid themselves of the Medici. Vasari described the statue as "a resurrection from the dead," more marvelous than anything created in antiquity. The Florentines were elated by it. The finding of a proper site was therefore a matter of great importance.

The commission consisted of no less than twenty-eight artists. They included Leonardo da Vinci, Andrea della Robbia, Piero di Cosimo,

Simone del Pollaiuolo, Sandro Botticelli, Giuliano da San Gallo, Pietro Perugino, and Lorenzo di Credi. Giovanni Cellini, the father of Benvenuto, was also a member of the commission. There were a number of goldsmiths, a master embroiderer, a clockmaker, a wood carver, and a worker in precious stones. All of them appeared and made their statements, which were recorded in the presence of the first herald of the Signoria.

Michelangelo himself wanted the *David* to stand outside the entrance to the cathedral on the Piazza del Duomo, although it had originally been commissioned for one of the cathedral buttresses. In Michelangelo's eyes it was a profoundly religious work worthy of a place beside the cathedral steps. The people of Florence saw it as a profoundly political work and wanted it in the Piazza della Signoria, not only because it was a warning to tyrants but because the Signoria provided a more suitable aesthetic setting. The question was whether it should be in the courtyard of the Signoria, which might suggest that it had been made captive by the authorities, or just outside, or within the Loggia close by, or in the square itself. Giuliano da San Gallo, a famous architect, sculptor, and engineer, thought it should be in the Loggia under the central vault, and perhaps far back against the wall. He insisted that it should be in a covered place because the marble would weather badly. This view was generally accepted. When Leonardo was called upon to speak, he said, "I agree that it should be in the Loggia, where Giuliano said, but on the parapet where they hang the tapestries, with decent ornament, and in such a way that it does not spoil the ceremonies of the officials."

Nearly everyone agreed that it should be on the steps, or on the parapet, or just inside, or deep within the Loggia. Characteristically, the authorities, having heard the opinions of the experts, decided to erect it on the *Ringhiera*, "the haranguing place," where people got up to speak their minds just in front of the palace. In this way they were able to show their contempt for the experts.

Leonardo returned to work on *The Battle of Anghiari* in the great room reserved for him in the Sala del Papa at Santa Maria Novella. We learn of payments made to the carpenter Benedetto Buchi to construct the ingenious scaffolding that permitted Leonardo to raise himself up along the wall to whatever height he pleased while making the cartoon. The mason Antonio di Giovanni was paid to open out a new door in the Sala del Papa. Giovandomenico di Filippo furnished one ream and twenty-nine quires of paper, while more paper amounting to eight quires of royal folio was supplied by Meo del Fontana, and there were payments for flour for pasting the sheets together. A small

army of men was at work erecting scaffoldings, opening up new doors, and bricking up windows.

On May 4, 1504, the gonfalonier and the priors of Florence met in solemn council with Leonardo to discuss the progress of the painting or rather of the cartoon, which was still unfinished. Leonardo promised to complete the painting by the end of February 1505 without fail. It was agreed that if he failed, the gonfalonier and the priors would seek restitution and Leonardo would be compelled to return all the money he had received and to make over the cartoon to the Signoria. The implication was clear that with the cartoon in their possession the Signoria would be able to find another artist to complete the painting to their satisfaction.

The terms were harsh but unavoidable in view of Leonardo's well-known propensity for taking his own time on anything he set his hand to. Florence was taking its tone from Piero di Tommaso Soderini, who had been elected perpetual gonfalonier: a precise, orderly, rather unimaginative man who believed in the sanctity of contractual obligations and double-entry bookkeeping. Soderini intended that Leonardo should keep his part of the bargain.

In the normal course of events Leonardo would have no difficulty in completing the work on schedule. He obviously wanted to complete the painting, and just as obviously he was capable of making a masterly picture of the famous battle. That the preliminary work was progressing well is proved by the two superb red chalk drawings of the faces of warriors now in the Szepmuveszeti Museum in Budapest, faces full of self-conscious pride and fury, and from the trial panel in a private collection in Munich which has all the appearance of being Leonardo's own work. This trial panel depicts the central motif, the fight for the standard, the inextricable knot of horsemen grappling with one another in their death grip, the silvery-gray horses like battering rams, while below them a fallen warrior is about to have a dagger plunged into his belly and another attempts to protect himself with a shield. The intricate design suggests an explosion of pure energy and vigor. A heraldic emblem is suddenly infused with life; the lion is transfixed by the unicorn. We are not concerned with the individual fates of the warriors; they are symbols of heroic virility locked in heroic conflict, and though they are alive they are deathless, they will never bleed, and though they wield daggers and scimitars we are aware that these murderous instruments have been positioned in such a way that they are more useful to the composition than to the warriors. The concentration of energy in the figures of the horsemen is joyous, like a crack-

ling bonfire. They hurl themselves impenitently at one another; almost
it is an embrace.

That Leonardo was happy in the undertaking is also shown by
many surviving sketches of horsemen dashing across the countryside
or cavorting or caracoling; they appear to be more on parade than in
the midst of a bloody war. These sketches for the battle reflect Leo-
nardo's passion for horses and tell us nothing about his attitude toward
war. And this, of course, is precisely what he intended: the painting
would be a celebration of men and horses in their vigor and their fury.

Leonardo's workshop was the Sala del Papa, the pope's reception
room, attached to the Church of Santa Maria Novella. This was an ex-
traordinary honor. The workshop was also his residence. Here he lived
contentedly for more than a year and a half.

On the morning of May 29, 1504, one of Leonardo's pupils in charge
of the management of his household wrote down in one of the
master's notebooks a list of the current expenses. It is a fascinating list
and tells us a good deal about the way Leonardo lived and his rather
cavalier attitude toward money. He had evidently gone to the bank,
removed fifteen gold ducats, and then given it to the pupil to pay out-
standing debts, buy provisions during the next few days, and settle ac-
counts with a certain Mona Margarita, evidently a servant, who re-
ceived the lion's share of the money. The accounts cover a period of
four days, from Saturday to Tuesday. Here they are, as scrawled over
three pages of Leonardo's notebook:

> On the morning of Santo Zanobio, May 29, 1504,
> I received from Lionardo Vinci 15 gold ducats and
> began to spend them.

to Mona Margarita	s62	d4
to remake the ring	s19	d8
clothes	s13	
good beef	s 4	
eggs	s 6	
to bank debt	s 7	
velvet	s12	
wine	s 6	d4
meat	s 4	
mulberries	s 2	d4
mushrooms	s 3	d4
salad	s 1	
fruit	s 1	d4
candles	s 3	
. . . .	s 1	
flour	s 2	

Sunday	s 198	d8
bread	s 6	
wine	s 9	d4
meat	s 7	
soup	s 2	
fruit	s 3	d4
candles	s 3	
Monday	**s 31**	
bread	s 6	d4
meat	s10	d8
wine	s 9	d4
fruit	s 4	
soup	s 1	d8
Tuesday	**s 32**	
bread	s 6	
meat	s11	
wine	s 7	
fruit	s 9	
soup	s 2	
salad	s 1	

These figures are not entirely satisfactory, for while the accounts for Sunday, Monday, and Tuesday make good sense and tell us a good deal about the household, no juggling with figures makes any sense of the long list of expenses and payments made on the Saturday, adding up to 198 soldi 8 denari, equivalent to nearly 10 ducats. Nevertheless we learn that the pupils ate meat, drank considerable quantities of wine, and enjoyed the fruit and salads in season. From other undated accounts we learn that they bought herbs, buttermilk, melons, bran, firewood, and various vegetables. At this time the household appears to have consisted of about five people: Leonardo, his servant Tommaso, Salai, and one or two pupils. Considerable sums of money were coming into Leonardo's possession and he could well afford to take fifteen ducats from the bank, spend it prodigally, and eat well. Since he ate no meat, the servings of meat were evidently intended for the rest of the household.

We know more about his income and expenditure during the summer of 1504 than during any other period of his life. We know, for example, that on May 4 he received 35 gold florins for his work on the Anghiari battle scene. He was promised further monthly payments of

15 gold florins and agreed to complete the cartoon by February 1505. After the burst of spending in May there followed another burst of spending at the end of June. He wrote in his notebook:

> On the morning of St. Peter's day, June 29, 1504, I took 10 ducats and gave 1 to Tommaso, my servant, to spend.
>
> Monday morning 1 florin to Salai to spend for the house.
>
> Tuesday I took 1 soldo for myself.
>
> Wednesday evening 1 florin to Tommaso before supper.
>
> Saturday morning 1 florin to Tommaso.
>
> Monday morning 1 florin less 10 soldi.
>
> Thursday to Salai soldi 1 florin less 10 soldi.
>
> For a jerkin 1 florin.
>
> For a jerkin and a cap 2 florins.
>
> To the hosier 1 florin.
>
> To Salai 1 florin.
>
> Friday morning July 19 1 florin less 6 soldi, leaving 7 florins and 22 in the box.
>
> Tuesday July 23 1 florin to Tommaso.
>
> Monday morning to Tommaso 1 florin.
>
> Thursday morning August 1 to Tommaso 1 florin.
>
> Sunday August 4 1 florin.
>
> Friday August 9 I took 10 ducats from the box.

From all this he shows he was not in the least parsimonious, but spent his money carefully, giving out an occasional florin, while on occasion there would be a sudden descent on his capital as when in the last entry he took ten ducats from the box. He kept his money in a strongbox in his house.

Sometimes he dealt in very small sums of money, for he recorded that on August 3, 1504, there came to live with him a certain Jacopo, a German, who agreed to pay 1 carlino a day. Jacopo was a pupil who paid for his tuition with the smallest unit of currency existing at that time—a farthing a day.

Sometimes, too, he dealt in much larger sums of money or received substantial gifts. When Isabella d'Este sent her agent, Agnolo Tovaglia, to him with a letter in her own handwriting, humbly requesting the painter to do her portrait or give her a painting of the Christ child, it is likely that an expensive gift would accompany her agent. She could hardly do otherwise, for the concept of *noblesse oblige* was uppermost in the minds of Renaissance princesses. The gift might take the form of a ring or a jewel or a book or a piece of embroidery; they were intended to remind the artist of the service he needed to render to his patrons.

For Leonardo it was a quiet and busy year. The work on the car-

toon for the Signoria continued; his interest in anatomy had revived as a result of studying men in attitudes of violent conflict, and he was once again dissecting corpses. He knew all the artists in Florence. He was a middle-aged man returning with pleasure to the city of his youth.

Suddenly an event of shattering significance occurred. His father died. He had been very close to the old man, admiring him, fearing him a little, drawing his stern features constantly in his notebook, recognizing the extraordinary power of that rather heavy and well-carved face, and now at last, at the age of eighty, he was dead. Ser Piero da Vinci, who had occupied so many high positions, married so often, and spawned so many children, died of old age.

Leonardo wrote in his notebook, "On 9th July 1504, Wednesday, at the seventh hour, died Ser Piero da Vinci, notary at the Palazzo del Podestà, my father, at the seventh hour, being 80 years old, leaving 10 male and 2 female children."

Because Leonardo appeared to show so little emotion Sigmund Freud assumed that he was not deeply moved by his father's death. Freud professed to find great significance in the fact that Leonardo wrote "at the seventh hour" twice, saying that was the least important fact about a man's death—the exact hour at which it happened. Here Freud erred, for in Catholic countries the hour of death is important and worth repeating, even when repeated by accident, by carelessness, or by design. *In hora mortis* . . . In the hour of death . . . It was an hour worth dwelling upon. By Florentine calculation Ser Piero's death took place at about 3 o'clock in the morning, in the dead of night, when men are most vulnerable. Sigmund Freud thought it would have been more appropriate if Leonardo had written "Today at 7 o'clock died my father, Ser Piero da Vinci, my poor father!" He was of the opinion that the repetition of the hour of death "robs the notice of all pathos and lets us recognize that there is something here to conceal and to suppress."

Freud was looking at Leonardo through nineteenth-century eyes, demanding a nineteenth-century pathos, and a peculiar nineteenth-century habit of concealment and suppression. In fact, Leonardo was concealing and suppressing nothing. He was making a statement which accorded with his fifteenth-century upbringing. The statement was abrupt, clean-cut, classical, and it was not entirely devoid of emotion, for the words *mio padre* come, as it were, at the apex of the statement with considerable force and tenderness. Leonardo himself had not been present at his father's death. It had been related to him by others, presumably by one of his half brothers or by family friends.

Ser Piero da Vinci died full of years, and there was nothing in the least surprising in the death of a man of eighty.

Yet even when a man dies at a great age, grief remains, and Leonardo's brief note, which seemed so cold to Freud, testifies to his very human sense of grief. The repetition of the words "at the seventh hour" can be understood as an expression of the deep emotion he felt when he heard of his father's death.

Everything we know about Leonardo suggests that he was a filial son. Like Leon Battista Alberti, who elevated filial affection to a principle of civilization, Leonardo was well aware that life becomes almost unendurable without it. He did not share his father's interests; it is possible and even likely that one of the reasons that induced him to escape from Florence to Milan was to avoid living in his father's shadow. Nevertheless a man can step away from his father without losing affection for him. Ser Piero was a sharp, opinionated, self-serving lawyer who climbed to a position of considerable power by carefully arranged marriages and by force of character. It was not only that Leonardo did not share his father's interests but he rebelled totally against them, attempting to live his life as though lawyers and notaries did not exist. Only a fragment of a letter from Leonardo to his father survives, and it testifies to a very real affection. He wrote, "Dearest father, I received your letter on the last day of last month and it gave me pleasure and pain at the same time—pleasure insofar as by it I have learned that you are well, for which I thank God. But I was pained to hear of your troubles. . . ."

I have referred earlier to the red chalk drawing at Turin, which is always regarded as a self-portrait by Leonardo. I have suggested that it is in fact a portrait of Ser Piero. The reasons are very simple ones. Leonardo, who was renowned for his good looks and sweetness of character, could not have looked like this harsh and thin-lipped man with the powerful, sardonic expression. If we compare this portrait with the profile portraits of Leonardo in the Ambrosiana Library and at Windsor, we find essential differences: forehead, eyes, nose, shape of mouth, length of upper lip, even the way the beard flows over the chin, are all different. The heavy, fleshy, curving nose of the father is not the same as the straight, unfleshy nose of the son. The father had prominent cheekbones and deep pouches under his eyes, the look of embittered old age. The Turin portrait shows a man who is in his seventies, going on for eighty, and Leonardo died when he was sixty-seven, and during the last four or five years of his life was probably incapable of producing a portrait of such penetrating psychological power. The style of drawing corresponds very closely to the preliminary red chalk drawings for *The Battle of Anghiari* in Budapest,

which can be dated in 1503 or 1504, and there are even some indications that it was a little earlier, at a time when he was still working his way toward the energy and monumental simplicity shown in the faces of the warriors in Budapest. We are far away from the idealized drawings of the apostles for *The Last Supper*. Leonardo's portrait of his father can therefore be dated between the spring of 1500 when he arrived back in Florence after an eighteen-year exile in Milan and the summer of 1504, when the father died.

We should not be surprised that there was a physical resemblance of a kind between father and son. What is surprising is that we should have assumed for so long that the portrait was a self-portrait, that Leonardo had depicted himself once and for all in that magnificent portrait of a man on the threshold of death. There is irony in the fact that Leonardo is remembered and will continue to be remembered in the image of his dominating father. And there is even more irony in the fact that the two most famous portraits of Leonardo—the painting of the *Mona Lisa* and the drawing of the father—have names attached to them that cannot possibly be the real names of the sitters.

Leonardo wrote, "The painter paints himself," by which he meant that everything he painted bore his signature and his features. So there was much of himself in the *Mona Lisa* and in the drawing of his father, just as there is much of himself in the serene drawings of plants and trees and animals. Even when he drew a map of Imola, it was as though he was drawing an abstract portrait of himself.

When Vasari prepared the second edition of *The Lives of the Most Excellent Architects, Painters and Sculptors,* he employed Cristofano Coriolano of Venice to make woodcut portraits of the artists. Of these likenesses Vasari himself said that they were no more than approximations and often problematical. Coriolano therefore made a portrait of Leonardo as an old man with wrinkled brow, hooked nose, and lank white hair falling straight down like the hair of a sheep dog. Leonardo is represented as old, venerable, coarse-featured. He is shown in profile, but Coriolano had evidently not seen the portrait now in the Ambrosiana Library, nor had he seen the Turin portrait. Coriolano's portrait of Michelangelo was a little better, for Vasari himself had painted Michelangelo's portrait and could testify to a proper likeness. The second edition of Vasari's *Lives* appeared in 1568, when Leonardo had been dead for nearly fifty years.

In this way the errors were compounded; the father became the son; the son became the father; the luxurious beards, curled like those of Assyrian emperors, were transformed into white strings; the eyes darkened; and Leonardo became invisible. A presumed self-portrait of Leonardo hung in the Uffizi for nearly two hundred years and was

regarded as an admirable likeness until it was examined with X rays in 1938 and shown to have under it a seventeenth-century painting of the penitent Magdalen with her hands folded over her naked breasts.

In the autumn of 1504 Michelangelo, then aged twenty-nine, received a contract from the Signoria to paint the companion piece to *The Battle of Anghiari*. The subject chosen was an obscure incident in the war of 1368 against Pisa when the Florentines miraculously escaped defeat after the Pisans attacked them while they were bathing. They quickly found their weapons, rallied, and drove off the enemy. Michelangelo was provided with a superb opportunity to paint muscular nudes and to display his phenomenal powers as a painter. Since this was the only period of their lives when they were living close to one another, working on projects of a very similar kind, one would have hoped that Leonardo and Michelangelo would have seen a good deal of one another, dined together, and talked through the night together. Instead, they appear to have been wary of one another and to have seen little of one another. The *Anonimo Gaddiano* relates a curious story that shows Michelangelo full of anger and derision of the master who was almost twice his age.

> Leonardo was walking with Giovanni di Gavina of Santa Trinità when they passed the benches of the Palazzo Spini and found a group of gentlemen disputing over a passage of Dante. They appealed to Leonardo to elucidate the lines for them. At that very moment Michelangelo passed by and Leonardo told the gentlemen, "Michelangelo will explain it to you." Michelangelo, thinking that Leonardo was mocking him, said angrily, "You are the one who made a design for a horse to be cast in bronze, and you couldn't cast it and shamefully abandoned it." Saying this, he turned on his heel and left the street, while Leonardo remained silent at these words and blushed. And further to annoy Leonardo, Michelangelo called after him, "And those Milanese idiots believed in you?"

Leonardo's silence and his blushes were in character; and so were Michelangelo's rages, which were sudden, unpredictable, and always terrible. Michelangelo worked through the winter on the cartoon for *The Battle of Cascina*. Leonardo took a working holiday. We learn from the newly discovered Madrid Codices that he spent the whole month of November at Piombino in the service of Jacopo IV Appiani, the lord of the port city that had considerable strategic importance to Florence. Machiavelli had spent part of the summer as an ambassador from Florence to Piombino, and it was on his recommendation that Leonardo was sent to the port to report on its fortifications, to strengthen them, and to drain the marshes. So much is clear from the

rather lengthy notes, which include a survey of the city walls, the citadel, the port, a moat intended to delay the progress of invaders, and designs for a new kind of fortress, rather squat, built low, without ornamentation, with as few projecting pieces as possible, and very modern in appearance. These drawings have a compactness and monumentality that is quite new in his work, and also what may be termed a characteristic Florentine dryness, as though his passion for decoration had been slaked during the long years of Milan.

Piombino, fifty miles south of Pisa, was an important town, being the port of entry of the iron ore of Elba. Alexander VI, the Borgia pope, had captured it from Jacopo IV Appiani, who was later restored to his small principality with the help of the Florentines. His aim now was to make the citadel and the port impregnable. Leonardo's task was clearly stated in his notebook:

> The lord of the castle must be able to go through the entire fortress, including the upper, the middle, and the lower parts, using tunnels and underground passages, which should be arranged in such a way that none of them may be used to reach the dwelling of the lord without his permission. And through these ways, using portcullises and sluice gates, he must be able to imprison in their own rooms all those of his retinue who may be plotting against him, and may close or open the door of the principal entrance and the relief route. And this is even a greater danger than the enemy because those within have greater opportunities to do harm than the enemy who is barred from entry.
>
> Portcullises and drawbridges must be buttressed from below, if there is the slightest danger that they can be used by an attacking force, and for this new inventions will be needed. . . .
>
> The lord of the castle must have the power to attack and expel whomever he pleases from the fortress, through secret passages, and without suffering any harm.

Leonardo's task was virtually impossible: he must defend the fortress against those within and without. In an age of electronic gadgetry it might be possible for the lord of the castle to press a button which would bring down bulkheads in all the passageways, thus cutting off all the members of his retinue from his private office and command post. With the resources available in the early sixteenth century this was far more difficult. Leonardo drew some plans of the fortress, but he seems not to have resolved the problem on the drawing board. Today, in Piombino, there is still a tower that is called "Leonardo's tower," but it belongs to a later date.

About this time Leonardo's interest in flight was revived, and he

began those researches that bore fruit in the small but exceedingly important Codex on the Flight of Birds, which he wrote in the following spring. He had not changed his belief that the bat provided the best model for a man-made flying machine, but he was beginning to inquire more deeply into the construction and movement of birds. It is a manuscript of thirty-six pages illuminated in the margins with quick and vivid sketches of birds in flight, with here and there the customary notes on subjects that have nothing to do with the main theme. Thus: "1505, Tuesday evening, April 14, Lorenzo came to stay with me; he says he is seventeen. And on the 15th of the said April I drew 25 gold florins from the treasurer of Santa Maria Nuova." We do not know whether Lorenzo was a servant or a pupil, but we know that he remained in Leonardo's employ for a long time, since he was in the small group that journeyed to Rome in 1513. From the Madrid Codices we learn that one Saturday morning he was given a florin, and then he vanishes from history.

The Codex on the Flight of Birds is more exciting for its promise than for its performance. He writes now with a kind of passionate certainty that human flight is possible and that it may take place within his own lifetime. He writes, "The great bird will take its first flight on the back of the great swan, filling the universe with amazement, filling all writings with its fame and eternal glory to the nest where it was born." It is generally assumed that by the "great swan" Leonardo meant Monte Cecero, the Swan Mountain, in Fiesole, where he possessed or had the use of a house, and this is almost certainly true, for in another note in the same codex he wrote, "From the mountain that takes its name from the great bird, the famous bird will take its flight, which will fill the world with its great fame." And while these statements are troubling because they remind us of the great and impossible claims made in the famous letter to the Duke of Milan, they are best understood as poetic expressions of the certainty of human flight, and his belief that he would be the instrument which would bring it about.

It is possible that he had already attempted to fly while he was staying in the Corte Vecchia in Milan. A mysterious note in the Codex Atlanticus reads, "Tomorrow morning, on January 2, 1496, I will make the thong [*soatta*] and the attempt." It is known that at this time he was working on a bat-winged model of a flying machine with a man lying prone in it, but he was also working on many other projects, many of them involving thongs, and there is no certainty whether he is writing about a flying machine or some form of catapult. Yet there is no doubt that he made many experiments in flight, and it is even possible that he attempted a flight and failed. Many years after Leo-

nardo's death, Girolamo Cardano, the son of Fazio Cardano, wrote, "Both of those who recently attempted to fly came to grief. Vinci attempted, and he too failed." *Vincius tentavit.* It is a good phrase to describe a man who attempted everything.

What distinguishes the Codex on the Flight of Birds from everything he wrote previously on the subject of flight is his sheer enjoyment, his growing delight in the complex and subtle movement of a bird's wings. The quick sketches of birds rising and descending testify to his pleasure, which is made visibly present in the margins of the notebook. He speaks about birds with a grave intimacy, as though he knew them almost too well. In the same notebook he reminds himself that the flying machine will inevitably have to be designed on the model of the bat, but he is not entirely convincing. The design of the bird, and the extraordinary powers concealed in the smallest bird, are uppermost in his thoughts, and he never wrote better than when he attempted to describe the reasons for their strength:

> If you should say that the sinews and muscles of a bird are incomparably more powerful than those of men, because all the flesh of the big muscles and fleshy parts of the breast go to increase the power of the wings' motion, and the bone of the breast is in one piece which affords the bird's very great power, while the wings are all compact of big sinews and other very strong ligaments of cartilages, and the skin is very strong with its various muscles: then reply to this by saying that all this strength is for the purpose of enabling it, over and above the ordinary action of the wings designed to support it in the air, to double and triple its motion in order to escape its attackers or to pursue its prey. For this purpose it has to double or triple the power in its claws and in addition it must carry as much weight through the air as it itself weighs. Thus we see a falcon carry off a duck, an eagle carry off a hare. All this sufficiently proves the purpose of such an excess of power, although they need little power to keep themselves up in the air and balance on their wings and flap them in the pathway of the wind and so direct the course of their journeyings, and a slight movement of the wings is sufficient, and the greater the bird, the slower it will be.

The Codex on the Flight of Birds was written between March 14 and April 15, 1505. It is not complete, and it is clear that Leonardo intended to revise it and to add many further observations and to include many he had made previously. All through his years in Milan he had been a prodigious bird watcher, and we find notes and jottings on birds in nearly all the surviving codices. But this manuscript has a unity of its own. For a period of three or four years he had abandoned

the study of birds completely, and now he came back to it with a sudden rush of joy which seemed to signify a recovery of his spiritual health. He enjoyed a month's holiday in Fiesole and then returned to Florence to work on *The Battle of Anghiari*. He had promised that it would be finished by February; it was still unfinished; the authorities raised no objections, continued to pay his salary and advanced money for the payment of his assistants and whatever was necessary for the work to go on. The detailed accounts have survived. The authorities were in an approving mood; they had evidently inspected the unfinished cartoon and found it to their satisfaction. Soon the cartoon would be hung on the wall and the design would be pricked out and the painting would begin.

From the recently discovered Madrid Codices we have learned the exact hour and day when Leonardo began to paint on the wall:

> On the 6th June 1505, a Friday, at the stroke of the 13th hour [i.e., at 9 A.M.] I began to paint in the palace. At the moment of putting the brush to the wall the weather changed for the worse, and the bell started to toll, calling the men to the trial. The cartoon came loose, the water poured down, and the vessel carrying it broke. And suddenly the weather worsened still more and a very great rain came down till nightfall. And it was as dark as night.

What had happened was something totally unexpected—a sudden increase in humidity had the effect of liquefying the paste attaching the cartoon to the wall: the immense cartoon began to slide off the wall just at the moment when Leonardo was making his first brush stroke. The cartoon fell in a crumpled heap on the floor. No great harm had been done; nothing had happened that could not be repaired; the cartoon could be hung again; the paint brush would be wielded again. But for Leonardo, who trembled whenever he was about to paint, it was as though heaven had spoken. As he stood high on the platform watching the cartoon falling while bells rang and a vast confusion surrounded him, he knew that heaven, for mysterious reasons of its own, had singled him out for punishment. It was as though he had been given the warning "Do not continue with the painting. No good will come of it."

The auguries were not propitious, but he went on painting.

The Persuasions of the Artist

The ruler of Milan in 1506 was Charles d'Amboise, the nephew of Georges d'Amboise, the French cardinal who hoped to take the papacy by storm. The nephew, with all the advantages of nepotism, was given resounding titles at an early age. He became Governor of Paris, and then Admiral of France, and now at the age of thirty-three he was the viceroy of Louis XII in Milan. He had many titles, but the most impressive one was Maréchal de Chaumont. Just as Georges d'Amboise was known by the Italians as Rohan, because he had been Bishop of Rouen, so Charles d'Amboise was generally known as Chaumont. The confusing names only add to the confusion of the times.

Charles d'Amboise was a voluptuary in an age of voluptuaries. He enjoyed luxury, the pursuit of women, the exercise of power, and all the advantages that came from being the lord of Milan with almost all the powers formerly enjoyed by Lodovico Sforza. Like many volup-

tuaries he was highly intelligent, practical, and a good judge of men. Surviving portraits show him with a rather lean face, a sallow complexion, heavily lidded eyes, and the expression of a man who is in pain but cannot tell where the pain is coming from. It is a curiously modern face; the features bear a close resemblance to those of André Malraux; and it is clear that he was a man of refinement and sensibility, unlike his rather coarse-featured uncle. He looked like a prince and behaved like one. In May 1506, Charles d'Amboise wrote to the Signoria of Florence requesting that Leonardo be permitted to return to Milan for a period of three months. The Signoria reluctantly acceded to his wishes. On August 18, 1506, Charles d'Amboise wrote again to the Signoria, saying that Leonardo had not finished the work that had been given to him and, "in spite of all previous promises," it was necessary that Leonardo should remain in Milan for some time. The letter was signed *d'Amboise, Regius citra montes locumtenens magnus Magr et Mareschallus Francie,* which may be translated "d'Amboise, Viceroy of the region beyond the Alps, great master and marshal of France."

On the following day d'Amboise had second thoughts. The terse statement to the Signoria was far from being diplomatic; the Florentines would be offended by its tone, its brevity, its total unconcern for the affairs of Florence. The Vice-chancellor Jafredus Karoli therefore composed a second and more temperate letter, explaining that Leonardo was only needed until the end of September, and it would give extraordinary pleasure to the Viceroy if the Signoria would see its way to complying with his wishes. Jafredus Karoli asked for a quick reply. The reply came; the Florentines bowed to the inevitable; Leonardo remained in Milan to the end of September and was still there at the beginning of October. The Florentines felt deeply insulted. It was evident that Charles d'Amboise had been toying with them. He had made promises without the slightest intention of keeping them. And since it was clear that Leonardo, too, was involved in all this duplicity, even though the decision to keep him was obviously made by the Viceroy, he must take his share of the blame. Pietro Soderini, the perpetual gonfalonier of Florence, wrote a blistering letter complaining that "Leonardo has not comported himself toward this Republic as he should have done, for he has accepted a goodly sum of money and has done very little of the great work he should have done, and out of love for Your Highness has indeed comported himself like a debtor. We demand that there should be no more extensions, for his work must satisfy the general body of our citizens and we cannot dispense him from his obligations without failing in our duty." This letter was written on October 9. Leonardo remained in Milan until the middle of De-

cember, and when he finally returned to Florence, Charles d'Amboise
sent the Signoria a letter of thanks full of sweetness and gentleness,
half-veiled threats, remonstrances, hidden meanings, and casual flat-
teries:

> The excellent works that your fellow citizen Master Leo-
> nardo da Vinci has left in Italy, and most especially in this city,
> have led all those who have seen them to feel a singular affec-
> tion for their author, and this is true even among those who
> have never set eyes on him.
>
> For ourselves, we confess we must be counted among those
> who loved him before he was personally known to us. And
> now, since we have employed him here and made trial of his
> many virtues, we see in truth that his renown in painting is ob-
> scure compared with the great merit he has achieved through
> the other great virtues he possesses.
>
> We desire to confess that with his accomplishments in archi-
> tecture and drawing and other matters relating to our gover-
> norship, he has satisfied us in such a way that we are not only
> content with him but have conceived an admiration for him.
> And therefore, since it has pleased you to let him remain here
> through all these days to our gratification, it would seem un-
> grateful if we did not tender you our thanks on his return to his
> own country.
>
> We therefore thank you as warmly as possible; and if a man
> of such genius may be recommended to his fellow citizens, we
> recommend him to you to the utmost possible extent, and we
> assure you that you can never do anything to augment his for-
> tune and comfort, and to honor him, without giving us as well
> as to him the most singular pleasure and putting us under the
> greatest obligation to Your Magnificences.
>
> AMBOISE

In the letter nothing was said about Leonardo's return to Milan. It
was implied, hinted at, so strenuously concealed that it was all the
more evident. Charles d'Amboise was saying very clearly that he
wanted Leonardo back in Milan at the earliest moment.

Pietro Soderini, an astute diplomat, took the letter at face value and
sensibly did nothing. The flattering letter gave him time to maneuver.
Charles d'Amboise, growing impatient, wrote to the king, who was at
Blois, insisting that the time had come to put pressure on the Signoria.
Francesco Pandolfini, the Florentine ambassador to the court of Louis
XII, was summoned to an audience with the king, who was under the
impression that Leonardo was in Milan—he had evidently misread the
letter from Charles d'Amboise or was deliberately concealing his
knowledge of the true state of affairs. Pandolfini was not above adding

more confusions to a confused situation, but he was a man trained to
report accurately to the Signoria what had been said to him and he
took some pleasure in recording the king's exact words. On the same
day that he was summoned in audience, January 12, 1507, he wrote to
the Signoria:

> Finding myself this morning in the presence of the Most
> Christian King, His Majesty summoned me, saying: "Your Si-
> gnoria must render me a service. Write to them that I wish to
> employ their painter, Maestro Leonardo, now in Milan, and
> that I desire him to do certain things for me. Do this in such a
> way that their Lordships will enjoin him to enter my service
> promptly, and he must not leave Milan before my arrival. He is
> an excellent master, and I desire to have certain things from his
> hand. So write at once to Florence in order to obtain the de-
> sired result, and do this quickly, and send me the letter." (This
> is the letter, which will reach you by way of Milan.)
> I replied to His Majesty that if Leonardo were in Milan, then
> Your Lordships would command him to obey Your Majesty, al-
> though since Your Majesty was the master of the city, he could
> give such orders as well as Your Lordships—and if it happened
> that Leonardo had in fact returned to Florence, Your Lordships
> would summon him back to Milan as soon as Your Majesty
> would demand it.
> All this has come about because a little picture by his hand
> has been lately brought here, and is regarded as a work of
> great excellence.
> During our conversation I asked His Majesty what kind of
> works he desired, and he answered, "Certain little Madonnas
> and other things, according to my fancy, and perhaps I shall
> ask him to do a portrait of me."
> Continuing my conversation with His Majesty in order to dis-
> charge my duty to Your Lordships, however matters turn out, I
> talked about the perfection of Leonardo's work and his other
> qualities. His Majesty said he was already aware of them, and
> asked me whether I knew him. I replied that we were very
> close friends, and he replied, "Then you must write to him tell-
> ing him he should not leave Milan before letters arrive from
> Your Lordships in Florence, etc."
> Therefore I have written some words to the aforementioned
> Leonardo, acquainting him of the good intentions of His Maj-
> esty toward him and exhorting him to be prudent [*essere savio*].
> Your Excellencies will no doubt do everything possible to sat-
> isfy His Majesty's great desire.

An absurd situation had arisen. It arose partly because the king's
courier service to Milan was quicker than the courier service of the

Florentine ambassador, and because neither the king nor Pandolfini claimed to know where Leonardo was at the time. Two days later the king wrote to the Signoria in his most imperial tones, demanding that they send Leonardo to Milan to wait on his pleasure:

> To our very dear and great friends, allies and confederates, the Princes and the Perpetual Gonfalonier of the Signoria of Florence.
>
> *Louis,* by the grace of God King of France, Duke of Milan, Lord of Genoa, etc.
>
> Very dear and great friends. Because we have an urgent need of Maestro Leonardo da Vinci, painter of your city of Florence, and because we desire from him some work by his hand upon our arrival in Milan which, God willing, will take place shortly, We therefore affectionately request that you will make it possible and that you will be pleased to let the afore-mentioned Maestro Leonardo remain in our service for a while until he has finished the work we desire him to do.
>
> Therefore, putting aside any other letters you receive, instruct him not to make any move until We arrive in Milan, and while he is waiting for us, We shall inform him concerning the work We desire from him. Make it especially clear that he must not leave the aforementioned city until our coming, as I have already explained to your Ambassador, telling him to write to you about the matter; and in doing this you will be giving me great pleasure.
>
> Very dear and great friends, may Our Lord have you in his keeping.
>
> LOUIS

There was something ludicrous about this epistolary war between Milan and Florence. Leonardo became booty, claimed by both sides. Leonardo himself appears to have been secretly amused by the barrage of letters and continued to work on many projects.

The Battle of Anghiari remained unfinished. After the storm in the summer of 1505, when the cartoon fell from the wall, he continued to work on the painting and finished the central scene of the fight for the standard. Vasari says the painting began to run and Leonardo abandoned it; Paolo Giovio says that the defective plaster persistently rejected the colors ground in walnut oil; the *Anonimo Gaddiano* says the painting could still be seen in his day. Francesco Albertini's guidebook to Florence, published in 1510, says that the fragment of the battle scene was still hanging on the wall, and another guidebook published in 1549 mentions it as "a marvelous thing." It vanished fourteen years later when Vasari was employed to paint over it his own enormous,

chaotic battle scene. Many scholars now believe that Leonardo's painting still survives beneath the painting of his biographer. Professor John F. Asmus of the University of California has been attempting to locate the painting by means of extremely sensitive sonar detectors, and it is possible that the buried masterpiece may come to light in all its original brilliance, having been protected for more than four centuries by paint or plaster or a brick wall.

The Battle of Anghiari fed the legend that Leonardo never completed anything he began. The evidence shows demonstrably that the central scene was completed, could be seen for nearly sixty years in the Sala del Gran Consiglio, and was greatly admired, and that it vanished only when the Grand Duke of Tuscany ordered a complete reconstruction of the room. An engraving of the central motif made by Lorenzo Zacchia in 1558 shows the influence of German engravers and lacks the pure violence of Leonardo. Rubens made a spirited copy in black chalk heightened with gray and white, which appears to derive from many sources—from Zacchia's engraving, from students' copies, and from one or other of the trial versions that still survive. Leonardo gave the work monumentality; Rubens gives it a certain Baroque looseness while retaining the fire and the energy.

. While Milan and Florence were disputing for possession of Leonardo, the artist was engaged in prolonged litigation with his half brothers over his uncle's will. Most of the documents concerning the litigation are lost, but enough remain to show that Leonardo felt outraged by his brothers' behavior, fought them tooth and nail, and was distressed by the action of the lawyers. He had a morbid horror of the law and of legal matters, which is not unnatural among artists.

Leonardo was not above using *force majeure* when his interests were at stake, and when he considered that his litigation with his brothers was in jeopardy, he had recourse to his big battalions. At least two letters from exceedingly important personages were sent on his behalf to the Signoria in Florence. The first letter, dated July 26, 1507, was from no less a person than King Louis XII, who wrote:

> To our very dear and great friends, allies and confederates, the
> Perpetual Gonfalonier and the Signoria of Florence.
>
> *Louis,* by the grace of God King of France, Duke of Milan,
> Lord of Genoa.
>
> Very dear and great friends. We have been informed that
> our dear and well-beloved Leonardo da Vinci, our painter and
> engineer in ordinary, has some dispute and litigation pending in
> Florence against his brothers over certain inheritances; and
> inasmuch as he could not devote himself properly to the pursuit
> of the said litigation by reason of his continual occupation in

our entourage and in our presence; and also because we are
singularly desirous that the said litigation should be brought to
an end in the best and briefest delivery of justice as possible:
for this reason we willingly write to you on the matter, request-
ing that you do indeed bring the said dispute and litigation to
an end with the best and briefest delivery of justice as possible;
and you will be giving us a very agreeable pleasure in doing so.
Very dear and great friends, may Our Lord have you in his
keeping.

Given in Milan, on the XXVI day of July.

<div align="right">

LOUIS
Robertet

</div>

Leonardo clearly obtained this letter through the good offices of
Florimond Robertet, who countersigned the letter, thus giving the
Florentines two good reasons for paying attention to it. The Floren-
tine Republic was an independent state and did not of course have to
obey an edict delivered by the King of France; but the request was
made twice in the course of a few lines and therefore demanded some
sort of action, even if that action consisted of merely replying to the
king and saying that the matter was being pursued as energetically as
possible. The Florentines had a healthy respect for the wishes of the
king.

In fact, nothing was done and Leonardo found himself nearly two
months later at his wits' end, still wondering what pressure he could
bring to bear on the Signoria. He learned that the man chosen to
preside over the lawsuit was Raphaello Hieronymo, a friend of Car-
dinal Ippolito d'Este. Probably with the help of Niccolò Machiavelli,
and certainly with the help of Agostino Vespucci, who was Machia-
velli's chief secretary, for the letter is in Vespucci's handwriting, he
drew up a letter to the cardinal:

> Most Illustrious and Most Reverend, My Unique Lord,
> The Lord Ippolito d'Este, Cardinal of Ferrara, My Supreme
> Lord,
> Most Illustrious and Most Reverend Lord.
>
> A few days ago I arrived here from Milan, and learning that
> one of my elder brothers refuses to carry out the provisions of a
> will made three years ago when our father died; as also, and no
> less, because I would not fail in my own eyes in a matter I es-
> teem most important, I cannot forbear to request of your most
> Reverend Highness a letter of recommendation and favor to Ser
> Raffaello Hieronymo, at present one of the most illustrious
> members of the Signoria before whom my case is being tried;
> and more particularly His Excellency the Gonfalonier has laid
> the matter in the hands of the aforesaid Ser Raphaello to the

end that his Lordship may be able to reach a decision and bring it to completion before the feast of All Saints.

Wherefore, my Lord, I entreat you, as urgently as I know how and am able, to write a letter to the said Ser Raphaello in that skillful and affectionate manner which you know so well, recommending to him Leonardo Vincio, Your Lordship's most abject servant, as I call myself and always wish to be: requesting him and urging him not only to do me justice but to do so with propitious urgency; and I have not the least doubt that, from the many reports that have reached me, Ser Raphaello, who is most affectionately disposed toward your Highness, will bring the matter *ad votum.* And this I shall attribute to the letter of your most Reverend Highness, to whom once more I commend myself. *Et bene valeat.*

Florence, 18 September 1507
E.V.R.D.[1]

Your most humble servant
LEONARDUS VINCIUS *Pictor*

Such was the letter that Leonardo caused to be written in an effort to subvert the normal course of justice, using his great influence to ensure a favorable verdict. He was deeply apprehensive that his brothers, being residents of Florence in good standing, while he remained technically a resident of Milan, would be regarded favorably by Raphaello Hieronymo. He wrote on September 18, and the feast of All Saints was only six weeks away.

Leonardo was not being entirely candid when he wrote to the cardinal, for he speaks about "the provisions of a will made three years ago when our father died," and in fact the father left no will, but Leonardo had claimed his full share of the inheritance. The present dispute was about something else altogether—the will of his uncle Francesco da Vinci. Leonardo had been on excellent terms with his uncle, lent him money, visited him frequently, seeing to his comforts in his old age. Francesco died early in 1507, and the greater part of his estate, including a property near Vinci called Il Botro, had been left to Leonardo. His will was being contested, and it was this will that was the cause of all the trouble. We are quite certain it was the uncle's will because Charles d'Amboise wrote to the Signoria on August 13, 1507, urging them to come to a quick decision on the case "concerning an inheritance left by his uncle," because the king wanted Leonardo to work on a painting.

When we ask ourselves why Leonardo was so deeply concerned that he should inherit the money and property left to him by his

[1] *Excellentissime Vestre Reverendissime Dominationis,* meaning "Of Your Most Excellent and Most Reverend Lordship."

uncle, which could never have amounted to great wealth, we discover
that there are several answers. First, he felt he had been treated
abominably by his brothers. Secondly, he was a man possessing a pre-
cise mind, and he wanted at all times the exact sum of money due to
him. Thirdly, he was growing old and determined to leave some prop-
erty to Francesco Melzi, who had been adopted by him and was now
legally his heir.

Some of Leonardo's waking thoughts on the matter are conserved
on one of the pages of the Codex Atlanticus, where he can be heard
arguing with one of his brothers, putting questions to him, receiving
replies, then commenting on them, as people do when they are
obsessed by a subject and not absolutely sure what responses will be
made by the adversary. In this imaginary dialogue Leonardo can be
seen probing restlessly, at a loss for certainties. He wrote:

> You wished the utmost evil to Francesco and have let him
> enjoy Il Botro during his life. To me you wished the greatest
> evil.
>
> To whom have you wished better, to Francesco or to me? To
> you. This one wants my money after I am gone, so that I can-
> not dispose of it according to my wishes, and he knows I can-
> not alienate my heir. He wishes then to demand of my heirs,
> and not as a brother, but as one entirely alien will receive him
> and his.
>
> Have you given such money to Leonardo? No. Or why could
> he say you have drawn him into this trap, whether feigned or
> true, if not because you wanted to take his money from him?
> Well, I will not say anything to him as long as he lives. You do
> not wish therefore to repay to his heirs the money lent on Il
> Botro, but you want him to pay over the revenues he receives
> from this property.
>
> Oh why don't you let him enjoy them during his life, as long
> as they would return to your children? Now couldn't he have
> lived many more years? Yes. Now suppose that I were that per-
> son. You would wish that I were the heir, so that I shouldn't
> ask of you, as heir, the moneys which I had to have from
> Francesco.

In this debate with his half brother Leonardo seems curiously in-
decisive, as though confronted by problems far too great for him to
resolve. Everything depended on Raphaello Hieronymo, on the
brothers, on the lawyers, over whom he has no control. He sees him-
self as *alienissimo*, "one who is entirely alien," but this word with all
its modern connotations can be misleading. It is a technical term,
meaning that he saw himself as "entirely alienated from his inherit-

ance." The hurt lay deep; he raged against his brothers; and the litiga-
tion dragged on.

Meanwhile he continued to work, pursued his anatomical studies,
wrote letters to the authorities in Milan explaining his long absence,
and enjoyed the company of Giovanni Francesco Rustici, in whose
house he was a welcome guest. Rustici, twenty years younger, re-
garded Leonardo with veneration and attempted to follow in the
master's footsteps. He was of noble birth, rich, generous with his
money, always joking and laughing and playing tricks. He trained a
porcupine to sit under the table like a dog and was amused when the
porcupine pricked the legs of his guests. He kept money in a basket:
anyone could take what he wanted. Once he heard someone saying,
"My God, if only I had what is in that basket, I could arrange all my
affairs." Rustici gazed at the man steadily for a while, and suddenly
poured the entire contents of the basket into the man's hat, saying,
"Go, and may God keep you!" But the story that tells us most about
him concerns a visit to one of the Medici palaces. He was sauntering
in the garden on a hot day when it occurred to him that it was too hot
to wear a gown, and so he removed it and hid it under a sloe bush.
Two days later he remembered the gown and sent a servant to find it.
When it was found he said, "The world is too good. It will not last."

Gifted, sensitive, an accomplished painter and sculptor in his own
right, Rustici had been under the influence of Leonardo since the day
they first met in Verrocchio's studio, which continued to exist with
various pupils acting as instructors long after Verrocchio died. At their
first meeting Rustici was about ten years old, and Leonardo was
thirty. Rustici was captivated by Leonardo's drawings, his gift for por-
traiture and for conveying a sense of rapid movement. He was also
captivated by Leonardo's character, his way of looking at the world,
and liked to repeat precepts he had learned from Leonardo about the
need to meditate at length before making a sketch, meditating again
before making a finished drawing, and then at all stages of the work
pausing, meditating, leaving it alone, and then coming back to it only
when the idea has come to fruition. "Everyone could not do this, cer-
tainly not those who work for gain," he said. He also said that works
should not be exhibited before they are completely finished so that
they can be changed as often and in as many ways as one pleases
without thought of ulterior considerations. All this he had learned
from Leonardo. Vasari tells us that Rustici was especially indebted to
Leonardo for his training as an artist of horses. Rustici produced
horses in clay, in wax, in bronze, free-standing or in relief. If he was,
as Vasari says, a pupil of Leonardo's in modeling horses, he must have
visited Leonardo in Milan. This is very likely, for one of Rustici's close

friends was the mathematician Piero di Baccio Martelli, whose father had been the Florentine ambassador to Milan.

Rustici's house was on property owned by Piero Martelli. Here, toward the end of 1506, Rustici began to make the clay models for three more-than-life-size statues of St. John the Baptist with a Pharisee on one side and a Levite on the other, to be placed above the north portal of the Baptistry in Florence. As we know, Rustici worked slowly and five years elapsed before the statues were completed. Vasari tells us that "Rustici would allow no one near him save Leonardo da Vinci, who never left him while he was molding and casting until the work was complete. Many therefore believe, although nothing definite is known, that Leonardo worked at them himself or at least helped Rustici with his advice and judgment. These bronze statues, the best ever executed by a modern master, were cast in three turns and polished in Rustici's house in the Via de' Martelli."

Although Leonardo was no longer in Florence when the actual castings were being made, it is very likely that he worked on the clay models, gave Rustici abundant advice on the casting, and helped him in every possible way. The St. John with the upraised hand and the heavenward-pointing finger is a curiously disappointing figure, without energy, without drama, but the Pharisee and the Levite, while deep in thought, seem to quiver with the energy of their intelligence and manhood. They listen, they understand, they are repelled and at the same time attracted to the words spoken by St. John announcing the coming of a new dispensation; and this repulsion and attraction is given shape by their powerful figures and the majestic folds of their gowns. Vasari says, "The bare arms and legs are also good and excellently joined, not to speak of the hands and feet, and the gracious pose and heroic gravity of the heads." This is true. But it is not enough. There is evidently something of Leonardo in these figures but there is more of Rustici. The visitor to the Baptistry who hopes to see a work of sculpture that has passed through the fires of Leonardo's mind finds instead a work by a master of the second order. How good Rustici was at his best we shall never know, because all, or nearly all, his sculptures were destroyed in 1528 when the Florentine mob sacked a villa which housed the greater part of his work. Rustici then fled to France and offered his services to King Francis I. Still following in the footsteps of Leonardo, he made plans for an equestrian statue of the king, which would be twice life-size. Nothing came of this statue, and he died at the age of eighty, warming himself with memories of his days in Florence when it would amuse him to invite his guests to eat a meal shaped like the Baptistry of Florence. The meal was designed by Andrea del Sarto. The pavement was formed of

jelly resembling many-colored mosaics; the columns, which looked like porphyry, were large sausages; the bases and the capitals were parmesan cheese; the cornices were made of pastry and sugar; the choir desk was made of cold veal, and the pulpit of marzipan.

Rustici was irreverent, good-humored, kind to excess. He was one of those men who make the air vivid around them. He enjoyed giving pleasure, and he did much to make Leonardo's stay in Florence pleasurable and to take his mind away from thoughts about the interminable litigation. In spite of the letters from the King of France and Cardinal Ippolito d'Este, the judiciary of Florence was taking its own time.

It was during this period, in the intervals of helping Rustici with his statues and painting two Madonnas for the King of France, that Leonardo began to spend more and more time dissecting corpses. In the winter of 1507 he dissected an old man who died very peacefully in the hospital of Santa Maria Nuova. Although he had dissected many people before, and many horses, cows, and monkeys, he was now for the first time dissecting in order to discover the cause of a man's death. He wrote in his notebook:

A few hours before his death he told me he was over a hundred years old and he said he was conscious of no failure of body, only feebleness. And then, sitting on a bed at the hospital of Santa Maria Nuova in Florence, without any untoward movement or sign, he passed out of this life.

And I made an anatomy to discover the cause of a death so sweet, which I found to proceed from debility through lack of blood and deficiency of the artery that nourishes the heart and the other lower members. I found this artery very desiccated, shrunken and withered. This anatomy I described very carefully and with great ease owing to the absence of fat and humor which rather hinder recognition of the parts. The other anatomy was that of a child of 2 years, in which I found everything to be the opposite to that of the old man.

The aged who enjoy good health die through lack of nourishment. This happens because the lumen of the meseraic is constantly constricted by the thickening of the coverings of those vessels: a process that progresses as far as the capillary vessels which are the first to close up entirely. In consequence, the old dread the cold more than the young, and those who are extremely old have a skin the color of wood or of dry chestnut because the skin is almost completely deprived of nourishment.

The coverings of the vessels behave in man as in oranges, in which the peel thickens and the pulp diminishes the older they become. And if you say that it is the thickened blood which

does not flow through the vessels, that is not true, for the blood does not thicken in the vessels because it continually dies and is renewed.

What Leonardo had discovered, after cutting through the old man's chest and examining the vital organs, the lungs, the spleen, the liver, and all the rest, was that death was caused by the thickening of veins and arteries that twisted like a snake. A dead child, on the contrary, had thin and supple veins that moved in a straight line; and so he drew them together, the wriggling and contorted veins of the old man beside the simple and direct veins of the child. On that day he discovered arteriosclerosis and became the father of gerontology.

On the top of the first page showing the dissection of the old man's arms and shoulders, he drew the old man with his head on a pillow, still alive, his eyes open, looking calm and confident in the face of death. He did this very delicately, with an exquisite courtesy.

Then for page after page he draws the muscles of the old man's right arm and shoulder, showing them at all angles, so that we come to know them in three dimensions, using different colored inks, color washes, and stippling, so that each drawing becomes a work of art. In medical textbooks such drawings look schematic or very dead. Leonardo seemed determined to give life to the dead. And so he went on for thirty pages to demonstrate the mechanism of the old man's body, the drawings very firm and controlled, the eye and the scalpel relentlessly probing, the words as beautifully proportioned as the drawings. The handwriting is unhurried; he never crosses anything out. He examines the stomach and the intestines, draws them carefully, and in the process of carving the body to pieces he noticed something that no one had previously noticed—the double curvature of the spine. He took the old man's liver in his hands and observed that "it resembled frozen bran both in color and substance." He made no dissection of the old man's legs, for by the time he reached the legs the body was rapidly decomposing.

Leonardo was not the first man to dissect the human body, but he was the first to draw it accurately, systematically, in depth, and in three dimensions. He would turn a shoulder around so that you would see it from eight different angles. He used the most primitive instruments. One day he listed them, as though by some chance it might occur to him to forget them: "Spectacles with cardboard, steel and fork, and histoury, charcoal, drawing board and sheets of paper and pencil and pipe clay and wax, thongs and quarrel, small-toothed bone saw, chisel, inkstand, penknife." He may have used ice to delay the processes of corruption, but never speaks of it. He used wax to fill

up orifices and discover their true shape, and was the first anatomist to do so. With cardboard sidepieces attached to his spectacles, with four instruments, with pen, pencil, and paper, he went about the discovery of the human body.

Leonardo was well aware that he was making discoveries of vast importance to mankind. "I reveal to man," he wrote, "the origin of the first or perhaps second cause of existence." He praised the Creator who had made such a marvelous instrument, "where nothing is superfluous or defective." On the same crowded page in which he reminds himself to describe the tongue of the woodpecker and the jaw of the crocodile, he sketches out the ileac and hypogastric vessels, and makes notes on the brain and many other things, Leonardo wrote down some of his deepest and most troubled thoughts on the subject of his anatomical studies. The passage should be quoted at some length because the heart and pith of the man is in them and because it appears to have been written after a long night spent at the dissecting table, when he was mortally weary and therefore incapable of concealing his emotions even from himself. He wrote:

> It appears that nature takes revenge on those who want to work miracles, so that they come to possess less than men who are not so assertive, and those who want to grow rich in a day live for a long time in great poverty, as always happens, and to all eternity will happen, to the alchemists, those who seek to create gold and silver, and to the engineers who would have dead water stir itself into life and perpetual motion, and to those supreme fools, the necromancer and the enchanter.

> And you who say it would be better to watch an anatomist at work than to see these drawings, you would be right, if it were possible to see all the details shown in these drawings in a single figure, in which you, with all your ingenuity, will not see nor acquire a knowledge of more than a few veins. In order to acquire a true and perfect knowledge of this, I have dissected more than ten human bodies, destroying all the various members, and removing even the most minute particles of flesh surrounding these veins, without causing them to bleed except for the imperceptible bleeding of the capillary veins. And as one single body did not suffice for so long a time, it was necessary to proceed by stages with as many bodies as would render my knowledge complete; and this I repeated twice in order to learn the differences.

> And if you should have a love for such things, you might be deterred by loathing, or if this did not sufficiently deter you, you might be restrained by the fear of living through the night hours in the company of these corpses, quartered and flayed and horrible to behold. And if this does not deter you, then

perhaps you may lack the ability to make good drawings essential for such a presentation, and even if you possess the ability to draw, it might not be combined with a knowledge of perspective, and if it were so, you might not understand the methods of geometrical demonstration or the method of estimating the forces and strength of muscles; patience also may be wanting, so that you will lack perseverance.

Concerning these things, whether or not they have all been found in me, the hundred and twenty books composed by me will give their verdict Yes or No. In these I have not been hindered by avarice or negligence, but only by want of time. Farewell.

So he wrote in the small cramped handwriting he employed when he was ill or tired, his thoughts rising to a poetry of despair and concluding with the triumphal announcement that a hundred and twenty books of anatomical drawings and commentaries would prove that his work was justified. He was writing for himself, but somewhere at the back of his mind there lurked the ghostly presence of the man he called his "adversary." This man had evidently poured derision on his work, saying that a demonstration with the corpse lying on the table was infinitely preferable to a set of drawings. The man was probably Andrea Cattaneo da Imola, a professor at the University of Florence and a physician at the hospital of Santa Maria Nuova, who was deeply rooted in the ideas of Avicenna and Galen. Leonardo, himself rooted in medieval anatomy, so that he sometimes made the same mistakes as men had made for centuries, regarded these drawings as essential steps in the discovery of man. He wanted them to be printed by means of copper engravings. Ironically the researches took so much of his time that he was never able to put them in their final order and no one took the trouble to print them until centuries later.

Leonardo appears to have regarded his anatomical work as his supreme contribution to knowledge. He probably spent more time on it than on anything else. Most things came easily to him, but not anatomy. He worked at it with obstinate rigor, tirelessly, assiduously, without much assistance, in lonely night vigils in the charnel house. Once, while describing his pathetic collection of surgical instruments, he mentions a certain Agnolo Benedetto, who may have been a servant who assisted him and kept him company. Yet one imagines him working alone among those corpses, "quartered and flayed and horrible to behold," if only because the horror was so great that he wanted no one else to share it.

There was irony in these anatomical researches. Once, long ago, he had spoken about the delights of the painter as compared with the

sculptor: of how the painter lives in sovereign ease, with great calm, without sweating, without exerting himself with manual labor, without being covered with chips of marble falling on him like snowflakes, without having to listen to the noise of hammers, with musicians playing for him and beautiful objects to contemplate. Painting was a fastidious and elegant occupation which could be savored among sweet scents and agreeable conversations, while wearing one's best clothes. But when he painted and drew in the charnel house, with a cloth over his nose and mouth to prevent him from inhaling the stench of death, and with caked blood and pieces of skin and tissue clinging to his smock, he was at the sheer antipodes of the heavenly world of the painter.

The winter of Florence came to an end, and in the spring he began to think once more about putting his vast array of notebooks in order. He wrote on the first page of a new notebook:

> Begun in Florence in the house of Piero di Braccio Martelli, on the 22nd day of March 1508: and this is to be a collection without order, taken from many papers which I have copied here, hoping afterward to arrange them according to the subjects of which they treat: I believe I will have to repeat the same thing several times; for which, O reader, blame me not, for the subjects are many, and memory cannot retain them and say "this I will not write because I have already written it," and if I wished to avoid falling into this error it would be necessary, in order to prevent repetition, that on every occasion when I wanted to copy out a passage I would have to read over all the passages that had gone before, and this especially because there have been long intervals of time between one writing and another.

The task, of course, was very nearly hopeless without the help of a small army of secretaries, and as he writes these instructions to himself we are aware from the heaviness of the style and from the constant repetitions that he is not too hopeful of the results. Meanwhile, at long last, the litigation with his brothers was coming to an end, there was still much work to do for Rustici, who was still making the figures for the north portal of the Baptistry, and there were two Madonnas to be completed for Louis XII. He was coming to the end of one period of his life and entering another. About this time rumors swept through Florence that in the mountains near Lucca and Pistoia flames had been seen in the sky, and "it appeared that horses and men-at-arms came out of these flames." And soon it was announced that the Pope had granted to the people of Florence a plenary indulgence, and a great Jubilee would be held to celebrate so great and

widespread a remission of sins, and there were parades and celebrations. A little later the Florentines heard that the war with Pisa was being renewed. It was not an auspicious time for traveling, but then there were very few auspicious times in Florence or Milan during the first decade of the century.

Leonardo set about renewing his contacts with the authorities in Milan. Salai was sent to Milan to learn the intentions of the French rulers of Milan toward him; he had written to them several times and was greeted with an ominous silence. Would he continue to receive a pension? Would there be suitable accommodation for him? Was he still in their good graces? There survive three drafts of his letters to Charles d'Amboise and to Girolamo Cusano, all couched in very much the same terms, all requesting information about his status. In one of these drafts he writes:

> *Magnifico Signore mio*, the love Your Excellency has always shown me and the benefits I have constantly received from you I have hitherto . . .
>
> I am afraid lest the small returns I have made for the great benefits I have received from Your Excellency may have made you somewhat annoyed with me, and for this reason you have not answered the many letters I have addressed to Your Excellency. I am now sending Salai to you to inform Your Excellency that I am almost at an end of my litigation with my brothers and I hope to be with you this Easter, bringing with me two pictures of two Madonnas of different sizes, which I began for our Most Christian King or for whomsoever you please.
>
> I would be glad to know where I am to have an apartment upon my return, because I do not wish to put Your Lordship to any further inconvenience, and also, since I have been working for the Most Christian King, whether my emoluments will continue or not. I wrote to the President concerning the water the King granted to me, which has never been put into my possession by reason of the great scarcity of water in the canal caused by the great drought and because the outlets were not regulated, but he promised me that as soon as they were regulated, I would be given possession of them. I therefore pray that if you encounter the President, you will kindly remind him, now that the outlets are regulated, to cause me to take possession of the water, since I understand that in great measure this is in his power. Nothing else occurs to me. I am always at your command.

In other drafts Leonardo promised on his arrival to construct various "machines and other things" which would bring great pleasure to

Louis XII. This draft also indicates that previously he had been stay-
ing in the villa or palace of Charles d'Amboise, and now in the most
courteous terms he requests permission to live elsewhere, in inde-
pendence. The question of his water rights was uppermost in his
mind, for the good reason that it was a source of income long prom-
ised to him.

When he was writing these drafts of letters to Charles d'Amboise
and to Girolamo Cusano, the president of the department of state con-
cerned with canals and water works, Leonardo scribbled a note to the
effect that "our case" (*causa nostra*), which was being fought against
Ser Giuliano da Vinci, "the chief of the brothers [*capo delli altri fra-
telli*]," was about to take a sudden turn. A letter had arrived from
Giuliano, urging the utmost haste in concluding a settlement in favor
of the estate of the dead Francesco, and very soon the litigation came
to an end.

We do not know whether Leonardo reached Milan before Easter,
which took place on April 23. By July he was back again, with Salai
and Francesco Melzi at his side, in the city where he had spent nearly
half his life, the city of Lodovico Sforza, now dead—he had died in his
prison at Loches and was perhaps killed by his jailers—and of all the
other Sforzas scattered to the winds. There was hope, but not too
much hope. *The Last Supper* was peeling from the walls; the litiga-
tion over *The Virgin of the Rocks* was continuing; the horse had
vanished long ago. At the age of fifty-six he was preparing to begin a
new life in Milan. A little more than ten years were left to him, and
there was far too much work to be done.

The Coming of Melzi

From the spring of 1508 to the autumn of 1513, Leonardo remained in Milan in the service of the French governor, Charles d'Amboise, and later of his successor, Giovanni Giacomo Trivulzio. He was accredited to the court of King Louis XII, who addressed him as *notre chier et bien ame Leonard de Vincy, nostre paintre et ingenieur ordinaire*. By *ingenieur ordinaire* the king meant that he was in actual and current service: it was not an honorary position. His advice could be called upon at all times, and in Milan he appears to have belonged to the inner cabinet, which ruled the city. He received a large salary, and could have everything he wanted within reason and even beyond reason. The French were well aware that he was one of their chief prizes, his very presence in Milan helping to give a kind of legitimacy to their rule.

Already he possessed a name which men spoke with bated breath,

as though he were a magician or a sage, even though little, if any-
thing, was known about the researches that filled his innumerable
notebooks. His fame rested on *The Last Supper* and on the horse, the
one already fading and the other already destroyed. But these were
staggering accomplishments vividly remembered by everyone who
saw them, and they talked about the greatness of the man, his audac-
ity, his technical skill, the divine spark in him. Accordingly the French
treated him with a grave courtesy and they seem to have been a little
afraid of him, in awe of him. Yet he never troubled to learn their lan-
guage. He had difficulty learning languages; it was not that he could
not apply himself to the task, for at one time he made a serious at-
tempt to learn Latin: it was simply that learning a language was time-
consuming, and he had so little time for it.

It would be a mistake to believe that Leonardo remained anchored
in Milan. He was continually traveling, visiting country estates, seek-
ing out libraries, sailing along the rivers. Restless always, he found a
multitude of reasons for slipping out of Milan into the countryside.
Among the places he visited was Vaprio d'Adda, a small town on the
steep left bank of the Adda River, about twenty miles east of Milan.
Between the bank and the river there was a canal wide enough to per-
mit heavy barges to pass, thus avoiding the river rapids. A mountain
called Tre Corni, the three peaks, lay at some distance from the river,
and this mountain and the canal appear in his drawings. One of the
most magnificent of his drawings, now somewhat faded, shows the
canal and the river with a barge moving slowly beneath the cliffs;
and there is a feeling of extraordinary affection, as though the artist
knew the scene well and loved it to distraction.

The largest house at Vaprio d'Adda belonged to Girolamo Melzi, a
nobleman belonging to the cadet branch of the important Melzi fam-
ily. Formerly he had served in the court of Lodovico Sforza and was
now a captain in the Milanese militia. He had two sons, Giovanni
Francesco and Bartolommeo. Leonardo loved the house and the fam-
ily. Here by the banks of the river he found a second home.

His meeting with Girolamo Melzi was to have extraordinary conse-
quences. In 1508 he adopted Giovanni Francesco, who was then about
fifteen, and spent the rest of his life with the young nobleman at his
side.

Giovanni Francesco wrote later that Leonardo possessed for him a
deeply felt and most ardent love. According to Vasari, who met him in
old age, Giovanni Francesco had been a beautiful child much beloved
by Leonardo. Vasari hints at a homosexual relationship, while the
young Melzi openly declared that there existed an intense affection
between them. Nevertheless it would be unwise to assume that the

relationship between the boy and the fifty-six-year-old man was based on a homosexual attraction. He possessed great physical beauty; he was gentle, cultured, and possessed some talent as a painter. It is much more likely that Leonardo, seeing that old age was coming, felt an overwhelming need for a son and heir, someone he could shape and mold according to his convictions and beliefs. He was himself a university; he would be the boy's professor. Nor is it likely that a Milanese nobleman would surrender his handsome son to a painter, however illustrious, in order for the son to share the painter's bed. A contract of adoption or apprenticeship must have been signed. It would be very long, with provisions for all eventualities. It would be drawn up by a notary in Milan and viewed and reviewed until it was completely satisfying to the three parties involved. By the law of the time a boy was the absolute property of the father and could be adopted or apprenticed only with the father's consent. It appears that Francesco was legally adopted, and that Leonardo in his will complied with an agreement made ten years earlier.

A portrait said to be of Francesco Melzi, by Boltraffio, hangs in the Heller Collection at the Berne Museum. There is no doubt that the painting is by Boltraffio, but there is considerable doubt whether it represents Leonardo's beloved adopted son and heir. It shows a rather square Germanic face with a slit mouth and an almost comically aggressive expression. He is overdressed; thick clouds of hair fall to his shoulders; he looks as though he has provided himself with sumptuous clothes and a heavy wig in order to conceal himself. A more likely portrait of Francesco Melzi is provided by Leonardo in a sketchbook at Windsor Castle. Here we come upon a series of portraits, which can be dated about 1508, showing a delicately featured youth with a high forehead, a straight nose, rather thin lips, and a small but well-modeled chin. The youth wears an expression of serenity and sweetness. These drawings (Windsor 12282r, 12554, 12557) are all recognizably of the same person, and there are two similar drawings in the Arundel Manuscript in the British Museum (136v and 137r). The near certainty that these are all portraits of young Melzi becomes a certainty when we discover in the Louvre a small drawing in Leonardo's manner of a youth with exactly the same profile, with thick curls reaching down to the shoulders, wearing an embroidered costume and with a kind of cape thrown negligently over his left shoulder. On the back of the drawing there can be made out the words: FRANᶜᵒ MELZO.

The drawing is much faded; it has been folded over, there are scratches, and there are some signs that it has been damaged by water; but it is a coherent portrait of the young Melzi at the age when

Leonardo knew him. It is either an original drawing by Leonardo or a copy made perhaps by Melzi himself, and it is clearly intended as a sketch for a painting. The drawing measures only 8" by 5". The expression on that clean-cut classical face is one of an extreme tenderness. What appears to be a circular decoration below the embroidery is in fact the pommel of a thin-bladed Milanese sword such as was carried habitually by the Milanese nobility.

Giovanni Francesco Melzi became Leonardo's adopted son, his amanuensis, confidant, traveling companion, and pupil. Henceforth, until Leonardo's death, they were inseparable. With the coming of Melzi there can be discerned a change in Leonardo: he appears to grow calmer, quieter, without the sense of urgency he demonstrated during the first long period in Milan. The handwriting in his notebooks becomes more orderly. There are few drawings and paintings. We hear rarely about Salai, although he remains in the household.

Manuscript F, now in the Institut de France, has a note on the opening page saying it was begun on September 12, 1508. On the inside of the thin gray cardboard cover he wrote to remind himself of things to be studied and books to be procured:

Write speech on the velocity of the heavens	Concave mirrors Books of Avicenna Italian and Latin vocabulary Knives from Bohemia Vitruvius Meteora Archimedes: on the center of gravity Anatomy Alessandro Benedetto The Dante of Niccolò della Croce	Philosophy of Aristotle Messer Ottaviano Palavicini for his Vitruvius go every Saturday to the hot bath and observe the naked men. Inflate the lungs of a pig and observe whether they increase in length and breadth or the breadth diminishes with length

It is, or course, a hodge-podge of scattered notes but it shows the extent of his interests. As usual, such notes provide scholars with an opportunity to write voluminous footnotes. Alessandro Benedetto was not an anatomist but a student of Greek medicine. Archimedes' works had not been printed. Vitruvius and Avicenna were available in Latin; hence the need for the Italian-Latin dictionary. Niccolò della Croce was a Milanese nobleman of the court of Lodovico Sforza. At the bottom of the page Leonardo writes down a rather bawdy joke about a man tilting at a jousting match, aiming his lance at a shield held up by a woman. "Alas," the man complains, "my tool is so small for so large a business."

Manuscript F, which consists of 192 pages, is largely concerned with the study of water. It was a subject that had always fascinated him, and he had written about it many times, marveling at its delicacy, its strength, and the strange laws it obeyed. Now at last he decided to write a study of water in fifteen or more chapters, a consistent account of water, beginning with the nature of water itself, then the sea, then springs, then rivers. He would write about the surface of water, currents, eddies, waterfalls, the banks of rivers and why they crumble, and the beds of rivers and what happens to them, and about canals and how water can be raised, and about all the things that move in water. It would be an exhaustive study, dry and accurate, gathering together all he had written previously and adding a vast amount of new material. This was the tenth or eleventh comprehensive study he had undertaken and like all the rest it would remain unfinished.

What is surprising at first is the dryness of the tone, the deliberate care and restraint of the writing and of the illustrations. When he discusses the intersecting of waves, he draws them in the margin so that they have the effect of a moving picture film. It was a precise and mechanical set of illustrations, without the gaiety of the drawings in the Codex on the Flight of Birds, perhaps because the subject was more resistant but also because Leonardo was clearly preparing a manuscript in a form ready to be published. He had never been neater. As we turn the small pages which measure only 4" by 5¾", we see him carefully shaping each page. Of all things in the world he loved faces and water most.

While Manuscript F is largely devoted to the study of water, it includes short chapters on many peripheral subjects: the moon (which he believed to be cold and moist), hydraulics, canals, geology, optics, astronomy, and there are also some notes on painting and the flight of birds, two subjects which still fascinated him, though he painted rarely and had by this time given up his attempts to create a flying machine. He began the notebook on September 12, 1508. In the following month he wrote, "In October I had 30 scudi. I lent 13 to Salai to complete his sister's dowry, which left me with 17." The loan to Salai was quite generous considering that his official salary from the French court came irregularly and in varying amounts. He later wrote a memorandum to himself: "The salary I received from the King from July 1508 to April next 1509 was first 100 scudi, then 100, then 70, then 50, then 20, and then 200 francs at 48 soldi the franc." He was well aware of the danger of lending money and wrote a stern warning to himself: "Lend not! If you lend you will not be repaid, if you are repaid it will not be soon, if it is soon it will not be good coin, if it is good coin you will lose your friend."

Young Melzi appears to have had an independent income, for there is no record of any loans or payments made to him. He was quiet, undemanding, courtly, and attentive. There survives a draft of a letter written by Leonardo to him: "Good morning, my dear Francesco. Why, in God's name, of all the letters I have written to you, have you never answered one? Now wait till I come, by God, and I shall make you write so much that you will perhaps be sorry for it."

Charles d'Amboise left Leonardo to his own devices. Leonardo sometimes worked for him. We know that he made sketches of a palace which was almost certainly intended as the *palais de luxe* of the French governor, rather small, with an elaborate façade and an ornamental stairway. In summer the rooms would be water-cooled, and he devised a plan by which a secret fountain could be turned on in the garden "should anyone wish to give a shower bath from below to the women or others who shall pass there." The garden would be roofed with thin copper netting, thus preventing the song birds from escaping, and "by means of a mill I will make unending sounds from all kinds of instruments, which will make music as long as the mill continues to move." What Charles d'Amboise was being offered was a small paradise fit for a voluptuary. This *palais de luxe*, however, was never built, and Charles d'Amboise appears to have made few demands on Leonardo, who acted as an adviser, a consultant on matters of art and as an expert on canal building. He had been granted by King Louis XII the right to take twelve inches from the canal of Santo Cristofano. This was part of his emoluments and had been valued at 72 ducats. Leonardo complained in a letter to the president of the Water Commission that owing to the drought the value of the water had dropped to seven ducats. He pointed out that he had received only twelve inches of water while the local magistrate received more than five hundred inches. It was a querulous letter written by a man who was obviously disappointed, not knowing where to turn.

It was a year of withdrawal, of absorption in his studies. Not all the studies were profitable. He noted that on the eve of the kalends of May 1509 at ten o'clock on a Sunday evening, he solved the problem of "squaring the angle of two curved sides, that is the angle, which has two curved sides of equal curve, that is the curve created by the same circle." The mathematician Fra Luca Pacioli was no longer at his side. Yet Leonardo must have thought often about the Franciscan father during this year. The book *De Divina Proportione* was published at last in Venice, beautifully printed, with Leonardo's drawings of solid geometrical figures admirably engraved, and there were many references to Leonardo's services in the court of Lodovico Sforza. The

book may have served as a much needed reminder that his own drawings could be magnificently reproduced on the printed page.

So many books! So many plans! But nothing came of them. He wrote, "During the winter of 1510 I look to finish this anatomy." It is certain that four years later he was still pursuing his anatomical studies and the book was never finished. Of all his books this was probably the one most needed, the one which was of the greatest service to humanity. He wrote and painted as though he had all eternity in front of him, passing from one study to the next, never finishing them, reserving to his old age the ordering and collecting of his manuscripts. He did not know that he would not be granted an old age.

Nor were Melzi or Salai of any help to him. Salai was twenty-seven, no longer an enchanting youth. Melzi was nineteen, not yet in a position where he could help to put the vast array of manuscripts in order. Leonardo refused to dictate; there were no secretaries or scribes; everything was painfully written down in his own hand. Time was running out and he pretended it was standing still.

Time was also running out for Charles d'Amboise, the earnest voluptuary who was perhaps the only patron worthy of Leonardo and who sensibly demanded little from him, permitting him to study as he pleased. Worn out by his sexual excesses, he died in his bed on March 10, 1511, at Correggio.

His successor as lord lieutenant and viceroy of Milan was Gaston de Foix, the brilliant nephew of King Louis XII. He was twenty-two years old. As commander of the French forces in Lombardy he had shown himself to be generous toward his enemies. One of the best officers on his staff was Pierre de Bayard, *le Chevalier sans peur et sans reproche,* whom the French have ever since regarded as the epitome of military virtue. Gaston de Foix was also brave to the point of madness. When the French armies drove south to confront the armies of Pope Julius II, who hoped to transform all Italy into a papal state and thus to become, in the words of the Venetian chronicler, "the lord and master of the game of the world," a decisive battle was fought in Ravenna. The French destroyed the army led by the aging pope, and the battle was already over when Gaston de Foix rode after some soldiers fleeing from the battlefield. They were many, and he was one. They made short work of him. The victor of Ravenna died horribly at the hands of men fleeing for their lives, and with his death the heart seemed to go out of the French army, which fell back on Milan. The new lieutenant general and viceroy was the turncoat Giovanni Giacomo di Trivulzio, wizened and prematurely old, with a nose like a small hatchet, a cruel mouth, and a jutting chin. The battle of Ravenna took place in April. In December, Massimiliano Sforza entered

Milan at the head of an army of Swiss mercenaries. Once more there
was a Sforza on the ducal throne. Trivulzio spent the remaining years
of his life as a refugee in France.

Today Trivulzio is nearly forgotten, as he deserves to be, for he did
little good to the world. If he is remembered at all, it is because dur-
ing the period of his vice-royalty, he asked Leonardo to design for him
a sepulchral monument of unparalleled splendor, worthy of the place
he believed he possessed in history. It was never built but Leonardo's
spirited drawings for it have survived. Trivulzio wanted a monument
that had never previously existed—a free-standing columned tomb in a
church, with a life-size equestrian statue on the top, with bound slaves
chained to the columns signifying his victories, and with enough fes-
toons, rosettes, trophies, and decorative adjuncts as would please a
taste debased by so many hollow triumphs. There would be two por-
traits of Trivulzio—alive, on horseback, and recumbent on the tomb.
He had the treasury of Milan at his disposal and could pay hand-
somely.

Leonardo, determined to make an equestrian monument that would
survive through the ages, set about the work with enthusiasm. His
designs for the horse have a flamelike force and resilience. He was
clearly excited by the prospect; the pen flows easily, and there is no
longer any question of studying the living horse. He draws horses
from his imagination, filling many pages with them. Usually they are
leaping up and sometimes there is a fallen soldier under the forelegs.
In one elaborate design he shows a fallen soldier reaching up to grasp
an upraised hoof, so that half the weight of the statue is supported by
a man's arm and a horse's leg. What is chiefly remarkable about these
drawings is a feeling of gaiety and untrammeled joy, the horse racing
the pencil, the pencil racing the thought. All together there are some
fifteen drawings and sketches for the new horse. For Leonardo it was
the purest entertainment to embark once more on an equestrian
statue. He also enjoyed presenting Trivulzio with a bill of particulars
and an estimate of the cost of his equestrian sepulcher, amounting to
1,971 ducats, an immense sum of money. He wrote it out carefully in
his notebook:

SEPULCHER OF MESSER GIOVANNI JACOMO DI TRIVULZIO
Cost of manufacture and materials for the horse

A courser, life-size, with the rider, requires for the cost of metal	duc	500
And for the cost of the ironwork which is inside the model, and charcoal, and wood, and the pit for the casting, and for binding the mold, and including the furnace where it is to be cast	duc	200

To make the model in clay and then in wax	duc	432
To the laborers for polishing it when it is cast	duc	450
In total	duc	1582

Cost of the marble for the sepulcher

Cost of the marble according to the design. The piece
of marble that goes under the horse which is 4
braccia long and 2 inches wide and 9 inches thick,
58 hundredweight, at 4 lire and 10 soldi per hun-
dredweight duc 58

And for 13 braccia and 6 inches of cornice, 7 inches
wide and four inches thick, 24 hundredweight
duc 24

And for the frieze and architrave, which is 4 braccia
and 6 inches long, 2 braccia wide and 6 inches
thick, 29 hundredweight duc 20

And for the capitals made of metal, of which there
are 8, 5 inches square and 2 inches thick, at the
price of 15 ducats each, they amount to duc 120

And for 8 columns of 2 braccia 7 inches, 4½ inches
thick, 20 hundredweight duc 20

And for 8 bases which are 5½ inches square and
2 inches high, 5 hundredweight duc 5

And for the slab of the tombstone 4 braccia 10 inches
long, 2 braccia 4½ inches wide, 36 hundredweight
duc 36

And for 8 feet of pedestals each 8 br. long and 6½
in. wide and 6½ in., 20 hundredweight, comes to
duc 20

And for the cornice below which is 4 br. and 10 in.
long, and 2 br. and 5 in. wide, and 4 in. thick,
32 cwt duc 32

And for the stone from which the dead man will be
made, which is 3 br. and 8 in. long, and one br.
and 6 in. wide, and 9 in. thick, 30 cwt duc 30

And for the stone on which the figure lies which is
3 br. and 4 in. long, and 1 br. and 2 in. wide and
4½ in. thick duc 16

And for the tablets of marble set between the ped-
estals, which are 8, and are 9 br. long and 9 in.
wide and 3 in. thick, 8 hundredweight duc 8

In total duc 389

There remained the cost of shaping and sculpting the marble—all
the work that Leonardo called *manifattura*. Rather surprisingly he
charged almost the same amount for making eight festoons, *festoni*, as
for carving the figure of the recumbent governor; the eight festoons

cost 92 ducats, and the statue 100 ducats. He charged 8 ducats for
each fluted column and 20 ducats for each rosette. About half the total
sum went to the bronze horse, the marble and what Leonardo called
the *manifattura* and only 130 ducats altogether went to the recumbent
figure.

These drawings can be dated with fair accuracy. There was a brief
period in 1512 between the battle of Ravenna and the coming of Mas-
similiano Sforza when Trivulzio ruled as the Viceroy of Milan. Be-
tween April and December, Trivulzio knew the satisfaction of being
the sole ruler, and he therefore gave himself up to feasts, spectacles,
parades, and processions in his own honor, and it must have been dur-
ing this period that he conceived the idea of being immortalized with
a sepulchral monument of the utmost splendor. He alone would be
commemorated by a horse fashioned by Leonardo; and not only the
horse. Every detail of the monument would be carved by Leonardo,
and the monument itself would find a suitable place in a chapel that
was being built for him. By the late autumn the ever-rebellious Mila-
nese had become weary of him, they warned him to remove himself
and his French soldiers, set buildings on fire, and waited for Mas-
similiano Sforza to enter the city. He came with much fanfare on De-
cember 29, 1512, and Trivulzio fled to France.

Instead of the great sepulchral monument designed by Leonardo,
Trivulzio received a more conventional monument. He died at
Chartres in 1518 and his body was brought to Milan and placed in a
sarcophagus inserted in a recess high in the wall of a chapel in the
Church of San Nazaro Maggiore.

The last months of Trivulzio's rule were feverish with despair. Like
Lodovico Sforza, he saw the end coming and could do nothing about
it.

For Leonardo the entry of Massimiliano Sforza, Duke of Milan,
could only be a disaster, for he had identified himself so closely with
the French invaders that it was scarcely possible that he would escape
suspicion. He fled to Vaprio d'Adda, where he occupied a chamber in
one of the towers of the Melzi mansion, and from there watched in
the distance the Venetian bombardment of the castle of Trezzo, which
lies in the bend of the river. So he drew a plan of the castle and
sketched the gun emplacements and the probable trajectories, and on
the same page he later drew the thorax of an ox and human intestines
and some architectural drawings related to his cherished project of
transforming the Melzi mansion into a kind of palace. He wrote at the
top of the page "January 9, 1513," which was four days after the Ve-
netians captured the castle.

Whenever there was trouble in Milan, the Venetian armies drove

deep into Lombardy. It was a time of almost total confusion, with the French withdrawing, the Venetians attacking, the Swiss mercenaries looting. Massimiliano Sforza ruled over a divided city, for although the French army was withdrawn, the French garrison still occupied the Castello and refused to surrender. In his tower Leonardo continued his anatomical studies, though he was reduced for a while to cutting up dogs and the heads of oxen. He wrote in his notebook, "Look at the dead dog, its lumbar region, the diaphragm and the motion of the ribs."

In September 1512 a sudden bloodless revolution in Florence returned the Medicis to power. Three months later, with the return of a Sforza to Milan, it was as though the past had been obliterated, for the familiar despots of the fifteenth century were being restored in the sixteenth. Outwardly nothing had changed. Once more a Medici was corresponding with a Sforza. Leonardo, too, was in correspondence with them. He appears to have returned to Milan briefly in March 1513, for the register of the Office of Works of the Duomo records that he was living in the house of the Magnifico Domino Prevostino Viola near the Porta Nuova.

In September 1513 there came the *coup de théâtre*. The large French garrison in the Castello marched out under a flag of truce. Their supplies had run out, they were exhausted, demoralized, and homesick, and the Milanese were happy to see them go. The long years of French rule seemed to be over. They left on September 19, and five days later Leonardo set out for Rome to take service under a new patron, Giuliano de' Medici, who was described by Castiglione in *The Courtier* as "a thoughtful and religious man, of a peaceful and generous nature, who revolted against the crimes which in those days were considered necessary to advance worldly ambitions."

The Milanese rejoiced too soon in the departure of the French, who would soon return and hold Lombardy in an iron grip. Leonardo rejoiced too soon in the discovery of a gentle and intelligent patron, for Giuliano de' Medici proved to be weak and unresourceful and the journey to Rome proved to be disastrous.

THE FACES OF THE ANGEL

The Road to Rome

Rumors traveled quickly in Italy, and so it happened that on March 11, 1513, in the early hours of the morning, the rumor reached Florence that Giovanni de' Medici, the second son of Lorenzo the Magnificent, had been elected pope by the conclave of cardinals that had been sitting for a week. Suddenly, at four o'clock in the morning, the church bells of Florence began ringing so loudly that the people tumbled out of their beds and went running into the street, for there could be no other explanation for the church bells than the election of Cardinal de' Medici. In the early dawn bonfires were lit at the crossroads, there was dancing in the streets, and everyone was rejoicing.

Strangely no official news of the election had reached Florence, and at the Signoria and the Medici Palace the officials explained patiently that they knew nothing at all about the election. Nevertheless the people celebrated, and all day the cry of *"Palle!"* resounded through the

streets. When night fell there was still no confirmation of the news, and it was not until ten o'clock that night that it became known that Giovanni de' Medici had indeed been elected pope, assuming the name of Leo X. Then the celebrations were redoubled, more bonfires were lit, and all through the night people raced through the streets shouting, *"Palle! Papa Leone!"* There were bonfires now outside every house. The poorest gathered their little piles of firewood, set fire to them, and then ran off to tear down the wooden roofs of the shops and burn them in bonfires such as had never been seen in Florence before. Luca Landucci, the apothecary, who kept a diary which is one of our main sources of information about events in Florence, was terrified by this explosion of joy. He wrote:

> It seemed as if the city were upside-down, and anyone who had seen it from overhead would have said: "Florence is burning down the whole city," for there was such a tumult of shouting and fires and smoke and reports of cannon large and small; and on Sunday the same, and on Monday worse than ever. They placed up on the gallery behind the parapets of the *Palagio* a gilt malmsey cask at each corner, full of firewood and other stuff to burn, and also on the *Ringhiera* and in the Piazza many gilt casks were burned, accompanied by the continual sound of small guns. It was really incredible what a number of fires there were in the city; every single person had one at his door. And in addition to this, they made several triumphal cars, and every evening set light to one in front of the house of the Medici in their honour; one was of discord, war, and fear, while another was of peace, and this latter they did not burn, as if to express that there was an end to all passions, and peace remained triumphant.

Leo X, the first of the three Medici popes, had been raised to the cardinalate at the age of fourteen and had thereafter pursued a career of energetic self-indulgence in spite of Lorenzo the Magnificent's repeated efforts to curb him. Pico della Mirandola and Marsilio Ficino had been his teachers; they had taught him to write passably well and to think clearly, but his thinking had not progressed beyond a general desire to bask in his own fame and to ensure that everything that happened to him should contribute to his fame. He was a master of manipulation, determined to advance not only his own fortunes but those of the entire Medici family, with the result that the cardinals were forced to extract from him a promise that he would not turn the cardinalate into a private Medici preserve; and he was permitted to appoint only two members of his family to the office of cardinal. Delighted with his new-found splendor and sudden wealth, Leo X

turned to his brother Giuliano and said, "*Godiamoci il Papato poichè Dio ce l' ha dato* [Let us rejoice in the papacy since God has given it to us]."

The new pope was ill-fitted for the papacy; everything about him suggested the complete voluptuary. He had a large, round, fleshy face, protuberant eyes, a heavy nose, a small mouth, a fat body, and very short legs. He had an ungainly walk and, though a good rider, he had to be lifted up on his horse. He spoke in a clear, soft, cultivated voice, laughed often, even when there was nothing to laugh at, and usually showed a genuine desire to please, often making promises without the least intention of carrying them out because it pleased him to see the look of gratification on the face of the man who had come so hope-fully into his presence. Since he was excessively short-sighted, he sometimes mistook one person for another; and on occasion he would lift a jeweled eyeglass to his eye and survey his guests in a lordly man-ner. There was little malice in him, and his enjoyment of the papacy was almost childish in its intensity. "How very profitable this fable of Christ has been to us through the ages," he remarked to Pietro Bembo. The last three words were perhaps an afterthought: the fable was proving very profitable in the present.

The coronation, which took place in April 1513, was held in a huge tent outside St. Peter's, which had been demolished and the ground prepared for rebuilding. There were the usual inscribed banners and placards, and the wording of one of these placards, which must have been especially pleasing to him, has been preserved. It read, "Venus ruled in Rome with Alexander, Mars with Julius, and now Minerva enters her reign with Leo." Just as he possessed a genuine desire to please, so he believed himself to be a genuinely creative benefactor of the arts. A new Leonine Age had come into existence at his bidding. Like Lorenzo the Magnificent, he would usher in a golden age of scholars, poets, painters, sculptors, and actors, which would be re-membered throughout history. Unhappily he lacked his father's good taste, intelligence, courage, and audacity. Although he was only thirty-seven when he came to the throne and could expect to live a reasona-bly long life, he failed even in this. He reigned briefly, did much harm in his short reign, and died suddenly, probably of poison. Leo X was not one of the great popes.

Leonardo, who was living in Milan and watching the affairs of Rome from a cautious distance, soon became aware that the new pope was summoning artists from all over Italy and proclaiming the new Leonine Age. He was also becoming aware that a great number of people detested and feared the pope, believed that he had bribed his way to the throne, and were accordingly working for his downfall.

Among these people were some Franciscan friars who set themselves the task of prophesying vigorously against him and threatening Italy with divine punishment for having permitted such a voluptuary to sit on the throne. Leo X was Antichrist, and worse. He was all that the Franciscans abhorred most in the world, and they had no hesitation in saying so. The campaign against the pope was well organized. Twelve friars, taking vows of extreme poverty and modeling themselves on the twelve disciples, went through Italy, each taking a province for himself, each declaiming that the world would come to ruin unless everyone dedicated himself to perfect purity, unless the pope was dethroned, unless God became the accepted ruler of each state. Like Savonarola, they were men with vivid and violent imaginations and they depicted the coming age of destruction with fervor and absolute conviction. The most famous of these friars was Fra Francisco de Montepulciano, who addressed the flock in Santa Croce in Florence until they cried out for mercy and wept unrestrainedly. He presented them with harrowing pictures of a world destroyed and themselves naked against the torments of a jealous God. *"Misericordia!"* they cried. "Pity! Mercy!" The friar's sermons were as fearful and terrible as those of Savonarola. "The ruin of the world is at hand!" he exclaimed, his small body shaking with emotion, his gaunt features lit with the flames of prophecy. He wore only a short gown reaching to his knees such as might be seen on some statues of St. John the Baptist.

The effect of the sermons was out of all proportion to the numbers of the friars who addressed the people. All Italy, for a few months, was caught in a wave of unrelenting prophecy: doom, destruction, damnation, the whole universe falling to ruin. The rhetoric of doom is always similar, and there cannot be many variations on the theme of imminent destruction. The prophets endlessly repeat themselves. Nevertheless they had the power to send a shiver through Italy. Only Leo X, enjoying his hawking and hunting parties in the Campagna or entertaining a select company of his friends in his villa of La Magliana five miles from Rome, seemed to be unaware of these prophecies of doom.

It was about this time, while staying at Vaprio, that Leonardo began to draw the extraordinary pastels now at the Royal Library at Windsor which are among his greatest and most haunting achievements. These eleven pastels show the earth in a state of convulsion, shattered by ferocious winds, rockfalls, and earthquakes, with men and animals no more than driven leaves in an apocalyptic storm. It is the end of the world, the end of time. Leonardo draws what he sees in

his mind's eye, and what he sees is the unrelieved horror of a world being swept away.

Usually these pastels are reproduced in monochrome; many of them are subtly shaded and colored. The most majestic and troubling of them (Windsor 12376) shows color washes of yellow, blue, a sickly green and purple with a great empty patch of livid white in the foreground. The hurricane is sweeping across the earth, the trees are bent to the ground, men and horses have been thrown down, and in the wake of the storm they have come to assume the shapes of roots and branches, no more human than the figures of another nightmarish drawing made about the same time, showing an army on the march while above the soldiers giant animals tumble in the sky, all terribly misshapen, and a huge headless horse with a howdah strapped to its back hurtles forward, and the banners fly from the howdah, and nearby an enormous cat or lion curls up and sleeps its life away. What is especially striking about these two drawings is their authority as visions of ultimate disaster: one shows the world being torn apart by an apocalyptic storm, the other by an apocalyptic army. Both drawings were made under the stress of intense visionary emotion and nothing like them had ever been attempted previously by Leonardo.

In *The Adoration of the Magi* Leonardo had sketched into the background a horse and rider, the horse turning its head far to the left, the rider leaning hard over to the right. The disconcerting effect, at first glance, is to suggest a headless horse, for the head is not immediately visible. This was not an accident. Continually drawing horses, Leonardo would sometimes forget to draw the head or, as in a famous drawing of a horse rearing up on its hind legs, he drew three lightly sketched heads in different positions. In addition he deliberately gave the horse six legs to convey a sense of movement. In the apocalyptic drawings the distortion is deliberate: headless horses, a horse with three curling elephant trunks issuing from its neck, horses shaped like the roots of dead trees. Strangely, throughout the history of art, there was only one brief period when animal shapes were distorted out of all recognition, and this happened during the Northern Wei Dynasty in China about 470 A.D. at a time when there was a head-on collision between the rich and settled culture of the Chinese and the culture of the powerful Mongolian tribe that had taken possession of the kingdom.

Leonardo's strange horses came out of nightmares, out of the vision of nature disintegrating before his eyes. Almost he was drawing abstract shapes of terror. Indeed, at least six of the Deluge drawings may be regarded as five-finger exercises on the theme of total destruction. In these the passion is lacking and Leonardo is concerned to de-

vise brilliant patterns of wheeling turbulence, the rocks falling and the
mountains crumbling. Destruction itself becomes an abstraction, be-
coming therefore less horrible; it was as though Leonardo had come to
terms with it and even mastered it. But even in those drawings there
is the sense of agony, and we almost hear the long-drawn screaming
of the earth as it is rent asunder.

These drawings are closely related to an extraordinary novel which
Leonardo wrote about the year 1500 and left uncompleted. The novel
took the form of a series of letters written to a mysterious Diodario di
Soria, lieutenant of the holy Sultan of Babylon, concerning the adven-
tures of a prophet who witnessed a deluge in Armenia, saw the cities
swept away, and was himself lost and found and lived to see his
prophecies come true. The prophet is evidently Leonardo himself; the
Diodario di Soria may be Giuliano de' Medici, and the holy Sultan of
Babylon can scarcely be anybody but the reigning Pope Leo X. The
novel would take the form of a recital and a warning; there would be
high adventure, strange encounters and intrigues, the final triumph of
the good prophet over his enemies. Twelve chapter headings or *divi-
sione del libro* provide the framework of the story:

> The preaching and persuasion of the faith
> The sudden deluge down to its end
> The destruction of the city
> The death of the people and their despair
> The search for the preacher, and his liberation and benevo-
> lence
> Description of the cause of the destruction of the mountain
> The havoc it created
> Destruction by snow
> Finding of the prophet
> His prophecy
> The deluge in the lower part of eastern Armenia, the draining
> of the waters achieved by cutting through the Taurus Moun-
> tains
> How the new prophet showed that the destruction occurred ac-
> cording to his prophecies

These chapter headings were jotted down by Leonardo as the
thoughts struck him; they are clearly not in their final order. "His
prophecy," shown late on the list, must have come before "the sudden
deluge down to its end." The prophet is both a man of faith and a hy-
draulic engineer, for the deluge, having scattered and destroyed the
city and drowned most of the people, is finally mastered by the drain-
ing of the waters through a tunnel in the Taurus Mountains. It is
therefore a story with a properly scientific and happy ending.

As far as we know, Leonardo never traveled to Asia Minor, never saw the Taurus Mountains, never witnessed anything comparable to the deluge he intended to describe. Yet, as a child of four, at Vinci, he had seen a storm which ravaged nearly all of Tuscany, uprooting oak trees, tearing off the roofs of churches, and hurling mule carts across the countryside. Neither Vinci nor Florence was in the direct path of the storm, but even in the towns and villages nearby there was an awareness that the heavens were in an uproar. It was such a storm as few people were able to forget, and when Machiavelli wrote his *History of Florence* he devoted a whole page to it, relying on the memories of those who had witnessed it, for he was not born until 1469, fifteen years after it took place. Leonardo may have remembered it vividly, and his visions of an apocalyptic deluge perhaps had their source in childhood memories. He was always fascinated by the destructive power of winds and water, and once wrote in his notebook, "I have seen movements of the air so violent as to carry away immense forest trees and whole roofs of great palaces."

Here and there in his notebooks we find scattered paragraphs that are evidently related to the story told in letters to the mysterious Diodario di Soria, where "Soria" is the conventional Italian Renaissance word for "Syria." Here, for example, is his description of the day of the deluge, which was also the day of hurricanes, avalanches, and fire storms:

> For ten hours we experienced such havoc as I would not have thought possible. First we were assailed and attacked by the violence and fury of the winds, and to this was added the fall of great mountains of snow that filled up the entire valley, thus destroying a great part of our city. Not content with this the storm brought a sudden flood of water that submerged all the city's lower part, and then there came a sudden rain, or rather a destructive flood or torrent of water, sand, mud, and stones, tangled with roots, and branches and fragments of many trees; and every manner of thing flying through the air fell on us; and finally a great fire broke out, not carried by the wind, but as it were carried by ten thousand devils, and it completely burned up this neighborhood and has not yet ceased.
>
> Those few who remained unharmed are in such dejection and terror that they scarcely have courage to speak to one another; it is as though they were stunned. Having abandoned all our affairs, we stay here together in the ruins of some churches, men and women mingled together, small and great, like herds of goats. The neighbors out of pity succoured us with victuals, they who were previously our enemies. And if it had not been

for some people who succoured us with victuals we would have
starved to death. Now you see the state we are in. And all these
evils are nothing compared with those that are promised to us
shortly.

I know that as a friend you will grieve over my misfortunes,
as I in former letters have shown my joy in your prosperity.

Leonardo is writing like a novelist, convincing us that imaginary
things really happened and succeeding well enough for his purpose.
He clearly intended to compose an imaginative work of literature, but
long descriptive passages on the Caucasus and Taurus Mountains held
up the progress of the story, and the complications involving a giant
and a journey to Cyprus proved to be unmanageable. Although the
chapter headings suggest that he had already worked out the general
direction of the story, he appears to have abandoned it because he
was left unconvinced that he had the makings of a storyteller.

Some commentators have seriously suggested that Leonardo must
have traveled to Armenia to write so authoritatively about it. By the
same argument Milton must have traveled to the Persian Empire be-
cause he wrote learnedly of Ormuz, and Shakespeare must have trav-
eled to Venice and Verona. In fact Leonardo was composing a work of
imagination based on available literary sources: Aristotle's *Meteor-
ologica*, Pliny's *Natural History*, and Sir John Mandeville's *Travels*, all
books which he possessed, are among the more obvious sources. He
introduces the name of a Cilician seaport, Calindra, otherwise un-
known to mapmakers. It may have been derived from Calenderis, a
seaport mentioned by Strabo, or it may have been a made-up name
derived from *calandra*, the Italian word for a woodlark, or from half a
dozen other sources. What is certain is that the story, as outlined by
Leonardo, possessed a deep significance for him, and was all the more
significant because the vision of destruction was followed by the vi-
sion of peace and plenty, for finally the deluge was drained away by
the hydraulic engineer with the gift of prophecy. It was a satisfying
way to lay the ghost of one of his most obsessive ideas—that the earth
was doomed to be destroyed by fire and water. He wrote in one of the
earliest entries in his notebook:

> The time will come when our luxuriant and fruitful earth will
> grow dry and sterile. By reason of the pent-up waters in the
> earth's womb and by reason of nature's laws, the earth will fol-
> low its inevitable course, and passing through the circle of ice-
> cold, rarefied air, it will complete the cycle through the element
> of fire. And the surface of the earth having become at last a
> burnt cinder, all earthly nature shall cease.

But perhaps after all the ghost was never laid, for he wrote convincingly about the deluge but there is no trace in his notebooks of the engineer's solution to the problem. On one of the most extraordinary pages of the notebooks (Windsor 12388) we see the storm breaking over a town and the mountains crumbling, while on one side small Giacometti-like men surround a man with upraised arms, who is perhaps the prophet, or perhaps a skeleton, and on the other side we see the fireball descending on a cluster of men kneeling and praying as the flames engulf them. It is annihilation in four stages graphically depicted, and like so much of Leonardo's work it is peculiarly modern and terrifying in the modern way.

Leonardo's Deluge drawings are sometimes compared with Giulio Romano's *The Fall of the Giants* in the Palazzo del Te at Mantua, where the giants are seen being crushed by rockfalls and boulders sailing haphazardly through the air, while others are being swept away in a raging torrent. The difference between Leonardo's work and Romano's work is the difference between a naked vision and a worn-out mythology. Giulio Romano has painted an arrangement of naked bodies struggling with rocks that resemble bales of cotton; he is playing a child's game. Leonardo has seen through the veils, and with his profound intuitions concerning the nature of the earth, of man and of matter, he has looked the Abyss in the face. "Do not stare too deeply into the Abyss," wrote Nietzsche, "lest it stare back at you." Leonardo was one of those who saw the Abyss staring back at him.

When Leonardo set out for Rome he was a deeply troubled man with many cares on his mind. He wrote in his notebook, "I left Milan for Rome on the 24th day of September, 1513, with Giovan Francesco de Melzi, Salai, Lorenzo, and il Fanfoia." Nothing is known about Lorenzo and il Fanfoia. Ostensibly Leonardo was journeying at the invitation of Giuliano de' Medici, the younger brother of Pope Leo X, who had arranged accommodation for Leonardo's party in the luxurious Belvedere Palace on top of Vatican Hill. The Belvedere commanded a magnificent view of the surrounding scenery; it was well kept; there were hundreds of attendants, and it was a signal honor to be invited to stay there. Within the courtyard were many of the recently excavated antique statues, including the *Laocoön,* the *Apollo Belvedere, Ariadne* lying down in a voluptuous sleep, several Venuses, and the towering *Tiber,* an old man whose streaming locks represented the river. On the slopes of the hill stood a famous menagerie and an equally famous botanical garden. Leonardo's apartments in the Belvedere were provided with new and presumably larger windows and new furnishings under the supervision of Giuliano Lenno, an architect of some merit, who had taken the place of the ailing Donato

Bramante as head of the Office of the Fabric of St. Peter's. An account book of that year has survived and it lists the cost of fourteen separate alterations and additions "for the rooms of Master Leonardo da Vinci," all of them completed by December 1, 1513.

We hear of various small commissions completed in Rome, including a *Virgin and Child* and the portrait of "a marvelously graceful and beautiful boy" painted for Baldassare Turini, the papal datary. Both paintings are now lost, and Vasari reports that in his own day the *Virgin and Child* was fading. Vasari also relates that Leonardo transformed a curious lizard found by a vinedresser in the Belvedere into a veritable monster, and by means of a smith's bellows inflated a small piece of bullock gut until it filled a whole room. And when commissioned by Leo X to do a painting, he immediately began to distil oil and herbs to make a varnish. "This man will never do anything," the pope said, "for he begins to think of the end before the beginning."

Leonardo was not the only great painter to be treated contemptuously in the court of Leo X. While Sodoma received a handsome commission and many lesser painters were highly regarded, because the pope found their work amusing or because they possessed influence at the court among the papal advisers, Leonardo was relegated to the background, like Luca Signorelli, another authentic master, who came to Rome, received no commissions, and was reduced to begging from his friends. He was a man of enormous talent, had been one of Piero della Francesca's favorite pupils, and was a profound colorist and student of the nude; and his crowded canvases remain to show us that he possessed a mind of great tenderness and complexity. He had served Lorenzo the Magnificent loyally and expected to be received by Lorenzo's son with the same affection. Instead he was totally rejected. Many years later Michelangelo remembered Luca Signorelli coming to his studio in Rome and begging for alms. Michelangelo wrote:

> While I was in Rome, in the first year of Pope Leo, there came the master Luca Signorelli of Cortona, painter. I met him one day near Monte Giordano, and he told me he had come to beg something from the Pope, I forget what, and he had once run the risk of losing life and limb in devotion to the house of Medici, and now it seemed, so to speak, that they gave him no recognition at all; and he said many other things in the same vein, which I no longer recall. To crown these arguments, he asked me for forty giulios and told me where I should send them, at his lodgings in the house of a shoemaker. I did not have the money on me, but offered to send it to him and did so.

As soon as I reached my house I sent him the forty giulios by the hand of a young man in my service, called Silvio, who is still alive, and living, I believe, in Rome. A few days later Master Luca came to my house in the Macello de' Corvi, the house which I still have today, and it appeared that he had not succeeded in his business with the Pope. He found me working on a marble figure, upright, four braccia in height, with the arms bound behind the back. He was bewailing his fate and begged me for another forty giulios because, as he said, he wanted to leave Rome. I went up to my bedroom and brought the money down in the presence of a Bolognese maid who was in my service, and I believe Silvio, who had taken the earlier money, was also there. He took the money and went with God. I have never seen him since. But I remember complaining to him, because I was ill at the time and unable to work, and he said, "Have no fear, for the angels from heaven will come down to take you in their arms and help you."

Michelangelo remembered the incident vividly fifty years later, for this letter was addressed to the capitano of Cortona, where Luca was living, in the hope of reclaiming the debt. Luca, then nearly eighty, appears to have thought he had repaid the debt, and the capitano, believing a fellow citizen, wrote back that Michelangelo must be a rascal of the worst kind to seek to reclaim a debt already paid.

Unlike Luca, Leonardo was not reduced to beggary at Leo's court. He survived, but with difficulty, and some of the worst difficulties came from the assistants he had hired: he complained that they quarreled with him, made demands on him that he could not meet, and were continually making his life unendurable. None of this could have happened if he had been given important commissions. The fact that he was not in the pope's good graces permitted the servants to treat him contemptuously; his enemies were very close to him, perhaps in his own household, and certainly among the people who worked for him.

For the first time we see Leonardo caught up in a world of papal intrigues. He had no protectors at court; Giuliano de' Medici, the pope's brother, was often ill and saw him only rarely. Leonardo was no longer allowed to continue his anatomical researches because the pope was offended by the mere thought of bodies being cut up in the nearby Hospital of Santo Spirito. Apparently Giovanni, a German mirrormaker, was intriguing against him and was able to bring these researches to the attention of the pope. The hospital authorities were also informed about the dissections that Leonardo hoped to conduct quietly and secretly. Giovanni belonged to the type that blurts out everything, if it is to his own advantage; and Leonardo, who had none

of the makings of an intriguer, found himself at a hopeless disadvantage.

An air of menace hung over these days which should have been spent calmly and comfortably. We become aware of spies and secret agents moving from the Belvedere to the Vatican and back again. Leonardo was being watched, but for what purpose? And in the midst of all these troubles Leonardo fell ill, very seriously ill, and was reduced to a state of querulous inactivity and almost total frustration. He was not the kind of man who makes a good patient. Restless, intractable, possessing a massive will power and an unyielding determination to remain active, he found himself bedridden. The shock appears to have unnerved him. How unnerved he was we learn when we examine three drafts of a letter which he transcribed in his notebook. Though there is no indication as to whom he was addressing the letter, there is not the least doubt that it was in fact addressed to Giuliano de' Medici, his protector, who had also been gravely ill.

Leonardo's writing is nearly always direct, well formed, with a precise sense of the music of words. Sometimes he hesitates, reworks a phrase, rethinks an opinion, but there is always the sensation that he is moving energetically in a chosen direction. But in this letter, written in the Belvedere, Leonardo shows himself for the first time to be halting, petulant, imprecise. He complains querulously, as a farmer might complain about thieving and lazy farm laborers. The argument proceeds in circles and he goes into details about matters which could scarcely be of interest to anyone but himself and which could not be expected to interest the lordly and aristocratic Giuliano de' Medici. I shall quote one of the drafts at some length because it shows us Leonardo in an unfamiliar light, sick, angry, at his wits' ends, remembering real or imagined slights, exploring his own hurts, and muttering to himself like an old woman who finds the burdens of the world too much for her. He begins with many scorings, as though in a terrible state of nervousness and uncertainty about the opening of the letter:

> [Most Illustrious my Lord, Greatly did I rejoice, Most Illustrious my Lord, at your]*
>
> So greatly did I rejoice, O Most illustrious my Lord, at the desired recovery of your health that I almost [regained my own health—I am at the end of my sickness]—my sickness has fled away from me—of Your Excellency's health now almost restored.
>
> Meanwhile I am extremely vexed that I have been unable completely to satisfy Your Excellency's desires by reason of the

* Brackets indicate words that were deleted in the original Italian manuscript.

malice of that deceiver, for whom I left nothing undone which could be done for him by me and by which I might be of some service to him. In the first place his salary was always paid to him before it fell due, and I believe he would gladly deny this if it were not that I had the signature witnessed by the hand of the interpreter. And I, seeing that he would not work for me unless he had no work to do for others, and this was something he solicited most diligently, invited him to have his meals with me and to work afterward near me, for in this way he would save money and it would be good for his work and help him to learn Italian. [He always promised to do this, but never willingly did so.]

He behaved in this way because Giovanni, the German who makes mirrors, went every day to the workshop and wanted to see and understand everything that was being done so that he could talk about it publicly through the land, finding fault with it. And because he took his dinner with the men of the Pope's guard, and accompanied them when they went out to kill birds with guns amidst the ruins, and this went on between dinner and the coming of evening; and when I sent Lorenzo to urge him to work he flew into a rage and said he refused to serve so many masters and he was at work on Your Excellency's Wardrobe, and in this way two months passed, and so it went on, and one day when I saw Gian Niccolò of the Wardrobe I asked him whether the German had finished his work for Your Magnificence, and he told me it was not true—the only work he had done was to clean two guns. After this, when I again expostulated with him, he left the workshop and began to work in his own room, and wasted a lot of time making another vise and files and other instruments with screws, and he made shuttles for twisting silk and gold, which he concealed when any of my people went in, and all this with a thousand oaths and curses, so that none of them went there any more.

There are many more scorings than I have indicated; so many words are crossed out and new words substituted that the letter resembles a patchwork. In the second draft Leonardo is more specific, tells the story more cogently, and without whining. We learn that the German deceiver, the *ingannatore tedesco,* was making wooden models of the mirrors which would later be cast in iron, and he was preparing to take the models to his own country and to sell finished mirrors at the country fairs. In the first draft Leonardo is incensed by the man's surliness and laziness; in the second he remembers more vividly the man's treachery. We learn from the second draft that Leonardo had not yet recovered from his illness. The third draft, which merely sketches out an opening paragraph, tells us that Gio-

vanni had been encouraged to work at a table by Leonardo's window so that he could be constantly under the master's supervision, and it is clear that the mirrormaker rejected the offer outright.

From another fragment of a letter we learn that Leonardo was troubled by another German workman who is called Maestro Giorgio and who has filled the whole Belvedere with workshops for making mirrors. Giorgio claimed that he had been promised a salary of eight ducats a month, and was incensed because he had not received the full amount. The French scholar Eugène Muntz discovered in the Vatican an inventory which gave his monthly salary as seven ducats. Leonardo goes on to say that Giorgio spent very little time at his work, ate a great deal, and rejected an offer of payment according to the amount of work he did. At last, taking counsel with his neighbor, who was presumably Giovanni, Giorgio sold his possessions, left the Belvedere, and took another job.

Quite evidently something had gone terribly wrong in the management of Leonardo's workshop. Either because he was too preoccupied with his own work, or because he was ill, Leonardo appears to have let the management get out of hand. The Germans were having their own way, and Leonardo was out of temper, all the more so because he could not speak to them in their own language. There was a sizable German community in Rome, and they often quarreled with the Italians. They were abrupt, ill-tempered, full of their own importance, domineering. Leonardo found them impossible to work with, and in his letter to Giuliano de' Medici he raged like a man who was almost out of his mind.

For every reason the journey to Rome proved to be a mistake, a waste of his energies and abilities. His health was failing and his hopes were shattered. Soon he would leave the Belvedere and wander about Italy, scarcely knowing what he was doing or where he was going, a man without sail or anchor.

In the Shadows

Toward the end of his life, while he was still in his early sixties, Leonardo began to withdraw into the shadows. From time to time there would be a sudden burst of activity, he would make plans, draw up designs, enter his thoughts in his notebook with his customary vigorous handwriting, and then for long periods there was silence. The sickness suffered in Rome had not broken his spirit, for his mind was as penetrating as ever, but it had broken his body. His father had lived to a great age, but it would not be given to him to live so long. The evidence lies in the two paintings of the angel, begun in Rome and perhaps continued up to the year of his death—paintings in which he summons the adversary into his presence. The world was closing in on the man who had attempted almost single-handedly to open up the world.

In the autumn of 1514 he left Rome and journeyed to Milan, which

was his home. His intention appears to have been to settle there, for
nothing or very little was to be gained by serving the pope. He wrote
in his notebook, "At the Campana at Parma on the 25th day of Sep-
tember, 1514." The Campana was a hostelry, indeed the only hostelry
of any worth in Parma. He was traveling slowly, for two days later he
wrote, "On the banks of the Po near San Angelo." San Angelo was a
small town only twenty miles from Parma. He reached Milan early in
October, and there he remained, living quietly on the small property
given to him by Lodovico. But he was scarcely settled in the house
and had scarcely put his affairs in order when he was summoned to
return to Rome. And so he set out on the long journey, having received
a promise of employment, or perhaps many promises. Perhaps Giuliano
de' Medici, now recovered from his illness, wanted him in attendance.
There had been long discussions between Giuliano and the pope
about the reclaiming of the Pontine Marshes and Leonardo's expertise
was certainly needed. Perhaps, too, the pope was once more thinking
of giving Leonardo a commission to paint a Madonna. Whatever the
reason, the summons came from a sufficiently high authority to make
it necessary for him to travel south. On December 14, 1514, his sister-
in-law Lesandra, the wife of Ser Giuliano da Vinci, wrote a gushing
letter to her husband, who was in Rome, asking to be remembered to
"vostro fratello Lionardo uomo excellentissima e singularissimo." The
letter, written in Florence, would take four or five days to reach
Rome, and some more days may have passed before Ser Giuliano de-
cided to show it to his brother. So it happened that about Christmas-
time Leonardo saw the letter, in which he is described as "most excel-
lent and singular," which might be translated as "very famous and
very strange." Lesandra was a woman who adored wealth and hated
her loneliness so bitterly that she could describe herself as "suffering
unto death." Yet there is a great deal of charm in the letter, and it de-
serves to be quoted in full:

> Ser Giuliano: Lesandra, your wife, is greatly troubled and
> suffers unto death.
> I forgot to ask you to remember me to your brother Leo-
> nardo, a most excellent and singular man. Lesandra has gone out
> of her mind and suffers from melancholy. Above all, I do com-
> mend myself greatly to you, and I do so twice and thrice. And
> do keep in mind that Florence is just as beautiful as Rome, es-
> pecially because your wife and daughter are here. To dry the
> ink I am using gold dust, thus demonstrating that as gold is su-
> perior to all other things, so do I prize you over all other things.

Soon after he reached Rome, Leonardo returned briefly to the serv-
ice of Giuliano de' Medici, who had been given the right to drain the

Pontine Marshes and to take possession of all the drained lands. There existed a written agreement between the two brothers, and it was expected that Giuliano would be the administrator of the project. On January 9, 1515, the agreement was revised and a certain Domenico de Juvenibus was placed in charge of it. On the same day Giuliano left Rome, and Leonardo wrote in his notebook, "The Magnifico Giuliano de' Medici departed on January 9, 1515, at daybreak, to take a wife in Savoy: on the same day there took place the death of the King of France." This entry was not simply a record of two historical events. In his classically abrupt way Leonardo was recording that he had lost two of his patrons, for he was in the service of both the Medici and the King of France.

As a surveyor and hydraulic engineer Leonardo was asked for his expert advice on the draining of the Pontine and he appears to have gone to work on it in the late autumn of 1514. His first task was to produce a map of the marshes and this was done with the assistance of Francesco Melzi, who did the lettering and perhaps most of the drawing. Leonardo was an accomplished map maker, who drew maps with so much spirit that the viewer seemed to be looking on a living landscape, but this map, which survives among the documents in the Royal Library at Windsor, is not one of them. It is precise, accurate, and informative, but there is a ghostly look about it, as though a failing hand had drawn the boundaries and someone else had filled in the details. Leonardo's hand touches it only lightly.

At this point the documents begin to fail, and this is what we might expect if he had fallen ill or was infirm. In the spring of 1515 he appears to be in Florence working on a project for a new Medici palace with great towers and battlemented walls, an imposing palace like a royal residence; and indeed Lorenzo di Piero de' Medici, Duke of Urbino, now the effective ruler of Florence, behaved like royalty. We have only a single sheet of designs for this palace and the stables, which were attached to it—the palace was never built and Lorenzo di Piero de' Medici would die in a few years—but there is not the least doubt that Leonardo drew them at this time, for a specific purpose, according to specific instructions. The designs are undated; there is only the sketchiest indication of a site; and without Professor Carlo Pedretti's gift for interpreting nearly indecipherable pages of Leonardo's manuscript we would not have known that these drawings have a time and a place. Lorenzo di Piero de' Medici wanted the palace built and Leonardo designed it. It was Leonardo's last, or almost his last, design made in Italy.

The map of Italy was changing again; new alliances were being formed; the Medici were in the ascendant. Guiliano de' Medici had

married Philiberta, sister of Louise of Savoy, the mother of Francis I.
Giuliano de' Medici was the uncle of the young King of France, his
brother was the pope, his nephew Lorenzo di Piero de' Medici was
ruling over Florence and would soon marry into the French royal fam-
ily. France, Florence, and the papacy were linked to one another by
ties of blood and marriage. All this augured ill for Massimiliano
Sforza, Duke of Milan, the son of Lodovico, who had succeeded in
capturing the city with the help of Swiss mercenaries. He was very
young and totally incompetent. In the summer of 1515, Francis I led
his army over the Alps and attacked the Swiss guards at Marignano,
near Milan, in September. It was a brief and decisive battle, and Mas-
similiano was captured. Francis, being unusually intelligent and mild-
mannered, permitted Massimiliano to retire to France and live out the
remaining years of his life as a country gentleman.

By December, Leonardo was back in Milan, and he, too, was living
the life of a country gentleman. Only one letter is known to have been
written by him during this period; it was addressed to Zanobi Boni,
the steward of the small vineyard he owned in Fiesole. Annoyed by
the quality of the wine he was receiving from the steward, he wrote in
rebuke and with some advice on improving its quality:

> The last four flagons were not equal to my expectations, and
> I was therefore much displeased. The vines of Fiesole, if they
> were better taken care of, ought to furnish our part of Italy
> with the best wines, as they do to Signor Ottaviano.
>
> You know I told you it would be better if you enriched the
> land and covered the roots with slaked lime or the dry mortar
> from old walls; in this way the roots are kept dry, as also the
> stem and the leaves, and thus there is abstracted from the air
> the necessary substance to bring the grapes to perfection. After
> all this the wine is very badly made in our days: for by placing
> it in open vessels, we let the air extract the essence in the fer-
> mentation, and nothing remains but an insipid liquor colored
> by the skins and pulp; and from not changing it from one ves-
> sel to another, the wine becomes thick and unwholesome.
>
> Notwithstanding all this, if you and the rest would pay some
> attention to these remarks, we would be drinking most excellent
> wine.

The letter was dated December 9, 1515. No more letters in Leo-
nardo's hand are known.

Thereafter Leonardo vanishes from sight for a whole year. We have
no documents, no reminiscences, no diary entries concerning his
movements. There are no royal patents and no messages delivered to
high officers of state. In the Codex Atlanticus there survives a single

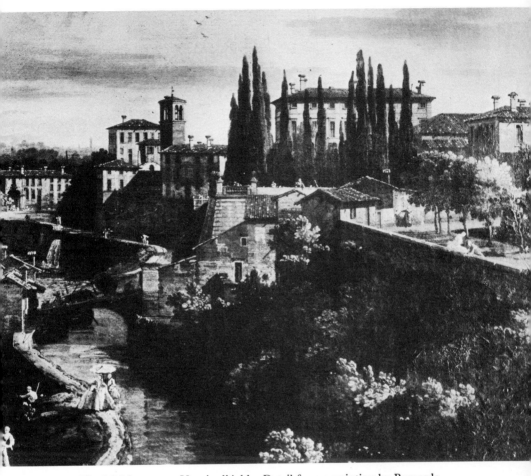

The Melzi estate at Vaprio d'Adda. Detail from a painting by Bernardo Bellotto, c.1780. (COURTESY DR. CARLO PEDRETTI)

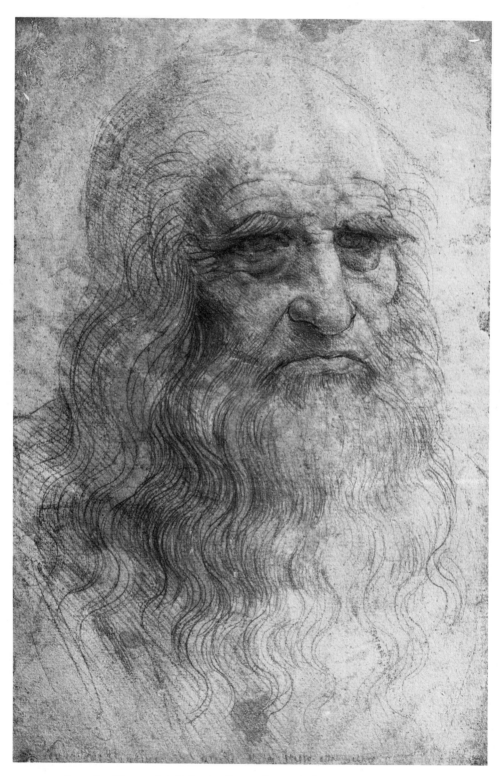

Portrait of Leonardo's father by Leonardo. Turin, Palazzo Reale. (ALINARI)

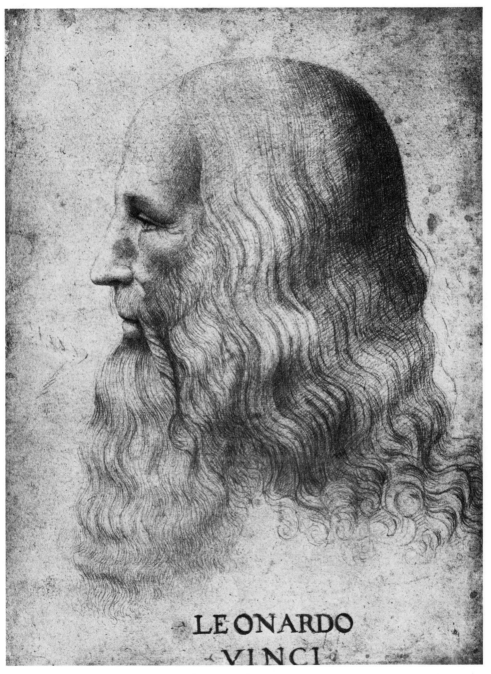

Portrait of Leonardo by Melzi or by Leonardo.
Milan, Pinacoteca Ambrosiana. (ANDERSON)

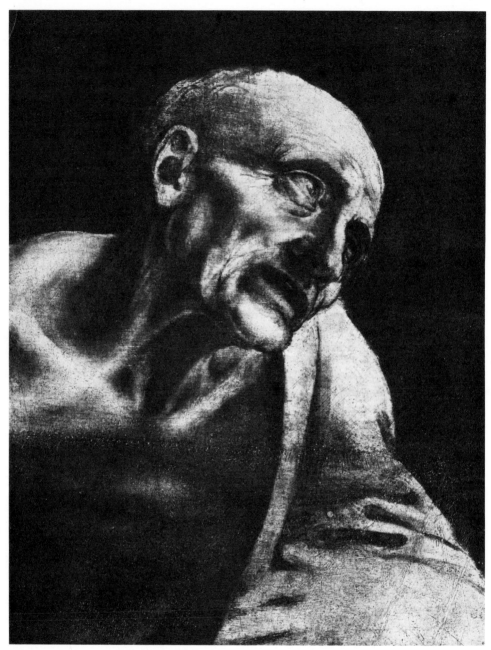

St. Jerome. Detail. Pinacoteca Vaticana. (ALINARI)

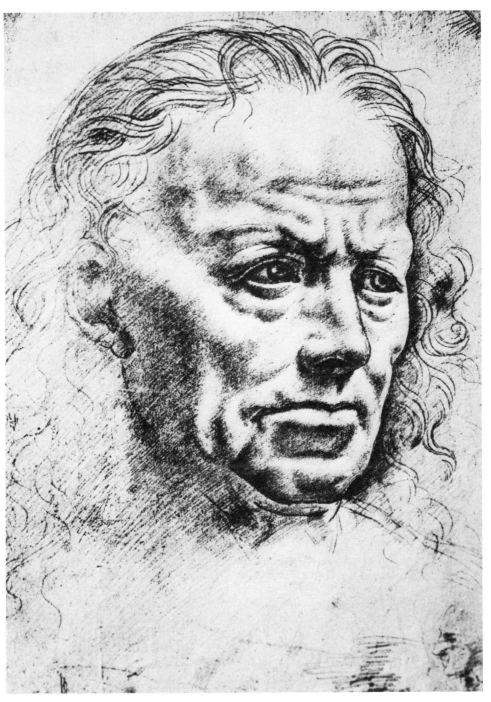

Presumed self-portrait of Leonardo. Paris, The Louvre.
(FROM DEMONTS, *The Drawings of Leonardo da Vinci*)

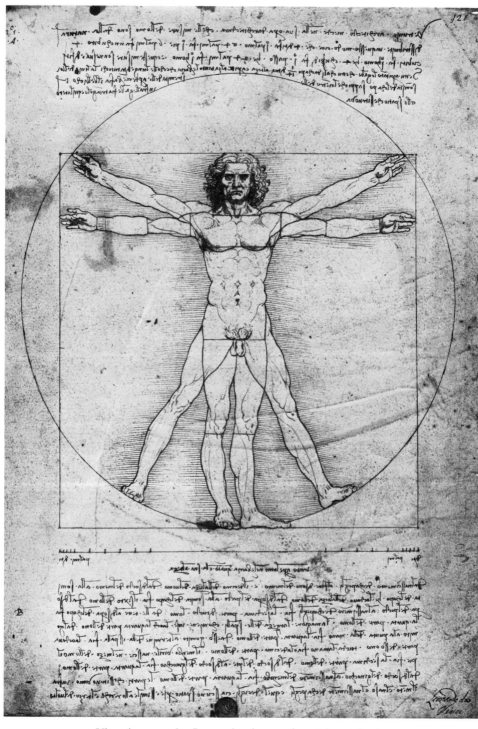

Vitruvian man by Leonardo. A page from his notebooks.
Venice, Accademia. (ANDERSON)

Limestone-sculpture monsters of Northern Wei Dynasty in China, about A.D. 470.
(COURTESY CATHAY HOUSE)

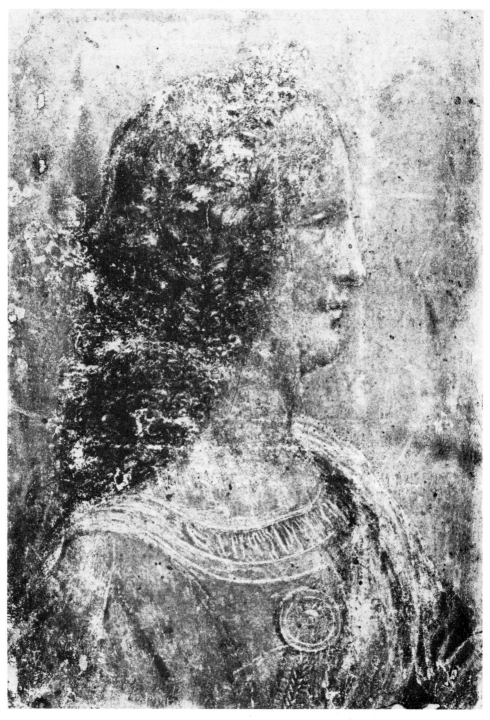

Contemporary painting of Francesco Melzi, perhaps based on a painting by Leonardo. (COURTESY DR. CARLO PEDRETTI)

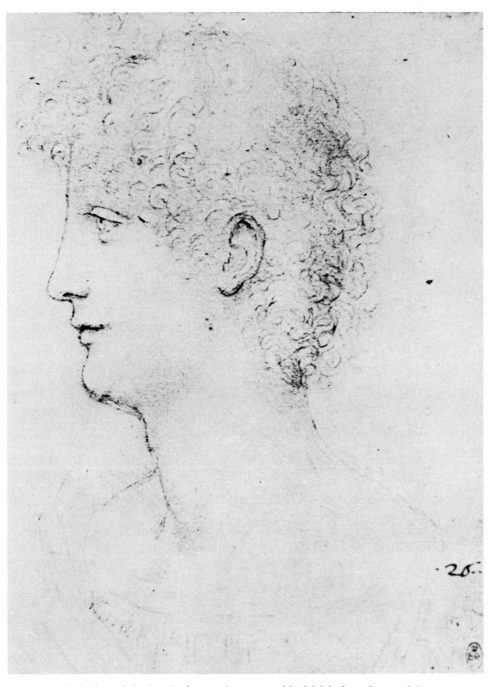

Drawing of the head of a youth, presumably Melzi, from Leonardo's notebooks. Windsor, Royal Collection. (REPRODUCED BY GRACIOUS PERMISSION OF HER MAJESTY QUEEN ELIZABETH II)

Destruction visited on the people, from Leonardo's notebooks.
Windsor, Royal Collection. (REPRODUCED BY GRACIOUS PERMISSION
OF HER MAJESTY QUEEN ELIZABETH II)

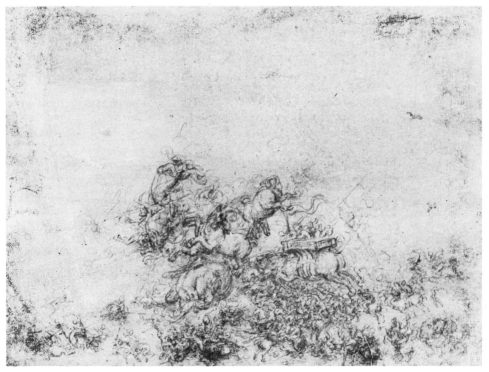

The monsters of his dreams by Leonardo. Windsor, Royal Collection.

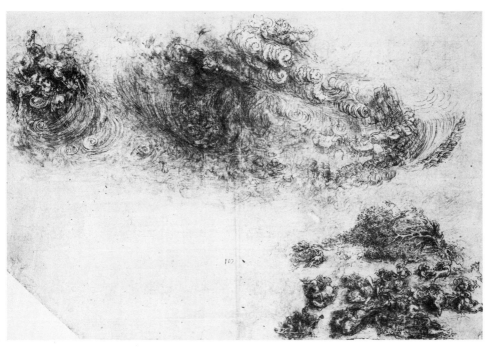

The Gathering of the Storm by Leonardo. Windsor, Royal Collection.

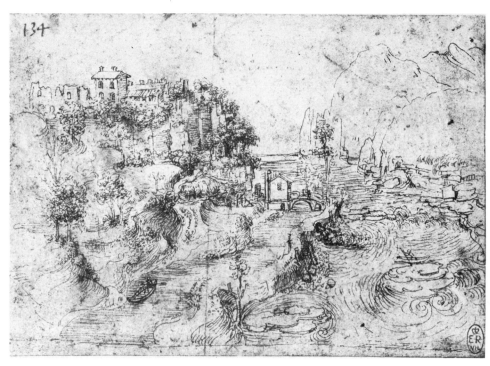

Adda landscape with canal by Leonardo. Windsor, Royal Collection.

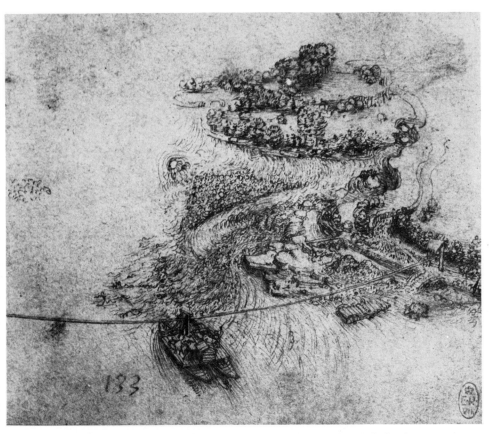

Ferryboat at Vaprio d'Adda by Leonardo. Windsor, Royal Collection.

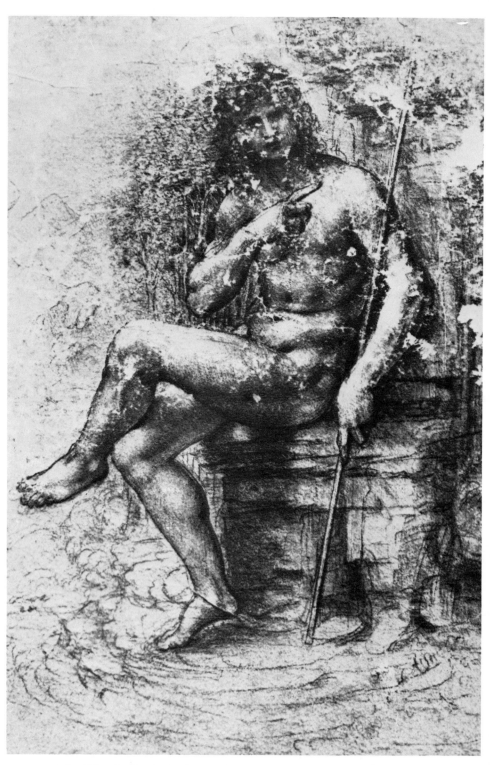

St. John the Baptist by Leonardo. Formerly in the Museo del Sacro Monte, Varese. (REYNAL AND COMPANY)

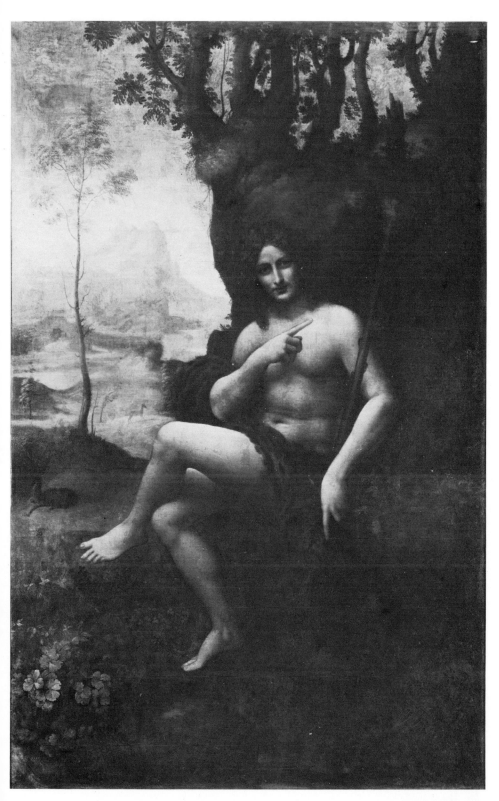

The Angel by Leonardo. Paris, The Louvre. (DOCUMENTATION PHOTOGRAPHIQUE)

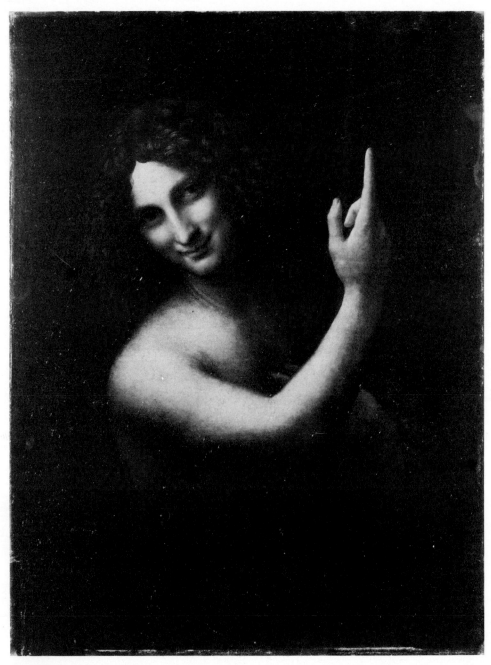

The Last Appearance of the Angel by Leonardo. Paris, The Louvre.
(DOCUMENTATION PHOTOGRAPHIQUE)

note about a subject which had never previously entered his mind: the great basilica of San Paolo fuori le Mura, just outside the Roman wall. He wrote:

> San Paolo at Rome has five naves and eight columns, and its width inside its naves is 130 braccia, and from the steps of the high altar to the gate 155 braccia, and from these steps in the end wall behind the high altar 70 braccia, and the porch is 130 braccia long and 7 braccia wide.
> Done on the . . . day of . . . ust 1516.

Exactly why he wrote this note, and where he wrote it, is a mystery. He would not need to go to Rome to find the measurements of one of the greatest and most famous basilicas in existence. Here St. Paul was buried under the high altar, not far from the place where he was beheaded. In honor of the apostle, Constantine erected the basilica, and future emperors had added to it, making it more sumptuous than any church except St. Peter's. It blazed with mosaics; the roof was gilded bronze; it was endowed with vast estates, and it was under the special protection of the King of England. The basilica was destroyed by fire in 1823 and then rebuilt. A visitor who carefully counts that vast forest of gleaming columns will discover that there are eighty, not eight, as Leonardo had written in his hurried note.

The note does not prove that Leonardo was in Rome in August 1516. It proves only that Leonardo was interested in the placement of an altar in relation to the church door, the porch, and the nave, perhaps because he was designing a church or because the relationships and distances intrigued him.

For the rest of the year there is only silence, the silence of a man who had grown prematurely old, and was ill, and was perhaps already partly paralyzed; who moved about very little and left no records of his movements; who was content to let time slip through his fingers. All his life he had been a private man guarding his privacy, and we should not therefore be surprised by his silence. We may imagine that he spent the year at his small estate in Milan and as a guest of the Melzis at Vaprio d'Adda, thinking, studying, basking in the sun, and regaining his health; and sometimes, when the spirit moved him, he would paint a little. The background of the dark angel was probably painted in that year at Vaprio. The shadows were closing in on him, and death was not far away.

And then quite suddenly—for we hear of no preparations, no preliminary discussions—Francis I, who was accustomed to acting suddenly, summoned him to France.

In those days no one in his senses rejected a royal summons. Leo-

nardo might have preferred to spend the remaining years of his life in Milan and Vaprio, but was given no choice. Frail as he was, he could still walk and still work. Francis had inordinately admired *The Last Supper,* and had even made inquiries about the possibility of transporting the wall in the refectory of Santa Maria delle Grazie bodily to France, since the painting could not otherwise be carried away. It was shown to him that the project was impractical. But it was not impractical to transport the painter to France.

Once he had conquered Milan, Francis I regarded himself as the possessor of all its valuables. Like Charles VIII and Louis XII before him, he was committed to the task of Italianizing France. Leonardo therefore was part of the booty, and not the least important part. Since Francis was also a man of great sensitivity and tenderness toward those he loved, and in addition possessed an exquisite courtesy, Leonardo may have realized that there were advantages in spending his declining years under the protection of the French king; and the Loire Valley was likely to be quieter than turbulent Lombardy, the pathway of armies. The decision, if he was permitted to decide, was all the easier for Leonardo because he possessed no firm roots in Italy, and was by nature a wanderer and an exile.

The summons came probably in October 1516, at a time when the roads were still passable and the weather was calm. The journey would be made in slow stages, and it may have taken a whole month, or even longer, with many stops at many wayside inns. Leonardo copied in his notebook, or someone copied for him, a document in French which is probably connected with this journey, for it consisted of a charge on the royal exchequer for the cost of horses and payments to be made to him. It read, "A monsieur le Ventie tollez des chevaux de l'escuyerie du Roy en comt XV frs. Caissez payement ou envoyer a Monsieur Lyonard Florentin paintre du Roy XV frs. a franchisment dudi S," where "S" clearly means "Seigneur." Monsieur le Ventie was probably the man who was given full responsibility for bringing Leonardo to France. Underneath the note Leonardo writes, "Amboyze. Amboyze. Amboyze. Amboyze." It was as though he was accustoming himself to the name of the small city where he would spend the rest of his days.

We do not know by what roads he traveled to France. At an earlier period he wrote about the river Arve, which runs near Geneva, and it is sometimes assumed that he passed through Geneva simply because he mentioned it in connection with the river; but he was a magpie who gathered up tidbits of information from a hundred books. It is unlikely that he would travel over the Alps, and more likely that he would travel the gentler way, descending to the coast from Milan and

then climbing up the Rhone Valley after reaching the southern shore of France.

Paintre du Roy he was called in the rescript, but he was more than that. He was *premier paintre et ingenieur et architect du Roy,* as we learn from other documents. He was given a salary of seven hundred crowns a year and a small palace at Amboise so close to the royal palace that it was possible to go from one to the other by means of a tunnel. Francesco Melzi accompanied him, and in addition there were all the paintings and notebooks in Leonardo's possession. Four or five carriages were required to transport all this treasure to France.

The treasure Leonardo was bringing to France was worth a kingdom. The paintings included the *Mona Lisa, The Virgin of the Rocks, La Belle Ferronnière, The Virgin with St. Anne and the Infant Christ and John the Baptist,* and the two paintings of the dark angel later known as *Bacchus* and *St. John,* together with some paintings like the *Leda,* which have since disappeared. In this way Francis acquired for France the lion's share of Leonardo's works.

Amboise, in the eleventh century, was one of the small towns belonging to the Counts of Anjou, of no particular importance. But Charles VIII had made it almost his capital, importing Italian architects and sculptors to renovate the palace in the style of the Renaissance: it was as though a blaze of Italy were ignited on the soft and misty banks of the Loire. The palace stood on a high parapet overlooking the river, and the residence chosen for Leonardo stood in a hollow a little below the palace in sight of the ravine and the bridge that led to the fortress gateway. From his bedroom Leonardo could look out at the entire length of the royal palace on its escarpment. The residence was known as Le Clos-Luce, which for some reason had been abbreviated to Cloux. It was built of pink brick with white sandstone facings, and there were pointed towers according to the fashion of the time. There were eight large rooms, excluding the servants' quarters, a private chapel, a helical stairway, a large garden. Until recently it had belonged to Louise of Savoy, the mother of Francis, and was therefore a royal palace in its own right. Leonardo was being accommodated as though he were royalty.

Leonardo wrote in his notebook, "June 24, St. John's Day, 1518, at Amboise, in the palace of Cloux." He wrote, *"nel palazzo del Clu,"* well aware that he was living in a palace. But this was written simply to remind himself that he was spending the great Florentine feast day in a foreign country. In fact he had been staying there for a long time before he wrote the note. He may have reached Amboise early in November 1516. It was a mild winter. In January he was already working for the king, who proposed to build a new palace for himself at

nearby Romorantin on the Saudre River, the birthplace of Queen
Claude, the wife of Francis, and a favorite residence of Louise of
Savoy.

The fact that Leonardo was already at work in January 1517 has
been deduced by some simple detective work. Leonardo writes in his
notebook, "On the eve of St. Anthony's Day I returned from Ro-
morantin to Amboise, and the King had left Romorantin two days be-
fore." There is no day, month, or year, but these can be found because
the king's movements were scrupulously recorded. Thus it is known
that Francis left Romorantin for Paris on January 14, 1517, and St. An-
thony's Day falls on January 17. In no other year did Francis leave
Romorantin on January 14. This note, although no date is mentioned,
provides us with our first certain record of Leonardo on French soil.

Once more, in that first winter in France, Leonardo's mind was
flowing with ideas. His handwriting is surprisingly vigorous as he
sketches out designs for a new palace at Romorantin, a new town to
be built around it, a new landscape to be formed around it by means of
dykes, weirs, and canals. He had fallen in love with the land and
writes about it caressingly. On a torn page of the Codex Atlanticus he
maps the region, gives a bird's-eye view of the village of Romorantin,
draws four separate octagonal structures which may represent
churches, and crowds what is left of the page with nine separate notes
concerning the canal system and the regulation of the rivers. He
suggested that the people of neighboring Villefranche should migrate
to Romorantin in the simplest possible way—by tearing down their
timber houses, piling the timber on boats, and re-erecting the houses
in Romorantin. There is no navigable waterway between Villefranche
and Romorantin, but that is not a problem of any importance: he will
make one. But the most characteristic passage occurs in the middle of
the page close to a map of rivers and their tributaries. "If the tribu-
tary of the Loire River, marked $m\ n$, were turned with its muddy
waters into the river of Romorantin, it would fatten the land it waters
and would make the land fertile, and would supply food to the inhab-
itants, and would serve as a navigable canal for commerce." It was as
though everywhere he looked he was seeing empty land made fertile
by man-made canals.

He sent Francesco Melzi to pace out the streets of the small town,
designed a majestic palace, considered the effect of damming the
waters above the town, and he seems to have worked on the project
for some months before the idea of transforming Romorantin was
abandoned altogether, either because of an epidemic or because the
king had chosen another site entirely or because Leonardo himself lost
interest in it. Instead of Romorantin there arose Chambord, and three

hundred years would pass before France possessed the canal system which Leonardo had first envisioned.

After that burst of activity there came another silence. The records of the French court have nothing to say about him. Salai arrived at Amboise, probably to look after Leonardo's failing health. In addition there was a manservant, Battista de Vilanis, whom he regarded highly, and a serving girl, Maturina, about whom nothing is known.

On October 10, 1517, Leonardo received at Cloux a distinguished visitor. He was Cardinal Luigi of Aragon, the natural son of King Ferrante of Naples, and therefore a close relative of Isabella of Aragon. The cardinal, who traveled in great state, arrived from Tours and was staying in the palace at Amboise when it occurred to him to pay a visit to Leonardo. Such visits would be announced beforehand to enable the·host to prepare refreshments and to see to the comfort of the cardinal's suite. Leonardo would have time to select the paintings and other works he was prepared to show the cardinal, and he would set about deliberately selecting those most likely to impress and please the cardinal's taste. Antonio de Beatis, the cardinal's secretary, wrote down an account of the visit, which provides us with the only contemporary description of Leonardo at any length during the years he spent in France. De Beatis wrote:

> In one of the bourgs [of Amboise] the Lord [Cardinal] and the rest of us went to see Messer Leonardo the Florentine, an old man more than seventy years of age, the most excellent painter of our time, who showed to His Eminence three paintings. One was of a certain Florentine lady, painted from life at the instance of the late Magnifico Giuliano de' Medici. Another was of a youthful St. John the Baptist, and there was a Madonna and Child who are resting on the lap of St. Anne, and all most perfect. However, one cannot expect any more good work from him because a certain paralysis has crippled his right hand, but he has a pupil, a Milanese, who works well enough, and although the aforesaid Messer Leonardo can no longer paint with the sweetness that was peculiar to him, nevertheless he still works at making drawings and teaches others.
>
> This gentleman has compiled a special treatise on anatomy, showing by illustration not only the members, but also the muscles, nerves, veins, joints, intestines, and all that one can study in the bodies of men and women in a way that has never yet been done by any other person. All of this we have seen with our own eyes; and he said he had already dissected more than thirty bodies of men and women of all ages. Also, of divers machines, and other matters, which he has set down in an infinite

number of volumes, all in the vulgar tongue, which if they were
published, would prove profitable and very pleasant.

Of the three paintings shown to the cardinal and his suite, two—*The
Virgin and Child with St. Anne* and the youthful *John the Baptist*,
both in the Louvre—are immediately recognizable, but no one has suc-
ceeded in identifying the portrait of the Florentine lady "painted
from life at the instance of the late Magnifico Giuliano de' Medici."
Guiliano had many mistresses, and Leonardo may very well have
painted one of them when he was in Rome during the years 1514 and
1516. De Beatis had a clear memory, made few mistakes, and those
that he made were perfectly understandable, and there is no reason to
doubt that he heard very clearly from Leonardo's lips that the portrait
was made *ad instantia del quondam magnifico Juliano de Medici*.
Leonardo would perhaps not have used the word *quondam* because
he rarely used Latinisms, but he would certainly have used *ad instan-
tia* with all that it implies about a woman well loved by the Medici
prince. Unless further documents turn up or the original painting is
found, the portrait of the Florentine lady will remain a mystery.

De Beatis has been criticized because he made two errors which are
obvious to those who have studied Leonardo's life. He said that Leo-
nardo was over seventy years of age when he was in fact only sixty-
four, and that his right hand was crippled by paralysis and this pre-
vented him from doing any good work. But although Leonardo's right
hand was crippled and he looked very old and worn, he could still
draw and still teach. De Beatis tells us much that we did not know
before, and one of the most significant things is that he could still
"teach others," thus implying that Leonardo, the perennial teacher,
still had a small group of pupils around him. The Milanese pupil
"who works well enough" was not the only one, and since it is un-
likely that Melzi's works were shown to the visitors, we may assume it
was Leonardo's verdict on the work of his favorite. *Chi lavora assai
bene* is not a very high commendation.

When De Beatis turns his attention to the volumes on anatomy, he
speaks with the authority of a man who had actually turned the pages
of the books and marveled at them. Here was something completely
new—something that has never yet been done by any other person.
This, too, was probably a phrase spoken by Leonardo, who was un-
derstandably proud of his anatomical studies and perfectly aware that
no one had ever explored the anatomy of the human body so deeply,
so relentlessly, and so artistically. At this point we may imagine the
cardinal turning to Leonardo and asking him how many bodies he had
cut up and receiving the answer that he had dissected more than

thirty. The books on mechanics, hydraulics, the nature of flight, and all the other subjects which fascinated Leonardo were evidently not shown to the visitors. They remained on the shelves, invisible and mysterious, dwelling in that limbo from which many would be rescued and others would be lost forever.

Before the cardinal retired from the meeting, one other subject appears to have been discussed—the eventual publication of the manuscripts. We have seen that Leonardo wanted them published, and now we hear again, perhaps in Leonardo's own words, the expressed desire that they should be published and made known. Literally De Beatis says, "*quali se vengono in luce saranno proficui e molto delectevoli* [which if they were brought to light, would prove profitable and very pleasant]." The sense is not that their publication would be profitable to Leonardo but that they would be profitable to the world.

We can see now that Leonardo, on receiving the cardinal, did exactly what all artists do when they receive important and influential visitors. Just as he studied all other things, so he studied the particular tastes of the cardinal and showed him those things which would most appeal to him. He chose four very different objects: a painting of a woman, a painting of the Virgin and Child with St. Anne, the haunting John the Baptist set against a dark background, almost certainly the last work he ever achieved, and the anatomical notebooks. He had many other paintings and notebooks in his possession, but these were among his most splendid creations worthy of the critical attention of a cultivated cardinal who belonged to the house of Aragon.

The cardinal continued his travels, and at the very end of the year, in Milan, he made a special point of seeing *The Last Supper* in Santa Maria delle Grazie. As usual, Antonio de Beatis accompanied him. The secretary observed that the painting was beginning to decay, "but I cannot say whether this was due to the humidity of the wall or to some other mischance." Even then, in Leonardo's lifetime, the painting was fading away.

The Angel

By the winter of 1516, when Leonardo went to France at the invitation of Francis I, the greater part of his work was done. There remained some architectural projects, some schemes of canalization, the ordering of his vast array of manuscripts, and the teaching of his chosen pupils, but none of these demanded the unremitting toil and concentration that he had given to his paintings and anatomical studies. The illness he contracted in Rome had sapped his energies; the journey to France in winter probably sapped them still more; and the last years of his life were a slow waiting for death.

There are geniuses who do their best work when they are old and in the shadow of death. Thus William Blake produced his astounding *Illustrations for the Book of Job* and went on to do even more astounding illustrations for *The Divine Comedy* in the last years of his life; he was drawing and painting and composing poetry on his deathbed.

Michelangelo worked strenuously to the very end of his life, dying in his ninetieth year. There are others like Shakespeare who display titanic energy during their working life and then abruptly call a halt, disengage themselves from creative life, renounce the kingdom they have conquered, and vanish into a peaceful obscurity. At forty-seven Shakespeare retired to Stratford and spent the remaining five years of his life looking after his estate. His work was finished, his passion spent.

So it was with Leonardo: his passion spent itself in Rome, and thereafter he worked only intermittently, gradually disengaging himself from creative life, and from life itself, so that he could pursue those inquiries which are beyond words and beyond painting, which can fill no notebooks or canvases, and which are all the more difficult and dangerous because they are concerned with a journey into unknown territory, where the seas remained uncharted and the shores were nameless. He was dying, and his last months were largely devoted to the examination of his coming death.

It was during this last period, probably in Rome, that he began to paint the two extraordinary paintings which are the least admired of all his paintings, perhaps for the very reason that they are concerned with death, his own death as he saw it unfolding in front of him. They are strange and haunting paintings. They hint at terrible things that cannot be spoken. They are overripe, like fruit left on the tree in the autumn, but they are not decadent. They have been constructed deliberately, after prolonged thought, to represent stages on the way to the death that lay so invitingly before him. It was something he knew well, for he had written about it many times in an elegiac strain, but never so convincingly as in an early passage written in the Arundel Manuscript in the British Museum:

> Now you see that the hope and the desire of returning home and to one's former estate is like the moth to the light, and that the man who with constant longing awaits with joy each new spring time, each new summer, each new month and new year —deeming that the things he longs for are ever too late in coming—does not perceive that he is longing for his own destruction. But this desire is the very quintessence, the spirit of the elements, which finding itself imprisoned with the soul is ever longing to return from the human body to its active agent [*mandatario*].
>
> And you must know that this same longing is that quintessence, inseparable from nature, and that man is the image of the world.

I have quoted this passage at length not only because it has some bearing on the two paintings to be discussed but also because there is in this passage dealing with ultimate things an extraordinary sense of structure. The argument is hammered out, as though he were dealing with precisely known things. Leonardo often uses legal terms, and the word *mandatario* has been deliberately chosen to convey an exact idea. It means "the agent" as distinguished from "the principle." Mac-Curdy translates it "the source," and it has nothing whatsoever to do with the source. It means the agent, the mandated one, the representative, the commander as distinguished from the general, the archangels as distinguished from God.

The painting known variously as *Bacchus* and *St. John* in the Louvre cannot be Bacchus, for we know that the vine leaves and the spotted leopard skin were added many years later, and it cannot be St. John, because there exists no iconographic system that would permit the dweller in the wilderness to sit at ease in a flowery landscape, smiling his most alluring smile. Cassiano del Pozzo, who saw it in the royal collection at Fontainebleau in 1642, described it quite accurately. "The figure," he wrote, "is less than one third life size, and is a most delicate work, but it does not please because it does not arouse feelings of devotion, and the background is unlikely. The saint is sitting and one can see rocks and an airy green landscape." Cassiano del Pozzo believed it to be St. John, but was puzzled by the fact that he was in the wrong landscape. He observed that it failed to arouse any feeling of devotion, and was evidently puzzled and disturbed by it. At the end of the century, in 1695, it was being described as a Bacchus, for in the official catalogue *St. John* was stricken out and the words *Baccus dans un paysage* were substituted. About that time some unknown painter had painted a leopard skin to hide the nakedness of the youth, given him a crown of vine leaves, thickened the staff, and added a bunch of grapes, thus transforming it into a thyrsus. In this way St. John, or what people thought was St. John, found himself transformed into a pagan god. Leonardo was not responsible for the transformation.

There survived until very recently Leonardo's preliminary sketch for the painting. It was exhibited in the Museo del Santuario di Santa Maria del Monte in the small town of Varese until a few months ago when it was stolen, like so many other treasures from Italian museums. The sketch, which is 9½" by 7", in red chalk on red prepared paper, shows a youth sitting on a rocky ledge with willow trees on one side of him and a small waterfall on the other, and the water races around the rocky ledge and swirls past his feet. The youth is naked, holds a staff, gazes directly at the spectator and points in the direction

of the waterfall. We are in the familiar landscape of so many of Leonardo's religious paintings: the rocky ledge, the water flowing past, the divine figure pronouncing the words of a mysterious ritual while performing a sacramental act. There can be no doubt that this little-known work is by Leonardo. What is in doubt is who the figure represents. Who is this youth who sits in so regal a posture while the waters flow past him?

If we look at the Louvre painting, mentally stripping the figure of his leopard skin and crown of vine leaves, giving him a slender staff and blotting out of our minds all that we have been told of Bacchus and St. John, and seeing him freshly, we cannot avoid the impression that he belongs to this landscape in the same way that the Virgin of the Rocks belongs to the rocks. He is a visionary figure in a visionary landscape. Half the landscape is in bright autumnal sunshine, and half is in shadow. In the distance we see the Adda River and the familiar peaks of the Tre Corni, not far from Vaprio. High above the mountains the storm clouds are gathering. Soon the storm clouds will engulf the whole world.

We must imagine Leonardo coming along the pathway, hurrying to return to Vaprio before night falls. In a patch of sunlight he sees a startled deer, and nearer at hand, at the foot of a birch tree, which stands thin and lonely on a small eminence, he sees another deer resting quietly; and involuntarily his thoughts turn to the Psalm "As the hart panteth after the water brooks, so panteth my soul after thee, O God." He is still journeying hurriedly, lost in thought, when he suddenly sees directly in front of him a naked youth, superbly built, with broad shoulders and deep chest, with a face of great beauty gazing at him fixedly. He is sitting there in the shadow of a small mound, his body lit by the dying rays of the sun. And what is chiefly remarkable about the youth, apart from his beauty, is that he is pointing away from the fair country in the distance, away from the deer in the meadows, the river and the mountains, away from the sunlight that can be seen raggedly among the twisted trees on top of the mound, pointing in another direction altogether. He is pointing to the shadows, the dark forest, the coming darkness.

In the mind of Leonardo there is not the least doubt that he is in the presence of an angel. In the figure of this naked youth there is a superhuman beauty. The broad shoulders have the shape of a bow, and his finger is an arrow; and in the negligence of his pose there is a sense of majesty and imperious dignity, so that he resembles the sculptures made in the Sung Dynasty of the *boddhisatvas*. At his feet are gathered the wild flowers that are under his protection: hellebore,

the deadly nightshade, the quick-fading anemones, and the strawberries with their blood-red fruit.

We may imagine Leonardo rooted to the spot, drinking in the visionary scene, seeing every small detail with elaborate precision, the shape of every leaf and petal, the thin birch tree with the snapped off branches, the small black bear ambling across a far-off meadow, but most of all he observes the youth whose long white thigh cuts across the picture like a knife and whose glowing body, which is not in the least androgynous, hints at mysterious pleasures which have little enough to do with the flesh. He is the *mandatario,* the agent of the heavenly powers, the herald, the summoner. He is not the angel of death so much as the angel who announces and points the way. He is therefore the angel of the Annunciation and he has come on an errand of mercy, but it is not the same mercy he announced to Mary.

One day, in January 1912, the poet Rainer Maria Rilke was pacing the ramparts of the centuries-old Castle of Duino above the sea when there came to him unbidden the opening lines of the first of his elegies:

> Who among the angelic hosts would listen to me
> If I were to cry out? Even if one among them
> Suddenly pressed me against his heart, I would faint away
> In the strength of his being. For beauty is nothing
> But the beginning of a terror made scarcely endurable,
> And we adore it because it serenely disdains
> To destroy us. Every angel is terrible.

The most terrible angel confronts Leonardo at the turning of the road on a quiet afternoon in mid-autumn, and while there is a sense of surprise, there is also a sense of inevitability. Leonardo's first known painting was of an angel. Now, at the close of his life, he comes full circle.

There remains a last painting, which hangs in the Louvre and is known as *St. John the Baptist.* This is puzzling, because he clearly wears a spotted skin, more suitable to Bacchus. He points urgently to heaven, and there can be seen very faintly in the darkness a cross which is not so much held as poised delicately against his thumb. He is the dark angel, seen at close quarters; the cross and the leopard skin are clearly the work of restorers. Happily, Vasari saw the work before the restorers changed it and before accretions of varnish darkened it. He found it in the collection of the haughty, tyrannical Cosimo de' Medici, who also possessed a painting by Leonardo of a Medusa's head, with a multitude of serpents streaming out of her hair. "Among the treasures in the palace of Duke Cosimo," wrote Vasari, "is the

head of an Angel, who is raising one arm in the air, so that it is foreshortened from the shoulder to the elbow, while holding the other hand against his breast." In time it passed into the collection of Louis XIII, who gave it to Charles I of England in exchange for Holbein's *Portrait of Erasmus* and the *Sacred Family* of Titian. After the execution of Charles I it was bought by a French banker and presented to Cardinal Mazarin, whose heirs sold it to Louis XIV. It remained in the possession of the French crown until the Revolution and was exhibited publicly for the first time in the Louvre in 1801.

The fate of Leonardo's last angel was to be handed about from one royal collection to another for nearly three hundred years. Yet such a fate was not surprising. Here, finally, was the ultimate distillation of Leonardo's work, the ultimate refinement of his style and intellect. It was therefore a work of an exquisite rarity worthy to be in the collections of kings.

For Leonardo, it was clearly not so much a painting as a gift of his whole being. It is recognizably the same angel that he met on the road to Vaprio, but now he has dared to draw closer and look directly into the angel's eyes. The two angels smile benignantly; they point the way; and though they are seen under different aspects—one in the daylight, and the other in the darkness of the night or the darkness of the soul—and though they point in different directions, they are saying the same thing, the different directions are the same direction, and their inviting smiles are the pilgrim's reward for his long pilgrimage.

This painting was never popular, as the *Mona Lisa* was popular. To many, who regarded it as a painting of St. John and were understandably puzzled by the lack of any reason why the saint should be painted in this way, it seemed to be meretricious, decadent, curiously unresolved, and therefore disturbing. The face was especially disturbing, for it seemed to be effeminate. The golden shoulder seemed too fleshy, the pointed hand too didactic, the arm seemed to be floating in space. All this, at first glance, was true enough. But at the second and third glance the painting visibly changes before one's eyes. Where there was effeminacy there appears strength. The face with the deep cavernous eyes begins to assume the triumphant form of an African mask. The broad shoulder becomes the wing of the great bird, the curving arm and hand being the trajectory of its flight. And then again we see the angel's burning eyes, the majestic shoulders, the hand that is pointing heavenward and opening like a flower.

A new generation more accustomed to contemplating last things may come to recognize the extraordinary quality of this painting, conceived in joy and despair, defiantly compressing all of experience into the face, the arm and shoulder of an angel.

Many scholars have wondered at the darkness of the background, and some have thought a landscape was hidden there. The authorities of the Louvre have examined the painting carefully and concluded that no landscape was ever painted. If there had been a landscape, the colors of the angel's flesh would have been rendered differently, with the "reflected lights" that appear abundantly in all of Leonardo's paintings. The angel is seen in the light of a single candle flame. It is the last vision, before the flame is snuffed out.

The Silence of Leonardo

The silence during Leonardo's last days can almost be felt. After Cardinal Luigi of Aragon we hear of no more visitors. Leonardo seems to retreat into the palace and close the doors behind him. The servants move about in stockinged feet, Francesco Melzi reads to him, and sometimes he peers out of the windows at the glittering palace of Amboise that rises, remote and inaccessible, only two or three hundred yards away.

All the evidence seems to suggest that Leonardo deliberately chose this silence, refrained from inviting visitors, and gave himself up to his contemplations. The palace was well furnished for contemplations, for his own paintings hung on the walls. Rarely, at long intervals, the king visited him.

Benvenuto Cellini tells another story. In his first *Discourse on Art* he says that Leonardo was visited almost daily by the king and they

engaged in such long discussions that Leonardo was prevented from doing his work. In Paris, around 1542, Cellini discovered "a book written in ink, copied from one by the great Leonardo da Vinci," and this discovery set him thinking earnestly about his own conversations with the king on the subject of Leonardo:

> This book was of great excellence, and beautifully made, with the marvelous genius of the aforesaid Leonardo (no greater man than he, I believe, has been born into the world), concerning the three great arts of sculpture, painting, and architecture. And because he abounded in great genius and had some knowledge of Greek and Latin literature, King Francis, being deeply enamored of his intelligence, took such pleasure in hearing him converse that few were the days in the year when he could bear to be separated from him, which was the reason why he failed to put into use the splendid studies over which he took such infinite pains. I must not fail to repeat the exact words I heard from the King's own lips, which he told me in the presence of the Cardinal of Ferrara, the Cardinal of Lorraine, and the King of Navarre, saying that he did not believe that there had ever been born in the world another man who knew so much as Leonardo—and this not only in matters of painting, sculpture, and architecture but more especially because he was a great philosopher.

No doubt Francis spoke in words very like these, honoring a great sage and friend, but it is scarcely possible to believe that "there were few days in the year" when the king was separated from Leonardo. The king was continually traveling between his palaces; he was absorbed in his public and private affairs; and if he came to see Leonardo once a month, it would be as much as he could manage. When Cellini said that they talked so much that Leonardo was unable to "put into use the splendid studies over which he took such infinite pains," he was either inventing the story or half remembering one of the king's polite exaggerations, for he would say anything to please an audience. Cellini's memories are not evidence.

Scholars have been so appalled by the silence surrounding Leonardo during his last days that they have imagined him participating in events in which there is no evidence that he took part. Edmondo Solmi, usually a most cautious and dedicated scholar, discovered five occasions in which he believed he found Leonardo's presence because things happened which in his view could not have happened without that presence. A letter written by Rinaldo Ariosto at Argentan in Normandy on October 1, 1517, discovered in the state archives of Mantua, describes Francis's visit to his sister Margaret of Valois and a *festa* in

which a mechanical lion was tapped by the king, whereupon the lion opened its breast to reveal a blue cavity, and another correspondent, Anastasio Turrioni, writing two days later, adds that there was a lily in the blue cavity. Both Vasari and Lomazzo speak of Leonardo's invention of a mechanical lion that approached the king, opened up its breast, and revealed the lilies of France. Solmi was quite sure Leonardo was present at Argentan.

From the same Mantuan archives comes an account of the double *festa* to celebrate the birth and baptism of the dauphin and the marriage of Lorenzo di Piero de' Medici with the king's niece, Madeleine de la Tour d'Auvergne. The double *festa* took place at Amboise in May 1518, and while the baptism took place quietly, with Lorenzo representing his uncle, Pope Leo X, serving as the substitute godfather, the marriage was celebrated with jousts, a mimic siege, dances, balls, and splendid entertainments which, in Solmi's view, could not have taken place without the choreography of Leonardo. In fact the most remarkable part of the entertainment consisted of mock battles that lasted for eight days and soon developed into murderous skirmishes with many people killed. Amboise became a battlefield; cannon and double cannon fired volleys over the town; at intervals artillery pieces roared and belched fire. What Leonardo thought of all this insane noise was not recorded. One imagines that while these battles were going on, he closed the windows of his palace and stuffed up his ears. Lorenzo di Piero de' Medici, the dissolute grandson of Lorenzo the Magnificent, came to his wedding suffering from syphilis, from which he died a year later. Madeleine de la Tour d'Auvergne died a few days before him, after giving birth to a daughter, Catherine de' Medici, of whom it may be said that it would have been better if she had never been born. Lorenzo di Piero de' Medici, the least worthy of all the Medicis, was commemorated with a marble tomb carved by Michelangelo, as though for the greatest of heroes.

On June 19, 1518, Francis held another *festa*, this time in the grounds of the palace of Cloux. It took place at night under a painted tent. The stars, the sun, and the moon could be seen shining with great radiance, transforming the night into day. A full account of the entertainment was provided by Galeazzo Visconti, who was present. Solmi concluded that this tent was erected by Leonardo according to the designs he had used in 1490 for Bellincioni's *Paradise* intended for the entertainment of Isabella of Aragon, but Visconti, who had known Leonardo in the past, does not mention him. If he had been present, he would certainly have been mentioned.

There is no evidence that Leonardo was present at any of these fes-

tivities. Indeed, the time for festivities was over. He was waiting, with
a little patience, for the coming of the dark angel.

Salai, who had belatedly reached Amboise, returned to Milan to
look after Leonardo's properties. He was given to chattering, and
probably he was sent away because he disturbed the quietness of the
place or because he wept too openly.

Many Italians worked in the palace at Amboise; there was a Francis-
can church in the town, and Franciscan monks in their black habits
sometimes came to visit Leonardo. This is not surprising, for Leonardo
possessed the Franciscan temperament. One of his closest friends had
been a Franciscan father. He shared with the Franciscans their gaiety
and humility, their love of song and music, their indifference to the
letter of the Scriptures, and above all he shared with them a kind of
intelligence that moves by sudden leaps and intuitions and intense
contemplations. From the time of Roger Bacon the Franciscans had
been devoted to the study of the natural sciences, seeking to find
order in the universe.

On April 23, 1518, shortly before the double *festa* for the dauphin
and the marriage of Lorenzo di Piero de' Medici, Leonardo made the
short journey to the chambers of the royal notary at Amboise for the
final reading of his last will and testament, a long document which
had occupied his thoughts for many days and perhaps for many
months. He must have been well enough to travel, for the will explic-
itly states that Leonardo appeared in person before the notary ac-
companied by five witnesses. There were two purposes for this visit to
the notary's chambers: the final reading, and the addition of a codicil
in favor of Battista de Vilanis, his servant, now to be splendidly re-
warded for his faithful services. In this final form the will was an intri-
cate document with eighteen separate clauses. Although the matter
was complex, the thrust was simple. Francesco Melzi became the heir
of the estate.

The royal notary was Guillaume Boreau, and of the five witnesses
three were French priests attached to the Church of St. Denis at Am-
boise and two were Italian monks from the Convent of the Friars
Minor in Amboise. The Italians were Francesco de Cortona and Fran-
cesco de Milano. Francesco Melzi was present, and so was Battista de
Vilanis. Since men usually choose as witnesses people they know well,
it is likely that the priests and the monks were frequent visitors to
Cloux and held services in the chapel inside the palace.

The will survives today only in an Italian copy made in 1799. It be-
gins in a way characteristic of the usage of the time with an appeal to
the Virgin, St. Michael, and all the angels:

Be it known to all persons present and to come that at the Court of our Lord the King at Amboise there has personally appeared before us Messer Leonardo de Vince, painter to the King, at present staying in the place known as Cloux near Amboise, duly considering the certainty of death and the uncertainty of the hour of its coming, has acknowledged and declared in the said court before us, to which he has submitted himself and does submit concerning what he does and has ordered in regard to these presents—his testament and declaration of his last will as follows.

First he commends his soul to Our Lord, Almighty God, and to the Glorious Virgin Mary, and to Monsignor St. Michael, and to all the blessed angels and saints, both male and female, in Paradise.

Item, the said testator desires to be buried within the Church of St. Florentin at Amboise by the *collegium* of the said church, that is to say the rector and the prior, or by the vicars and chaplains of the Church of St. Denis of Amboise, also the brothers of the Order of Friars Minor of the said place; and before his body is carried into the said church, this testator desires that three high masses with deacon and subdeacon shall be celebrated in the Church of St. Florentin; and on the day when these three high masses are celebrated, thirty low masses shall be celebrated at St. Gregory.

Item, in the Church of St. Denis similar services shall be celebrated, as above.

Item, in the church of the said Friars and Minors there shall be the same services.

Leonardo has not finished with the services; he will return to them again later in the testament. He has asked altogether for nine high masses and ninety low masses in four separate churches, all in Amboise and all very close to one another. Such services were unusual except in the case of the king, princes of the blood royal, or very high officials of state. He was demanding that the Church bury him with all the honors due to a man of eminence.

The testament continues with bequests to Francesco Melzi and the three servants Battista de Vilanis, Salai, and the woman Maturina, described as *sua fantesca*, his maid servant. The name Mathurine was common in France, and Maturina was common in Italy. There is no way of knowing whether she was French or Italian.

The aforesaid Testator gives and bequeaths to Messer Francesco da Melzi, nobleman of Milan, as a reward for the gracious services he has rendered in the past, all and each of the books the said Testator possesses at the present time, and the

other instruments and portraits appertaining to his art and
calling as a painter.

Item, the same Testator gives and bequeaths in and forever
to Battista de Vilanis, one half, that is the moiety, of his garden
that lies outside the walls of Milan, and the other half of the
garden to Salai, his servant, in which garden the aforesaid Salai
has built and constructed a house which shall be and shall re-
main in perpetuity the property of the said Salai, his heirs and
successors; and this shall be in remuneration for the good and
gracious services which the said de Vilanis and Salai, his ser-
vants, have performed for him in the past until now.

Item, the said Testator gives to Maturina, his maid servant, a
gown of good black cloth lined with fur and a bolt of cloth and
two ducats to be paid only once, and this is in remuneration for
the good services rendered to him by the said Maturina in the
past until now.

Having made these bequests, Leonardo then returns to the subject
which is clearly of overwhelming importance to him: the church serv-
ices. Maturina, the maid servant, would have been in charge of the
candles and tapers for Cloux, and he was therefore reminded that
large numbers of tapers would be needed in the four churches where
his obsequies would be celebrated.

Item, he desires that at his obsequies sixty tapers shall be
borne by sixty poor persons, who shall be paid for carrying
them at the discretion of the said Melzi, and these tapers shall
be distributed among the four churches previously mentioned.

Item, the said Testator gives to each of the said churches ten
pounds weight of wax in thick tapers which shall be placed in
the said churches to be used on the day when those services are
celebrated.

Item, that alms shall be given to the poor at the Hôtel-Dieu
and to the poor of Saint Lazare d'Amboise, and to this end
there shall be given to the Treasurers of that same fraternity
the sum and amount of seventy soldi of Tours.

There is a sense in which all this is only the introduction: the main
task Leonardo set for himself was to insure that Francesco Melzi was
the principal heir, executor of the estate, and guardian of his proper-
ties. Another task, very minor in comparison to this, was to prevent his
brothers from contesting the will. He therefore emphasized the role of
his principal heir and bequeathed a derisory sum to be shared among
his brothers. He had no interest in his half sisters and left them
nothing.

Item, the said Testator gives and bequeaths to the said
Messer Francesco Melzi, being present and consenting, the re-

mainder of his pension and of the sums of money owing to him from the past until the day of his death by the receiver or Treasurer-general, M. Johan Sapin, and each and every sum of money he has received from the aforesaid Sapin of his said pension, and in case he should die before the said Melzi and not otherwise, which moneys are at present in the keeping of the said Testator in the said place called Cloux, as he says. And likewise he gives and bequeaths to the said de Melzi all and each of his clothes at present in his possession at the said place of Cloux as much to reward him for his good and gracious services up to the present as in payment for the vexations and annoyances he may incur in regard to the present testament, and all this shall be at the expense of the said Testator.

He orders and desires that the sum of four hundred scudi in his possession which he has deposited in the hands of the Camarlingo of Santa Maria de Nove in the city of Florence shall be given to his natural brothers living in Florence with all the interest and usufruct that may have accrued up to the present time and be due from the aforesaid Camarlinghi on account of the said four hundred scudi, since they were given and made over to the said Camarlinghi by the Testator.

Item, the said Testator desires and orders that the said Messer Francesco de Melzi shall be and remain the only and sole executor of the said will of the said Testator, and that the said testament shall be executed to its full and complete effect and according to what is here narrated and said, to have, hold, keep and observe, the said Messer Leonardo de Vince, legal Testator, has bound and binds by these presents his said heirs and possessors with all his goods movable and immovable, and has renounced and expressly renounces by these presents all and each of the things that are to the contrary.

The question of Leonardo's pension was an important one because it represented a very large sum of money in the currency of the time, and it appears to have been paid irregularly, with much still left to be paid. The French archives have revealed very little information about his stay in France, but one important document has been found in the archives of Paris. It states that *Maistre Lyenard de Vince, paintre ytalien,* would receive the sum of 2,000 *écus soleil* during the two years 1517–18, while *Francisque de Melce, ytalien, gentilhomme, qui se tient avec le dit Maistre Lyenard,* was to receive 800 *écus,* while Salai, who is described simply as *serviteur,* was to receive only 100 *écus.* Since Salai came later, and stayed only briefly at Cloux, the document appears to have been drawn up about the summer of 1517, many months after Leonardo arrived in Cloux. Francis, like Lodovico,

sometimes found it convenient to postpone the payment of his employees.

Throughout the will we are aware that Leonardo is hoping above all to avoid any of the pitfalls lying in wait for foreigners on French soil. He asked specifically that it should be sealed with the royal seal, *il sigillo regale,* used on all important legal acts in Amboise. And to be certain that Francesco Melzi should faithfully carry out the will, he extracted from the young man a promise *per fede et sacramento,* by faith and oath, that he would never do anything or act in any way contrary to the explicit words of the will. In the codicil Leonardo bequeathed to Battista de Vilanis the water rights of the canal of Santo Cristoforo in Milan, granted to him by "the King Louis XII of pious memory, lately deceased," together with all the articles of furniture and all the utensils in the house.

It was not a well-constructed will, but it served its purpose. Descendants of Maître Guillaume Boreau, living in the nineteenth century, said that according to a family tradition the original will was written in French, but this statement does not accord with the fact that the Italian version can be translated easily into Latin and with some difficulty into French. Probably there were three versions, Latin, French, and Italian.

When Vasari wrote the first edition of his *Life of Leonardo* he was convinced that he was writing about a man who possessed "such a heretical frame of mind that he did not adhere to any form of religion, believing that it was perhaps better to be a philosopher than a Christian." By the time he came to prepare the second edition in 1568, he had met Francesco Melzi and learned that it was simply not true. In the first edition he describes Leonardo arguing about the faith and suffering a deathbed conversion, but in the second edition he wrote, "At last Leonardo grew old and fell sick for many months, and desiring to be carefully instructed concerning our good and holy Christian and Catholic religion, and having made his confession and repented with many tears, he insisted on leaving his bed, although he could not stand upright and had to be supported in the arms of his friends and servants in order to receive the most blessed Sacrament."

The candle that had burned so fiercely was going out; the great bird that had flown so far was flying back to its nest; and the dark angel was beckoning.

On May 2, 1519, Leonardo's life flickered out in the small palace at Cloux. We know nothing about the circumstances of his death except that he received all the consolations of religion and was well prepared; and perhaps the Franciscan monks whose names appear in his

will were gathered by his bedside until the end. The legend that Leonardo died in the arms of Francis I cannot be true, because the king is known to have been at his palace at Saint-Germain-en-Laye, at the bedside of Queen Claude, who had just presented him with a second son. Vasari tells the story with appropriate embellishments: how Leonardo rose from his bed, supported by his servants and friends, to receive the sacraments, and how the king entered the room shortly afterward to comfort the dying man, who "lamented his fear that he had offended God and man, since he had not labored in art as he should have done." Then came a violent paroxysm, and the king rose and cradled his head to alleviate the pain, and he died in the king's arms. But all this was the purest invention designed to portray Leonardo as a heretic. Leonardo died in the Christian faith, to which he had always adhered. He confessed, was shriven, received the sacraments, and died as all men died in that age in the belief in the Resurrection. He had no regrets. He had written long before, "As a well-spent day brings happy sleep, so life well used brings happy death."

From Lomazzo we learn that Melzi announced the death of Leonardo to the king, which can only mean that he set out from Amboise to Saint-Germain-en-Laye to inform the king in person, and it is certain that he would carry with him a gift or a token from the hand of the dead master. In this way the *Mona Lisa* or *The Virgin and Child with St. Anne* probably entered the royal collection. As an honorary Gentleman of the Bedchamber, Melzi owed an immediate duty to the king, who was as much his benefactor as Leonardo had been. He must therefore attend on the king's pleasure before any ultimate decisions could be taken. There were unresolved questions concerning the funeral and about the inheritance and about whether he would be permitted to return to Milan and about the disposition of the palace at Cloux and how long Melzi would be permitted to remain there. The death of Leonardo was a matter concerning the highest officers of the state, for Leonardo was not an ordinary mortal. He was referred to in state documents as "the first painter and engineer and architect to the king, mechanician to the state and former director of painting to the Duke of Milan." He was also referred to as *noble millanois,* though in fact he bore no title of nobility. Melzi's journey to Saint-Germain-en-Laye therefore had something of the character of an embassy from one court to another.

Since he was astute, intelligent, handsome and exceedingly well mannered, Melzi enjoyed the favor of the king, whom he had met frequently in Amboise. He succeeded in obtaining everything he desired: permission to remain at Cloux as long as he pleased, to return to Milan at a time chosen by him, and to receive a clear title to Leo-

nardo's estate. Lomazzo, in his *Rime,* tells us that "King Francis wept bitterly when he heard from Melzi that Vinci was dead."

The burial was long delayed, probably because the decision about where he should be buried was a matter of prolonged discussion. Should the bones be returned to Italy? Should he be buried in the Church of St. Florentin? Or should some more important burial place be found for him? Although the funeral services were held earlier, the actual burial took place on August 12, 1519, more than three months after his death, in the cloisters of the Royal Chapel at Amboise. The decision to bury him in the shadow of the Royal Chapel could only have been made by the king.

By the end of May most of the matters concerning the estate had been settled, and Melzi wrote at last to Leonardo's brothers in Florence. He knew how litigious they were, and he therefore gave them as little information as possible. It was a rather devious letter, sonorous and high-sounding, simultaneously expressing his grief over Leonardo's death, his indifference to Leonardo's brothers, and his sense of triumph that he was the inheritor of the estate. He wrote as follows:

> Ser Giuliano and his honorable brothers.
> I believe you have been informed of the death of Maestro Leonardo, your brother, and to me so much the best of fathers that it is impossible for me to express the anguish his death has caused me; and as long as my body holds together I shall feel perpetual unhappiness, and not without justice, since he showed me every day a deeply felt and most ardent love.
> The loss of such a man is a sorrow to everyone, for it is not in the power of nature to create his equal again. May Almighty God give him eternal rest. He departed from this present life on the 2nd day of May with all the sacraments of Holy Mother Church, and well prepared.
> Since he had in his possession a letter from the Most Christian King empowering him to make a will and leave his possessions to whomsoever he pleased, that is, *Eredes supplicantis sint regnicolae,* without which letter it would not have been possible to make a valid will and everything would have been lost, according to the custom here, at least in regard to what is owned in this country, the aforesaid Maestro Leonardo made a will which I would have sent to you if I could have found a trustworthy messenger. I await an uncle of mine who is coming to see me and will then go on to Milan. I will give it to him, and he will convey it faithfully, since I have not found any other means.
> As to what is contained in the will, in so much as concerns

your part in it, there is only this to say: the aforesaid Maestro Leonardo has deposited in Santa Maria Nuova in the hands of the Camarlingo 400 gold scudi in marked and numbered notes, bearing interest at 5 per cent, which on 16th October will have been there for 6 years, and there is also a property at Fiesole which he desires to be distributed among you. The will does not contain anything more that concerns you, *nec ultra*, except that I offer you all I possess and all my powers most speedily and most readily to do your will and I continue to recommend myself to you.

Given at Amboise the first day of June 1519.

Send me a reply through the Gondi.

<div align="center">

Tanquam fratri vestro
FRANCISCUS MENTIUS

</div>

For its purposes the letter was brilliantly written, for it conveyed the real state of affairs with ice-cold precision. It was evidently composed with the assistance of a lawyer. Melzi had no intention of permitting any litigation to arise, and he was so arranging his affairs that no litigation would be possible. When he wrote *Tanquam fratri vestro*, Just as if I were your brother, he clearly meant the reverse. He claimed an intimate relationship to Leonardo closer even than brotherhood, since he claimed openly to have received every day the expressions of Leonardo's "deeply felt and most ardent love." He uses the words *sviscerato et ardentissimo amore*. Now, *sviscerato* literally means "eviscerated" or "disemboweled." It is a strong word to describe a strong emotion, and might be translated "visceral." It is not intended to be polite, and it does not hint at a homosexual relationship. In Italian rhetoric it does suggest a relationship which is deep, unyielding, absolute. From the moment when Ser Giuliano da Vinci read these four words, he may have realized that the da Vinci family in Florence was confronted by an implacable enemy who would yield nothing to them either of wealth or possessions. In his will Leonardo had flung them the very least he could offer them with a good conscience. He would offer nothing more. His real family had consisted of Melzi, Salai, his two servants, and perhaps the King of France.

Melzi's concluding words in the letter have a characteristically Milanese thrust. "The will does not contain anything more that concerns you," he says, dismissing them altogether from the picture. Then with excessive politeness he offers them "all I possess and all my powers most speedily and most readily to do your will," although he has not the slightest intention of doing so. It is a masterful letter written by a master to servants.

"Send me a reply through the Gondi." The Florentine merchants had their agents in Paris, and private citizens could sometimes make use of the merchants' couriers. All through his life Leonardo probably made use of Gondi couriers, for in his youth he had known Giuliano Gondi, Il Magnifico, the merchant prince with agents all over the world, who had been a close friend of his father. The sign of the golden battle-ax was familiar to him in Florence, and now that he was dead, the Gondis still acted as the messengers of his desires and intentions.

For a few more weeks Melzi remained at Cloux, clearing up his affairs. He was still there at the end of August, for there survives a deposition made by the servant Battista de Vilanis at Amboise on August 29, 1519, concerning the property that Leonardo had left to him. He describes himself as "the servant of the nobleman Messer Francesco de Melzo, gentleman of Milan and pensioner of our lord the King," and he makes an official request that "the noble and magnificent Messer Heironymo de Melzo, gentleman residing in Milan" will superintend the division of the property in Milan which has been bequeathed to Salai and himself. Hieronymo de Melzo is Gerolamo Melzi, young Melzi's father. Presumably there was some urgency in the matter, and Battista de Vilanis was anxious to secure his property. He remained in France for as long as he was needed to make an inventory of Leonardo's estate and to prepare the crates, and then with Melzi and Maturina and with treasure chests filled with Leonardo's paintings, drawings, and manuscripts, returned to Milan before winter set in.

The site of Leonardo's grave is unknown. It lies perhaps just outside the walls of St. Hubert's Chapel within the Royal Palace at Amboise. The chapel was built on a terrace close to the palace overlooking the Loire. It is very small and very delicately built in late Gothic style. In 1863, Arsène Houssaye, a French poet and a man of letters, believing that the instructions given in Leonardo's will had been carried out, and that the bones would be found in the graveyard of the ruined Church of Saint-Florentin-du-Château, excavated the graveyard and found a skeleton with a massive skull. Nearby he found fragments of a tombstone. By putting them together, he thought he could make out the letters:

EO DUS VINC

Arsène Houssaye thought he had made a happy discovery, but unfortunately he was careless with the evidence—the three fragments of stone vanished. Gathering these bones and some others together, he placed them in a coffin and arranged that they should be buried in the

west transept of the Chapel of St. Hubert and composed a curious in-
scription to be carved on the stone above the bones:

> Under this stone
> lie the bones
> gathered during excavations
> of the ancient Royal Chapel
> of Amboise,
> and it is supposed that
> among them are to be found
> the mortal remains
> of Leonardo da Vinci.

Arsène Houssaye had not excavated in the grounds of the Royal
Chapel; he had somehow deluded himself that the Church of Saint-
Florentin-du-Château was, in the time of Francis I, a royal chapel in its
own right. He had found the skeleton of a man with a massive skull,
and deluded himself that he had found Leonardo. He was a man who
rejoiced in his delusions and he liked to say that this was the supreme
discovery of his lifetime.

Wars and revolutions came; Huguenots were hanged on the palace
ramparts; the palace itself became briefly a prison. But the palace and
the Chapel of St. Hubert survived, and the mortal remains of Leo-
nardo may still be lying in the shadow of the Royal Chapel in the place
selected for them by the king who loved him, delighted in his com-
pany, and said that no wiser man had ever lived.

The Losing and Finding
of the Treasure

When Leonardo died, there remained of his lifework about twenty-five paintings, about a thousand drawings, and close to ten thousand pages of manuscript. His paintings were highly prized, and so were the few remaining cartoons on which he sketched out, with pencil and color-wash, paintings which he never completed. His drawings, except those which found their way into royal and private collections, were little known, and his manuscripts were unknown except to Melzi, his intimate friends, and the visitors who from time to time were permitted to glance at them by their sole owner. As we shall see, Melzi did very little to publish the manuscripts, although he edited a version of *The Treatise on Painting*, collating various texts and arranging them in order, before losing interest in them altogether. He stood guard over the manuscripts, kept them in the *soffitta*, or garret, of his house in Vaprio d'Adda, and never attempted to find a more secure place for

them. Leonardo had wanted his discoveries known and Melzi made only the most ineffectual efforts to see that they were known.

The fault lay in his character, for he belonged to the class of the Italian aristocracy which scarcely understands or tolerates the needs of people outside the aristocracy. A Milanese nobleman and landowner, conscious of his high birth and the power of his position, he had very little intention of exerting himself for others. He continued to paint; it was not a career but a hobby; and from time to time visiting dignitaries would be told about the great wealth of Leonardo manuscripts in his possession. So it happened that Alberto Bendidio, the Ferrarese ambassador at Milan, representing Duke Alfonso I of Ferrara, wrote to his master on March 6, 1523, an account of some jousting that had taken place in Milan and went on to draw a brief sketch of Francesco Melzi, whom he had met several times in the past but apparently did not know well. The ambassador wrote:

> . . . and since I have already mentioned the house of Melzi, I must inform Your Excellency that a brother of the man who took part in the jousting was the pupil and heir of Leonardo da Vinci, and possesses many of his secrets and all his ideas, and I have been told that he paints very well, and he has no little skill in conversation, and is a most courteous young man. I have asked him several times to come over to Ferrara. . . . I believe he has the little books of Leonardo on anatomy, and many other charming things.

Alberto Bendidio makes clear that he did not see the manuscripts, nor did he see any of Melzi's paintings, which he knew only by repute. He uses the word *creato* for "pupil," meaning that he was rather more than a pupil, almost the artistic creation of the master. This note about Francesco Melzi is clearly an afterthought to a letter concerning the very serious business of jousting, and to this afterthought we are indebted for our first news about the continued existence of the anatomical manuscripts which eventually found their way into the Royal Library at Windsor. Thereafter, until Vasari visited Milan in 1566, forty-seven years after Leonardo's death, we hear nothing more about these manuscripts.

According to Vasari, Francesco Melzi, "a beautiful and gentle old man," possessed a considerable store of Leonardo's manuscripts on art and on "the nerves, muscles, and veins," which would suggest that the anatomical manuscripts were still in his keeping together with many other manuscripts which could be included under the generic heading of "art"; these might include Leonardo's descriptions of cloud formations, water flow, aviation, and hydraulic engineering. Vasari also informs us that there were at this time "some writings by Leonardo

written in reverse characters belonging to a certain Milanese painter
———, which treat of painting and the methods of drawing and color-
ing." Unfortunately the unknown Milanese painter, who was probably
Lomazzo, had gone to Rome to see about getting these works printed,
and nothing more is known about them. There is no evidence that
Vasari examined the collection at any length, and it would appear that
he was permitted to see only a few pages of the anatomical drawings.
Francesco Melzi knew Lomazzo, who had very likely borrowed the
manuscripts from Melzi or perhaps he had borrowed a copy of the
treatise called *Trattura della Pittura,* which Melzi had been compiling
from Leonardo's rather disorganized notebooks. Vasari says that Melzi
kept his collection of manuscripts *come per reliquie,* like relics. The
implication would be that like religious relics they would be shown
very rarely and in very special circumstances.

We know very little about Melzi's life in Milan and Vaprio d'Adda
after the death of Leonardo. He vanishes into the strangely exotic
world of the Milanese aristocracy where traditions, titles, and posses-
sions are everything, and neither intelligence nor skill are demanded.
He painted a little in a leisurely fashion, he looked after his estates, he
put together the *Trattato della Pittura,* he married and had children,
who were given ancient Roman names, and made no very serious
effort to get the works of Leonardo published. They were curiosities,
treasures of unknown value, *bric-à-brac.* There is not the slightest evi-
dence that he felt duty-bound to make every effort to see that these
works of genius reached a wider public. They did not belong to him;
they belonged to humanity. And if someone had said this to him, he
would have been astonished and incredulous.

But Leonardo had been well aware of the importance of his re-
searches in anatomy and had wanted them published. He wrote on
one of the pages of his anatomical drawings, "In order that this ad-
vantage I am giving to humanity may not be lost, I am going to
describe the way of proper printing, and I beg you, my successors, not
to allow avarice to induce you to make the printing by means of
woodcuts." It was not avarice that left the works unpublished: it was
first indifference, and then the theft and scattering of the manu-
scripts, and then indifference again.

The story of the theft and scattering was told by a remarkable
Milanese engineer, Don Ambrogio Mazenta, more than a hundred
years after Leonardo's death. Mazenta was studying law in Pisa when
he was a young man, and while living in the house of Aldus Manutius
the Younger he encountered Lelio Gavardi, who had been the tutor in
the Melzi family. Gavardi's position of trust permitted him to explore
the Melzi mansion and he was one of the very few who had seen the

drawings and manuscripts left by Leonardo and knew their value. Francesco Melzi died in 1570; his eldest son, Orazio Melzi, showed no interest in the documents: Gavardi purloined them in 1587, intending to sell them to Francesco I, the Grand Duke of Tuscany. He had chosen well, for the grand duke was one of the very few Italian princes devoted to science, with a laboratory of his own and possessing considerable skill in conducting scientific experiments. Gavardi could expect to receive a great deal of money for the stolen property, which consisted of thirteen volumes, the entire legacy of Leonardo except for a few volumes that had already been dispersed. Gavardi swept the cupboard bare.

He arrived in Florence in October 1587 only to learn that the grand duke was dying and the Grand Duchess Bianca Capello, the most beautiful woman of her time, was also dying. If Gavardi had reached Florence a month earlier, he would have been a rich man and the greater part of Leonardo's manuscripts and drawings would have remained for all time in Florence.

It was at this time, in the winter of 1587, that Gavardi came to Pisa, staying with Manutius. One day he confessed that he had purloined the manuscripts and desired to make amends by returning them to Orazio Melzi. He dared not do this himself and asked Mazenta to do this service for him. Accordingly, sometime in the following year Mazenta carried the manuscripts to Vaprio d'Adda and presented them to their rightful owner only to discover that he had not the slightest interest in them. "He was amazed that I had gone to all this trouble and gave me a present of the manuscripts, saying that he had many other drawings by the same artist, which for many years had been lying neglected in some chests in the attic." The fate of the greater part of the treasure now lay in Mazenta's hands.

Unfortunately Mazenta made no effort to find a proper home for them. He regarded them as his own, to do with them as he pleased. In 1590 he entered the Barnabite Order, taking the vow of poverty and divesting himself of all his possessions. He therefore gave the treasure to his brothers, who were inordinately excited by their new possessions, frequently talked about them, and had no hesitation in relating the long and by now complicated story of how they had passed from Orazio Melzi's house to Lelio Gavardi and to Ambrogio Mazenta. The inevitable result was that the kindly Orazio Melzi was soon inundated with requests for the remnants of the Leonardo collection, which included sculptures, drawings, and anatomical designs. He gave nearly everything away, and at the time of his death only one document relating to Leonardo remained in the possession of the Melzis: this

was the official passport signed by Cesare Borgia, which still remains in the Melzi archives.

In the years immediately after 1590 there took place the great scattering of the treasure. Francesco Melzi never made an inventory and it is therefore impossible to tell how much was lost. Although Lelio Gavardi had taken the lion's share, there was enough left over for the jackals.

Among the jackals was Pompeo Leoni, the son and successor of Leone Leoni, the favorite sculptor of King Philip II of Spain. Pompeo Leoni was on a visit to Italy, and it occurred to him that King Philip would offer him a huge sum if by chance he was able to lay his hands on the manuscripts and present them to the king. He therefore set about acquiring as many volumes as possible, seeking the assistance of Orazio Melzi, begging him to use his influence to force the return of the manuscripts from Ambrogio Mazenta's brother Guido, who now owned them, or at least claimed to be their owner. Milan was at this time a dependency of the Spanish crown, and Pompeo Leoni was known to be very close to the king. He was in a position to arrange that high positions and great appointments should be granted to those who performed faithful services to the king, and Orazio Melzi, a lawyer, was told he would receive magistracies and a seat on the senate of Milan and other rewards if he would assemble all the volumes and make a solemn presentation of them to the king. According to Ambrogio Mazenta, Melzi was tempted, did everything he could to collect the volumes, sought out Guido Mazenta, and succeeded in acquiring seven volumes out of the thirteen that Lelio Gavardi had originally purloined. These seven volumes came in this way into the possession of Pompeo Leoni and were taken to Spain.

Leoni was a good but not especially imaginative sculptor, and he was an astute businessman. He was also a liar, a thief, and a bungler. It occurred to him that Leonardo's manuscripts would look better if the large sheets were put together and if drawings from various notebooks were cut out and assembled on a page. In the arranging and rearranging of the manuscripts he altered the order of the pages so successfully that it later proved to be extremely difficult to discover Leonardo's original numbering. Moreover, Leoni had no intention of offering all the manuscripts to the king. The king received the two volumes recently discovered in Madrid and known as the Madrid Codices; Leoni sold one or two other volumes quietly and kept the rest. At his death in 1608 an inventory was made, and four volumes of Leonardo's drawings and manuscripts were listed. Of these, two volumes passed into the hands of Thomas Howard, Earl of Arundel, and came to England. One of these volumes consisted of the vast collec-

tion of anatomical drawings together with a miscellaneous collection of drawings and notes made over the greater part of Leonardo's life, now in the Royal Library at Windsor. The other was the thick notebook on pure white paper now in the British Museum and known as Arundel 263. What happened to the two remaining books is unknown. As for the very large collection of drawings and notes that Leoni had assembled by appropriating pages from various notebooks, this suddenly turned up in the possession of Polidoro Calchi, Leoni's son-in-law and heir, who sold it to the Marchese Galeazzo Arconati, a famous Milanese collector, for 300 scudi. Arconati subsequently acquired eleven other manuscripts under circumstances that have never been completely explained. Unlike Pompeo Leoni, he was a man of honor and his chief desire was that these manuscripts should be preserved in Milan, where many of them were written, and in a deed drawn up on January 22, 1637, he gave the entire collection in perpetuity to the Ambrosian Library, which had been founded by his friend Cardinal Federico Borromeo.

The vicissitudes of the manuscripts were by no means over. Guido Mazenta had retained six volumes: he sold one to Cardinal Borromeo, another to the painter Ambrosio Figgini, a third to Duke Carlo Emanuele of Savoy, while the remaining three found their way into the collection of Pompeo Leoni. The volume sold to Cardinal Borromeo was given to the Ambrosian Library, which now possessed a total of thirteen volumes, and the volumes sold to Ambrosio Figgini and Duke Carlo Emanuele have vanished. The Figgini volume can be traced until about 1750, when it was owned by Joseph Smith, the English consul in Venice, but he appears to have sold it before his death, for no record of it is to be found in the inventory of his estate made in 1759. It is thought that the volume owned by Duke Carlo Emanuele may have been destroyed in the fires that took place in the Royal Library at Turin in 1667 and 1679.

From time to time other volumes mysteriously turned up, and volumes already found and believed to be anchored in famous libraries were lost again. Thus it happened that two volumes in the Ambrosiana Library mysteriously vanished. One was never seen again; the other was sold about 1750 by a certain Gaetano Caccia to Carlo Trivulzio, of the noble Milanese family, and survives today in the Royal Library at Turin, where it is known as the Codex Trivulzianus. It consists very largely of word lists and is perhaps the least interesting of all the surviving manuscripts. In 1674, Count Orazio Achinti presented the Ambrosian Library with still another volume. The library had also acquired a ten-page volume on optics, a work of unknown provenance, and was once more in possession of thirteen volumes. The crown and

summit of all these works was the large volume compiled by Pompeo Leoni, known as the Codex Atlanticus, either because of its great size or because it was mounted on heavy map paper.

The manuscripts in the Ambrosiana Library were well guarded and few people were allowed to see them. John Evelyn, the seventeenth-century English diarist, describes his visit to the library with an appropriate sense of frustration:

> Early the next morning came the learned Dr. Ferarius to visit us, and took us in his coach to see the Ambrosian Library, where Cardinal Fred. Borromeo has expended so vast a sum on this building and in furnishing it with curiosities, especially paintings and drawings of inestimable value among painters. It is a school fit to make the greatest artists. There are many rare things of Hans Breughel, and amongst them the *Four Elements*. In this room stands the glorious (boasting) inscription of Cavaliero Galeazzo Arconati, valuing his gift to the library of several drawings by Da Vinci, but these we could not see, the keeper of them being out of town and he always carrying the keys with him.

Although Evelyn was unable to see them, he knew someone who had examined them carefully. This was the Earl of Arundel, who reported that they were all small notebooks except one huge folio of four hundred leaves "full of scratches of Indians, &c." Arundel probably said "engines," not "Indians." He had in fact attempted to buy the volumes on behalf of the King of England, and the Milanese were justly proud of the fact that they had resisted all his offers. Arundel, a Roman Catholic, died in exile in Padua in 1646, and with his death the first sustained attempt to acquire Leonardo's manuscripts for England came to an end.

The English were lucky. In time four more volumes came into their possession. In 1690 the painter Giuseppe Ghezzi paid "a great sum of gold" for a manuscript that came on the market in Rome. This was a treatise on the nature and movement of water in fifteen books and seventy-two pages. In 1717 he sold the manuscript to Thomas Coke, a wealthy nineteen-year-old Englishman who was making the Grand Tour in great style. Thomas Coke later became the Earl of Leicester and built for himself a palatial residence called Holkham Hall in Norfolk, where Leonardo's manuscript, now known as the Leicester Codex, is still preserved. Finally, in the middle of the nineteenth century, three small Leonardo notebooks were bought for a trifling sum in Vienna by Lord Lytton, who gave them to his friend John Forster, who in turn bequeathed them to the Victoria and Albert Museum in London in 1876. The three notebooks contained a short treatise on

stereometry, many miscellaneous jottings, and a red chalk drawing by Leonardo of Fra Francisco Nani, general of the Franciscan Order, thus testifying once more to Leonardo's Franciscan connection.

The great, the towering, the unhoped-for find was made by Robert Dalton, George III's librarian, in a forgotten chest in Kensington Palace in London. The exact date is unknown, but since it was said to be during the very early years of the king's reign, it was probably about 1762. Dalton had no idea of the value of the treasure that had suddenly come to light. What he had found was the essence of Leonardo, a concentrated miscellany of magnificent drawings, maps, and studies of all kinds: portraits, nudes, mountains, flowers, architectural designs, grotesqueries, costumes, anatomical drawings, and nearly always, as though in the background and providing a constant setting, there was Leonardo's crisp mirror writing. Here, too, were many studies of horses and the preliminary studies for the apostles of *The Last Supper*. It was a breath-taking collection, and he seems not to have been particularly interested.

Some years passed before Dalton showed these manuscripts and drawings to someone who could appreciate them. This was William Hunter, the great eighteenth-century surgeon, who was staggered by the anatomical drawings, so beautifully and accurately drawn. "I am fully persuaded," he wrote, "that Leonardo was the best Anatomist, at that time, in the world." Those papers that had miraculously appeared from the chest "in the Buroe of His Majesty's Great Closet at Kensington" were to him a stunning revelation of a great and hitherto unknown anatomist. He made plans for reproducing these anatomical drawings to make them available to the public, but died in 1783, and nothing came of it. From time to time a few reproductions of selected drawings, badly copied, were published; Queen Victoria showed no interest in one of her greatest treasures; the Prince Consort turned over the pages in his leisurely fashion and expressed a mild interest in them. A few of the Leonardo drawings from the Royal Collection were publicly displayed for the first time in a London gallery in 1876, nearly three hundred and sixty years after Leonardo's death.

Exactly how these great works reached the chest in Kensington Palace remains unknown. It is certain that they were part of the spoils gathered by Pompeo Leoni, for there was an inscription on the cover reading: *Disegni di Leonardo da Vinci restaurati da Pompeo Leoni.* The word "restaurati" was a bad joke; he had not restored them; he had stolen them, scattered them, cut them up, pasted them on the page in the most haphazard and incompetent manner. At some later time they came into the hands of the Earl of Arundel and then in some unexplained way passed into the possession of the king.

In May 1796, Napoleon entered Milan in triumph: Leonardo's cod-
ices were included among the spoils of victory. The Codex Atlanticus
was sent to the Bibliothèque Nationale while the other twelve vol-
umes in the Ambrosiana Library were deposited in the library of the
Institut de France. Paris acquired the treasure of Milan. With the fall
of Napoleon the Codex Atlanticus was sent back to Milan, but by
some strange oversight the manuscripts in the Institut de France were
left untouched. They remain in Paris to this day.

Leonardo's manuscripts moved about, vanished, and emerged in a
mysterious fashion. One might have thought their wanderings were
over, but it was not so. In the thirties of the last century a certain
Count Guglielmo Libri, a historiographer of some note, received per-
mission to study the twelve Leonardo codices in the Institut de
France. He could not resist the temptation of stealing a few pages,
and then growing bolder, he stole 110 pages, assembled them in three
small volumes, and sold them at high prices. It would have been un-
derstandable and perhaps pardonable if he had stolen the pages in
order to replace them in the Ambrosian Library, where they legally
belonged. He sold two of the volumes to Lord Ashburnham and a
third to Count Manzoni. It was some time before the librarians at the
Institut de France learned about the missing pages. When they dis-
covered the loss, suspicion fell on Count Libri, who was the only
scholar working on the manuscripts. He slipped out of France only
just in time to avoid a trial. Nevertheless he was put on trial *in absen-
tia* and sentenced to ten years' imprisonment. Lord Ashburnham, hav-
ing bought the manuscripts in good faith, returned them to the Insti-
tut de France. Count Manzoni sold his small Codex on the Flight of
Birds to a Russian scholar, Theodor Sabachnikoff, who gave it to the
Royal Library in Turin. And since On the Flight of Birds was a docu-
ment of the first magnitude, Italy gained from the transaction.

There remained at least two codices waiting to be discovered. A
handwritten index drawn up by the chief librarian of the Royal Li-
brary in Madrid about 1825 included "Vinci, Leonardo da. *Treatise on
fortification, stability, mechanics and geometry written in reverse
handwriting, and in the years 1491 and 1493. Aa 19–20.*" The
handwritten index was later printed, and the same shelf mark ap-
peared. Unfortunately a careless copyist had written on the back of
the codices "Aa 119–120." Since there was now no correlation between
the shelf mark and the place of the volumes on the shelves, and since
no one had described the volumes at any length and therefore no one
knew what they looked like, it was generally assumed that they were
lost. From time to time someone would inquire about them, but the li-
brarians were unable to give any information at all. Finally, in 1964, a

French scholar, André Corbeau, suggested that it was very possible that the codices were in fact in the library and that their failure to come to light was due to an error in the catalogue. The wheels began to turn, but very slowly. Some months passed before Don Ramon Paz y Remolar, the director of the manuscript section of the library, found the two volumes under the shelf marks Aa 119–120. Surprisingly no official announcement was made, and it was only in 1967 that it became generally known among the scholarly community that two important Leonardo codices had been found.

This was the official version; there were other versions. According to a report in the New York *Times*, Dr. Jules Piccus, a professor of Romance languages at the University of Massachusetts, was hunting in the Madrid library for popular ballads of the medieval period when he noted a gap in the numerical sequence of catalogue cards. When he asked for books bearing the missing numbers, he was given the two manuscript volumes by Leonardo. He recognized their importance, somehow obtained microfilms of these pages which had never been published, and showed them to Dr. Ladislao Reti, who agreed that these were indeed the long-lost manuscripts of Leonardo. Dr. Reti was later employed in transcribing and translating the texts, but died in 1973 before his work was published. The five-volume edition of the Madrid Codices—two volumes of facsimiles, two of text and translation, and a brief commentary—was one of the major publishing events of 1975.

It is impossible to reconcile the various versions of the discovery of these codices. There is some reason for believing that they were found in the late 1950s and that the Madrid library authorities were deeply concerned about the best way to bring them to the world's attention, that intense rivalries arose, and that under the strain of these rivalries arrangements for exhibiting them were deadlocked. The library claims that the volumes were exhibited publicly in 1965, but if so, the exhibition was conducted so quietly that it escaped the attention of all Leonardo scholars. It is also possible that Dr. Jules Piccus found the missing volumes exactly in the way he described without knowing that they had already been found and were the object of protracted negotiations and discussions by the authorities.

It was as though, over the ages, Leonardo's manuscripts possessed a secret life of their own. They arose out of the darkness or vanished into darkness of their own will; they came to light at the right time, when they were most needed. In due course other manuscripts, long buried in libraries in Milan and northern Italy, will be discovered; and just as all over the earth the archaeologists are only just beginning to find the treasure buried in it, so we may expect to find many more

manuscripts hidden away in deep chests and forgotten hiding places.

In spite of the discovery of so much treasure, it must be admitted that the task of publishing Leonardo's works has not been carried out in a manner worthy of his genius. He asked that "this advantage I am giving to humanity" should be printed and be made available; he begged those who came after him not to permit avarice to stand in the way of their publication. In fact the manuscripts were published avariciously, in small and limited editions, at great price, and were never in any real sense made available to the public, which remains in ignorance of their astounding beauty.

Beginning with the photographic reproductions of the manuscripts in the Institut de France published by Charles Ravaisson-Mollien in the last years of the nineteenth century to the far more accurate reproduction of the Codex Atlanticus at present being made by the Centro Editoriale Giunti, these books have always been sold at a price that removes them from the common market place and keeps them in the hands of a wealthy elite. No serious effort has ever been made to bring his drawings and manuscripts to the people who have most needed them. He said of himself that he was like the man who arrives last at the fair, and because of his poverty must buy only the despised and rejected leavings of the fairground before loading them in his modest pack and marching off to sell them not in the great cities but in the mean villages, receiving only those rewards that are given by the poor. Although we may find it difficult to recognize the princely Leonardo in this description of himself, we must recognize that this is how he saw himself, exploring what no one else had troubled to explore, wandering in the mean places where no one else had troubled to wander. He thought of himself as a man who belonged to all men, not to the favored few.

They said of him that he was a man so scrupulous and indecisive, so much a prey to doubts, so Hamlet-like, that he never completed anything he began. It was not true. He drew his magnificent drawings, painted his paintings, carved his great horse, dissected the human body, created machines designed to relieve men from the sweat of labor, designed canals and cities and churches so that men should live better, filled notebook after notebook with his discoveries, and it was not from any fault of his that the notebooks should remain unpublished for nearly four hundred years. Time, neglect, wars, the perfidy of tyrants destroyed what he created, while he continued to create. His *ostinato rigore* was proof against the devilments of the world. He explored the nature of man and the world, and came to understand the earth's machinery as no one had ever understood it, and

to both man and the world he showed a grave courtesy. Thereby he ennobled knowledge and gave dignity to all the arts he pursued.

With obstinacy and rigor there went a great gentleness that is reflected in his dancing line. His eye possessed a pure lucidity. To see a painting or a drawing by Leonardo is to see through the veils, to be aware of a perfection beyond the reach of our ordinary senses. Rubens said of him that he gave every object he painted "its most appropriate and most living aspect, and exalted majesty to the point where it becomes divine." This was not merely a manner of speaking. The leap from man to majesty to divinity was accomplished between his hand and his eye. In this way he gave dignity to mankind.

Above all, he was the father of the modern age: the visionary inventor of machines, the student of flowing water, of the power that comes from water and winds and burning glasses and the sun. He saw man as the master of nature, the superb conqueror of the earth's resources. In the silence of the night, writing in his endless notebooks, he conjured up the future, and sometimes it seems that we are only the dreams of his teeming brain.

The great bird spread his wings and flew farther and higher than any man had flown before, and even today we lie in his shadow.

APPENDIX

Some Memories Concerning the Deeds of Leonardo da Vinci in Milan and Concerning His Books, by Don Ambrogio Mazenta

The Memorie of Don Ambrogio Mazenta have never previously been published in full in English, and since they provide us with one of our chief sources for understanding what happened to Leonardo's manuscripts, they are given here for the first time.

One would like to know more about Mazenta, an intelligent and kindly man, who once possessed a great store of Leonardo's manuscripts and who wrote this wryly humorous account of how they slipped out of his hands. He was a Milanese who began life as a lawyer and then became an engineer. He built fortifications in Livorno and wrote a book on the navigation of the river Adda. In 1590 he abandoned his engineering career and entered the Barnabite Order, a missionary organization centering upon the Church of St. Barnabas in Milan. The missionaries were known as "Clerics Regular of St. Paul," and their chief tasks were to study the Pauline epistles and succor the multitudes reduced to misery by the wars.

Mazenta begins his Memorie with the statement that the events he is about to relate happened about fifty years before. Since Francesco Melzi died in 1570, and Leonardo's manuscripts then passed into the possession of his son, Orazio Melzi, we may assume that Mazenta came upon the manuscripts about the year 1575 and wrote this account about the year 1625. He died at a great age ten years later.

About fifty years ago there fell into my hands thirteen books by Leonardo da Vinci, some in-folio, others in-quarto, written from right to left, following the custom of the Hebrews, with well-formed characters: easy enough to read with the aid of a large mirror. I received them by accident, and they came into my possession in the following way.

I was at this time studying law at Pisa in the company of Aldus Ma-
nutius the Younger, a great lover of books, when Lelio Gavardi of
Asola, the provost of San Zeno in Pavia, and a close relative of Ma-
nutius, came to the house. He had been a teacher of humanities in the
family of Melzi known in Milan as da Vavero because this was their
town, to distinguish them from the other noble Melzis in the same
city. And he had discovered in their house in an old chest many draw-
ings, books, and documents left there by Leonardo, written by him
during the many years he stayed there as the teacher of Francesco
Melzi in the arts, and also at the orders of Duke Lodovico Sforza
known as Il Moro for the purpose of philosophizing and studying how
to overcome the difficulties encountered in diverting the river Adda,
the overflow channel and great navigable canal which is called the
Martesana, after the province and land it passes through. Thus water
is brought to Milan through two hundred miles of navigable rivers
right up to the valleys of Chiavenna and Valtellina, the lakes of Bri-
vio, Como, and Lecco, and in an infinite number of irrigations. This
was a marvelous work worthy of the genius of Leonardo, carried out
in noble rivalry with the other waterworks built two hundred years
ago at the time of the Milanese Republic, from the river Tesino to
Lake Maggiore and the valleys of the Alps in Germany, forming two
hundred more miles of navigable waterways which reach to the walls
of the city by means of locks and hydraulic devices wonderfully con-
structed by Leonardo in order to level, intercommunicate, and make
navigable the said rivers, lakes, and landscapes rendered happily pro-
ductive because they are joined to the navigation on the Po, and thus
to the sea. All this extraordinary work redounded to the immortal
memory of Leonardo, who showed by his studies how ships of 300
and 400 tons burden could rise to the height of mountains, descend
and rise or navigate on level waters, and all this by means of water
leveled and contained by locks and docks with great facility and secu-
rity.

How long Leonardo had studied this heroic project one can see in
the above-mentioned books full of beautiful observations illustrated
with drawings, on the nature, weight, motion, and swirls of water, and
on the various machines designed to regulate it, and also many other
facilities. One enjoys reading these books because of the intelligence
and erudition of the Author in Arithmetic, Geometry, Optics, Painting,
and Architecture. His observations extend to historical matters, and he
explains how the ancient locks were used by the Ptolemies of Egypt in
order to profit by the waters and the wealth of the Nile, and the won-
derful inventions discussed by Pliny and Trajan in their letters, inven-
tions devised for the project of making a navigable waterway from

Nicomedia to the sea by means of rivers and lakes, if it was not, as seems possible, that they were thinking about a similar project from Milan to Nuovocomo, which was the birthplace of this most interesting engineer.[1]

These works were notably interrupted by the war with the French and the imprisonment of Duke Lodovico Sforza, and thus for several years, to the great loss of art, Leonardo was able to enjoy his leisure and spend his days in the solitude of a beautiful and pleasant villa in Vaprio philosophizing, drawing, and writing to the benefit of all mankind, and here he also promoted his school and the Academy which had been founded under Lodovico Sforza for the purpose of cultivating excellent virtues in his nephew Giovanni Galeazzo and other Milanese noblemen, and as for the students in the afore-mentioned Academy, a most fruitful seminary of artists, they were able to achieve perfection in painting, sculpture, and architecture, and also in the engraving of crystal and precious stones, in marble, iron, and also in the art of casting gold, silver, bronze, etc.

Many of his pupils were specially distinguished in painting, to such an extent that their works were believed to be by the hand of Leonardo their Master, and valued and sold accordingly. Among these eminent ones were Francesco Melzi, Cesare da Sesto, both Milanese nobles, Bernardino Luini, Bramante and Bramantino, Marco da Oggiono, Il Borgognone, Andrea del Gobbo, excellent painter and sculptor, Giovanni Pedrino, Il Bernazzano, Il Civetta, and another of the same name, an admirable landscape painter, Gaudenzio da Novara, Il Lanino, Calisto da Lodi known as Tocagno, Il Figgino the Elder, and there were others who passed through Bergamo, Mantua, Cremona, Brescia, Verona, Venice, Parma, Correggio, Bologna, and became the masters of Lotti, Mantegna, Moretti, Montagnani, Caravaggio, Giorgione, Paolo Veronese, Soiardi, Boccaccini, Franci, Amici, Correggio, Parmegianino, Dossi, and other eminent Lombard painters. I am leaving out the schools of Venice, Florence, and Rome, all exemplifying the example and perfection of Leonardo, the prime promoter and restorer of the art of painting.

The one who studied most to imitate him was Giovanni Paolo Lomazzo, known as Il Brutto, who collected many of Leonardo's drawings, paintings, and writings, which went to enrich the gallery and museum of the Emperor Rudolf II. He was a man passionately addicted to painting, and if he had not gone blind when quite young, he would have surpassed all the rest. When he could no longer see, he gave himself up to writing about everything he had experienced and

[1] This most interesting engineer, *quel curiosissimo ingegno*, was Pliny the Younger, who constructed canals when he was governor of Bithynia.

learned about the works and writings of Leonardo, whom he had
adopted as his ideal. Annibale Fontana, the very eminent sculptor, en-
graver of cameos, crystal, precious stones, and marble, used to say he
learned everything he knew about the work of Leonardo from him.
But no one imitated him more than Luini and Cesare da Sesto unless it
was Francesco Melzi, who was his host for many years, and in whose
hands and in whose house remained the books and drawings of the
Maestro at the time when Francis I, King of France, took Leonardo to
France as the richest booty following the conquest of Milan.

When Melzi died, he would have left a small estate were it not that
he left behind many fine and finished paintings which today have
been attributed to the Maestro, and all this precious treasure re-
mained in his villa at Vavero, and his heirs, who pursued very
different tastes and interests, neglected it and soon dispersed it; thus it
was easy for the afore-mentioned Lelio Gavardi, who was the teacher
of humanities to the family, to possess himself with as much as he
pleased, and he carried thirteen volumes to Florence in the hope of re-
ceiving for them a good price from the Grand Duke Francesco, who
was eagerly seeking works of this kind, for Leonardo had acquired a
great reputation in Florence, his home town, where he lived briefly
and worked very little. But no sooner had Gavardi reached Florence
when the Grand Duke fell ill and died. He then went to Pisa and the
house of Manutius, and it was there that I told him that he had
acquired them illegally, and he agreed, and begged me, as soon as I
had completed my legal studies, to go to Milan and place them in the
hands of the Melzis. I acquitted this task in good faith, and consigned
them all to Signor Orazio Melzi, doctor-in-law, who was the head of
the family. He was amazed that I had gone to all this trouble, and
gave me a present of the manuscripts, saying that he had many other
drawings by the same artist, which for many years had been lying
neglected in some chests in the attic. Thus these books remained in
my hands and later they came into the possession of my brothers, who
making too much parade of this acquisition and the ease with which
they had come into my hands, sent many others to the same Doctor
Melzi and they ran off with drawings, molds, sculptures, anatomical
designs, and other precious relics from Leonardo's studio. One of
these fishermen was Pompeo Aretino, the son of Cavaliere Leone who
was a pupil of Buonarotti and who was in the service of Philip II,
King of Spain, for whom he made all the bronze sculptures in the Es-
corial. Pompeo promised Doctor Melzi high offices, magistratures, a
seat in the Senate in Milan if he succeeded in recovering the thirteen
volumes so that they could be offered as a gift to King Philip, who
was a lover of such curiosities. Excited by these prospects Doctor

Melzi flew to my brother's house and sought him on his knees to return this gift to him, as one Milanese colleague to another, worthy of compassion, courtesy, and great benevolence. Seven of the above-mentioned books were returned, and six remained with the Mazentas, and of these one was given to Cardinal Federico and is now in the Ambrosiana Library. It is in-folio, bound in red velvet, treats of light and shade, and is very useful to painters interested in perspective and optics. A second book was given to Ambrosio Figgini, a noble painter of his time, who left it to his heir, Ercole Bianchi, together with the rest of the contents of his studio. Urged by Duke Carlo Emanuele di Savoia, I obtained from my brother a third book and presented it to His Highness. My brother dying at some distance from Milan, the rest of the books came into the possession of the above-mentioned Pompeo Leone. And he reassembled the leaves and formed a large book out of them, which later passed to his heir Polidoro Calchi and was then sold to Signor Galeazzo Arconato for 300 scudi, and this most generous knight keeps it in his gallery, which contains a thousand other precious things. He has many times rejected the offers of His Highness of Savoy and other princes with the utmost courtesy; he has refused more than six hundred scudi for them.

I have read in these books the most learned discussions and rules for finding the center line in statues and paintings, with drawings and examples most beautifully and ingeniously set before the eyes.

He teaches how to make studios for painters, with the light proportioned to that of the sun, saying that square windows with their angles make the light false and discordant with nature.

Here he debates and decides on the famous question of the primacy of painting over sculpture by having a blind man and a fool give their judgment in favor of painting, for a most beautiful painting of men in a landscape was set before him, and when he touched it, he found it smooth and even, and marveled and could not believe there were animals, forests, mountains, valleys, and lakes until Duke Lodovico il Moro testified that it was indeed so. And when a statue was placed in front of him, he touched it and knew immediately that it represented a man. Then they summoned an idiot, and gave him brushes and blocks of clay, but he was unable to paint anything of any grace whatever, but with the clay he was able to form perfectly natural shapes of arms, legs, a face, all done perfectly after nature, and showed excellent relief.

The machines drawn by Leonardo which appear in great numbers in his books have been put to use in the region of Milan, such as weirs, locks, and gates, mostly invented by Leonardo, as for example at the so-called Arena, where the Adda and the Tesino, although they

are at different levels, provide a single highway of navigation. The Office of Works of the Duomo of Milan receives a thousand scudi a year in payment for the use of these machines, and this was a gift from Duke Lodovico Moro to pay for prayers for the soul of Beatrice d'Este, his wife; so, at any rate, reads the inscription, but I believe that it was so arranged by the governors of the Office of Works for the use of the public, something which would perhaps not have been accomplished with intelligence and diligence by the Royal Council.

A similar machine is credited to Leonardo and known as "the French one," because it was designed when they were governing the country, and by its means ships of 45 tons burden, that is, more than 90 geometric feet in length, were raised and lowered. This massive construction was built on the Adda River at vast cost many years after Leonardo, and today it has been abandoned by the city which can no longer afford it and is exhausted by the wars, and also, I believe, because the architect Giuseppe Meda has failed to understand the secrets of the Maestro by which only a certain volume of water was permitted to flow into the lock and the canal under complete control.

In the *botteghe* of the arts many machines invented by Leonardo are in use, for cutting and polishing crystal, iron, and stones, and there is one much used in the *cantine* of Milan for grinding large amounts of meat to make *cervellato*[1] with the help of a wheel turned by a boy without being troubled by flies or the stench. There are also many sawmills for cutting marble and wood, and designs for wheels and barges for sucking up the sand with the stream providing the motive power.

Rare are the paintings of this great Master in Milan, perhaps because they have been taken by the French to Fontainebleau, together with the Master himself, who painted little by reason of his persistent studies to arrive at the perfection of nature; and the painters who quickly finished their work were, he declared, insufficiently aware of natural perfection. He was also distracted by the pleasures of horsemanship and weaponry, and he was devoted to music; and he played skillfully on his fine-toned great silver lyre, and he was perhaps the inventor of the *arcicimbalo* formerly preserved in the Academy of Signor Prospero Visconti, where many of his drawings are kept.

The Last Supper painted in the great refectory of the Dominican friars in Santa Maria delle Grazie in Milan is famous. King Francis I attempted to carry it off to France, but in vain, because it was painted on a wall thirty feet square. And this precious and ideal work was ruined because it was painted in oils on a humid wall. There exists an

[1] *Cervellato* is a Milanese specialty, a sausage made of minced pork and brains.

excellent copy by Giovanni Paolo Lomazzo in the refectory of the fathers of San Girolamo al Castellazzo. In the church of San Barnabas in Milan there can be seen a smaller and finer copy made by Giovanni Pedrino during the lifetime of Leonardo, but only the heads have been finished. In the church of San Francesco there exists his painting in the Chapel of the Conception, together with other smaller paintings on the same altar. Il Vespino, a Milanese painter, made a copy which was very faithful, and if it were not for the weight of the painting it would be comparatively easy to acquire it. In Rome in the great Chapel of the Queens at San Francesco, and also on the organ, there are works by his pupils which do credit to the Maestro. It is not to be wondered at that in Milan the perfection of Leonardo is seen in the works of his pupils, or so many people believe. In the sacristy of San Celso there is a painting thought to be by Leonardo which totally destroys one of the finest works of Raphael which hangs nearby. This painting descended by hereditary right from Pius IV and was brought to Milan by St. Charles Borromeo, and was said to have cost 300 gold scudi. In San Rocco di Porto Romana there is a painting divided by columns according to the antique manner, these columns enclosing many beautiful compositions and designs; it is said to be by Leonardo but is in fact by Cesare da Sesto. Exactly the same can be said about many small paintings in private hands. The most authentic ones were those given by my brothers to Cardinal Borromeo which are now preserved among the drawings and paintings in the Ambrosiana Library. There are others in Florence which in my own time were purchased by the Grand Duke Ferdinando, but I believe them to be by Bernardino Luini. The Emperor Rudolf II possessed the best paintings, and this for the reason that they had been collected by Giovanni Paolo Lomazzo, himself a most intelligent artist, and a most studious follower of Leonardo, the first father of painting, and a most eminent practitioner of philosophical studies.

Acknowledgments

I owe a great debt to Max Raphael, Herbert Read, and Arthur Upham Pope, who were my teachers. It seemed to me that they were surprisingly alike in the intensity and range of their ideas about art. I also owe a debt to Jacob Epstein, who took me around the museums of Paris, and to André Malraux, who argued vehemently about the nature of art and the nature of revolution until I came to see that he was talking about the same thing. I owe much to Rexford Stead and by studying him learned most of what I know about Renaissance man. I am grateful to Miss A. H. Scott-Elliot of the Royal Library, Windsor Castle, for permitting me to see some of Leonardo's drawings in the royal collection. I owe most of all to Carlo Pedretti, who, learning that I wanted to write a modern life of Leonardo, invited me to his house in Los Angeles, fed me with mountains of food, gave me books, dazzled me with his talk, led me firmly by the hand to Luca Beltrami, and permitted me to carry away most of his own works on Leonardo. When my book was finally completed, he read through it and corrected most of its errors. To have worked with him is to know something about Leonardo's tender and generous spirit.

Select Bibliography

Ady, Cecilia. *A History of Milan under the Sforza*. London: Methuen, 1907.

Alberti, Leon Battista. *The Family in Renaissance Florence*. Columbia: University of South Carolina Press, 1969.

——. *On Painting*. New Haven: Yale University Press, 1966.

——. *On Painting and Sculpture*. New York: Phaidon, 1972.

——. *Ten Books on Architecture*. London: Alec Tiranti, 1965.

Anglo, Sydney. *Machiavelli: A Dissection*. London: Paladin, 1969.

Avery, Charles. *Florentine Renaissance Sculpture*. New York: Harper & Row, 1970.

Babinger, Franz. "Vier Bauvorschläge Leonardo da Vincis an Sultan Bajezid II," *Akademie der Wissenschaften zu Göttingen, Philologische-historische Klasse, Nachrichten*, No. 1, 1952.

Baring, Maurice. *Thoughts on Art and Life by Leonardo da Vinci*. Boston: Merrymount Press, 1906.

Battifol, Louis. *The Century of the Renaissance*. New York: G. P. Putnam's Sons, 1935.

Belt, Elmer. *Leonardo the Anatomist*. New York: Greenwood Publishers, 1955.

Beltrami, Luca. *Documenti e Memorie riguardanti la Vita e le Opere di Leonardo da Vinci*. Milan: Fratelli Treves, 1919.

Bérence, Fred. *Léonard de Vinci: Ouvrier de l'Intelligence*. Paris: Payot, 1938.

Blunt, Anthony. *Artistic Theory in Italy 1450–1600*. London: Oxford University Press, 1973.

Bode, Wilhelm von. *Studien über Leonardo da Vinci*. Berlin: G. Grote'sche Verlag, 1921.

Brion, Marcel, and others. *Léonard de Vinci*. Paris: Hachette, 1959.

Brizio, Anna Maria (ed.). *Scritti Scelti di Leonardo da Vinci*. Turin: Unione Tipografico, 1952.

Brown, John William. *The Life of Leonardo da Vinci*. London: William Pickering, 1828.

Brucker, Gene (ed.). *The Society of Renaissance Florence*. New York: Harper & Row, 1971.

Burckhardt, Jacob. *The Civilization of the Renaissance in Italy*. New York: Modern Library, 1954.

Calder, Ritchie. *Leonardo and the Age of the Eye*. New York: Simon & Schuster, 1970.

Cartwright, Julia. *Beatrice d'Este*. London: J. M. Dent, 1905.

——. *Isabella d'Este, Marchioness of Mantua*. New York: E. P. Dutton, 1903.

Castiglione, Baldesar. *The Book of the Courtier*. Translated by Charles S. Singleton. Garden City: Anchor Books, 1959.

Cellini, Benvenuto. *The Autobiography of Benvenuto Cellini*. New York: Modern Library, n.d.

Chamberlin, E. R. *Cesare Borgia*. London: International, 1969.

Chastel, André. *The Flowering of the Italian Renaissance*. New York: Odyssey Press, 1965.

——. *The Genius of Leonardo da Vinci*. New York: Orion Press, 1961.

Clark, Kenneth. *Leonardo da Vinci: An Account of his Development as an Artist*. Baltimore: Penguin Books, 1961.

Clark, Kenneth, and Pedretti, Carlo. *Leonardo da Vinci's Drawings at Windsor Castle*. 3 vols. New York: Phaidon, 1969.

Clogan, Paul Maurice (ed.). *Medievalia et Humanistica*. New Series, No. 1. Cleveland: The Press of Case Western Reserve University, 1970.

Cook, Herbert. *Reviews and Appreciations of Some Old Italian Masters*. London: Heinemann, 1912.

Cooper, Margaret. *The Inventions of Leonardo da Vinci*. New York: Macmillan, 1965.

Della Chiesa, Angela. *The Complete Paintings of Leonardo da Vinci*. New York: Harry N. Abrams, 1969.

Demonts, Louis. *Drawings by Leonardo da Vinci*. Paris: Albert Morancé, 1922.

Denieul-Cornier, Anne. *The Renaissance in France*. London: George Allen & Unwin, 1969.

Dobson, Austin (ed.). *The Diary of John Evelyn*. London: Macmillan, 1908.

Eissler, K. R. *Leonardo da Vinci: Psychoanalytic Notes on the Enigma*. New York: International Universities Press, 1961.

Ewart, K. Dorothea. *Cosimo de' Medici*. London: Macmillan, 1899.

Eyre, John R. *Leonardo da Vinci's 'Mona Lisa'*. London: H. Grevel, 1915.

Finger, Frances. *Catalogue of the Incunabula in the Elmer Belt Library of Vinciana*. Los Angeles: Friends of the U.C.L.A. Library, 1971.

Freud, Sigmund. *Leonardo da Vinci: A Study in Psychosexuality*. New York: Vintage Books, 1955.

Friedenthal, Richard. *Leonardo: A Pictorial Biography*. New York: Viking, 1959.

Fumagalli, Giuseppina. *Leonardo: Omo sanza Lettere*. Florence: Sansoni, 1943.

Gadol, Joan. *Leon Battista Alberti: Universal Man of the Early Renaissance.* Chicago: University of Chicago Press, 1972.

Gage, John. *Life in Italy at the Time of the Medici.* London: B. T. Batsford, 1968.

Gardner, Edmund G. *Florence and its Story.* London: J. M. Dent, 1953.

Gille, Bertrand. *The Renaissance Engineers.* London: Lund Humphries, 1966.

Goldscheider, Ludwig. *Leonardo da Vinci.* London: Phaidon, 1959.

———. *Leonardo da Vinci: Landschaften und Pflanzen.* London: Phaidon, 1952.

Gombrich, E. H. *Norm and Form.* London: Phaidon, 1971.

Gould, Cecil. *Leonardo: the Artist and the Non-Artist.* Boston: New York Graphic Society, 1975.

Grammatica, Luigi. *Le Memorie su Leonardo da Vinci di Don Ambrogio Mazenta.* Milan: Alfieri & Lacroix, 1919.

Gronau, Georg. *Leonardo da Vinci.* London: Duckworth, 1920.

Guicciardini, Francesco. *The History of Italy.* Translated by Sidney Alexander. New York: Collier Books, 1969.

Hart, Ivor B. *The Mechanical Investigations of Leonardo da Vinci.* Berkeley: University of California Press, 1963.

———. *The World of Leonardo da Vinci.* New York: Viking Press, 1961.

Heidenreich, Ludwig. *Leonardo da Vinci.* 2 vols. New York: Macmillan, 1954.

———. *Leonardo: The Last Supper.* New York: Viking, 1974.

Herlihy, David. "Tuscan Town in the Quattrocento," *Medievalia et Humanistica*, No. 1. Cleveland: Case Western Reserve University, 1970.

Hevesy, André de. *Pèlerinage avec Léonard de Vinci.* Paris: Firman-Didot, n.d.

Houssaye, Arsène. *Léonard de Vinci.* Paris: Firman-Didot, 1863.

Hurd, Arthur M. *Catalogue of Early Italian Engravings.* London: Bernard Quaritch, 1948.

Huyghe, René (ed.). *Connaissance de Léonard de Vinci.* Paris: L'Amour de l'Art, 1953.

Landucci, Luca. *A Florentine Diary.* London: J. M. Dent, 1927.

Lomatius, Paul. *Tract containing the Artes of Curios Paintings, Carvinge, Buildinge.* Translated by Richard Haydocke. Oxford: Ioseph Barnes, 1598.

Lomazzo, Gian Paolo. *Scritti sulle Arti.* 2 vols. Florence: Marchi e Bertolli, 1973, 1974.

MacCurdy, Edward. *Leonardo da Vinci's Note-Books.* New York: Empire State Book Company, 1935.

———. *The Mind of Leonardo da Vinci.* New York: Dodd, Mead & Company, 1928.

———. *The Notebooks of Leonardo da Vinci.* New York: George Braziller, 1956.

Machiavelli, Niccolò. *History of Florence and of the Affairs of Italy.* New York: Harper & Row, 1960.

———. *The Prince and the Discourses.* New York: Modern Library, 1952.

McLanathan, Richard. *Images of the Universe: Leonardo da Vinci: The Artist as Scientist.* Garden City: Doubleday, 1966.

McMahon, A. Philip. *Treatise on Painting by Leonardo da Vinci.* 2 vols. Princeton: Princeton University Press, 1956.

McMullen, Roy. *Mona Lisa: The Picture and the Myth.* Boston: Houghton Mifflin, 1975.

McMurrish, J. Playfair. *Leonardo da Vinci, The Anatomist.* Baltimore: William & Wilkins, 1930.

Mallett, Michael. *The Borgias.* London: Paladin, 1971.

Merejkowski, Dmitri. *The Romance of Leonardo da Vinci.* New York: Modern Library, 1928.

Möller, Emil. *La Gentildonna dalle Belle Mani di Leonardo da Vinci.* Bologna: Carlo Pedretti, 1954.

Monti, Raffaele. *Leonardo da Vinci.* New York: Grosset & Dunlap, 1967.

Morison, Stanley. *Fra Luca de Pacioli of Borgo S. Sepolcro.* New York: Grolier Club, 1933.

Müntz, Eugène. *Leonardo da Vinci: Artist, Thinker and Man of Science.* 2 vols. London: William Heinemann, 1898.

Musée du Louvre. *Hommage à Léonard de Vinci.* Paris: Editions des Musées Nationaux, 1952.

Nicodemi, Giorgio. *Leonardo da Vinci: Gemälde, Zeichningen, Studien.* Zurich: Fretz & Wasmuth, 1959.

Nicodemi, Giorgio, and others. *Leonardo da Vinci.* New York: Reynal & Company, 1956.

Noyes, Ella. *The Story of Milan.* London: J. M. Dent, 1926.

O'Malley, Charles D., and Saunders, J. B. de C. M. *Leonardo da Vinci on the Human Body.* New York: Henry Schuman, 1952.

O'Malley, Charles D. (ed.). *Leonardo's Legacy: An International Symposium.* Berkeley: University of California Press, 1969.

Origo, Iris. *The Merchant of Prato.* New York: Alfred A. Knopf, 1957.

Orlandi, Enzo (ed.). *The Life and Times of Leonardo.* Philadelphia: Curtis Publishing Company, 1965.

Passavant, G. *Verrocchio: Sculpture, Paintings and Drawings.* London: Phaidon, 1969.

Pater, Walter. *The Renaissance: Studies in Art and Poetry.* London: Jonathan Cape, 1928.

Payne, Robert. *The Deluge: A Novel by Leonardo da Vinci.* New York: Twayne Publishers, 1954.

Pedretti, Carlo. *A Chronology of Leonardo da Vinci's Architectural Studies after 1550.* Geneva: Librairie E. Droz, 1962.

———. *Disegni di Leonardo da Vinci e della sua scuola alla Biblioteca Reale di Torino.* Florence: Giunti Barbèra, 1975.

———. "La Verruca," *Renaissance Quarterly.* Winter, 1972.

———. *Leonardo: A Study in Chronology and Style.* London: Thames and Hudson, 1973.

———. "Dessins d'une Scène, exécutés par Léonard de Vinci pour Charles

d'Amboise," *Le Lieu Théatral à la Renaissance*. Paris: Editions du Centre Nationale de la Recherche Scientifique, 1964.

——. *Fragments at Windsor Castle from the Codex Atlanticus*. London: Phaidon, 1957.

——. *Leonardo da Vinci Inedito*. Florence: G. Barbèra, 1968.

——. *Leonardo da Vinci: On Painting*. London: Peter Owen, 1965.

——. *Literary Works of Leonardo da Vinci: A Commentary on J. P. Richter's Edition*. 2 vols. Berkeley: University of California Press, 1977.

——. *Studi Vinciani: Documenti, Analisi e Inediti leonardeschi*. Geneva: Librairie E. Droz, 1957.

——. "The Sforza Sculpture." Unpublished article.

——. *Uno "Studio" per la Gioconda*. Milan: L'Arte, 1959.

Philipson, Morris (ed.). *Leonardo da Vinci: Aspects of the Renaissance Genius*. New York: George Braziller, 1966.

Popham, A. E. *The Drawings of Leonardo da Vinci*. New York: Reynal & Hitchcock, 1945.

Posner, K. W. G. *Leonardo and Central Italian Art 1515–1550*. New York: New York University Press, 1974.

Pouzina, I. V. *La Chine, l'Italie et les Débuts de la Renaissance*. Paris: Les Editions de l'Art et d'Histoire, 1935.

Ramsden, E. H. *The Letters of Michelangelo*. 2 vols. Stanford: Stanford University Press, 1963.

Reti, Ladislao (ed.). *The Madrid Codices*. 5 vols. New York: McGraw-Hill, 1974.

——. *The Unknown Leonardo*. New York: McGraw-Hill, 1974.

Reti, Ladislao, and Dibner, Bern. *Leonardo da Vinci: Technologist*. Norwalk; Burndy Library, 1969.

Richter, Irma. *Selections from the Notebooks of Leonardo da Vinci*. London: Oxford University Press, 1952.

——. *Paragone: A Comparison of the Arts by Leonardo da Vinci*. London: Oxford University Press, 1949.

Richter, Jean Paul. *Leonardo da Vinci*. London: Sampson Low, Marston and Co., n.d.

——. *The Literary Works of Leonardo da Vinci*. 2 vols. New York: Phaidon, 1970.

Rigaud, John Francis. *A Treatise on Painting by Leonardo da Vinci*. London: J. Taylor, 1802.

Ross, James, and McLaughlin, Mary. *The Portable Renaissance Reader*. New York: Viking, 1968.

Rud, Einar. *Vasari's Life and Lives*. Princeton: D. Van Nostrand Company, 1963.

Schevill, Ferdinand. *History of Florence*. New York: Frederick Ungar, 1961.

Séailles, Gabriel. *Léonard de Vinci*. Paris: Henri Laurens, n.d.

Seidlitz, Woldemar von. *Leonardo da Vinci der Wendepuncte der Renaissance*. 2 vols. Berlin: Julius Bard, 1909.

Seward, Desmond. *Prince of the Renaissance: The Life of François I*. London: Cardinal, 1974.

Seymour, Charles. *The Sculpture of Verrocchio.* Greenwich: New York Graphic Society, 1977.

——. *Michelangelo's David: A Search for Identity.* Pittsburgh, University of Pittsburgh Press, 1967.

Sizeranne, Robert de la. *Beatrice d'Este et sa cour.* Paris: Hachette, 1923.

Solmi, Edmondo. *Leonardo (1452–1519).* Florence: G. Barbèra, 1907.

——. *Scritti Vinciani.* Florence: La Voce, 1924.

Steinberg, Leo. "Leonardo's Last Supper," *The Art Quarterly,* No. 4, 1973.

Stokes, Adrian. *The Quattro Cento.* London: Faber & Faber, 1932.

Thiis, Jens Peter. *The Florentine Years of Leonardo and Verrocchio.* Translated by Jessie Muir. London: H. Jenkins, 1913.

Toni, G. B. de. *Giambattista Venturi e la sua Opera Vinciana.* Rome: P. Maglione, 1924.

Trevelyan, Janet. *A Short History of the Italian People.* New York: Pitman, 1956.

Valentiner, W. R. (ed.). *Leonardo da Vinci: Loan Exhibition.* Los Angeles: Los Angeles County Museum, 1949.

Valeri, Francesco Malaguzzi. *La Corte di Lodovico il Moro.* 4 vols. Milan: Hoepli, 1915.

——. *Leonardo da Vinci e la Scultura.* Bologna: Nicola Zanichelli, n.d.

Valéry, Paul. *Leonardo Poe Mallarmé.* Princeton: Princeton University Press, 1972.

Vallentin, Antonina. *Leonardo da Vinci: The Tragic Pursuit of Perfection.* New York: Grosset & Dunlap, 1938.

Vaughan, Herbert M. *Studies in the Italian Renaissance.* London: Methuen, 1924.

Walker, John. "Ginevra de' Benci by Leonardo da Vinci." Report and Studies in the History of Art 1967. Washington: U.S. Government Printing Office, 1967.

Wallace, Robert. *The World of Leonardo.* New York: Time Incorporated, 1966.

Wasserman, Jack. *Leonardo da Vinci.* New York: Harry N. Abrams, 1975.

Zubov, V. P. *Leonardo da Vinci.* Cambridge: Harvard University Press, 1968.

Chapter Notes

References have been given in an abbreviated form. Luca Beltrami's *Documenti e Memorie* = B, Edward MacCurdy's *The Notebooks* = M, and Richter's *The Literary Works* = R. Beltrami gives Vasari's account of Leonardo at B, 260 and all references to Vasari are included under this number.

132	I regret very much . . .	B, 93
134	Having today seen . . .	B, 88
134	Most Illustrious . . .	B, 89
135	*Rara huic forma* . . .	B, 210
136	Cover up the boards . . .	Pedretti, *Literary Works*, 1,122–1,126d
139	The presence that rises . . .	Clark, Leonardo, p. 110
139	Leonardo undertook to paint . . .	B, 260
142	*Quel bon pittor* . . .	Pedretti, *Uno Studio*, Illustration 21
145	*fatto per la stufa* . . .	Pedretti, *Literary Works*, 752
147	A portrait as large as life . . .	Müntz, II, 158
148	My Most Illustrious . . .	B, 85
149	"the most illustrious prince . . .	B, 90
151	*Così Leonardo parea* . . .	B, 263
153	One of them was a most beautiful . . .	B, 263
153	He did not intend to reproduce . . .	B, 263
154	"entirely nude . . .	B, 263
155	"he sits in great ease . . .	McMahon, I, p. 37
156	"Alone you are all yourself . . .	M, p. 886
156	"The painter who imitates . . .	R, I, 512
157	*Se 'l Petrarca* . . .	M, p. 1,058
158	On the duello, see Toni,	p. 204
158	I am myself a practicer . . .	R, I, 39
161	No painter ought to think . . .	Ramsden, II, p. 75
166	My most illustrious Lords . . .	Pedretti, *Literary Works*, 1,057
167	Most illustrious Lady . . .	Müntz, II, 110
168	"Giorgione saw and greatly admired . . .	B, 260
169	The governor of the Castello . . .	B, 100
175	When he returned . . .	B, 260
177	Seeing that there exists . . .	B, 111
178	Today I was received . . .	B, 112
179	Here follows the copy . . .	Babinger, 1 f.
180	"Bridge from Pera . . .	Richter, II, 1,109
181	Caesar Borgia of France . . .	B, 117
183	"The Duke is a man of splendor . . .	Chamberlin, p. 60
183	"Columbarium at Urbino . . .	M, p. 1,158
184	"On August 1, 1502 . . .	M, p. 1,158
184	"On St. Mary's day . . .	M, p. 1,158
187	"Vante the miniaturist . . .	M, p. 1,158
187	"a pair of rose-colored . . .	M, p. 1,159
187	Leonardo da Vinci, himself . . .	Pedretti, "La Verruca," p. 417
188	Yesterday Alessandro . . .	B, 126
189	Florentines: Neri . . .	B, 138
192	"it lasted for four hours . . .	Machiavelli, *History*, p. 253
195	Since we have learned . . .	Cartwright, *Isabella d'Este*, I, 88
195	Most Reverend Father . . .	B, 106
196	Most illustrious . . .	B, 107
197	Most illustrious . . .	B, 108

Index